DAVID BUSCH'S
PANASONIC
LUMIX® DMC-GF1

GUIDE TO DIGITAL PHOTOGRAPHY

David D. Busch | Dan Simon

Course Technology PTR

A part of Cengage Learning

COURSE TECHNOLOGY
CENGAGE Learning™

Australia, Brazil, Japan, Korea, Mexico, Singapore, Spain, United Kingdom, United States

COURSE TECHNOLOGY
CENGAGE Learning™

David Busch's Panasonic Lumix® DMC-GF1 Guide to Digital Photography
David D. Busch | Dan Simon

Publisher and General Manager, Course Technology PTR:
Stacy L. Hiquet

Associate Director of Marketing:
Sarah Panella

Manager of Editorial Services:
Heather Talbot

Marketing Manager:
Jordan Castellani

Executive Editor:
Kevin Harreld

Project Editor:
Jenny Davidson

Technical Reviewer:
Michael D. Sullivan

Interior Layout Tech:
Bill Hartman

Cover Designer:
Mike Tanamachi

Indexer:
Katherine Stimson

Proofreader:
Sara Gullion

For product information and technology assistance, contact us at
Cengage Learning Customer & Sales Support, 1-800-354-9706.

For permission to use material from this text or product, submit all requests online at **cengage.com/permissions**. Further permissions questions can be e-mailed to **permissionrequest@cengage.com**.

All images © David D. Busch unless otherwise noted.

Panasonic and Lumix are registered trademarks of Panasonic Corporation.

All other trademarks are the property of their respective owners.

Library of Congress Control Number: 2010925131

ISBN-13: 978-1-4354-5738-6

ISBN-10: 1-4354-5738-2

Course Technology, a part of Cengage Learning
20 Channel Center Street
Boston, MA 02210
USA

Cengage Learning is a leading provider of customized learning solutions with office locations around the globe, including Singapore, the United Kingdom, Australia, Mexico, Brazil, and Japan. Locate your local office at: **international.cengage.com/region**.

Cengage Learning products are represented in Canada by Nelson Education, Ltd.

For your lifelong learning solutions, visit **courseptr.com**.

Visit our corporate Web site at **cengage.com**.

Printed in the United States of America
1 2 3 4 5 6 7 12 11 10

For Cathy and Lisa

Acknowledgments

Once again, thanks to the folks at Course Technology PTR, who recognize that a camera as popular as the Panasonic Lumix DMC-GF1 deserves in-depth full-color coverage at a price anyone can afford. Special thanks to executive editor Kevin Harreld, who always gives me the freedom to let my imagination run free with a topic, as well as my veteran production team, including project editor Jenny Davidson and technical editor Mike Sullivan. Also thanks to Bill Hartman, layout; Katherine Stimson, indexing; Sara Gullion, proofreading; Mike Tanamachi, cover design; and my agent, Carole Jelen, who has the amazing ability to keep both publishers and authors happy.

—David Busch

Thanks to my best friend and wife, Lisa, whose love, support, and encouragement provides my inspiration and enthusiasm. Thanks, too, to my friend and graphic artist, Karissa Demi and the people who were nice enough to pose for me for many of the illustrations in this book. Tom Roberts, Heather Malikowski, Elise LeMay, Krissy the Pink Haired Waitress, Karina Balfour, Devon Winfrey, Cassie, Amanda Scull, Christa McL, and, especially, Meghan Angelos. I'd also like to thank Longwood Gardens in Kennett Square, PA, and the Grand Canyon Railway in Williams, AZ, for the help they've given me on many of these projects.

—Dan Simon

About the Authors

With more than a million books in print, **David D. Busch** is the world's #1 selling digital camera guide author, and the originator of popular digital photography series like *David Busch's Pro Secrets* and *David Busch's Quick Snap Guides*. He has written eleven hugely successful guidebooks for Panasonic digital SLR models, and nearly a dozen additional user guides for other camera models, as well as many popular books devoted to dSLRs, including *Mastering Digital SLR Photography, Second Edition* and *Digital SLR Pro Secrets*. As a roving photojournalist for more than 20 years, he illustrated his books, magazine articles, and newspaper reports with award-winning images. He's operated his own commercial studio, suffocated in formal dress while shooting weddings-for-hire, and shot sports for a daily newspaper and upstate New York college. His photos have been published in magazines as diverse as *Scientific American* and *Petersen's PhotoGraphic*, and his articles have appeared in *Popular Photography & Imaging, The Rangefinder, The Professional Photographer*, and hundreds of other publications. He's also reviewed dozens of digital cameras for CNet and *Computer Shopper*. His advice has been featured on National Public Radio's *All Tech Considered*.

When About.com named its top five books on Beginning Digital Photography, debuting at the #1 and #2 slots were Busch's *Digital Photography All-In-One Desk Reference for Dummies* and *Mastering Digital Photography*. During the past year, he's had as many as five of his books listed in the Top 20 of Amazon.com's Digital Photography Bestseller list—simultaneously! Busch's 100-plus other books published since 1983 include bestsellers like *David Busch's Quick Snap Guide to Using Digital SLR Lenses*.

Busch earned top category honors in the Computer Press Awards the first two years they were given (for *Sorry About The Explosion* and *Secrets of MacWrite, MacPaint and MacDraw*), and he later served as Master of Ceremonies for the awards. Visit his website at http://www.nikonguides.com.

Dan Simon is an adjunct professor in the Culture and Communications Department at the College of Arts and Sciences at Drexel University. He teaches courses on a wide variety of topics, including online journalism, fundamentals of journalism, public relations, public speaking, desktop publishing, electronic publishing, professional presentations, business and technical communications, mass media and society, and principles of communication. He has also taught courses in camera techniques and digital photography for East Stroudsburg University, desktop publishing and basic composition for Gloucester County College, and introduction to communications media and introduction to computer arts and digital photography for Salem Community College.

Simon has more than 30 years of experience as a writer and photographer. His published works include the *Digital Photography Bible Desktop Edition* (John Wiley and Sons

Publishing), *Digital Photography All-in-One* (Wiley), and *Digital Photos, Movies, & Music Gigabook for Dummies* (Wiley), *David Busch's Quick Snap Guide to Photo Gear,* and *David Busch's Olympus PEN E-P2 Guide to Digital Photography.* He is also a regular contributor to the *Growing Edge Magazine* (hydroponics) and *PENnsylvania Magazine* (regional, travel).

He began his career as a Navy journalist with assignments aboard several ships, and in Norfolk, Virginia; Dededo, Guam; and McMurdo Station, Antarctica. He has traveled to all seven continents and photographed many of America's scenic and wild places. Dan also serves as a guest lecturer for Norwegian Cruise Line, the Delta Queen Steamboat Company, and Royal Caribbean International.

Contents

Chapter 2
Panasonic Lumix DMC-GF1 Roadmap 37

Chapter 3
Setting Up Your Panasonic Lumix DMC-GF1 59

Chapter 4
Fine-Tuning Exposure 111

Chapter 5
Advanced Shooting Tips for Your
Panasonic Lumix DMC-GF1 139

Chapter 6
Working with Lenses 179

Chapter 7
Making Light Work for You 211

Chapter 8
Useful Software for the Panasonic Lumix DMC-GF1 249

Chapter 9
Panasonic Lumix DMC-GF1: Troubleshooting and Prevention 261

Glossary 285

Index 297

Preface

You don't want good pictures from your new Panasonic Lumix DMC-GF1—you demand *outstanding photos*. After all, the GF1 is the most compact interchangeable lens digital camera that Panasonic has ever introduced. It boasts 12 megapixels of resolution, an array of tiny, virtually pocket-sized lenses, and enough sophisticated features and customization options to please the most avid amateur photographer. But your gateway to pixel proficiency is dragged down by the slim little pamphlet included in the box as a manual.

You know that most of what you need to know is in there, somewhere, but you don't know where to start. In addition, the "official" camera manual doesn't offer much information on photography or digital photography. Nor are you interested in spending hours or days studying a comprehensive book on digital SLR photography that doesn't necessarily apply directly to your GF1.

What you need is a guide that explains the purpose and function of the GF1's basic controls, how you should use them, and *why*. Ideally, there should be information about file formats, resolution, aperture/priority exposure, and special autofocus modes, but you'd prefer to read about those topics only after you've had the chance to go out and take a few hundred great pictures with your new camera. Why isn't there a book that summarizes the most important information in its first two or three chapters, with lots of illustrations showing what your results will look like when you use this setting or that?

If you can't decide on what basic settings to use with your camera because you can't figure out how changing ISO or white balance or focus defaults will affect your pictures, you need this guide. I won't talk down to you, either; this book isn't padded with dozens of pages of checklists telling you how to take a travel picture, a sports photo, or how to take a snapshot of your kids in overly simplistic terms. There are no special sections devoted to "real world" recipes here. All of us do 100 percent of our shooting in the real world! So, I give you all the information you need to cook up great photos on your own!

Introduction

Panasonic has done it again! The company has packaged up many of their most allur-
ing Four Thirds-format features in an advanced digital non-SLR that eschews the bulky
mirror box to allow designing a camera that uses super-compact Micro Four Thirds
lenses. Yet, the Panasonic Lumix DMC-GF1 also accepts full-size (but still compact)
Four Thirds lenses, plus a host of other optics available from other manufacturers (when
used with an adapter).

Even so, the GF1 retains the ease of use that smoothes the transition for those new to
digital photography. For those just dipping their toes into the digital pond, the experi-
ence is warm and inviting. The Panasonic Lumix DMC-GF1 isn't a snapshot camera—
it's a point-and-shoot (if you want to use it in that mode) for the thinking photographer,
who desires lens interchangeability and more advanced options.

But once you've confirmed that you made a wise purchase decision, the question comes
up, *how do I use this thing?* All those cool features can be mind numbing to learn, if all
you have as a guide is the manual furnished with the camera. Help is on the way. I sin-
cerely believe that this book is your best bet for learning how to use your new camera,
and for learning how to use it well.

If you're a Panasonic Lumix DMC-GF1 owner who's looking to learn more about how
to use this great camera, you've probably already explored your options. I expect that as
the popularity of this camera grows, there will be DVDs and online tutorials available—
but who can learn how to use a camera by sitting in front of a television or computer
screen? Do you want to watch a movie or click on HTML links, or do you want to go
out and take photos with your camera? Videos are fun, but not the best answer.

There's always the manual furnished with the GF1. It's compact and filled with infor-
mation, but there's really very little about *why* you should use particular settings or fea-
tures, and its organization may make it difficult to find what you need. Multiple
cross-references may send you flipping back and forth between two or three sections of
the book to find what you want to know. The basic manual is also hobbled by black-
and-white line drawings and tiny monochrome pictures that aren't very good examples
of what you can do.

I've tried to make *David Busch's Panasonic Lumix DMC-GF1 Guide to Digital Photography* different from your other GF1 learn-up options. My first step was to enlist the aid of Dan Simon, a veteran professional photographer and educator who has helped as co-author of some of my previous books, and who, actually, made me aware of the GF1 long before it appeared on my own radar.

We both got to work making this book something special. The roadmap sections use larger, color pictures to show you where all the buttons and dials are, and the explanations of what they do are longer and more comprehensive. We've tried to avoid overly general advice, including the two-page checklists on how to take a "sports picture" or a "portrait picture" or a "travel picture." Instead, you'll find tips and techniques for using all the features of your Panasonic Lumix DMC-GF1 to take *any kind of picture* you want. If you want to know where you should stand to take a picture of a quarterback dropping back to unleash a pass, there are plenty of books that will tell you that. This one concentrates on teaching you how to select the best autofocus mode, shutter speed, or f/stop to take, say, a great sports picture under any conditions.

This book is not a lame rewriting of the manual that came with the camera. Some folks spend five minutes with a book like this one, spot some information that also appears in the original manual, and decide "Rehash!" without really understanding the differences. Yes, you'll find information here that is also in the owner's manual, such as the parameters you can enter when changing your GF1's operation in the various menus. Basic descriptions—before I dig in and start providing in-depth tips and information—may also be vaguely similar. There are only so many ways you can say, for example, "Hold the shutter release down halfway to lock in exposure."

David Busch's Panasonic Lumix DMC-GF1 Guide to Digital Photography is aimed at both Panasonic and dSLR veterans as well as newcomers to digital photography and interchangeable lens digital cameras. Both groups can be overwhelmed by the options the GF1 offers, while underwhelmed by the explanations they receive in their user's manual. The manuals are great if you already know what you don't know, and you can find an answer somewhere in a booklet arranged by menu listings and written by a camera vendor employee who last threw together instructions on how to operate a camcorder.

Once you've read this book and are ready to learn more, I hope you pick up one of my other guides to digital SLR photography. Four of them are offered by Course Technology PTR, each approaching the topic from a different perspective. They include:

Quick Snap Guide to Digital SLR Photography
Although the Lumix DMC-GF1 isn't a single lens reflex, it does have interchangeable lenses, and there is a lot in this book that will help someone who is graduating to the GF1 from a point-and-shoot camera. Consider this a prequel to the book you're holding in your hands. It might make a good gift for a spouse or friend who may be using

your GF1, but who lacks even basic knowledge about digital photography, interchangeable lens photography, and Panasonic photography. It serves as an introduction that summarizes the basic features of digital cameras in general (not just the GF1), and what settings to use and when, such as continuous autofocus/single autofocus, aperture/shutter priority, EV settings, and so forth. The guide also includes recipes for shooting the most common kinds of pictures, with step-by-step instructions for capturing effective sports photos, portraits, landscapes, and other types of images.

David Busch's Quick Snap Guide to Using Digital SLR Lenses

A bit overwhelmed by the features and controls of interchangeable lenses, and not quite sure when to use each type? This book explains lenses, their use, and lens technology in easy-to-access two- and four-page spreads, each devoted to a different topic, such as depth-of-field, lens aberrations, or using zoom lenses. If you have a friend or significant other who is less versed in photography, but who wants to borrow and use your Panasonic Lumix DMC-GF1 from time to time, this book can save you a ton of explanation.

Mastering Digital SLR Photography, Second Edition

This book is an introduction to digital photography with interchangeable lens cameras, with nuts-and-bolts explanations of the technology, more in-depth coverage of settings, and whole chapters on the most common types of photography. While not specific to the GF1, this book can show you how to get more from its capabilities.

Digital SLR Pro Secrets

This is my more advanced guide to photography with greater depth and detail about the topics you're most interested in. If you've already mastered the basics in *Mastering Digital SLR Photography*, this book will take you to the next level. Again, even though the Lumix DMC-GF1 isn't an SLR, you'll find lots of interest in this book.

Family Resemblance

If you've owned previous models in the Panasonic digital camera line, and copies of my books for digital cameras, you're bound to notice a certain family resemblance. The features and menus of the GF1 are very similar to those of previous Panasonic Four Thirds and Micro Four Thirds format digital cameras, but with new capabilities and options. You benefit in two ways. If you used a Panasonic camera prior to acquiring the latest GF1 model, you'll find that parts that haven't changed have a certain familiarity for you, making it easy to transition to the newest model. There are lots of features and menu choices of the GF1 that are very similar to those in the most recent models. This family resemblance will help level the learning curve for you.

Similarly, when writing books for each new model, I try to retain the easy-to-understand explanations that worked for the earlier cameras, and concentrate on expanded descriptions of things readers have told me they want to know more about, a solid helping of fresh sample photos, and lots of details about the latest and greatest new features. Rest assured, this book was written expressly for you, and tailored especially for the GF1.

Who Are You?

When preparing a guidebook for a specific camera, it's always wise to consider exactly who will be reading the book. Indeed, thinking about the potential audience for *David Busch's Panasonic Lumix DMC-GF1 Guide to Digital Photography* is what led me to taking the approach and format I use for this book. I realized that the needs of readers like you had to be addressed both from a functional level (what you will use the GF1 for) as well as from a skill level (how much experience you may have with digital photography, dSLRs, or Panasonic cameras specifically).

From a functional level, you probably fall into one of these categories:

- Professional photographers who understand photography and digital SLRs, and simply want to learn how to use the Panasonic Lumix DMC-GF1 as a backup camera, or as a camera for their personal "off-duty" use.

- Individuals who want to get better pictures, or perhaps transform their growing interest in photography into a full-fledged hobby or artistic outlet with a Panasonic Lumix DMC-GF1 and advanced techniques.

- Those who want to produce more professional-looking images for their personal or business website, and feel that the Panasonic Lumix DMC-GF1 will give them more control and capabilities.

- Small business owners with more advanced graphics capabilities who want to use the Panasonic Lumix DMC-GF1 to document or promote their business.

- Corporate workers who may or may not have photographic skills in their job descriptions, but who work regularly with graphics and need to learn how to use digital images taken with a Panasonic Lumix DMC-GF1 for reports, presentations, or other applications.

- Professional webmasters with strong skills in programming (including Java, JavaScript, HTML, Perl, etc.) but little background in photography, but who realize that the GF1 can be used for sophisticated photography.

- Graphic artists and others who already may be adept in image editing with Photoshop or another program, and who may already be using a film SLR (Panasonic or otherwise), but who need to learn more about digital photography and the special capabilities of the GF1.

Addressing your needs from a skills level can be a little trickier, because the GF1 is such a great camera that a full spectrum of photographers will be buying it, from absolute beginners who have never owned a digital camera before up to the occasional professional with years of shooting experience who will be using the Panasonic Lumix DMC-GF1 as a backup body. (I have to admit I tend to carry my GF1 with me everywhere.)

Before tackling this book, it would be helpful for you to understand the following:

- **What an interchangeable lens digital camera is:** It's a camera that has lenses that can be removed and replaced with other lenses that provide wider or closer fields of view, or other special features, such as close-up focusing.

- **How digital photography differs from film:** The image is stored not on film (which I call the *first* write-once optical media), but on a memory card as pixels that can be transferred to your computer, and then edited, corrected, and printed without the need for chemical processing.

- **What the basic tools of correct exposure are:** Don't worry if you don't understand these; I'll explain them later in this book. But if you already know something about shutter speed, aperture, and ISO sensitivity, you'll be ahead of the game. If not, you'll soon learn that shutter speed determines the amount of time the sensor is exposed to incoming light; the f/stop or aperture is like a valve that governs the quantity of light that can flow through the lens; the sensor's sensitivity (ISO setting) controls how easily the sensor responds to light. All three factors can be varied individually and proportionately to produce a picture that is properly exposed (neither too light nor too dark).

It's tough to provide something for everybody, but I am going to try to address the needs of each of the following groups and skill levels:

- **Digital photography newbies:** If you've used only point-and-shoot digital cameras, or have worked only with non-SLR film cameras, you're to be congratulated for selecting one of the very best entry-level interchangeable lens digital cameras available. This book can help you understand the controls and features of your GF1, and lead you down the path to better photography with your camera. I'll provide all the information you need, but if you want to do some additional reading for extra credit, you can also try one of the other books I mentioned earlier. They complement this book well.

- **Advanced point-and-shooters moving on up:** There are some quite sophisticated pocket-sized digital cameras available, including those with many user-definable options and settings, so it's possible you are already a knowledgeable photographer, even though you're new to the world of more sophisticated cameras. You've recognized the limitations of the point-and-shoot camera: even the best of them may

have more noise at higher sensitivity (ISO) settings than a camera like the Panasonic Lumix DMC-GF1; the speediest sometimes have an unacceptable delay between the time you press the shutter and the photo is actually taken; even a non-interchangeable super-zoom camera with 12X to 20X magnification often won't focus close enough, include an aperture suitable for low-light photography, or take in the really wide view you must have. Interchangeable lenses and other accessories available for the Panasonic Lumix DMC-GF1 are another one of the reasons you moved up. Because you're an avid photographer already, you should pick up the finer points of using the GF1 from this book with no trouble.

- **Film veterans new to the digital world:** You understand photography, you know about f/stops and shutter speeds, and thrive on interchangeable lenses. If you have used a newer film camera, it probably has lots of electronic features already, including autofocus and sophisticated exposure metering. Perhaps you've even been using a film SLR or digital SLR and understand many of the available accessories that work with both film and digital cameras. All you need is information on using digital-specific features, working with the GF1 itself, and how to match—and exceed—the capabilities of your film camera with your new Panasonic Lumix DMC-GF1.

- **Experienced dSLR users broadening their experience to include the GF1:** You may have used a digital SLR from Panasonic or another vendor and are making the switch to a smaller, more compact camera. You understand basic photography, and you want to learn more. And, most of all, you want to transfer the skills you already have to the Panasonic Lumix DMC-GF1, as quickly and seamlessly as possible.

- **Pro photographers and other advanced shooters:** I expect my most discerning readers will be those who already have extensive experience with intermediate and pro-level cameras. I may not be able to teach you folks much about photography. But, even so, an amazing number of GF1 cameras have been purchased by those who feel it is a good complement to their favorite advanced dSLR. Others (like myself) own a more advanced camera and find that the GF1 fills a specific niche incredibly well, and, is useful as a backup camera, because the GF1's 12-megapixel images are often just as good as those produced by more "advanced" models. You pros and semi-pros, despite your depth of knowledge, should find this book useful for learning about the features the GF1 has that your previous cameras lack or implement in a different way.

Who Am I?

After spending years as the world's most successful unknown author, I've become slightly less obscure in the past few years, thanks to a horde of camera guidebooks and other photographically oriented tomes. You may have seen my photography articles in *Popular Photography & Imaging* magazine. I've also written about 2,000 articles for magazines like *Petersen's PhotoGraphic* (which is now defunct through no fault of my own), plus *The Rangefinder*, *Professional Photographer*, and dozens of other photographic publications. But, first, and foremost, I'm a photojournalist and made my living in the field until I began devoting most of my time to writing books. Although I love writing, I'm happiest when I'm out taking pictures, which is why I took off 11 days last year to travel out West to Zion National Park in Utah, the Sedona "red rocks" area and Grand Canyon in Arizona, and, for a few days, Las Vegas (I did a lot more shooting than gambling in Sin City). A few months later, I traveled to Prague, in the Czech Republic, and wound up my year with my biennial visit to Spain (Valencia, in October 2009). In 2010, I've already been to Ireland and am headed back to Spain in a few months for a couple weeks in Barcelona.

Over the years, I've worked as a sports photographer for an Ohio newspaper and for an upstate New York college. I've operated my own commercial studio and photo lab, cranking out product shots on demand and then printing a few hundred glossy 8 × 10s on a tight deadline for a press kit. I've served as a photo-posing instructor for a modeling agency. People have actually paid me to shoot their weddings and immortalize them with portraits. I even prepared press kits and articles on photography as a PR consultant for a large Rochester, N.Y., company, which shall remain nameless. My trials and travails with imaging and computer technology have made their way into print in book form an alarming number of times, including a few dozen on scanners and photography.

Like you, I love photography for its own merits, and I view technology as just another tool to help me get the images I see in my mind's eye. But, also like you, I had to master this technology before I could apply it to my work. This book is the result of what I've learned, and I hope it will help you master your Panasonic Lumix DMC-GF1 too.

As I write this, I'm currently in the throes of upgrading my website, which you can find at www.dslrguides.com/blog, eventually adding tutorials and information about my other books. I hope you'll stop by for a visit. You'll find comments, plus a special page devoted to errata cited by readers like yourself, providing correction for what I hope are the few typos that managed to creep into this book. You can send queries to questions@dslrguides.com.

Getting Started with Your Panasonic Lumix DMC-GF1

Panasonic's Lumix DMC-GF1 provides a winning new entry into the Micro Four Thirds camera world. This small, versatile camera captures many of the best attributes of bigger, heavier dSLRs (such as interchangeable lenses, rugged construction) and those of smaller, lighter point-and-shoot cameras (lightweight and compact, capable of fitting in a very roomy pocket). Like its point-and-shoot relatives, the GF1 is also easy to use.

Try it. Insert a memory card and mount the lens (if you bought the GF1 at a store, they probably did that for you). Charge the battery and insert it into the camera. If the lens and camera were packaged separately, mount the lens. If it's already attached, remove the lens cap, and turn on the camera. (The ON/OFF switch is located just behind the shutter release. Slide it from left to right to turn on the camera.) Then set the big ol' dial on top to the red iA (Intelligent Auto) icon. Point the GF1 at something interesting and press the shutter release. Presto! A pretty good picture will pop up on the color LCD on the back of the camera. Wasn't that easy?

Chances are though, you're probably not going to be satisfied with pretty good photos. You want to shoot *incredible* images. The GF1 can do that, too. All you need is this book and some practice. The first step is to familiarize yourself with your camera. The first three chapters of this book will take care of that. Then, as you gain experience and skills, you'll want to learn more about how to improve your exposures, fine-tune the color, or use the essential tools of photography, such as electronic flash and available

light. You'll want to learn how to choose and use lenses, too. All that information can be found in the second part of this book. The Lumix GF1 is not only easy to use, it's easy to *learn* to use, as long as you have a guide like this one to help.

As I've done with my guidebooks for previous cameras, I'm going to divide my introduction to the Panasonic Lumix DMC-GF1 into three parts. The first part will cover what you absolutely *need* to know just to get started using the camera (you'll find that in this chapter). The second part offers a more comprehensive look at what you *should* know about the camera and its controls to use its features effectively (that'll be found in Chapter 2). Finally, you'll learn how to make key settings using the menu system, so you'll be able to fine-tune and tweak the GF1 to operate exactly the way you want, in Chapter 3. While you probably should master everything in the first two chapters right away, you can take more time to learn about the settings described in Chapter 3, because you won't need to use all those options right away. I've included everything about menus and settings in that chapter so you'll find what you need, when you need it, all in one place.

Some of you may have owned a Panasonic digital camera before. Perhaps you owned a Panasonic Lumix DMC-G1, or one of the FZ or FP point-and-shoot cameras, enjoyed using it, and wanted more megapixels and some of the added features the GF1 offers. Maybe you even own another manufacturer's Four Thirds or Micro Four Thirds system cameras and know you can use their lenses on the GF1. You'll need an adapter to use a Four Thirds lens on a GF1, but not for another manufacturer's Micro Four Thirds lens. (I'll explain the difference between Four Thirds and Micro Four Thirds optics in Chapter 6.)

If you fall into any of those categories, you may be able to skim through this chapter quickly and move on to the two that follow. The next few pages are designed to get your camera fired up and ready for shooting as quickly as possible. If you're new to digital cameras or even digital photography, you'll want to read through this introduction more carefully. After all, the Panasonic GF1 is not a point-and-shoot camera, although, as I said, you can easily set it up in fully automated Auto mode, or use the semi-automated Program exposure mode and a basic autofocus setting for easy capture of grab shots. But, if you want a little more control over your shooting, you'll need to know more. So I'm going to provide a basic pre-flight checklist that you need to complete before you really spread your wings and take off. You won't find a lot of detail in this chapter. Indeed, I'm going to tell you just what you absolutely *must* understand, accompanied by some interesting tidbits that will help you become acclimated to your GF1. I'll go into more depth and even repeat some of what I explain here in later chapters, so you don't have to memorize everything you see. Just relax, follow a few easy steps, and then go out and begin taking your best shots—ever.

First Things First

This section helps get you oriented with all the things that come in the box with your Panasonic camera, including what they do. I'll also describe some optional equipment you might want to have. If you want to get started immediately, skim through this section and jump ahead to "Initial Setup" later in the chapter.

The Panasonic GF1 comes in an impressive box filled with stuff, including connecting cords, booklets, a CD, and lots of paperwork. The most important components are the camera and lens, battery, battery charger, and, if you're the nervous type, the neck strap. You'll also need a Secure Digital memory card, as one is not included. If you purchased your GF1 from a camera shop, as I did, the store personnel probably attached the neck strap for you, ran through some basic operational advice that you've already forgotten, tried to sell you a Secure Digital card, and then, after they'd given you all the help you could absorb, sent you on your way with a handshake.

Perhaps you purchased your GF1 from one of those mass merchandisers that also sell washing machines and vacuum cleaners. In that case, you might have been sent on your way with only the handshake, or, maybe, not even that if you resisted the efforts to sell you an extended warranty. You save a few bucks at the big-box stores, but you don't get the personal service a professional photo retailer provides. It's your choice. There's a third alternative, of course. You might have purchased your camera from a mail order or Internet source, and your GF1 arrived in a big brown (or purple/red) truck. Your only interaction when you took possession of your camera was to scrawl your signature on an electronic clipboard.

In all three cases, the first thing to do is to carefully unpack the camera and double-check the contents against the standard accessories list on page nine of the user manual. While this level of setup detail may seem as superfluous as the instructions on a bottle of shampoo, checking the contents *first* is always a good idea. No matter who sells a camera, it's common to open boxes, use a particular camera for a demonstration, and then repack the box without replacing all the pieces and parts afterwards. Someone might actually have helpfully checked out your camera on your behalf—and then mis-packed the box. It's better to know *now* that something is missing so you can seek redress immediately, rather than discover two months from now that the video cable you thought you'd never use (but now *must* have) was never in the box.

At a minimum, the box should hold the following:

- **Panasonic Lumix DMC-GF1 digital camera.** It almost goes without saying that you should check out the camera immediately, making sure the color LCD on the back isn't scratched or cracked, the Secure Digital and battery doors open properly, and, when a charged battery is inserted and lens mounted, the camera powers up and reports for duty. Out-of-the-box defects like these are rare, but they can happen. It's probably more common that your dealer played with the camera or, perhaps, it was a customer return. That's why it's best to buy your GF1 from a retailer you trust to supply a factory-fresh camera.

- **Camera lens.** If you purchased your camera as a kit, then you should also have either a Lumix G20 mm F1.7 ASPH or Lumix G VARIO 14-45 F 3.5-5.6 ASPH/MEGA O.I.S. lens with it. It may also have a lens shade to go with the lens.

- **Lens storage bag.** Panasonic provides a soft bag to help protect your lens when it is not mounted on the camera.

- **Rechargeable Li-ion battery.** You'll need to charge the Panasonic DMW-BLB13PP battery before using it. I'll offer instructions later in this chapter.

- **Quick charger.** This charger is required to vitalize the DMW-BLB13PP battery.

- **AC cable.** This connects to the quick charger.

- **USB cable.** You can use this cable to transfer photos from the camera to your computer (I don't recommend that because direct transfer uses a lot of battery power), or to upload and download settings between the camera and your computer (which is highly recommended). This cable is a newer mini USB one. Panasonic recommends you only use this cable with the GF1.

- **AV cable.** This three-part cable is used to connect the camera to your television or other compatible source so you can view images directly from the camera.

- **Neck strap.** Panasonic provides you with a "steal me" neck strap emblazoned with your camera model, and while useful for showing off to your friends exactly which nifty new camera you bought, it's not very adjustable. I never attach the Panasonic strap to my cameras, and instead opt for a more serviceable strap from UPstrap (www.upstrap-pro.com) or Op-Tech (www.optechusa.com). If you carry your camera over one shoulder, as many do, I particularly recommend UPstrap (shown in Figure 1.1). It has a patented non-slip pad that offers reassuring traction and eliminates the contortions we sometimes go through to keep the camera from slipping off. I know several photographers who refuse to use anything else. If you do purchase an UPstrap, be sure to tell photographer-inventor Al Stegmeyer that I sent you hence.

Figure 1.1
Third-party
neck straps, like
this UPstrap
model, are often
preferable to the
Panasonic-
supplied strap.

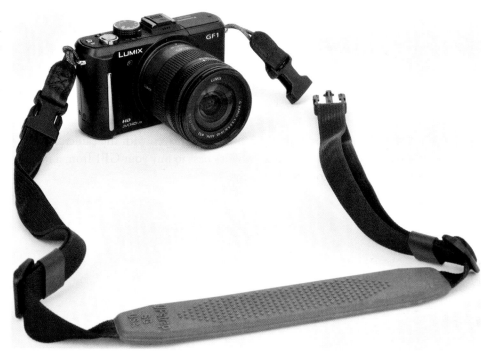

- **Body cap/rear lens cap.** The body cap keeps dust from getting into your camera when a lens is not mounted. Always carry a body cap (and rear lens cap, also supplied with the GF1) in your camera bag for those times when you need to have the camera bare of optics for more than a minute or two. (That usually happens when repacking a bag efficiently for transport, or when you are carrying an extra body or two for backup.) The body cap/lens cap nest together for compact storage.

- **User manual/Quick Guide.** The printed user manual you receive with the Panasonic GF1 is a 204-page booklet that includes basic setup and usage information. It's decent for what it does, but it makes a book like this one even more necessary.

- **Software CD-ROM.** Here you'll find the Panasonic software applications bundled for your camera. The CD holds both Mac and PC software apps. These applications provide the ability to move your files from camera or memory card to your computer and serve as useful image management and editing programs.

- **Warranty and registration card.** Don't lose these! You can register your Panasonic GF1 by mail or online and may need the information in this paperwork (plus the purchase receipt/invoice from your retailer) should you require Panasonic service support.

Don't bother rooting around in the box for anything beyond what I've listed previously. There are a few things Panasonic classifies as optional accessories, even though you (and I) might consider some of them essential. Here's a list of what you *don't* get in the box, but might want to think about as an impending purchase. I'll list them roughly in the order of importance:

- **Secure Digital card.** First-time digital camera buyers are sometimes shocked that their new tool doesn't come with a memory card. Why should it? The manufacturer doesn't have the slightest idea of how much storage you require, or whether you want a slow/inexpensive card or one that's faster/more expensive, so why should they pack one in the box and charge you for it? The GF1 is a 12.3-megapixel camera and can shoot high quality video. If you plan on taking full advantage of such capabilities, you'll probably want at least a 4GB SD or SDHC memory card or larger. According to Panasonic, the GF1 can work with even a 32GB memory card. If you're going to be shooting at lower resolution settings most of the time, or don't expect to take a lot of photos, then a smaller card or cards will do.

- **Extra battery.** Even though you might get 300 to more than 400 shots from a single battery, it's easy to exceed that figure in a few hours of shooting sports at 3 fps. The more time you spend viewing images on the LCD screen the faster your battery will drain too. Batteries can unexpectedly fail too, or simply lose their charge from sitting around unused for a week or two. Buy an extra (I own four, in total), keep it charged, and free your mind from worry. Since Panasonic doesn't offer an AC adapter for this camera, extra batteries become particularly important.

- **Add-on speedlight.** Flash can function as the main illumination for your photo, or be softened and used to fill in shadows. Although the GF1 has a built-in flash, you still may find an accessory shoe mount flash useful if you want more than just fill lighting. If you do much flash photography at all, consider an add-on speedlight as an important accessory.

- **Lens or additional lenses.** While the GF1 is sold primarily in kit form with either the 14-45mm zoom lens or 20mm fixed focal length lens, some people do buy the camera body alone because neither of those lenses suits their needs. Depending on what type of photography you prefer, an additional lens or two might be necessary. The GF1 can use a variety of different lenses thanks to an assortment of adapters. This will be discussed further in Chapter 6.

- **Remote Control.** Panasonic does not offer a wireless remote for the GF1, but does have the DMW-RSL1 remote cable release, which works through the camera's USB connector.

■ **Live viewfinder.** The GF1 doesn't come with a viewfinder of any kind except for the LCD screen. While this works quite well for photography, many of us prefer using an electronic viewfinder either out of habit, or because it provides a more stable way of using the camera (the camera is more stable pressed against your head than it is held out away from your body). If you feel this way, purchasing the Panasonic DMW-LVF1 Live Viewfinder is worth considering (see Figure 1.2). It's also very helpful if you're shooting in bright sun since it can be hard to view the image on the LCD screen under bright lighting.

■ **LCD screen protector.** These inexpensive screen protectors help keep the LCD safe from dust, fingerprints, and scratches.

Figure 1.2
The DMW-LVF1 Live Viewfinder is an electronic viewfinder that can supplement the back panel LCD, especially in bright sunlight.

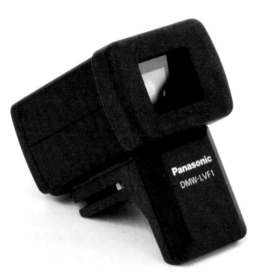

Initial Setup

This section helps you become familiar with the controls most used to make adjustments: the mode and rear dial. You'll also find information on charging the battery, setting the clock, mounting a lens, and making diopter vision adjustments. If you're comfortable with all these things, skim through and skip ahead to "Choosing a Release/Drive Mode" in the next section.

Once you've unpacked and inspected your camera, the initial setup of your Panasonic GF1 is fast and easy. Basically, you just need to charge the battery, attach a lens, and insert a Secure Digital card. I'll address each of these steps separately, but if you already are confident you can manage these setup tasks without further instructions; feel free to skip this section entirely. I realize that some readers are ambitious, if inexperienced, and should, at the minimum, skim the contents of the next section, because I'm going to list a few options that you might not be aware of.

A Quick Look at Navigational Controls

I'll be saving descriptions of most of the controls used with the Panasonic GF1 until Chapter 2, which provides a complete "roadmap" of the camera's buttons and dials and switches. However, you may need to perform a few tasks during this initial setup process, and most of them will require using the GF1's various navigational tools. The primary navigation tools for the camera are the cursor pad buttons and the rear dial located to the right of the LCD screen. The cursor buttons function as both directional keys and also switches for certain camera functions depending on whether you're working in shooting mode or navigating through various menus and screens. Nestled in between these buttons is the MENU/SET button, which is used to bring up the menu screen or confirm choices once you're ready to make them. (See Figure 1.3.)

The rear dial may remind you of the similar control found on many point-and-shoot cameras, and other digital SLRs. It consists of a notched ring on the upper-right rear of the camera back and can be spun either to the left or the right to change settings. The rear dial can also be pushed inward to switch from one control to another.

So, from time to time in this chapter (and throughout this book) I'll be referring to the rear dial, the cursor pad left/right/up/down buttons, and the MENU/SET button.

Rear dial

MENU/SET button

Figure 1.3
The camera has four directional buttons for navigating up/down/left/right, a rear dial, and a MENU/SET button to confirm your selection or bring up the menu screen.

Directional buttons

Setting the Clock

It's likely that your Panasonic GF1's internal clock hasn't been set to your local time, so you may need to do that first. (However, the in-camera clock might have been set for you by someone checking out your camera prior to delivery.) If you do need to set the clock, the current time set may be incorrect, or, if the time has never been set, the flashing CLOCK indicator on the LCD will be the giveaway. You'll find complete instructions for setting the options for the date/time (actual date and time and the date format) in Chapter 3.

However, if you think you can handle this step without instruction, press the MENU/SET button, and then use the cursor pad's down arrow key (which is also the Fn button) to scroll down to the Setup menu (it's marked with a wrench icon) and press the right arrow key (which is also the White balance button). Then press the right arrow, and then press the up button to scroll up to the clock icon (if necessary). This should put you at the Clock Set submenu.

One more press of the right arrow key brings you to the screen where you can set the date and time. You'll then be able to set the year, month, day, time and choose in which order you want that information to be displayed. Keep in mind that you'll need to reset your camera's internal clock from time to time, as it is not 100 percent accurate. Of course, your camera will not explode if the internal clock is inaccurate, but your images will have the wrong time stamped on them. If you do a lot of traveling, the GF1 has a neat travel option that lets you set your travel date and time plus your destination so you can switch back and forth between your home time zone and wherever you might be going. This of course is just perfect for when you're traveling between your main home and a vacation home or are a frequent traveler. I'll cover setting up the travel option in Chapter 3.

Battery Included

Your Panasonic GF1 is a sophisticated hunk of machinery and electronics, but it needs a charged battery to function, so rejuvenating the DMW-BLB13PP lithium-ion battery pack furnished with the camera should be your first step. A fully charged power source should be good for a minimum of 380 shots, based on standard tests defined by the Camera & Imaging Products Association (CIPA) document DC-002. Panasonic says 380 shots with the 20mm F1.7 lens and 350 clicks with the 14-45mm F3.5-5.6 lens. The power-hungry image stabilization, which steadies images to allow you to shoot at lower shutter speeds, is certainly the reason for the reduction in shots. In the real world, of course, the life of the battery will depend on how often you review the shots you've taken on the LCD screen, how many pictures you take with the built-in flash, and many other factors. You'll want to keep track of how many pictures *you* are able to take in your own typical circumstances, and use that figure as a guideline, instead.

A BATTERY AND A SPARE

I always recommend purchasing Panasonic brand batteries (for about $50) over less-expensive third-party packs, even though the $30 substitute batteries may offer more capacity at a lower price (some top the 1,250 mAh offered by the Panasonic battery). My reasoning is that it doesn't make sense to save $10 on a component for a sophisticated camera, especially since batteries have been known to fail in potentially harmful ways, and some vendors have issued recalls. You're unlikely to get efficient support from a third-party battery supplier that sells under a half-dozen or more different brand names, and may not even have an easy way to get the word out that a recall has been issued.

It's even more important to stick with Panasonic batteries since the company has announced a firmware upgrade (Ver. 1.3) that checks to see if the camera is using a third-party battery and will not operate if it is. (Panasonic maintains this is to protect the camera from poor-quality batteries.) The company also notes that if a third-party battery damages your camera, the camera will not be repaired under warranty.

If your pictures are important to you, always have at least one spare battery available, and make sure it is an authentic Panasonic product.

All rechargeable batteries undergo some degree of self-discharge just sitting idle in the camera or in the original packaging. Lithium-ion power packs of this type typically lose a small amount of their charge every day, even when the camera isn't turned on. Li-ion cells lose their power through a chemical reaction that continues when the camera is switched off. So, it's very likely that the battery purchased with your camera is at least partially pooped out, so you'll want to revive it before going out for some serious shooting.

Charging the Battery

When the battery is inserted into the battery charger properly (it's impossible to insert it incorrectly), as you can see in Figure 1.4, the contacts on the battery line up and mate with matching contacts inside the charger. When properly connected, a green charge light glows solid. Once the battery has completed charging, the light will turn off. When the battery is charged, slide the latch on the bottom of the camera and ease the battery in, as shown in Figure 1.5.

Final Steps

Your Lumix DMC-GF1 is almost ready to fire up and shoot. You'll need to select and mount a lens, adjust the viewfinder for your vision (if you're using the optional viewfinder), and insert a Secure Digital card. Each of these steps is easy, and if you've used any Panasonic camera before, you already know exactly what to do. I'm going to provide a little extra detail for those of you who are new to the Panasonic or interchangeable lens camera worlds.

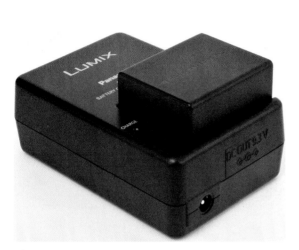

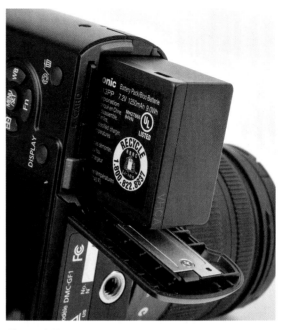

Figure 1.4 When the charger is plugged in, the solid status light will glow green while the battery is being charged.

Figure 1.5 Insert the battery in the camera; it only fits one way.

Mounting the Lens

As you'll see, my recommended lens mounting procedure emphasizes protecting your equipment from accidental damage and minimizing the intrusion of dust. If your GF1 has no lens attached, select the lens you want to use and loosen (but do not remove) the rear lens cap. I generally place the lens I am planning to mount vertically in a slot in my camera bag, where it's protected from mishaps, but ready to pick up quickly. By loosening the rear lens cap, you'll be able to lift it off the back of the lens at the last instant, so the rear element of the lens is covered until then.

After that, remove the body cap by rotating the cap away from the release button. You should always mount the body cap when there is no lens on the camera, because it helps keep dust out of the interior of the camera. (While the GF1's automatic sensor cleaning mechanism works fine, the less dust it has to contend with, the better.) The body cap also protects the camera's innards from damage caused by intruding objects (including your fingers, if you're not cautious).

Once the body cap has been removed, remove the rear lens cap from the lens, set it aside, and then mount the lens on the camera by matching the alignment indicator on the lens barrel with the red dot on the camera's lens mount. (See Figure 1.6.) Rotate the lens

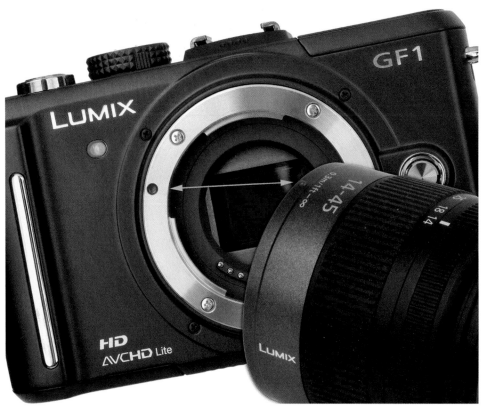

Figure 1.6
Match the indicator on the lens with the red dot on the camera mount to properly align the lens with the bayonet mount.

away from the shutter release until it seats securely. Some lenses are trickier to mount than others, especially telephoto lenses with special collars for attaching the lens itself to a tripod.

If your lens has a focus mode switch, choose the setting you want (either AF or M/A). If your lens doesn't have such a switch, you can still set its focus setting through the camera's menu controls. (Press the AF/MF button, which is to the right of the LCD screen all the way by the top edge.) It will bring up the focus control menu options. Choose the setting you prefer: AFS (the camera focuses once when the shutter button is pressed halfway), AFC (the camera continually follows focus for moving subjects as long as the shutter button is pressed halfway), or MF (manual focus). If the lens hood is bayoneted on the lens in the reversed position (which makes the lens/hood combination more compact for transport), twist it off and remount with the "petals" (if present) facing outward. (See Figure 1.7.) A lens hood protects the front of the lens from accidental bumps, and reduces flare caused by extraneous light arriving at the front of the lens from outside the picture area.

Mounting the Live Viewfinder

Although the GF1 doesn't come with a hot shoe mounted electronic viewfinder, many photographers do end up buying the high quality one Panasonic offers. Since this unit connects electronically, it can only be used on the GF1. Other electronic viewfinders, such as the one for the Olympus E-P2, can't be used on the GF1 either. When the viewfinder is mounted, an external electronic flash cannot be mounted in the hot shoe at the same time.

The Panasonic LVF refreshes quickly, offers a high-quality view of what the camera sees, and includes a built-in diopter correction control for those of us with less than perfect eyesight. It can also be tilted upward 90 degrees so it can be used like a waist level finder. Panasonic likely designed this as an accessory rather than building it into the camera so the user could have the option of using it or not. Mounting it on the camera is pretty simple. Remove the plastic hot shoe protector and then slide the Live Viewfinder into the hot shoe mount (there is a small, black plastic rectangle on the underside of the LVF, this slides into the hot shoe mount). The even smaller metal connection slides into the camera's accessory port below the hot shoe mount. The LVF comes with its own carrying pouch.

Adjusting Diopter Correction

Those of us with less than perfect eyesight can often benefit from a little optical correction when using the accessory Live Viewfinder. Your contact lenses or glasses may provide all the correction you need, but if you are a glasses wearer and want to use the GF1 without your glasses, you can either take advantage of the Live Viewfinder's built-in diopter adjustment, which can be varied from –4.0 to + 4.0 correction or just use the LCD screen for composition. Turn the Live Viewfinder's diopter adjustment dial (it's the small dial on the side of the LVF next to the LVF/LCD button—see Figure 1.8), while looking through the viewfinder until the subject appears sharp.

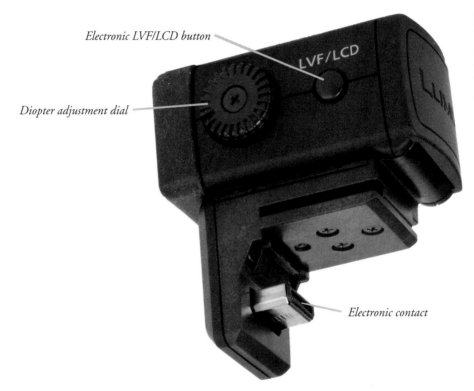

Electronic LVF/LCD button

Diopter adjustment dial

Electronic contact

Figure 1.8
Viewfinder diopter correction from –4 to +4 can be dialed in.

Inserting a Secure Digital Card

The GF1 warns you that a memory card is not loaded, but will still trip the shutter if you insist, without recording an image. So, your final step will be to insert a Secure Digital card. Turn the camera over (holding the upside down camera in the palm of your left hand if you're right handed) and push the small switch on the battery/memory compartment to open the hinged door. Slide the memory card into its slot (the card face should be facing toward the front of the camera) and push it in until it locks. You can then close the compartment. You should only remove the memory card when the camera is switched off, or, at the very least, the yellow-green card access light (just to the

right of the LCD and "trash can" icon on the back of the camera) that indicates the GF1 is writing to the card is not illuminated. It is possible to open the memory card/battery door while the camera is writing to the card without affecting the storage process, but there's really not a good reason for doing so.

Insert the memory card with the label facing the back of the camera oriented so the edge with the gold edge connectors goes into the slot first. (See Figure 1.9.) Close the door, and, if this is your first use of the card, format it (described next). When you want to remove the memory card later, press the card inwards, and it will pop right out.

Figure 1.9
The Secure Digital card is inserted with the label facing the back of the camera.

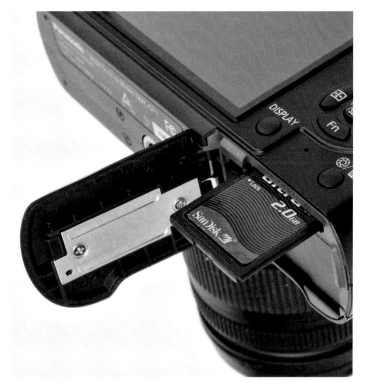

Formatting a Memory Card

There are three ways to create a blank Secure Digital card for your GF1, and two of them are at least partially wrong. Here are your options, both correct and incorrect:

■ **Transfer (move) files to your computer.** When you transfer (rather than copy) all the image files to your computer from the Secure Digital card (either using a direct cable transfer or with a card reader, as described later in this chapter), the old image files are erased from the card, leaving the card blank. Theoretically. Unfortunately, this method does *not* remove files that you've labeled as Protected (using the Protect option in the Playback menu while viewing the image on the LCD), nor does it

identify and lock out parts of your SD card that have become corrupted or unusable since the last time you formatted the card. Therefore, I recommend always formatting the card, rather than simply moving the image files, each time you want to make a blank card. The only exceptions are when you *want* to leave the protected/unerased images on the card for a while longer, say, to share with friends, family, and colleagues or if you want to show images on a television via the video cables that come with the camera.

- **(Don't) Format in your computer.** With the SD card inserted in a card reader or card slot in your computer, you can use Windows or Mac OS to reformat the memory card. Don't! The operating system won't necessarily arrange the structure of the card the way the GF1 likes to see it (in computer terms, an incorrect *file system* may be installed). The only way to ensure that the card has been properly formatted for your camera is to perform the format in the camera itself. The only exception to this rule is when you have a seriously corrupted memory card that your camera refuses to format. Sometimes it is possible to revive such a corrupted card by allowing the operating system to reformat it first, then trying again in the camera.

- **Setup menu format.** To use the recommended methods to format a memory card, press the MENU/SET button, use the up/down buttons (that thumb-pad-sized control to the right of the LCD) to choose the Setup 5 menu (which is represented by a small wrench icon), navigate to the Format entry with the right button of the main dial, and press the SET button in the center of the up/down/left/right buttons. Then use the down button to select the format entry from the screen that appears. Press Yes and press MENU/SET to begin the format process.

HOW MANY SHOTS?

The GF1 provides a fairly accurate estimate of the number of shots remaining on the LCD, as well as at the lower-right edge of the viewfinder display when the display is active. (Tap the shutter release button to activate it.)

It is only an estimate, because the actual number will vary, depending on the capacity of your memory card, the file format(s) you've selected (more on those later), and the content of the image itself. (Some photos may contain large areas that can be more efficiently squeezed down to a smaller size.)

For example, an 8GB card can hold about 370 shots in the format known as RAW plus JPEG Fine at the GF1's maximum resolution (Large) format; 1,160 shots using the Large (Fine) JPEG setting; 2,310 shots using the Large Normal JPEG setting; or 4,090 shots with Middle Normal JPEG setting.

Table 1.1 shows the typical number of shots you can expect using a modestly sized 8GB SD memory card (which I expect will be the most popular size card among GF1 users as prices continue to plummet during the life of this book). All figures are by actual count with my own 8GB SD card. Take those numbers and cut them in half if you're using a 4GB SD card; multiply by 25 percent if you're using a 2GB card, or by 12.5 percent if you're working with a 1GB SD card. (You can use the Shooting menu's Image Quality option to change the file/formats in column 1, and to change the image sizes in columns 2, 3, and 4, or change either value using the information edit display, described next.)

Table 1.1 Typical Shots with an 8GB Memory Card

	Large	Medium	Small
JPEG Fine	1,160	2,310	4,910
JPEG Normal	2,310	4,090	9,440
RAW	530	N/A	N/A
RAW+JPEG Basic	370	480	510

Choosing a Release/Drive Mode

This section shows you how to choose from Single, Burst mode, Auto Bracket mode, and Self-Timer modes, as well as how to change settings using the Display screen.

You shouldn't skip this section because it provides basic information on how to change settings, including choosing exposure, metering, and autofocus modes.

This shooting mode determines when (and how often) the GF1 makes an exposure. If you're coming to the interchangeable lens camera world from a point-and-shoot camera, you might have used a model that labels these options as Drive modes, dating back to the film era when cameras could be set for single-shot or "motor drive" (continuous) shooting modes. Your GF1 has the following release (shooting/drive) modes: Single, Burst, Auto Bracket, Two-Second Self-Timer, Ten-Second Self-Timer/3 pictures, and Ten-Second Self-Timer. Set the release mode using the lever on the top of the camera right next to the mode dial. This lever offers four settings, Single, Burst, Auto Bracket, and Self-timer. Once you've set the release mode, press the MENU/SET button and navigate to Rec menu 4 (press the right arrow to move to the middle column, then press

the up arrow twice to get to the fourth menu screen), then go to either the Burst menu, the Self-timer submenu or the Auto Bracket menu to set the specific setting you want to use.

I'll show you how to use the information display first, because it's a useful tool when you want to change many of the basic options, before explaining each of the release modes.

Using the Information Display

When you press the DISPLAY button on the back of the camera (the bottom button on the right side of the LCD, the information display (shown in Figure 1.10) appears.

The shooting information display is a useful status screen, which performs a variety of functions. It can take you from a screen that provides a wealth of information (Normal display), a blank LCD (Minimal display), to a completely turned off screen.

Pushing the DISPLAY button lets you choose between three different display screens:

- Full screen information
- Minimal screen information
- LCD turns off

Figure 1.10
The information display shows the status of your current settings.

Using the Q(uick) Menu

The Lumix GF1 has a handy button that helps keep you from journeys to menuland. Pressing the Q. MENU button (it's to the right of the LCD screen just below the AF/MF button) brings up a range of choices. This nifty little button makes it possible for you to cycle through the various icons on the LCD display, pick one, and then change its settings, all without ever bringing up a menu screen. Depending on your shooting mode, this button can give you access to as many as 16 different camera settings.

Just press the Q.MENU button and then use either the left and right cursor keys or the rear dial to highlight the different icons. Once you've gotten to the icon for the setting you want to change, press the up or down arrow key to navigate to change settings. Once you've highlighted your desired setting, either press the rear dial in or press the MENU/SET button. At this point your options will appear on the LCD and you can choose the one you want by highlighting it and then pressing either the rear dial or the MENU/SET button. This well thought out design makes it possible for you to change every important shooting setting (except for exposure mode and drive mode) through this one approach. See Chapter 2 for more information.

Drive Modes

The GF1 offers four different drive modes, which are selected using the drive modes lever. These modes are as follows:

Single

In this single-shot mode, the default, the GF1 takes one picture each time you press the shutter release button down all the way. If you press the shutter and nothing happens (which is very frustrating!), you may be using a focus mode that requires sharp focus to be achieved before a picture can be taken. This is called focus priority, and it is discussed in more detail under "Choosing Focus Modes," later in this chapter.

Burst

This shooting mode can be set to produce bursts of three frames per second, useful for grabbing action shots of sports, or for capturing fleeting expressions (especially of children). You can also switch between H ("High"—3 fps) or L ("Low"—2 fps).

1. Use the lever on the top of the camera that sits in front of the mode dial to choose Burst mode (the lever should be switched to the icon depicting multiple rectangles).

2. Press the MENU/SET button and navigate to the fourth Rec screen.

3. Cursor down to the Burst Rate submenu and then push the right arrow.

4. Choose between H ("High" about 3 fps) or L ("Low" about 2 fps).

5. Push the MENU/SET button again to confirm the choice.

6. Tap the shutter button halfway to return to the live view.

Or, use this alternate method:

1. Use the lever on the top of the camera that sits in front of the mode dial to choose Burst mode (the lever should be switched to the icon depicting multiple rectangles).

2. Press the Q.MENU button and use the rear dial or arrow keys to navigate to the Burst mode icon on the LCD screen.

3. Push the rear dial in or press the MENU/SET button, then select either "H" or "L".

4. Press either the rear dial or the MENU/SET button to confirm the choice.

Keep in mind that while H provides a maximum shooting rate of 3 frames per second, slower shutter speed settings will slow down the shooting rate, and while L provides a shooting rate of 2 frames per second, slower shutter speeds can reduce this too.

Auto Bracket

You can set the GF1 to automatically bracket your images (shooting a series of images at varying exposure settings to make sure you get the best possible exposure). There are two ways of setting this control. Each is explained here:

1. Use the lever on the top of the camera that sits in front of the mode dial to choose Auto Bracket mode (the lever should be switched to the icon depicting a +/- sign over multiple rectangles).

2. Press the MENU/SET button and navigate to the fourth Rec screen.

3. Cursor down to the Auto Bracket submenu and then push the right arrow. Here, you'll find two more submenus (Step and Sequence) which each offer more choices. Use the arrow key to pick the one you want and proceed to its next screen. (We'll consider both in this list.)

4. Choose "Step" and pick an option (three shots at 1/3 f/stop intervals all the way up to seven shots at 2/3 f/stop intervals). (You need to press the shutter the appropriate number of times or hold the shutter down until the appropriate number of shots has been taken. Once the set number of images has been made, the camera will stop shooting until you release the shutter button. Press and hold it again and it will take another sequence of bracketed images.)

5. Push the MENU/SET button again to confirm the choice. This returns you to the previous screen.

6. Use the down arrow to choose the Sequence submenu and the right arrow to change the sequence if you wish. You have a choice between 0/–/+ and –/0/+.

7. Once you've made your choice, press the MENU/SET button to confirm it and then press the shutter button halfway to return to the Live View screen.

Or, use this alternate method:

1. Use the lever on the top of the camera that sits in front of the mode dial to choose Burst mode (the lever should be switched to the icon depicting multiple rectangles).

2. Press the Q.MENU button and use the rear dial or arrow keys to navigate to the Auto Bracket mode icon on the LCD screen.

3. Push the rear dial in or press the MENU/SET button, then pick the number of shots to be bracketed and the amount of bracketing.

4. Press either the rear dial or the MENU/SET button to confirm the choice. (You can't set the sequence through the Q.MENU approach, so you're done at this point. Also, you can only take one shot using flash and can't use this if the number of recordable pictures left for your memory card isn't sufficient for the number of shots in the sequence.)

Self-Timer

The GF1 offers three different self-timer options. A self-timer is a handy option since it can serve several functions. Often, it provides the easiest way for the photographer to also get into the picture, since wireless remotes (which may not even be available for you camera) are expensive. Another added benefit of a self-timer is the delay it provides in actually tripping the shutter. It gives the camera time to settle down from any vibration induced by pushing the shutter button. This can be handy if you're making a long exposure with the camera mounted on a tripod or other stable surface.

The GF1's self-timer options are as follows:

■ **10-Second Self-Timer.** You can use the self-timer as a replacement for a remote release, to reduce the effects of camera/user shake when the GF1 is mounted on a tripod or, say, set on a firm surface, or when you want to get in the picture yourself. The picture will be taken after about 10 seconds. A red lamp on the front of the camera will blink slowly until just before the shutter is about to trip; it then blinks four times at a faster rate until the picture is taken.

■ **10-Second Self-Timer/3 pictures.** This is the same as the previous option, but when set, the camera will take three pictures in succession after about 10 seconds. There is about a half-second delay between each shot. A red lamp on the front of the camera will blink slowly until just before the shutter is about to trip; it then blinks four times at a faster rate until the picture is taken.

■ **2-Second Delayed Remote.** Set this release mode, and the GF1 will take a picture two seconds after you press the shutter button.

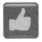

> **Note**
>
> If you plan to dash in front of the camera to join the scene, consider using manual focus so the GF1 won't refocus on your fleeing form and produce unintended results. (Panasonic really needs to offer an option to autofocus at the *end* of the self-timer cycle.)

You can make this change via the Self-Timer selection on the fourth screen of the Rec menu. Just press the MENU/SET button and navigate to the Rec menu's fourth screen. Choose Self-Timer and select 10-Second Self-Timer, 10-Second Self-Timer/3 pictures, or 2-Second Self-Timer.

An alternative approach to setting this option is by using the Q.MENU (provided the drive mode lever is set to Self-Timer) and navigating to the Self-Timer selection where you can make your desired selection simply by using the up or down cursor and pressing either the MENU/SET button or pushing in on the rear dial.

Selecting a Shooting Mode

> This section shows you how to choose an exposure mode. If you'd rather have the GF1 make all of the decisions for you, just rotate the mode dial to iA (Intelligent Auto) and jump to the section titled "Reviewing the Images You've Taken." If you'd rather choose one of the Scene modes, tailored to specific types of shooting situations, or try out the camera's semi-automatic modes, continue reading this section.

The Panasonic GF1 has four types of shooting modes, Advanced modes/Exposure modes, MyColor modes, Scene modes, and Custom modes. The Advanced modes include Intelligent Auto (or iA), Program AE (or Program mode), Aperture-priority AE, Shutter-priority AE, and Manual exposure mode. These are the modes you'll use most often after you've learned all your GF1's features, because they allow you to specify how the camera chooses its settings when making an exposure, for greater creative control.

MyColor Mode

MyColor mode lets you pick a color setting for various effects. An example of MyColor modes is shown in Figure 1.11. Your choices include

- **Expressive.** Exaggerates colors for a "Pop Art" type feel.
- **Retro.** Soft image effect, kind of like an old photo that hasn't been stored properly.
- **Pure.** Produces a brighter image with a slight bluish tint.

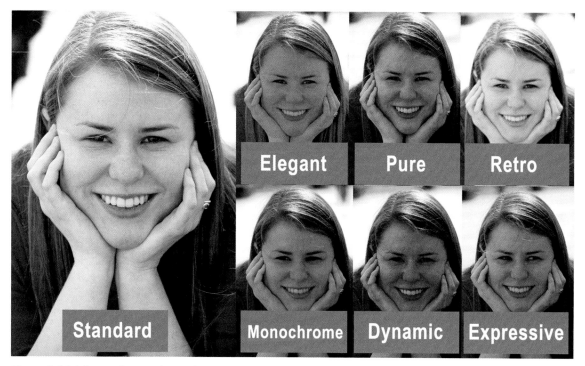

Figure 1.11 The GF1's MyColor mode provides a variety of options for your artistic efforts (Model: Meghan Angelos).

■ **Elegant.** Panasonic says this choice creates a "tranquil atmosphere and projects a feeling of stateliness". Panasonic also says the image will come out slightly dark and amberish.

■ **Monochrome.** Creates a black-and-white image with a hint of color.

■ **Dynamic Art.** Enhances dark and light areas while also enhancing colors.

■ **Silhouette.** Enhances shadow areas as a black silhouette taking information from the background colors of the sky, sunset, or other backgrounds.

■ **Custom.** User-defined color effects.

Scene Mode (SCN)

The GF1's Scene modes option is designed to help you shoot certain conditions more effectively. All you have to do is match the scene choice to the scene you're photographing and the camera picks a group of settings for best result. You'll end up with decent photos using appropriate settings, but your opportunities to use a little creativity (say, to underexpose an image to create a silhouette, or to deliberately use a slow shutter speed to add a little blur to an action shot) are minimal.

Choosing a Scene Mode

The 17 Scene modes can be selected by rotating the mode dial on the top right of the Panasonic GF1 to the SCN icon (shown in Figure 1.12). You then use the rear dial or arrow keys to maneuver through the choices:

- **Portrait.** Use this mode for shooting outdoor portraits of people. It also makes their skin tones look healthier. The camera also chooses face recognition for autofocus.

- **Soft Skin.** While this is similar to Portrait mode, this setting creates smoother skin tones than the Portrait mode does. This mode is also for outdoor photography.

- **Scenery.** Select this mode when you want extra sharpness and vivid blues and greens.

- **Architecture.** Maximizes image sharpness and displays guidelines to help you line up your photo.

- **Sports.** Use this mode to freeze fast-moving subjects. The GF1 selects a fast shutter speed to stop action. It also activates Intelligent ISO with a ceiling of ISO 800.

- **Peripheral Defocus.** Use this mode when you want to isolate your subject from the background. Once set, you'll have to use the arrow keys to move the focus point around the LCD screen or LVF view to mark your subject. Once you do, the camera will choose settings that help minimize depth-of-field to help blur everything but your subject.

- **Flower.** The camera records natural colors and places guidelines on the view screen while choosing settings appropriate for macro photography.

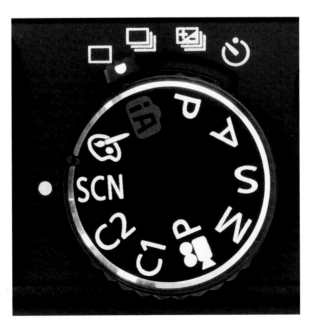

Figure 1.12
Rotate the mode dial to select an automated Scene mode.

■ **Food.** Shooting food in restaurants can be challenging because the restaurant lights can throw a color cast on the food. This setting helps correct for any lighting color errors and lets you get more accurate photographs of the food. An example is shown in Figure 1.13.

Figure 1.13
Here's a comparison shot using the Food Scene mode (top) and Standard mode (bottom).

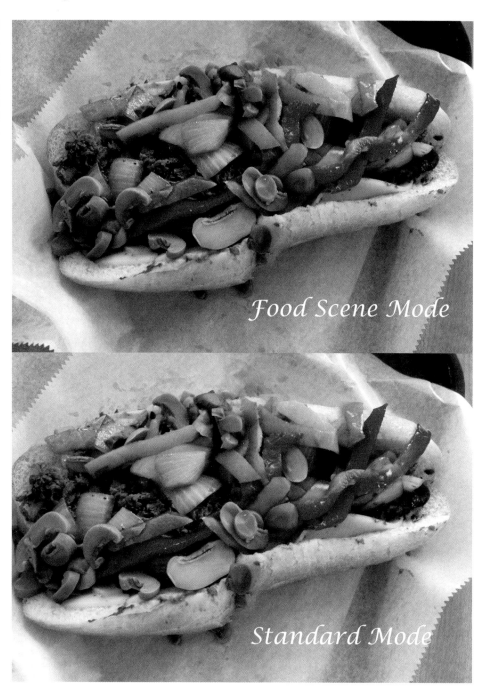

- **Object.** This mode is designed for close ups of small objects. It's useful for people who are photographing collections of things or creating images for online auctions.

- **Night Portrait.** Designed for shooting people at night, in this mode the camera sets a slow shutter speed in order to let the ambient light register so the background is properly exposed. For best results, the camera should be mounted on a tripod or steady surface and your subject asked to remain as still as possible. Activating the camera's built-in flash unit will help freeze any subject movement.

- **Illuminations.** Use this mode for shooting Christmas lights, nighttime cityscapes, and other scenes where colorful lights are in play.

- **Night Scenery.** Use this for nighttime scenic photos with more vivid colors.

- **Baby1 and Baby2.** Reduces flash power for healthier looking babies. The two versions are available so you can record different birthdates and names for your kids (and have that information displayed on the image). (Note: If you're the star of a TV show about big, big families, you'll need to buy more than one GF1.)

- **Pet.** Similar to Baby1 and Baby2 in that you can set a birthday and pet name (and have that information displayed on the image if you wish). You could probably use this for a third kid rather than a pet if necessary, but if the little one finds out, you could be in for years of therapy bills.

- **Party.** Manages exposure to record scene ambience at a party or wedding. (Unable to test this one, could somebody please invite me to a party?)

- **Sunset.** Emphasizes vivid reds of sunset.

Using a Custom Mode (C1 and C2)

The Lumix GF1 offers two Custom modes you can use to save four preferred shooting configurations affecting 20 different camera settings each. Choosing C1 on the mode dial automatically sets the camera to the configuration you've saved for that Custom mode. Choosing C2 sets the camera to one of three user set configurations, which you then choose by pressing the MENU/SET button and selecting. While the setup process is a little confusing (and information on it is scattered over three different areas of the user manual), configuring the four shooting variations can be a very good idea.

Suppose, for instance, you have to share your camera with a loved one. You can each set up the camera the way you prefer and save the configurations. Now you can just switch from, say, C2-1 to C2-2 and all the settings will be switched to the next shooter's preferences. Another possibility is if you have several shooting scenarios that present themselves regularly and require drastically different camera configurations. Just create a Custom setup for each of them and you can shift photographic gears in an instant.

Panasonic suggests registering your favorite camera configuration as C1. This way a simple turn of the mode dial makes sure many of your preferred settings are immediately

chosen. Use C2 for configurations that are either extremely different or for the preferences of multiple camera users. There are only a few settings (Clock Set; Travel Date; No. Reset; Reset; Language; Baby1, Baby2, and Pet birthday and name settings; and data registered with Face Recognition) that can't be changed via the custom configurations. Exposure settings (if you registered Manual as the exposure mode) also won't be stored.

Choosing an Advanced Mode

If you're very new to digital photography, you might want to set the camera to P (Program mode) or iA (Intelligent Auto) if you want the camera to take even more control and start snapping away. That mode will make all the appropriate settings for you for many shooting situations. If you have more photographic experience, you might want to opt for one of the semi-automatic modes, or even Manual mode. These, too, are described in more detail in Chapter 4. These advanced modes all let you apply a little more creativity to your camera's settings. Figure 1.14 shows the position of the modes described next.

■ **M (Manual).** Select when you want full control over the shutter speed and lens opening, either for creative effects or because you are using a studio flash or other flash unit not compatible with the GF1's automatic flash metering.

■ **A (Aperture-priority).** Choose when you want to use a particular lens opening, especially to control sharpness or how much of your image is in focus. Specify the f/stop you want, and the GF1 will select the appropriate shutter speed for you.

Figure 1.14
Rotate the mode dial to select an advanced mode.

Shutter-priority

Aperture-priority

Program

Manual

Intelligent Auto

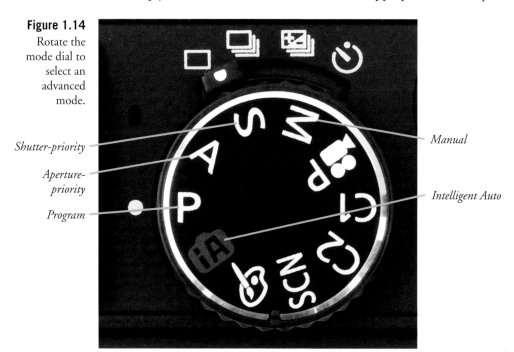

- **S (Shutter-priority).** This mode is useful when you want to use a particular shutter speed to stop action or produce creative blur effects. Choose your preferred shutter speed, and the GF1 will select the appropriate f/stop for you.

- **P (Program).** This mode allows the GF1 to select the basic exposure settings, but you can still override the camera's choices to fine-tune your image, while maintaining metered exposure.

- **iA (Intelligent Auto).** This mode has the GF1 make pretty much every exposure decision for you, but you can still make some adjustments via the camera's exposure compensation system.

Choosing a Metering Mode

This section shows you how to choose the area the GF1 will use to measure exposure: giving emphasis to the center of the frame; evaluating many different areas of the frame; or measuring light from a small spot in the center of the frame.

The metering mode you select determines how the GF1 calculates exposure. You might want to select a particular metering mode for your first shots, although the default Multiple metering is probably the best choice as you get to know your camera. (It is used automatically in many of the GF1's Scene modes.) I'll explain when and how to use each of the three metering modes later. The fastest and easiest way to change metering modes is by using the Q.MENU. (You can also specify metering mode using the Recording menu, as I'll describe in Chapter 3.)

1. Press the Q.MENU button once and use the rear dial or an arrow key to navigate to the metering selection (it's in the lower-left part of the Live View).

2. Use the up/down arrows to highlight the desired mode (Multiple, Center weighted, or Spot).

3. Press the MENU/SET button to confirm your choice and exit the metering display.

Here's a closer look at how each of the three metering modes works (See Figure 1.15.):

- **Multiple.** The standard metering mode, the GF1 judges how light is spread throughout 144 zones within the image to calculate exposure.

- **Center weighted.** The GF1 meters the entire scene, but gives the most emphasis to the central area of the frame, measuring about 8mm. Good for when you're concerned the lighting on the background may throw off the exposure reading.

- **Spot.** Exposure is calculated from a smaller 3.5mm central spot, about 2.5 percent of the image area.

You'll find a detailed description of each of these modes in Chapter 4.

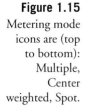

Figure 1.15
Metering mode
icons are (top
to bottom):
Multiple,
Center
weighted, Spot.

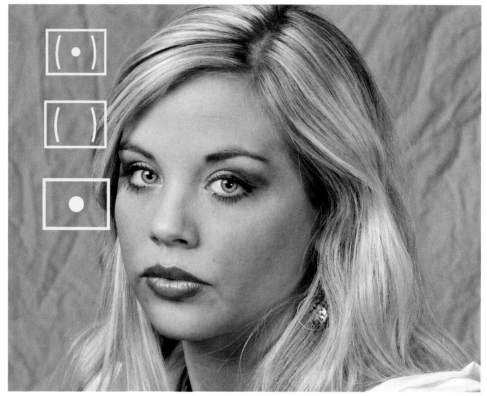

Choosing a Focus Mode

This section shows how to select *when* the GF1 calculates focus, either all the time (continuously), only once when you press a control like the shutter release button (single autofocus), or manually when you rotate a focus ring on the lens.

The Panasonic GF1 can focus your pictures for you, or allow you to manually focus the image using the focus ring on the lens. (I'll help you locate this ring in Chapter 2.) Switching between automatic and manual focus is easy depending on the lens you are using. While I don't know of any Panasonic Micro Four Thirds system lenses that have an AF on/off switch, the GF1 can work with lenses from other Micro Four Thirds systems and even other Four Thirds and 35mm systems via adapters. While none of the 35mm lenses will autofocus on the GF1, some of the Four Thirds system lenses can and a few of these lenses have an AF/MF switch that needs to be set to the desired position. The GF1 also has several internal focusing settings including AFS (Autofocus Single), AFC (Autofocus Continuous), and MF (Manual focus). (See Figure 1.16.)

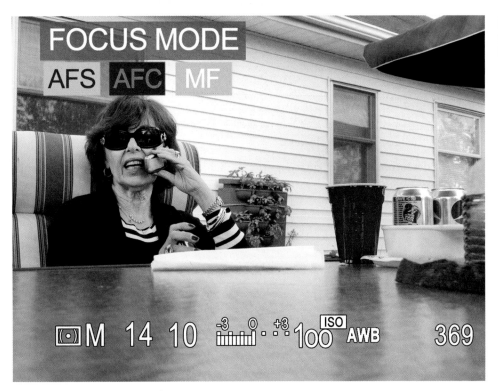

Figure 1.16
Choose a focusing mode.

The camera's internal focus setting and the lens's AF/MF switch (if there is one) must be in agreement. If not, the camera/lens will stay in manual focus. (If the lens is set to MF and the camera is set to an autofocus setting, or if the lens is set to AF and the camera is set to manual focus, either way, the combination will be at manual focus only.)

When using autofocus, you have additional choices (see Figure 1.16). The GF1 offers four different approaches as to how the camera determines to which area of the image to give focusing priority. These four modes range in power from the camera making all the decisions to you having complete control over the focus point. The GF1 even provides a setting where the camera tries to anticipate focus before you've decided what it is you want to photograph. (It's not as scary as it sounds; my wife is always telling me I've made a decision before I've reached one too. You get used to it after a while.)

You can choose the focusing mode you prefer no matter what mode you have the camera set to. The fastest and easiest way to change focusing modes is to press the AF/MF button on the back of the camera at the top-right side of the LCD screen. You'll be given three options: AFS, AFC, and MF, but keep in mind, AFC will not be available for every lens (for instance you can't choose AFC when using the Panasonic 20mm 1.7 lens). (You can also choose the focus mode in a slightly slower way using the Custom Settings menu, as I'll describe in Chapter 3.)

Choosing Autofocus Area Mode

I'll explain autofocus in more depth in Chapter 5, but you can still learn to set the AF area mode now, using the Display screen.

You can also tell the GF1 how to approach determining where in the scene to establish the sharpest point of focus. The camera gives you four different options, which you access by pushing the Q.MENU button and then picking the focusing method using either the rear dial or the arrow keys:

- **Face detection**. The camera recognizes the subject's face and sets focus so your subject is properly in focus no matter where in the scene the subject is. The GF1's face detection algorithm can track as many as 15 different areas in the scene.

- **AF Tracking.** You can designate a specific subject in the scene and the camera will keep that subject in focus as that subject moves through the scene (also known as "Dynamic tracking").

- **23-area focusing.** As many as 23 different points can be focused. This is particularly helpful when your main subject is not in the center of the image.

- **1-area focusing.** You determine the exact area of the screen that the camera focuses on. This would be useful when you need to achieve critical focus on a stationary subject.

Note

As mentioned before, note that the AF/MF switch on the lens and the setting made in camera body must agree; if either is set to Manual focus, then the GF1 defaults to Manual focus regardless of how the other is set.

Pre AF

The Panasonic Lumix DMC-GF1 offers an interesting feature designed to help you get more in-focus pictures. The idea behind Pre AF is that the camera can do certain things to improve autofocus performance. Here's a rundown of your options and how they work:

- **Off.** The GF1 works like any other camera and won't begin focusing until you press the shutter button halfway.

- **Q-AF (Quick AF).** The GF1 will adjust focus automatically when it detects that camera vibration has been minimized. (The idea being that the camera has sensed the photographer steadying the camera just before starting to take the photo.)

■ **C-AF (Continuous AF).** The camera continuously adjusts focus. Once you press the shutter button, focus adjusts even faster. This setting can speed up battery drain and can't be used with lenses that can't be set to AFC or manual focus only lenses. Zooming the lens while in C-AF mode can slow focus time, and it can also be a bit disconcerting to have your camera constantly trying to focus.

Set the Pre AF control via the Custom menu. Press the MENU/SET button, then the left arrow key. Use the down arrow key to get to the Custom menu, then the right arrow key to enter the Custom Menu. Use the down arrow key to reach the Pre AF option (it's located on screen two and is the fourth option down). Once At Pre AF, press the right arrow button and you'll see a submenu with three options, OFF, Q-AF, and C-AF (depending on how your camera is set, one or more may be grayed out). Once you've picked the desired version, press the MENU/SET button to confirm the choice.

Adjusting White Balance and ISO

This section describes some optional features you can select if you feel you need to choose the white balance or change the camera's sensitivity setting.

There are a few other settings you can make if you're feeling ambitious, but don't feel ashamed if you postpone using these features until you've racked up a little more experience with your GF1.

If you like, you can custom-tailor your white balance (color balance) and ISO (sensitivity) settings. I'll explain more about what these settings are, and why you might want to change them, in Chapter 3. To start out, it's best to set white balance (WB) to Auto, and ISO to ISO 100 or 200 for daylight photos, and ISO 400 for pictures in dimmer light. (Don't be afraid of ISO 1600, however; the GF1 does a *much* better job of producing low-noise photos at higher ISOs than most other cameras.) You'll find complete recommendations for both these settings in Chapter 4. You can adjust either one now using the Q.MENU button. I won't repeat the instructions again. The ISO and WB (for white balance) settings are third and second at the bottom of the right-hand side of the LCD display (respectively). Another way to change these settings is to use the appropriate arrow key on the arrow keypad for each setting (top arrow for ISO and right arrow for WB).

Reviewing the Images You've Taken

> Here you'll discover how to review the images you've taken in a basic way. I'll provide more detailed options for image review in Chapter 2.

The GF1 has a broad range of playback and image review options. For now, you'll want to learn just the basics. Here is all you really need to know at this time, as shown in Figure 1.17:

■ **Display an image.** Press the Playback button (marked with a blue-green right-pointing triangle) at the top of the LCD screen just to the right of the camera's accessory port (where the LVF goes) to display the most recent image on the LCD.

■ **Scroll among images.** Press the right arrow key to advance to the next image, or left arrow key to go back to a previous image.

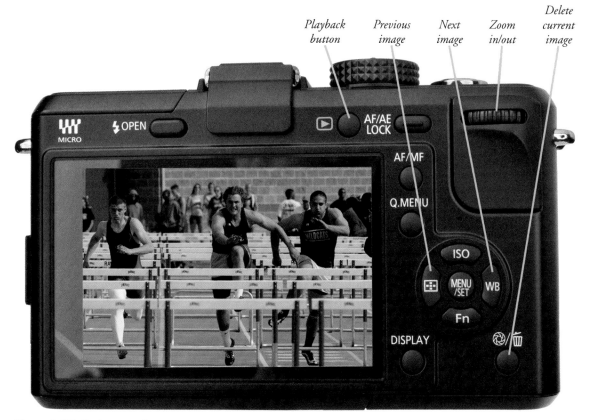

Figure 1.17 Review your images.

- **Change image information display.** Press the DISPLAY button to change among overlays of basic image information or detailed shooting information.

- **Magnify/reduce image on screen.** Use the GF1's rear dial to zoom in and out of an image while in playback mode. Turning it to the right zooms in and twisting it to the left zooms out. If you turn it to the left while in full-size playback the camera will set to thumbnail view. Continuing to turn the dial to the left will take you to smaller thumbnails and eventually calendar view.

- **Protect images.** Press the MENU/SET button and navigate to the Playback menu. The Protect setting is on the third screen, second submenu from the top. Use the right arrow key to get to the next screen and then choose the desired option. If you want to protect more than one image, choose MULTI and use the arrow keys to navigate through the thumbnails. Each time you get to an image you want to protect, press the MENU/SET button. When done, push the Trash button once. Your protected images should have a little key icon on them when you review them in Playback mode after that. (Note, protecting an image doesn't protect it if you reformat the card.)

- **Delete current image.** Press the Trash button once and then use the left arrow to choose "yes" followed by pressing the MENU/SET button to remove the photo currently being displayed. You'll also have options for deleting more than one image or deleting all images.

- **Exit playback.** Press the Playback button again, or just tap the shutter release button to exit playback view.

You'll find information on viewing thumbnail indexes of images, automated playback, and other options in Chapter 3.

Transferring Photos to Your Computer

When you're ready to transfer your photos to your computer, you'll find everything you need to know in this section.

The final step in your picture-taking session will be to transfer the photos you've taken to your computer for printing, further review, or image editing. Your GF1 allows you to print directly to PictBridge-compatible printers and to create print orders right in the camera, plus you can select which images to transfer to your computer. I'll outline those options in Chapter 3.

I always recommend using a card reader attached to your computer to transfer files, because that process is generally a lot faster and doesn't drain the GF1's battery. However, you can also use a cable for direct transfer, which may be your only option when you

have the cable and a computer, but no card reader (perhaps you're using the computer of a friend or colleague, or at an Internet café).

To transfer images from the camera to a Mac or PC computer using the USB cable

1. Turn off the camera.

2. Open the cover that protects the GF1's USB port, and plug the USB cable furnished with the camera into the USB port. (See Figure 1.18 to see how I upload photos from my GF1 to my Apple iPad.)

3. Connect the other end of the USB cable to a USB port on your computer. The camera will automatically turn itself on.

4. The LCD screen will activate and present you with two choices: PictBridge(PTP) and PC. Use the up/down arrow keys to select the desired option (in this case, "PC"). Press the MENU/SET button to make the selection.

5. The memory card appears on your desktop as a mass storage device, enabling you to drag and drop the files to your computer.

Figure 1.18
Images can be transferred to your computer using the supplied mini USB cable.

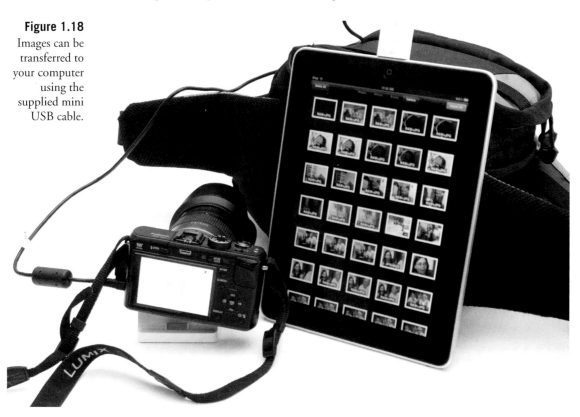

To transfer images from a Secure Digital card to the computer using a card reader, as shown in Figure 1.19, do the following:

1. Turn off the camera.

2. Open the memory card door and remove the SD card.

3. Insert the Secure Digital card into your memory card reader. Depending on your operating system or software, your computer detects the files on the card and offers to transfer them. The card can also appear as a mass storage device on your desktop, which you can open and then drag and drop the files to your computer.

Figure 1.19
A card reader is the fastest way to transfer photos.

2

Panasonic Lumix DMC-GF1 Roadmap

With the DMC-GF1, Panasonic has continued its emphasis on creating a super-compact interchangeable lens digital camera that retains the convenience and easy access to essential controls but also more closely fits the vision many expected for the Micro Four Thirds format (at the cost of a view finder). Most of the Panasonic Lumix DMC-GF1's key functions and settings that are changed frequently can be accessed directly using the modest array of dials, buttons, and knobs that populate the camera's surface, or via the Quick menu's Q.MENU button. With so many quick-access controls available, you'll find that the bulk of your shooting won't be slowed down by a visit to the vast thicket of text options called Menuland.

Remember, learning to use your new camera isn't about memorizing every little control, menu, or feature it contains. Instead, it's all about turning your new piece of equipment into a creative tool you can rely on and use to achieve your photographic vision. Knowing how to make your camera do what you want it to do is why you're reading this book, not because you've got an exam coming up that's going to test your ability to remember what happens if you turn the rear dial four times to the left.

However, if you want to operate your DMC-GF1 efficiently, you'll need to learn the location, function, and application of all these controls. You may have seen advice from well meaning digital interchangeable lens camera veterans who tell you that a guide like this one isn't necessary because, "everything is in the user's manual." Of course, the basics on each control are in the manual supplied with the camera—but how do you find it, and once you've located the information, how do you figure out what it *means*?

What you *really* need is a street-level roadmap that shows where everything is, and exactly how it's used. Instead, what Panasonic gives you in the user's manual is akin to a world globe with an overall view and many cross-references to the pages that will tell you what you really need to know. Check out the "Camera" pages in Panasonic's manual, which compress views of the front, back, top, and bottom of the DMC-GF1 into two tiny black-and-white line drawings and a couple insets. There the tiny drawings with more than four dozen callouts point to various buttons and dials crammed into the pair of illustrations. If you can find the control you want within this cramped layout, you'll still need to flip back and forth among multiple pages (individual buttons can have several different cross-references sometimes a hundred pages apart!) to locate the sometimes poorly written information.

Most other third-party books follow this format, featuring black-and-white photos or line drawings of front, back, and top views, and many labels. I originated the up-close-and-personal, full-color, street-level roadmap (rather than a satellite view) that I use in this book and my previous camera guidebooks. I provide you with many different views, like the one shown in Figure 2.1 (with the electronic viewfinder mounted), and lots of

Figure 2.1

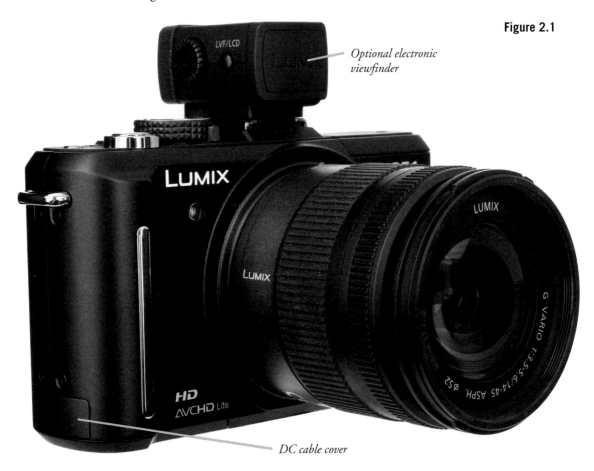

Optional electronic viewfinder

DC cable cover

explanation accompanying each zone of the camera, so that by the time you finish this chapter, you'll have a basic understanding of every control and what it does. I'm not going to delve into menu functions here—you'll find a discussion of your Setup, Shooting, and Playback menu options in Chapter 3. Everything here is devoted to the button pusher and dial twirler in you.

You'll also find this "roadmap" chapter a good guide to the rest of the book, as well. I'll try to provide as much detail here about the use of the main controls as I can, but some topics (such as autofocus and exposure) are too complex to address in depth right away. So, I'll point you to the relevant chapters that discuss things like setup options, exposure, use of electronic flash, and working with lenses with the occasional cross-reference.

I wish it were possible to explain all there is to know about every feature the first time a feature is introduced, but I know you'd rather not slog through an impenetrable 200-page chapter. Instead, I'm going to provide you with just enough information about each control to get you started, and go into more detail after you've had a chance to absorb the basics. Often when you're learning a new camera, you want to start out just learning how to master these things. Once you've "locked" them in, you can work on delving deeper into the camera's capabilities.

Panasonic Lumix DMC-GF1: Front View

This is the side of the DMC-GF1 seen by your victims as you snap away. For the photographer, though, the front is the surface your fingers curl around as you hold the camera, and there are really only a few buttons to press, all within easy reach of the fingers of your left and right hands. There are additional controls on the lens itself. You'll need to look at several different views to see everything.

The front side of the Lumix GF1 is shown from another angle in Figure 2.2. The key features here are as follows:

- **DC cable cover.** An AC adapter can be connected to the camera through this port, which you can see best in Figure 2.1.

- **Self-timer/AF assist lamp.** When using the self-timer, this lamp blinks while the camera counts down before firing. This lamp also flashes to provide additional illumination to aid the camera in autofocusing under low light conditions.

- **Lens release button.** Press this button to unlock the lens, and then rotate it to the right to remove your optics.

- **Finger grip.** This provides a small handhold.

- **Flip-up flash.** Here the built-in flash is retracted and tucked away.

- **Speaker.** Sounds from your camera emerge here.

Finger grip

Self-timer indicator/ AF assist lamp

Speaker

Flip-up flash

Figure 2.2

Lens release button

Figure 2.3 shows the Panasonic Lumix DMC-GF1 from the side. The main components you need to know about are as follows:

- **Optical image stabilization switch.** Lenses that offer O.I.S. will have an on/off switch that allows you to enable/disable the feature when its anti-shake qualities are not needed (say, when the camera is mounted on a tripod).

- **Neck strap ring.** Fasten your camera's neck strap to this ring, and to its mate on the opposite side of the GF1.

- **Flip-up flash.** Pop up this light source when you need some extra illumination for your scene.

- **Port cover.** This cover flips open to reveal the HDMI and USB ports, which you can use to connect the GF1 to an HDTV and to your computer.

Figure 2.4 shows the connector ports that allow you to use the following accessories with your GF1:

- **Remote control socket.** Attach a wired remote control here.

- **HDMI mini-connector.** You can link this connector with an HDMI capable television to view your photos on a large screen. (Requires the purchase of a separate cable.)

Figure 2.3

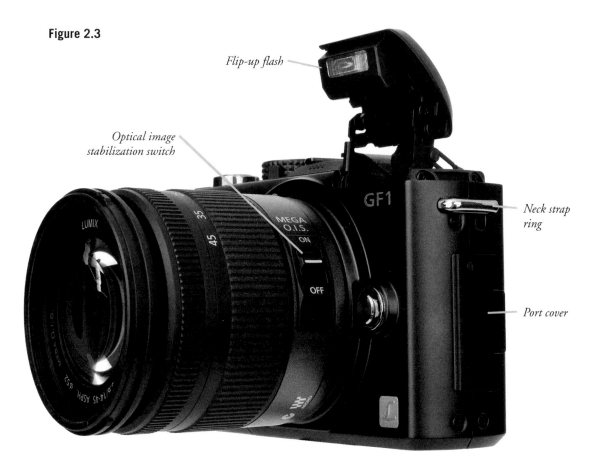

Flip-up flash

Optical image
stabilization switch

Neck strap
ring

Port cover

Figure 2.4

Remote control socket

HDMI port

USB port

■ **USB port/AV Out/Digital port.** Plug in the USB cable furnished with your Panasonic Lumix DMC-GF1 and connect the other end to a USB port in your computer to transfer photos, or to interface with the Panasonic Camera Control Pro software described in Chapter 8. This port can also be used to connect the camera with a standard television equipped with composite video inputs via an included video cable in order to display images at standard (non-HD) television resolutions. Panasonic recommends using the supplied USB cable only.

Going Topside

You'll find more controls on the top of the DMC-GF1, shown in Figure 2.5. The main points of interest include those on the left and right sides of the top panel:

■ **Mode dial.** This dial sets exposure modes, including Scene (SCN), C1, C2, and MyColor modes; iAuto; Manual, Shutter-priority, Aperture-priority, and Program semi-automatic modes, and turns the DMC-GF1 into an HD video camera when you rotate the dial to the movie camera icon.

■ **Drive mode lever.** This lever changes the camera's drive mode to one of four options: Single, Burst, Auto Bracket, or Self-timer.

■ **Shutter button.** On top of the camera is the shutter release button, which has multiple functions. Press this button down halfway to lock exposure and focus. Press it down all the way to actually take a photo or sequence of photos if you're using Burst mode. Tapping the shutter button when the DMC-GF1's exposure meters have turned themselves off reactivates them, and a tap can be used to remove the display of a menu or image from the rear color LCD.

■ **ON/OFF switch.** Turns the DMC-GF1 on or off. An LED next to the switch glows green to show the camera is turned on.

■ **Accessory/flash shoe.** Slide an electronic flash into this mount when you need a more powerful speedlight. A dedicated flash unit, like the Panasonic DMW-FL220 TTL External Flash can use the multiple contact points shown to communicate exposure and other data between the flash and the camera. There's more on using electronic flash in Chapter 7. This shoe is also used to mount the Optional External Viewfinder (but only one item at a time can be mounted in the shoe), as shown in Figure 2.6. Chances are, Panasonic will offer additional accessories that use the hot shoe and accessory port, but no others have been announced at this time.

- **Movie mode quick switch.** This button puts the camera into Movie mode and begins recording as soon as you press the button (provided you've instructed the camera to use the button for this purpose).

- **Speaker.** Sound emitted by your DMC-GF1 emerges here.

- **Microphone.** The microphone records sound when shooting movies.

- **Sensor plane.** Some specialized kinds of scientific and close-up photography require precise measurements from the focal/sensor plane, which is represented by the symbol here.

Figure 2.5

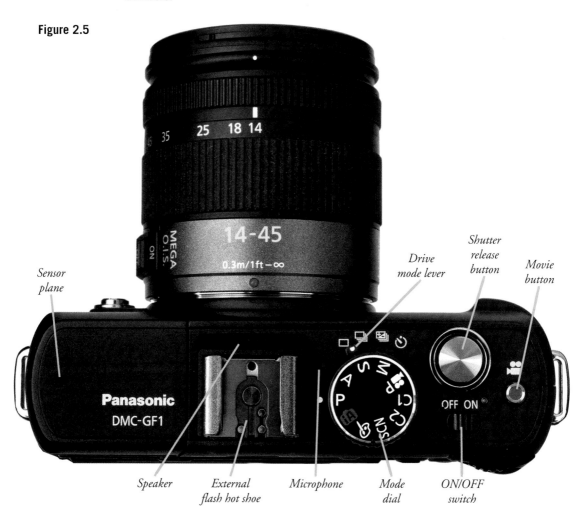

Figure 2.6
The optional electronic viewfinder slides into the hot shoe and connects electrically to a port on the back of the camera.

The Panasonic Lumix DMC-GF1's Business End

The back panel of the Panasonic Lumix DMC-GF1 (see Figure 2.7) bristles with almost a dozen different controls, buttons, and knobs. That might seem like a lot of controls to learn, but you'll find that it's a lot easier to press a dedicated button and spin a dial than to jump to a menu every time you want to access one of these features.

Key buttons and controls on the back of the camera let you change many of the GF1's settings. You can see the controls clustered along the right edge of the back panel in Figure 2.8. The key buttons and components and their functions are as follows:

- **Flash open button.** This button on the upper-left rear of the camera activates the built-in pop-up flash unit. (See Figure 2.7.)

- **LCD.** View your images and navigate through the menus on this screen. (Also seen in Figure 2.7.)

- **Playback button.** Press this button to review images you've taken, using the controls and options I'll explain in the next section. To remove the displayed image, press the Playback button again, or simply tap the shutter release button lightly (if you tap it heavily, the camera will take a picture).

Figure 2.7

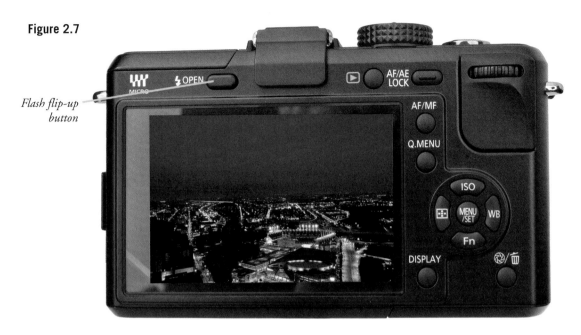

Flash flip-up button

Figure 2.8

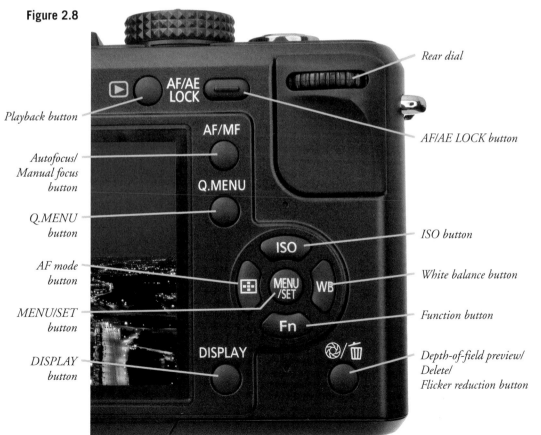

Rear dial

Playback button

AF/AE LOCK button

Autofocus/ Manual focus button

Q.MENU button

ISO button

AF mode button

White balance button

MENU/SET button

Function button

DISPLAY button

Depth-of-field preview/ Delete/ Flicker reduction button

■ **AF/AE LOCK button.** Use this button to lock focus or exposure. (You'll have to tell the camera which option you prefer via the Custom menu. I'll explain how to do this in Chapter 3.)

■ **Rear dial.** This dial is located on the upper-right side of the back of the camera. It performs a number of functions including navigation, zooming in and out of images, repositioning the AF sensor point, changing shutter speed or aperture depending on what exposure mode you're in, and more. I'll describe these functions later in this chapter.

■ **AF/MF button.** Press this button to bring up your focus mode choices.

■ **Q.MENU button.** Summons/exits the Quick menu displayed on the rear LCD of the DMC-GF1.

■ **Fn (Function button).** This button can be programmed to perform any one of several functions (including changing the film mode (the default), autofocus mode, aspect ratio, or other settings).

■ **Arrow pad.** Four buttons that pull double duty. While they serve as the up, down, left, and right arrow keys, they also work as the ISO, Fn, AF mode selector, and WB buttons.

■ **DISPLAY button.** This button cycles through the various LCD display modes when the camera is in Shooting mode or through the various information modes when the camera is in Playback mode.

■ **Depth-of-field preview/Trash/Flicker reduction button.** Press to stop down the lens to the current aperture, allowing you to better judge the depth-of-field. In Playback mode, press this button to erase the image shown on the LCD. A display will pop up on the LCD offering you a variety of choices regarding whether you want to delete one image, multiple images, or all images on the memory card. Once you've selected your answer, pressing the MENU/SET button completes the process. When you're working with submenus, this button also serves to exit a submenu and return to the main menu. When shooting movies, this button can be used to reduce flicker.

■ **MENU/SET button.** Summons/exits the menu displayed on the rear LCD of the DMC-GF1.

Playing Back Images

Reviewing images is a joy on the Panasonic Lumix DMC-GF1's big 3-inch LCD. Here are the basics involved in reviewing images on the LCD screen (or on a television screen you have connected with a cable). You'll find more details about some of these functions later in this chapter, or, for more complex capabilities, in the chapters that I point you to. This section just lists the must-know information.

■ **Start review.** To begin review, press the Playback button. It's the button right below the exposure mode dial and is colored aqua. The most recently shot image will appear on the LCD unless you were recently reviewing images. Then it returns to the last image you viewed.

■ **View thumbnail images.** To change the view from a single image to 12 or 30 thumbnails, rotate the rear dial to the left, following the instructions in the "Viewing Thumbnails" section next.

■ **Zoom in and out.** To zoom in or out, rotate the rear dial to the right, following the instructions in the "Zooming the Panasonic Lumix DMC-GF1 Playback Display" in the next section. (It also shows you how to move the zoomed area around using the arrow keys.)

■ **Move back and forth.** To advance to the next image, use the right arrow; to go back to a previous shot, press the left arrow. When you reach the beginning/end of the photos in your folder, the display "wraps around" to the end/beginning of the available shots.

■ **See different types of data.** To change the type of information about the displayed image that is shown, press the DISPLAY button. To learn what data is available, read the "Working with Photo Information" section later in this chapter.

■ **Remove images.** To delete an image that's currently on the screen, press the Trash button once, and then press the left arrow button to select "Yes" followed by the MENU/SET button to actually delete the image. You can also delete multiple images or all images.

■ **Cancel playback.** To cancel image review, press the Playback button again, or simply tap the shutter release button.

Zooming the Panasonic Lumix DMC-GF1 Playback Display

Here's how to zoom in and out on your images during picture review:

1. **Magnify/reduce from thumbnail to 16X.** When an image is displayed (use the Playback button to start), turn the rear dial to the right. You can keep turning the rear dial to increase or decrease the magnification it provides, with a maximum of 16x and back down to thumbnail size. The LCD screen provides the magnification information on the left side of the screen (higher magnification setting upper left, lower magnification, lower left) so you can see exactly what magnification options you have by turning the dial in either direction.

2. **Move within zoomed image.** You can use the up, down, left, and right arrow keys to move through the image to examine it more closely. (See Figure 2.9.)

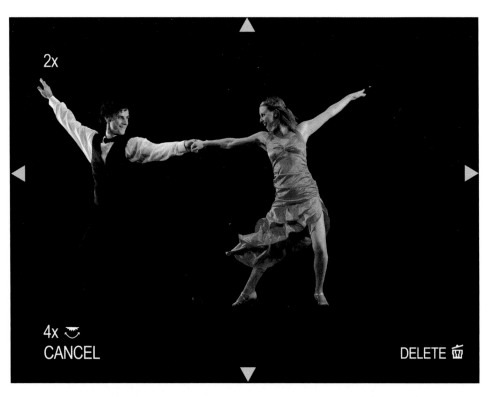

Figure 2.9
The DMC-GF1 shows an image with small yellow triangles showing you can move in any of four directions to examine the entire image area while zoomed in. At the upper left side of the LCD screen you'll see the current magnification setting. At the lower left you'll see the results if you turn the rear dial to the right or the left.

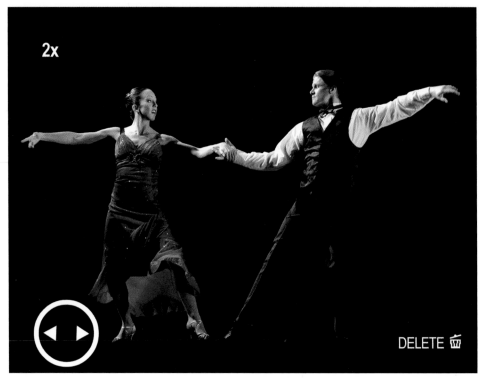

Figure 2.10
Press the rear dial in and instead of maneuvering around the enlarged image, you move to the next or previous image by using the right or left arrow.

3. **Change to next/previous image.** Pushing the rear dial in while zoomed in on the image changes how the zoomed-in playback image behaves. Instead of using the left and right arrow keys to maneuver around the image, the left and right arrow keys take you to either the next image (right arrow) or the previous image (left arrow) making it possible to examine the same spot on a series of images. Pressing the rear dial again returns you to the directional screen and the ability to examine different parts of the same image. (See Figure 2.10.)

4. **Exit zoom.** To exit Zoom in/Zoom out display, turn the rear dial to the left until the full-screen/full-image/information display appears again.

Viewing Thumbnails

The Panasonic Lumix DMC-GF1 provides other options for reviewing images in addition to zooming in and out. You can switch between single image view and either 12 or 30 reduced-size thumbnail images on a single LCD screen.

Pages of thumbnail images offer a quick way to scroll through a large number of pictures quickly to find the one you want to examine in more detail. The DMC-GF1 lets you switch quickly from single- to 12- or 30-image views, with a scroll bar displayed at the right side of the screen to show you the relative position of the displayed thumbnails within the full collection of images in the active folder on your memory card. Figure 2.11 shows the 3 × 4 view with 12 thumbnails, while Figure 2.12 shows the

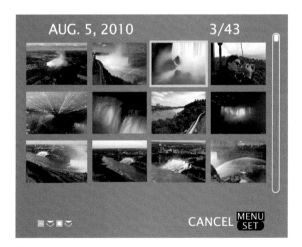

Figure 2.11 Switch between various thumbnail sizes by turning the rear dial. Here, 12 thumbnails are displayed.

Figure 2.12 Switch between various thumbnail sizes by turning the rear dial. Here, 30 thumbnails are displayed.

5 × 6 view with 30 thumbnails. The rear dial is used to change the thumbnail views. If you go past the 5 × 6 view screen, the LCD screen displays Calendar view. (See Figure 2.13.)

- **View more thumbnails.** To increase the number of thumbnails on the screen, turn the rear dial to the left (turning to the right at single-image view will zoom in on the image). The DMC-GF1 will switch from single image to 12 to 30 thumbnails, and then to Calendar view (discussed next). Use the arrow keys to navigate to a specific thumbnail or to move the cursor around Calendar view. If you press the OK button while an image is selected, the LCD will go to single-image view and show the image that was selected (see "Working with Calendar View," next). (The dial will not do anything if turned left at Calendar view, but turning it to the right will return the display to the thumbnail views, and finally to a single image again.)

- **Reduce number of thumbnails.** To decrease the number of thumbnails on the screen, turn the rear dial to the right. Each turn will take you back one setting.

- **Change highlighted thumbnail area.** Use the main dial arrow keys to move the yellow highlight box around among the thumbnails.

- **Delete images.** When viewing thumbnails or a single-page image, press the Trash button. This brings up the delete menu overlay where you can confirm the deletion (YES), choose to delete multiple images (DELETE MULTI), or delete all the images on the card (DELETE ALL). Be advised though, if you really want to delete every image on the card, it's probably better to just reformat the card instead.

- **Exit image review.** Tap the shutter release button or press the Playback button to exit image review. You don't have to worry about missing a shot because you were reviewing images; a half-press of the shutter release automatically brings back the DMC-GF1's exposure meters, the autofocus system, and cancels image review.

Working with Calendar View

Once in Calendar view, you can sort through images arranged by the date they were taken. This feature is especially useful when you're traveling and want to see only the pictures you took in, say, a particular city on a certain day.

- **Change dates.** Use the arrow keys to move through the date list (see Figure 2.13).

- **View a date's images.** Press the MENU/SET button to return to single-image view with the first image taken on the date you've selected.

- **Delete images.** Pressing the Trash button brings a highlighted image into delete mode. You will then have the standard delete images dialog panel and use the up/down arrow to select the desired choice. Push the MENU/SET button to confirm that choice.

Figure 2.13
Switch between
various thumb-
nail sizes by
turning the rear
dial. Here,
Calendar view
is displayed.

■ **Exit Calendar view.** In Thumbnail view, if you highlight an image and press the MENU/SET button, you'll exit Calendar view and the highlighted image will be shown on the LCD in the display mode you've chosen. (See "Working with Photo Information" to learn about the various display modes.) You can also exit Calendar view by tapping the shutter release (to turn off the LCD to ready the camera for shooting) or by pressing the MENU/SET button.

Working with Photo Information

When reviewing an image on the screen, your DMC-GF1 can supplement the image itself with a variety of shooting data, ranging from basic information presented at the top and bottom of the LCD display, to a pair of screens that detail virtually every shooting option you've selected. This section will show you the type of information available. Most of the data is self-explanatory, so the labels in the accompanying figures should tell you most of what you need to know. To change to any of these views while an image is on the screen in Playback mode, press the DISPLAY button.

■ **Normal display.** This display provides basic shooting information such as shot number (first number is the frame number, second number is the number of shots made on card), exposure settings, if flash was used, exposure compensation, ISO, and more. (See Figure 2.14.)

Figure 2.14
Normal
display.

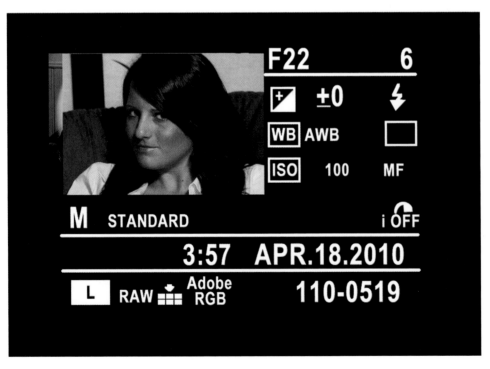

Figure 2.15
Detailed infor-
mation display.

■ **Detailed information display.** This shows a thumbnail of the image and shooting information against a black background instead of being overlaid over the image as in the previous screen. The display also provides some additional details such as date the shot was made and the image file number. (See Figure 2.15.)

■ **Histogram display.** This display provides a thumbnail of the image as well as four histograms (one for exposure and the rest for color [RGB]). The display also contains a variety of shooting information. (See Figure 2.16.)

■ **Highlight display.** Use this display to check for blown-out highlights (blinking areas of the display indicate highlights that are blown out). This display shows blown highlights and battery status and nothing else. Figure 2.17 shows the over-exposed highlights (on the model's left and right sleeves, nose, and mouth) in black, as the blinking effect is difficult to achieve on the printed page.

■ **No display.** Shows image only, no information at all. (See Figure 2.18.)

Figure 2.16
Histogram display. The LCD shows a smaller version of the image, plus four histograms. It shows, in order, Red, Green, Blue, and exposure. This view also provides additional shooting information.

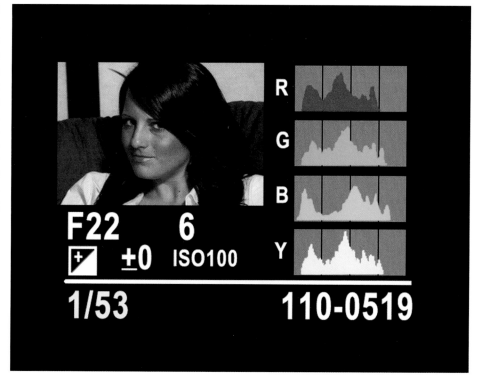

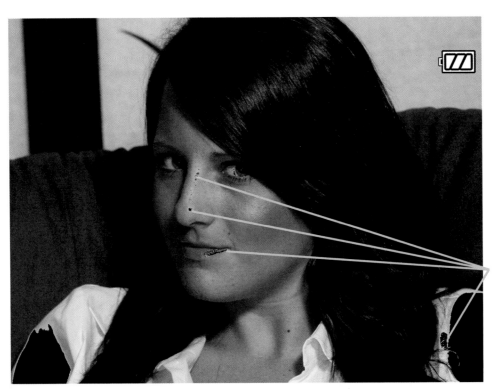

Figure 2.17
Highlight display.

Highlight warnings

Figure 2.18
No display.

Lens Components

The lens shown in Figure 2.19 is a typical lens that might be mounted on the Panasonic Lumix DMC-GF1. It is, in fact, the 14-45mm "kit" lens often sold with the camera body. Components found on some or all lenses include

- **Filter thread.** Most lenses have a thread on the front for attaching filters and other add-ons. Some also use this thread for attaching a lens hood (you screw on the filter first, and then attach the hood to the screw thread on the front of the filter). Some lenses have no front filter thread because their front elements are too curved to allow mounting a filter and/or because the front element is so large that huge filters would be prohibitively expensive. Some of these front-filter-hostile lenses allow using smaller filters that drop into a slot at the back of the lens.

- **Lens hood bayonet.** Lenses like the 14-45mm zoom shown in the figure use this bayonet to mount the lens hood. Such lenses generally will have a dot on the edge showing how to align the lens hood with the bayonet mount.

- **Focus ring.** This is the ring you turn when you manually focus the lens, or fine-tune autofocus adjustment. It's a narrow ring at the very front of the lens (on the 14-45mm kit lens), or a wider ring located somewhere else.

Figure 2.19

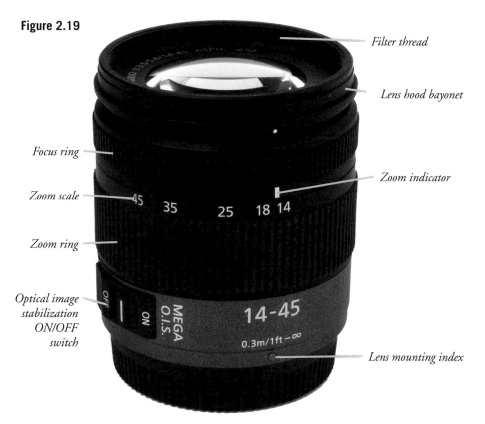

Filter thread

Lens hood bayonet

Focus ring

Zoom indicator

Zoom scale

Zoom ring

Optical image stabilization ON/OFF switch

Lens mounting index

- **Focus scale.** This is a readout found on many lenses (not shown) that rotates in unison with the lens' focus mechanism to show the distance at which the lens has been focused. It's a useful indicator for double-checking autofocus, roughly evaluating depth-of-field, and for setting manual focus guesstimates. Chapter 6 deals with the mysteries of lenses and their controls in more detail.

- **Zoom scale.** These markings on the lens show the current focal length selected.

- **Zoom ring.** Turn this ring to change the zoom setting.

- **OIS switch.** This switch allows you to turn optical image stabilization on or off.

- **Rear contacts.** The electrical contacts on the rear of the lens allow it to communicate with the camera. (See Figure 2.20.)

- **Lens mount bayonet.** This mates with the mount on the camera body to allow attaching the lens.

Figure 2.20

Bayonet mount flange

Electronic contacts

Underneath Your Panasonic Lumix DMC-GF1

There's not a lot going on with the bottom panel of your Panasonic Lumix DMC-GF1 (Figure 2.21). You'll find the battery compartment access door and a tripod socket, which secures the camera to a tripod. The socket accepts other accessories, such as flash brackets and quick release plates that allow rapid attaching and detaching of the DMC-GF1 from a matching platform affixed to your tripod.

Figure 2.21

Tripod socket

Battery
door release

Looking Inside the Viewfinder

Much of the important shooting status information is shown inside the viewfinder of the Panasonic Lumix DMC-GF1 (if you are using the accessory viewfinder. If you aren't, the same information is displayed on the LCD screen). Not all of this information will be shown at any one time. Figure 2.22 shows what you can expect to see. The possible readouts include

- **Flash mode.** Shows the flash setting.
- **Film mode.** Shows which film style the camera is set to.
- **Optical image stabilization setting.** Shows which image stabilization setting you've chosen.
- **Jitter alert.** Provides a warning that camera shake is likely. This is the camera's way of suggesting you make sure you use image stabilization (if your lens has it) and consider using a tripod and a remote shutter cord.
- **Burst mode.** Shows the Burst mode you have chosen.
- **Motion picture record mode quality.** Shows the quality setting you've set for motion picture recording.
- **Aspect ratio/picture size.** Shows the aspect ratio and picture size you have chosen.
- **Quality mode.** Shows the image quality setting you have chosen.
- **LCD mode.** Shows the LCD mode setting you have chosen—either the traditional camera viewfinder style or something that approximates a computer display.
- **Intelligent exposure mode.** Shows the setting you've chosen for this mode.

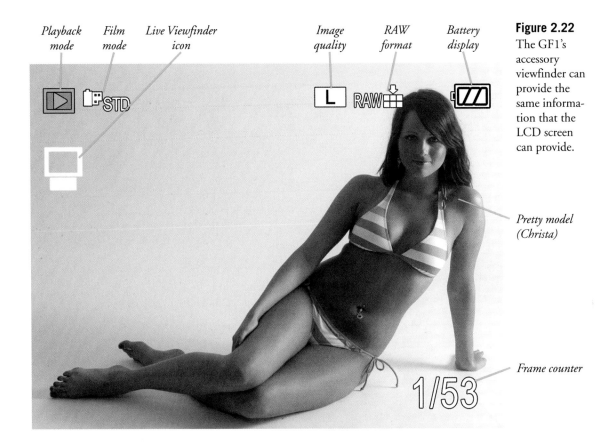

Playback mode · Film mode · Live Viewfinder icon · Image quality · RAW format · Battery display

Pretty model (Christa)

Frame counter

Figure 2.22
The GF1's accessory viewfinder can provide the same information that the LCD screen can provide.

- **Battery status.** Shows how much power your battery has remaining.

- **Histogram.** A live histogram that shows exposure information as you operate the camera.

- **Metering mode.** Shows the metering mode you have chosen.

- **f/stop.** Shows the f/stop you have chosen.

- **Shutter speed.** Shows the shutter speed you have chosen.

- **Exposure meter.** Shows how close to proper exposure you are or how much exposure compensation you've dialed in.

- **ISO sensitivity.** Shows the ISO setting you have chosen.

- **White balance setting.** Shows the white balance setting you have chosen.

- **Shots/time remaining.** Shows how many images can be made with the space available remaining on the memory card if you're shooting stills, or the time remaining if you're shooting video.

Setting Up Your Panasonic Lumix DMC-GF1

The Panasonic Lumix DMC-GF1 is a versatile camera that gives its user the ability to fine-tune the camera's operation to many of his or her personal preferences. Not only can you change shooting settings used at the time the picture is taken, but you can adjust the way your camera behaves. Indeed, if your GF1 doesn't operate in exactly the way you'd like, chances are you can make a small change in the Rec, Motion Picture, Custom, Setup, My Menu, or Playback menus that will tailor the GF1 to your needs.

This chapter will help you sort out the settings for all the GF1's menus. These include the Playback and Rec menus, which determine how the GF1 displays images on review, and how it uses many of its shooting features to take a photo. In the section on the Setup menu, you'll discover how to format a memory card, set the date/time and LCD brightness, and do other maintenance tasks.

As I've mentioned before, this book isn't intended to replace the manual you received with your GF1, nor have I any interest in rehashing its contents. You'll still find the original manual useful as a standby reference that lists every possible option in exhaustive (if mind-numbing) detail—without really telling you how to use those options to take better pictures. There is, however, some unavoidable duplication between the Panasonic manual and this chapter, because I'm going to explain all the key menu choices and the options you may have in using them. You should find, though, that I will give you the information you need in a much more helpful format, with plenty of detail on why you should make some settings that are particularly cryptic. If you've looked at the Panasonic manual that accompanies the camera, you may have also noticed

it's not written in the clearest English. I've tried hard to make sure this book is much more understandable.

I've written this book to be a companion to the owner's manual that comes with the GF1. I'll start with an overview of using the GF1's menus themselves.

Anatomy of the Panasonic Lumix DMC-GF1's Menus

The GF1 offers six separate main menu listings (Rec, Motion Picture, Custom, Setup, My Menu, and Playback) as well as a number of submenus. If you've never used a Panasonic digital interchangeable lens camera before, this chapter will help you learn how to access and apply all these choices and, most importantly, *why* you might want to use a particular option or feature. While the Panasonic Lumix DMC-GF1's menu lineup is quite sound, it's also very comprehensive and can take some effort to learn.

The GF1 does offer a lot of menu choices. And while it's nice to have choices, things get confusing when you have a lot of them. Fortunately, many of the GF1's choices can be figured out fairly easily or set once and then forgotten about.

If you're lucky enough to be able to work with more than one Panasonic camera, you also gain the opportunity to learn several different menu systems in the bargain. It's fortunate that so many menu options are duplicated in the Quick menu, because you can make many settings there and avoid the Lewis Carroll-like trip through Menuland entirely if you want.

The MENU/SET button and basic operation of the GF1's menus are simple. Press the MENU/SET button, located inside the circle formed by the arrow keys at the right side of the LCD. The menus consist of a series of six separate screens with rows of entries, as shown in Figure 3.1. (Note that your menu choices can vary depending on which of the GF1's shooting modes you're using. In some shooting modes, such as iA (Intelligent Auto), some of your menu choices may be grayed out or not even visible. This means you can't change these options when working in the particular mode you're shooting in.)

There are multiple columns of information in each menu screen.

- **Top-level menus.** The left-hand column includes an icon representing each of the top-level menu screens. From the top in Figure 3.1, they are Rec, Motion Picture, Custom Menu, Setup, My Menu, and Playback.

- **Current menu entries.** The center column includes the name representing the function of each choice in the currently selected menu. If you're in the Rec menu, your first screen's options include: Film Mode, Aspect Ratio, Picture Size, Quality, and Face Recognition (you can have as many as five different screen's worth of choices with the GF1 depending on exposure mode). If you press the right arrow

Figure 3.1
The "main" menu screen appears when you press the MENU/SET button. The GF1 remembers the last submenu setting you visited (the center selection) even if you power down the camera. Pressing the MENU/SET button will toggle between Shooting mode and menu choices.

key, one of these choices will be highlighted in yellow. You can then cursor up or down to any option available on the screens in that top-level menu system. Once you get to the choice you want, use the right arrow key again to activate the third column menu.

■ **Current setting.** The menu screen shows three columns (far left—master menu group, center—menu sub group, far right—either blank or displays icon or information regarding the current setting). In Figure 3.2, the Picture Size option is highlighted and a letter L (Large) is showing in the right column. Pressing the right arrow key activates the options submenu (shown) with its three choices (L, M, S).

Navigating among the various menus is easy and follows a consistent set of rules.

■ **Press MENU/SET to start.** Press the MENU/SET button to display the main menu screens.

■ **Navigate with the arrow buttons/rear dial.** Pressing the up or down arrow keys or turning the rear dial will move the highlight bar up or down the screen. Use the right arrow or push the rear dial in and you will activate the third column.

■ **Highlighting indicates active choice.** As you use the rear dial's right button to move into the column containing that menu's choices, you can then use the up/down buttons to scroll among the individual entries. (See Figure 3.2.)

- **Select a menu item.** To work with a highlighted menu entry, press the MENU/SET button or push in the rear dial. Any additional screens of choices will appear, like the one you can see in Figure 3.3. You can move among them using the same movements. If there is more than one screen of menu options, the number of screens and the series they're in is posted at the top-right corner of the LCD display, the same way it is when you're navigating the main screens.

- **Choose your menu option.** You can confirm a selection by pressing the MENU/SET button.

- **Leaving the menu system.** Depending on the menu option, you may either press the Trash button to cancel the choice or the left arrow key to return to the previous screen. Look to the bottom of the LCD display for instructions as to which method to use. You can also exit the menu system by tapping the shutter release button.

- **Quick return.** The Panasonic Lumix DMC-GF1 "remembers" the top-level menu and specific menu entry you were using the last time the menu system was accessed, so pressing the MENU/SET button brings you back to where you left off. (You can change this to have the camera automatically return to the main menu instead if you wish. It's covered later in this chapter.)

Figure 3.2
When working within a menu, the selected menu entry is highlighted.

Figure 3.3
Submenus let
you choose
actual menu
options.

There are six top-level menus: Rec, Motion Picture, Custom, Setup, My Menu, and Playback. Each menu provides a collection of submenus to further customize your camera.

Rec Menu

The Rec (recording) menu has five screens worth of options related to setting up the camera for photography. These choices depend on which Shooting mode you're using. Not all of these will even be visible depending on the mode you've chosen. The choices you'll find include

- Film Mode
- Aspect Ratio
- Picture Size
- Quality
- Face Recognition
- Stabilizer
- Flash
- Red-Eye Removal
- Flash Synchro
- Flash Adjust
- Metering Mode

- I. Exposure
- Long Shutter NR
- ISO Limit Set
- ISO Increments
- External Optical Zoom
- Digital Zoom
- Burst Rate
- Auto Bracket
- Self-Timer
- Color Space
- Audio Rec.

Film Mode

The GF1 offers a dozen different film mode settings. These modes let you change the color performance of your camera the same way changing from one type of film to another did back when photographers chose films for their color characteristics.

An added feature of this mode are two custom options that let you set your own color parameters plus a multi option that tells the camera to alternate between three different film modes in sequence for each three presses of the shutter.

1. **Standard.** This is the camera's normal color setting and should give you the most accurate colors.

2. **Dynamic.** This setting increases the camera's color saturation and contrast.

3. **Nature.** Enhances red, blue, and green to create better nature photos.

4. **Smooth.** Contrast is reduced in order to produce smoother looking colors.

5. **Nostalgic.** Uses lower color saturation and contrast to give the effect of an image that's faded over time.

6. **Vibrant.** Pumps up the contrast and color saturation even more than the dynamic setting.

7. **Standard B&W.** Provides the most accurate black-and-white reproduction of a scene.

8. **Dynamic B&W.** Increases contrast in a black-and-white image.

9. **Smooth B&W.** Creates smoother tones in a black-and-white image without affecting texture.

10. **My Film 1 and My Film 2.** Saves the color settings you dial in.

11. **Multi film.** Sequences between three film modes that you set (you have to press the shutter button three times). (See Figure 3.4.)

Aspect Ratio

While the GF1 is a Micro Four Thirds format camera, you can set it to work at three other sets of proportions, or *aspect ratios*. This makes it possible for you to tailor the aspect ratio to your planned display format. Your options (shown in Figure 3.5) include

1. **4:3.** This is the standard four-thirds format and also consistent with a standard television.

2. **3:2.** This is the aspect ratio for a 35mm film camera.

3. **16:9.** This produces an image with an aspect ratio for an HD television.

4. **1:1.** This results in a square aspect ratio, which would be familiar to users of the medium format cameras that employ the 6 × 6cm frame.

Figure 3.4
Multi film lets you create the same image using three different user selected film mode settings. You still have to trip the shutter three times.

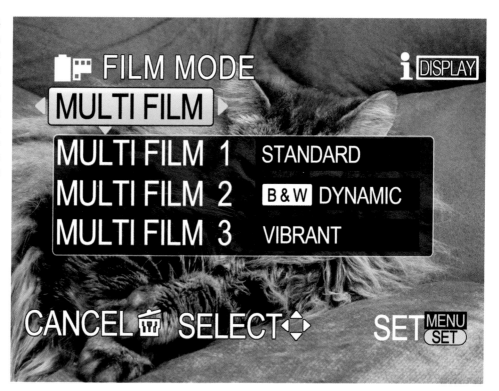

Figure 3.5
The GF1 offers four different aspect ratio choices.

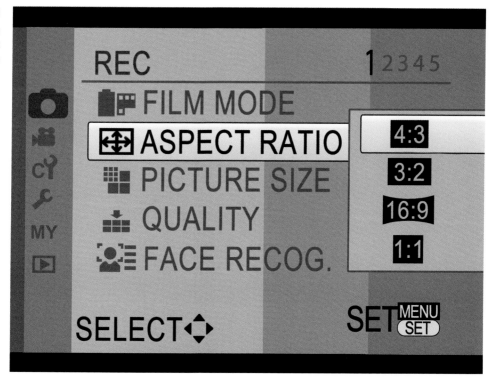

Picture Size

The Picture Size setting lets you choose the resolution for your image. The camera provides three basic options: L (large), M (medium), and S (small) (shown in Figure 3.6). The higher the resolution setting, the finer the detail in the images and the larger the file sizes.

You can set a specific picture size for each aspect ratio the camera offers, but the total pixel count will vary depending on which aspect ratio you're using.

4:3 Picture Size Settings

L (large).	4000×3000 pixels	(12 million pixels)
M (medium).	2816×2112 pixels	(5.9 million pixels)
S (small).	2048×1536 pixels	(3.1 million pixels)

3:2 Picture Size Settings

L (large).	4000×2672 pixels	(10.7 million pixels)
M (medium).	2816×1880 pixels	(5.3 million pixels)
S (small).	$204\ 8 \times 1360$ pixels	(2.8 million pixels)

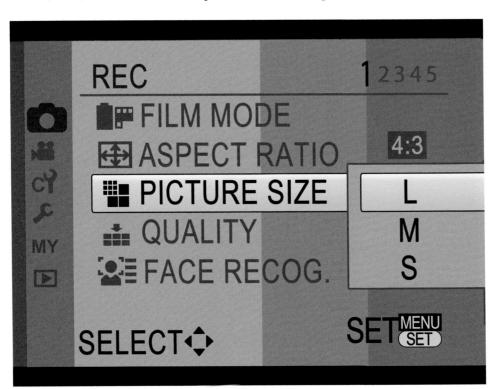

Figure 3.6
The GF1 offers three picture size settings, large (L), medium (M), and small (S).

16:9 Picture Size Settings

L (large). 4000 × 2248 pixels (9 million pixels)

M (medium). 2816 × 1584 pixels (4.5 million pixels)

S (small). 1920 × 1080 pixels (2.1 million pixels)

1:1 Picture Size Settings

L (large). 2992 × 2992 pixels (9 million pixels)

M (medium). 2112 × 2112 pixels (4.5 million pixels)

S (small). 1504 × 1504 pixels (2.3 million pixels)

Quality

In addition to offering different size options, the GF1 also provides different quality settings as well. These options also make it possible for you to shoot both RAW and JPG files simultaneously.

Choose your setting carefully as your choice can have consequences regarding file size and image quality. While choosing a low quality setting can allow you to fit many more images on a memory card, those images will not be high enough in resolution to make very big prints. At the other extreme though, shooting at RAW plus highest resolution JPG mode can fill even a large memory card faster than you might like. Still, with 8GB cards often going for less than $20 each, and even larger capacity versions going for not a lot more, it's not that onerous to carry sufficient memory.

The GF1's quality options (shown in Figure 3.7) include

- **Fine.** This is a minimal compression JPEG setting. It produces larger file sizes with fewer JPEG artifacts (unwanted defects in the image caused by aggressive "squeezing" or compression of the image by discarding some information).

- **Standard.** This setting applies more JPEG compression in order to reduce file sizes without reducing image sizes. It results in more JPEG artifacts when the image is opened or printed than the fine setting.

- **RAW plus Fine.** The camera simultaneously records both a RAW file and Fine quality JPEG file. While this gives you multiple options when it comes to image editing, it also fills up memory cards faster than any other setting.

- **RAW plus Standard.** Similar to RAW plus Fine, but JPEGs are saved with the Standard compression setting rather than the Fine setting. Fills memory cards a little bit slower.

- **RAW.** The GF1 creates a RAW file every time the shutter is tripped.

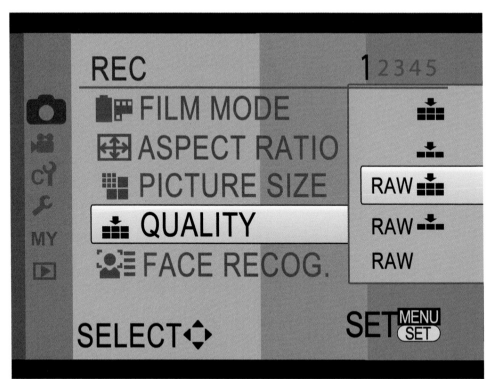

Figure 3.7
The GF1 provides five different quality settings. These determine the amount of file compression applied to an image and whether or not the camera creates a RAW file in addition to a JPEG file. This setting can do a lot to determine how many images your memory card can manage.

Face Recognition

The GF1 offers an impressive face recognition system, which provides several options. Besides the obvious, On and Off, the camera can also be set to remember as many as six faces plus names and birthdays and keep that information in memory. This is a cool feature for tagging family members and others who you photograph frequently.

In order to use this option, you must first register an individual's face with the camera (see Figure 3.8). Once you get to the Face Recognition option, choose the Set option and then turn Auto Registration on. You can also set the level of sensitivity (High, Normal, Low) the camera uses in determining whether stored information matches the face the camera is pointed at. Keep in mind, using a stored face setting instead of the generic Face Recognition option can slow autofocus, especially as you go to greater sensitivity settings.

You then have to register each face you want the camera to remember:

1. Choose Face Recognition.
2. Choose Memory.

Figure 3.8
When register-
ing a face,
make sure the
subject's face is
directly facing
the camera and
the eyes are
both exposed.

3. Position the subject's face inside the target brackets. Make sure the subject is facing the camera and has her eyes open and mouth closed (insert ex-wife joke here). The subject should also be evenly lit and her hair should not be hiding any part of the face. Your subject should also try to stay as still as possible.

4. Take the picture. (If recognition fails, you'll get an error message.)

5. Press the up arrow to select "Yes" and then press the right arrow.

6. You can register as many as three face images for one individual. To do so, repeat the process.

7. You can also register names and birthdays for up to three faces.

Stabilizer

The GF1 does not have an internal image stabilization system; instead, it relies on lenses that offer that technology. If you're using such a lens (Panasonic Mega O.I.S. lenses or other compatible micro four thirds lenses), then you can set the camera's control of the stabilization function through the Rec menu. It's the first option on the second screen.

If you're shooting with a lens that does not offer image stabilization, the stabilization setting will be grayed out on your menu. Also, keep in mind, stabilization is helpful, but can't work miracles. You still have to try to hold the camera steady and use a reasonable shutter speed. Also, if you want to turn stabilization off, it's generally done via a switch on the lens.

You have a choice of three different image stabilization modes (see Figure 3.9):

1. **Mode 1.** Camera shake is always compensated for, as long as the camera is in Record mode (drains battery faster).

2. **Mode 2.** Camera shake is compensated for only when the shutter is tripped.

3. **Mode 3.** The GF1 only compensates for up/down movements. This is useful for "panning" or moving the camera horizontally while shooting (such as when you follow a moving runner at slow shutter speed to blur the background while keeping the runner in focus). (See Figure 3.10.)

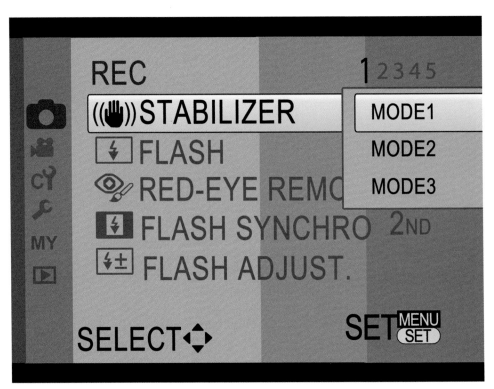

Figure 3.9
If you're using a lens that is capable of image stabilization, you'll be able to choose from one of three IS modes.

Figure 3.10 When panning, use IS Mode 3.

Flash

Depending on your shooting mode, the GF1 gives you multiple options for controlling flash performance (both for the camera's built-in flash or for a shoe mount unit). While the camera is capable of a half a dozen or more different flash modes, your ability to use a particular mode depends entirely on which exposure mode you're using.

For instance, if you're shooting in Manual exposure mode, your only options are Forced flash on, Forced flash with red-eye reduction on, or Flash off. (With Forced flash the flash fires every time the shutter is pressed, as long as the flash has had a chance to recharge.) Shutter-priority automation gives you two choices: Forced flash on and Auto flash. Here's a complete rundown on what flash options you have for each of the seven exposure modes where flash mode selection is possible (P, A, S, M, C1, C2, and SCN):

Manual Mode

Forced flash is your only choice. In this setting you set shutter speed and aperture manually for proper exposure and use the flash to fill in shadows. You can adjust the flash output via the Flash Compensation Setting submenu, which is located just a couple of lines below the Flash Mode submenu (see Figure 3.11). The Forced Flash option means the flash will fire every time the shutter button is pressed no matter what lighting conditions are like, provided the flash has had a chance to recharge.

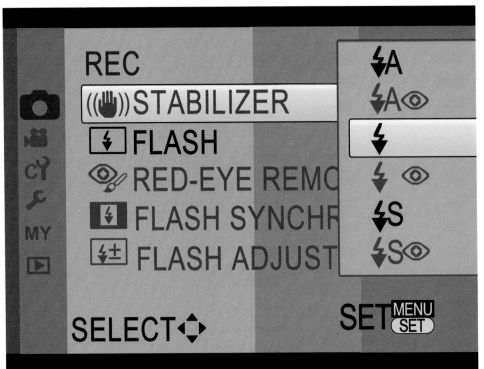

Figure 3.11
The Forced Flash mode will trigger the flash (built in or shoe mounted) every time you trip the shutter (so long as the flash unit has a sufficient charge built up to fire).

Shutter-Priority Automation

Shutter-priority exposure mode gives you four choices when it comes to using flash: Forced flash on, Forced flash with red-eye reduction on, Auto flash or Auto flash with red-eye reduction on. The Forced flash option means the flash will fire every time the shutter button is pressed no matter what lighting conditions are like. Auto flash on the other hand only fires the flash unit if the camera determines supplemental lighting is necessary. (The built-in flash must be extended or an accessory flash mounted in the hot shoe for this option to work. The camera will not automatically extend the built-in flash even if it determines there's not enough light.)

Aperture-Priority and Program Automation

In Program mode or Aperture-priority exposure mode your flash options increase to all six choices: Forced flash, Forced flash with red-eye reduction, Auto flash, Auto flash with red-eye reduction, Slow sync. flash, and Slow sync with red-eye reduction. Slow sync. flash is useful when you're dealing with a dark background. Normally when you use flash to photograph a person in front of a dark background you end up with a well-exposed subject in front of a black background. Slow sync. flash sets a slow enough shutter speed to better expose the background. Be careful if you use this mode since the possibility of blur from camera shake is increased by the slow shutter speed. Using

a tripod or placing the camera on a solid surface is suggested (as is warning your subject to stay still even after the flash has fired).

C1 (Custom 1)

The C1 mode gives you access to every flash mode the GF1 offers. This includes Forced, Auto and Slow sync, plus Auto flash with red-eye reduction (the camera fires a burst of flashes to contract the subject's pupils and reduce the risk of redeye), Forced flash with red-eye reduction, and Slow sync with red-eye reduction.

C2 (Custom 2)

Unlike C1, the C2 mode only gives you two options: Forced flash or Forced flash with red-eye reduction.

SCN (Scene)

Choosing SCN gives you a variety of preset exposure options based on your subject matter. Not surprisingly then, the camera tailors the available flash options to suit the particular scene mode you've chosen. Here's a list of scene modes and their available flash options:

- **Portrait, Soft skin, Peripheral defocus, Baby1, Baby2.** Auto flash, Auto flash plus red-eye reduction, Forced flash, No flash.

- **Scenery, Architecture, Night Scenery, Illuminations, Sunset.** No flash.

- **Sports, Flower, Food, Objects, Pet.** Auto flash, Forced flash.

- **Night portrait.** Slow sync plus red-eye reduction. The camera will ask you to open the flash when you set this mode if you have not already done so.

- **Party.** Flash with red-eye reduction, Slow sync flash with red-eye reduction, No flash.

Red-Eye Removal

While the Panasonic Lumix DMC-GF1 offers a red-eye reduction flash mode, its ability to deal with this problem doesn't stop there. Right below the Flash submenu you'll find another flash-related option, Red-eye removal submenu. Here you can turn this feature either on or off.

Of course, the question is whether you should turn it on, isn't it? While it seems like a no-brainer, keep in mind, this feature corrects red-eye by turning red pixels black. That's fine if your subject's glowing red orbs are the only red in the image, but suppose she's wearing a red shirt? Plan on turning this feature off when there's a significant amount of red in the scene that has nothing to do with the eyes. (See Figure 3.12.)

This option works in P, A, S, M, C1, C2, SCN, and My Color modes.

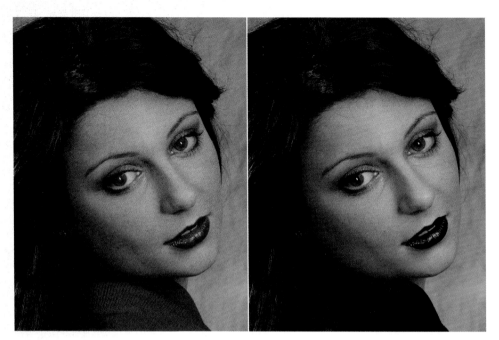

Figure 3.12
Red-eye removal turns red tones black—so use it with care.

Flash Synchro

The GF1 makes it possible for the flash to sync with either its first shutter or second shutter curtain (modern cameras use a two-shutter curtain operation, you can read about it later in the chapter on using flash). This setting determines whether the flash fires as the first shutter curtain is opening, or just before the second curtain closes.

This option works in P, A, S, M, C1, and C2 modes.

Flash Adjust.

This setting lets you adjust the output of any flash connected to the GF1. This is a handy control since sometimes you're photographing something that is higher in reflectivity than the camera is calibrated for. Under such circumstances dialing down the flash output via this setting is the answer. It's also useful if you have a darker subject than the camera is set for, then you can increase the flash output to compensate.

Press the right arrow button and then use the right and left arrow keys to adjust the output in 1/3 f/stop increments. You have a four f/stop range (two minus and two plus) giving you a lot of control (see Figure 3.13).

This option works in P, A, S, M, C1, C2, SCN, and My Color modes.

Figure 3.13
The flash adjust control lets you add or subtract light output from your flash unit.

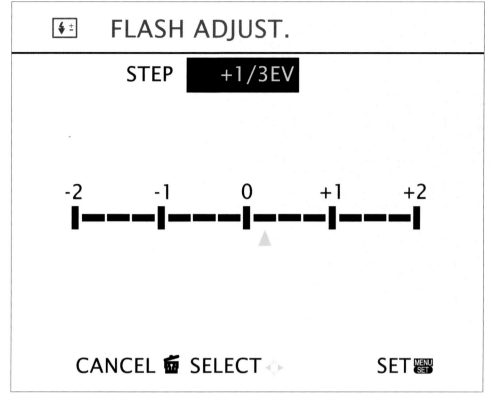

Metering Mode

The GF1 offers three different metering modes. Each of these modes offers its own strengths and weaknesses and is an appropriate choice for different shooting situations. Let's take a closer look at each of these modes. (See Figure 3.14.)

- **Multiple.** This metering mode reads the light striking the entire scene the camera sees and bases exposure allocation based on what it reads. This is the setting Panasonic recommends.

- **Center weighted.** This metering mode works under the principle that the most important element in the scene will be found in the center of the frame and weights its reading accordingly. It's a good choice when photographing people or other subjects that fill the center of the frame.

- **Spot.** In this mode the camera meters a very small spot in the center of the frame (certain face recognition autofocus modes will change the metering point to align with the face the camera has recognized). Spot metering is helpful when you're trying for critical exposure or to set lighting contrast ratios.

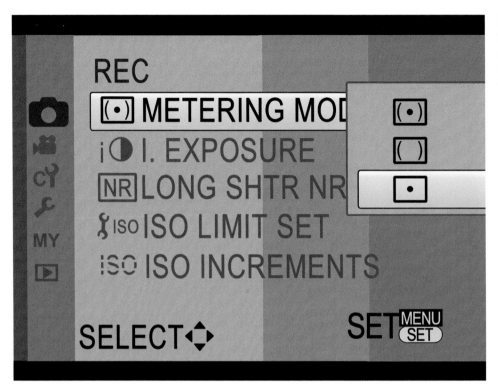

Figure 3.14
The GF1 offers three different metering modes.

I. Exposure

I. Exposure (Intelligent exposure adjustment) tries to make adjustments for shooting situations where there's a big difference in brightness between the subject and background. This feature tweaks brightness and contrast to fix what often can be an annoying problem.

You have four choices with this feature: Off, Low, Standard, or High. As you progress through the choices, the effect gets stronger and stronger. Also, if you've set your ISO to 100 or 125 and have I. Exposure turned on, the camera may shift your ISO to a different setting.

This option works in P, A, S, M, Movie, C1, and C2 modes.

Long Shutter Noise Reduction

This option corrects for the noise that builds up during long exposures. It works by taking a blank exposure of the same duration as the actual exposure. The camera then compares the two images for pixels that have mis-registered, checking the blank image for pixels that are any other color than black. When it finds a pixel that's misfired, it adjusts the corresponding pixel in the image file. Keep in mind, this means the camera needs to create a second exposure with the same duration as the original image. If you're

making a 10-second exposure, you'll also have to wait for the camera to make the 10-second dark comparison file. Panasonic stresses the camera needs to be held steady during the dark exposure too. A tripod is recommended.

Your long shutter noise reduction options are "yes" or "no". This feature works in P, A, S, M, C1, C2, SCN, and My Color modes.

ISO Limit Set

While the GF1 offers a wide range of ISO sensitivities, not every photographer may want to use all of the higher options. The ISO limit submenu lets you set an upper limit for the ISO choice the camera offers. This can be useful when you're using the camera in one of the automated sensitivity modes such as Auto or ISO. This feature works in P, A, S, M, C1, and C2 modes.

Your options range from 200 to 1600 ISO in full f/stop increments (200, 400, 800, 1600).

ISO Increment Set

How much control do you want over ISO adjustments? If you seldom need less than a full f/stop adjustment, you'll probably prefer the camera offer full stop increments. On the other hand, if you like to exercise fine control, 1/3 f/stop changes may be more your speed. Fortunately, the GF1 lets you choose between the two.

If you choose 1/3 f/stops, ISO changes will proceed as follows: 100, 125, 160, 200, 250, 325, 400, 500, 640, 800, 1000, 1250, 1600, 2000, 2500, 3200. If you choose full f/stop increments, then your ISO settings will proceed from 100 to 200 to 400 to 800 to 1600 to 3200.

This feature works in P, A, S, M, C1, C2, SCN, and My Color modes.

Extra Optical Zoom (EZ)

The GF1 gives you several options for extending the reach of your lenses if your current optics just can't get you close enough. Keep in mind though, each of these options is a way of optically cheating, and as such, does have a price to pay.

The first of these is the Extra Optical Zoom (EZ) feature accessed through the EZ submenu. This is a compromise between the limits of your actual lens and the digital zoom feature. As you may know, "digital" zooms work by cropping the image and then interpolating to resize the cropped image to the camera's normal file size. The result is a photo that is the same size as other images created with the camera, but often of lesser quality because of the interpolation. The EZ feature takes a different approach. Instead of interpolating, it simply uses a 3.1-megapixel part of the center of the image to create a smaller, but zoomed in photo. (At least for the S-EZ size.)

This is a rough figure since the file size will vary depending on what aspect ratio the camera is set to. You could do the same thing yourself by creating the photo and later cropping it in an image-editing program. This option can be handy if you aren't going to be editing your photos before doing something with them (such as printing images directly from the camera or memory card or immediately uploading them to a website via an EyeFi WiFi card). Keep in mind, you'll have the same problems you'd have when trying to create an image with a longer lens. Framing the image will be harder and you'll need a faster shutter speed to minimize blur from camera shake. You should be particularly concerned if you're working with a lens that doesn't have image stabilization too, since the magnification the EZ feature provides will also magnify any vibration. Panasonic also says that image stabilization may not be effective in this mode.

There are some limitations as to when you can use this feature. It won't be available if you're shooting in RAW mode (even if you're shooting in RAW plus mode). It also can't be used in iA mode or any of the Scene modes. This feature works in P, A, S, M, C1, C2, SCN, and My Color modes.

Digital Zoom

The GF1 also offers a digital zoom capability for times when you really need greater reach. Of course, a digital zoom is nothing but an in-camera crop and enlargement. The GF1 offers a 4X digital zoom option that can combine with the extra optical zoom for even greater range. Keep in mind, there will be a loss of image quality when using the digital zoom. Figure 3.15 shows the kind of magnification you can get with digital zoom.

Burst Rate

Like most cameras, the GF1 offers a continuous shooting capability. Panasonic calls this the camera's "burst" rate. You can choose between single and continuous via the lever by the camera's exposure mode button. Use the submenu to set the camera to either High (three frames per second) or Low (two frames per second). I'll explain more about continuous shooting in Chapter 5.

Auto Bracket

"Bracketing" is a process of shooting three exposures to improve your chances of getting the best possible exposure. To "bracket" an exposure, the photographer takes one shot at what seems to be the appropriate exposure and then a shot under that exposure and another over the appropriate setting. This way, if the recommended exposure is actually incorrect, one of the other two shots should be good.

Figure 3.15
Digital zoom enlarges a portion of your image up to 4X.

The Auto Bracket function, which is located on the GF1's fourth Rec menu screen offers not just the ability to set the amount of bracketing (either 1/3 of an f/stop or 2/3 of an f/stop), but also the order in which the photos are created and the number of bracketing steps you prefer (three shots, five shots, or seven shots). A separate option in the same submenu (see Figure 3.16) lets you choose the order you want the shots made in (recommended exposure, underexposure, overexposure or underexposure, recommended exposure, over exposure).

Once you've set the Auto Bracket feature to your desired parameters, use the drive lever by the mode dial to set the camera to Auto Bracket. No matter which settings you've chosen, you'll still have to make sure the camera fires the appropriate number of times to go through the full auto bracket sequence. Auto Bracket won't start if there isn't enough room on the memory card for the full sequence.

Self-Timer

The Panasonic Lumix DMC-GF1 offers three different self-timer options, including one that will automatically fire off three shots with one press of the shutter. Your choices are a 2-second delay, 10-second delay, and a 10-second delay with a 3-shot burst. When you choose this last option, the camera uses the Auto Bracket settings for the three exposures and trips the shutter three times at about two-second intervals. The three-shot option is not available in Intelligent Auto mode.

Color Space

Your camera is capable of operating in one of two different color spaces. The first submenu on the Rec menu's fifth screen is the Color Space option. Your choices include Adobe RGB (because it was developed by Adobe Systems in 1998), and sRGB (supposedly because it is the *standard* RGB color space). These two color gamuts define a specific set of colors that can be applied to the images your camera captures.

You're probably surprised that the GF1 doesn't automatically capture *all* the colors we see. Unfortunately, that's impossible because of the limitations of the sensor and the filters used to capture the fundamental red, green, and blue colors, as well as that of the LEDs used to display those colors on your camera and computer monitors. Nor is it possible to *print* every color our eyes detect, because the inks or pigments used don't absorb and reflect colors perfectly.

Instead, the colors that can be reproduced by a given device are represented as a color space that exists within the full range of colors we can see. That full range was developed by scientists at an international organization back in 1931. Regardless of which triangle—or color space—is used by the GF1, you end up with 16.8 million different colors that can be used in your photograph. (No one image will contain all 16.8 million!)

Figure 3.16
The Auto Bracket control lets you set the camera to bracket images in a three-, five-, or seven-shot sequence. You can bracket in 1/3 or 2/3 of an f/stop increments.

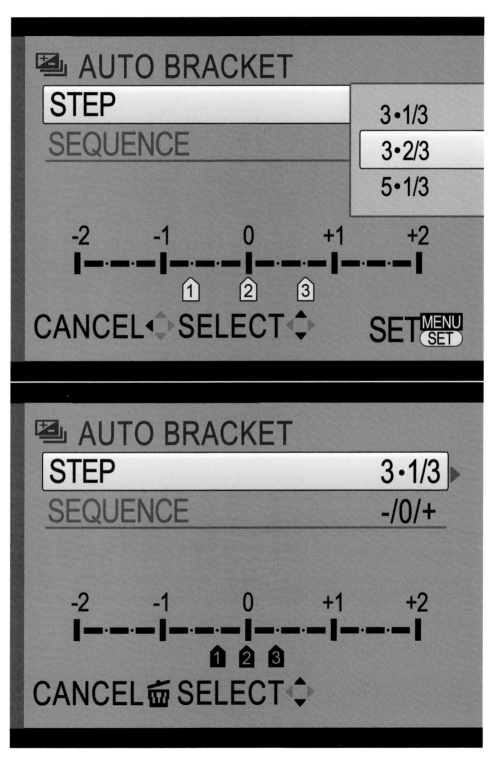

ADOBE RGB vs. sRGB

You might prefer sRGB, which is the default for the Panasonic GF1 camera, as it is well suited for the colors displayed on a computer screen and viewed over the internet. The sRGB setting is recommended for images that will be output locally on the user's own printer, or at a retailer's automated kiosk.

Adobe RGB is an expanded color space useful for commercial and professional printing, and it can reproduce a wider range of colors. It can also be useful if an image is going to be extensively retouched within an image editor. You don't need to automatically "upgrade" your camera to Adobe RGB, because images tend to look less saturated on your monitor and, it is likely, significantly different from what you will get if you output the photo to your personal inkjet printer.

Strictly speaking, both sRGB and Adobe RGB can reproduce the exact same absolute *number* of colors (16.8 million when reduced to 8 bits per channel from the original capture). Adobe RGB spreads those colors over a larger space, much like a giant box of crayons in which some of the basic colors have been removed and replaced with new hues not in the original box. The "new" gamut contains a larger proportion of "crayons" in the cyan-green portion of the box, a better choice for reproduction with cyan, magenta, and yellow inks at commercial printers, rather than the red, green, and blue phosphors of your computer display.

Adobe RGB is what is often called an *expanded* color space, because it can reproduce a range of colors that is spread over a wider range of the visual spectrum. Adobe RGB is useful for commercial and professional printing.

Audio Recording

You can record audio while creating images, provided you turn on the camera's audio recording option. Keep in mind, this isn't the same as leaving notes on a file after you've made the shot; this is just for recording while the shutter is open. This feature only works in certain modes and resolution settings (it doesn't work if you're using RAW mode for instance). Page 122 in the camera manual shows the full list of settings where this feature isn't available.

Motion Picture Menu

In addition to being a terrific still camera, the GF1 is also capable of making high quality HD videos. The two screens of options provided by the Motion Picture menu screens give you the ability to tweak the camera's video settings to align with your artistic vision (see Figure 3.17).

Figure 3.17
The Motion Picture menu provides the controls you need to set up the GF1 for video recording.

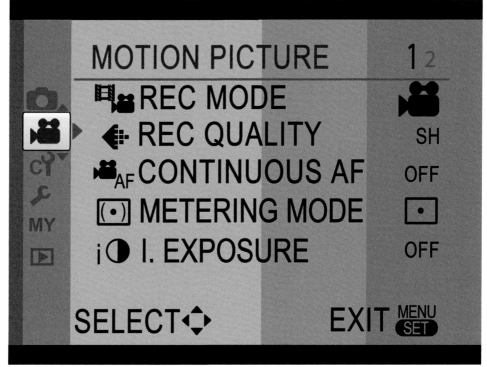

Rec Mode

You can choose between two recording modes for your video depending on whether you expect to show your video on a television or via the internet. AVCHD Lite is the appropriate choice for showing HD video on TV, while Motion JPEG is the right choice for emailing or playing on a computer.

Rec Quality

The GF1 offers three different quality levels: SH, H, and L. Keep in mind, the higher the quality setting, the faster video recording will fill a memory card. The camera records video at a rate of 30 frames per second (fps) and at a 16:9 aspect ratio.

One other thing that affects recording time is subject movement. If you're recording a scene with lots of movement, it will fill the memory card faster than if you're shooting static scenes. (This happens because the camera has to keep track of the movement from frame to frame as compared to a static scene where it can use the same information over and over.)

■ **SH.** This is the highest quality shooting mode. When set to SH, the camera records as 1280 × 720 pixels recording at a rate of 17 megabits per second.

- **H.** This is the next highest quality setting. It also records at 1280 × 720 pixels, but with greater compression resulting in a recording rate of 13 megabits per second.

- **L.** This is the GF1's lowest quality video setting. It also records at 1280 × 720 pixels, but with greater compression resulting in a recording rate of 9 megabits per second.

Continuous AF

Should the camera work to maintain focus continuously or focus once and then hold the focus point? It depends in part on how active a scene you're contemplating. For a reasonably static scene, you may want to turn continuous autofocus off to avoid having the lens "hunt" plus this will also minimize noise from the AF system.

Movie Metering Mode

The GF1 offers three different metering modes. Each of these modes offers its own strengths and weaknesses and is an appropriate choice for different shooting situations. Let's take a closer look at each of these modes:

- **Multiple.** This metering mode reads the light striking the entire scene the camera sees and bases exposure allocation on what it reads. This is the setting Panasonic recommends.

- **Center weighted.** This metering mode works under the principle that the most important element in the scene will be found in the center of the frame and weights its reading accordingly. It's a good choice when photographing people or other subjects that fill the center of the frame.

- **Spot.** In this mode the camera meters a very small spot in the center of the frame (certain face recognition autofocus modes will change the metering point to align with the face the camera has recognized). Spot metering is helpful when you're trying for critical exposure of a specific area.

I. Exposure

I. Exposure (Intelligent exposure adjustment) tries to make adjustments for shooting situations where there's a big difference in brightness between the subject and background. This feature tweaks brightness and contrast to fix what often can be an annoying problem.

You have four choices with this feature: Off, Low, Standard, or High (see Figure 3.18). As you progress through the choices, the effect gets stronger and stronger. Also, if you've set your ISO to 100 or 125 and have I. Exposure turned on, the camera may shift your ISO to a different setting.

Figure 3.18
You can choose from one of four different settings for I. Exposure. This feature can help you deal with high contrast situations.

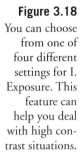
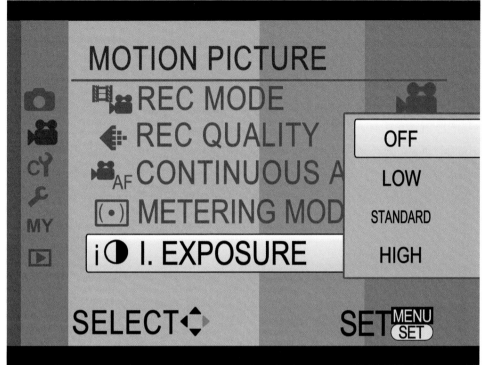

Wind Cut

Wind noise can be an annoying problem when you're shooting video. The GF1 offers three Wind Cut settings that can reduce wind noise. Keep in mind though, employing the Wind Cut feature will alter the sound of your audio recording in other ways too. This could be a bit of a problem if you're shooting a complicated video with a variety of indoor and outdoor scenes and the audio sounds different because some was recorded with Wind Cut on and some wasn't.

Including "Off" there are four Wind Cut settings: Off, Low, Standard, and High. It only works when recording audio in Movie mode.

Digital Zoom

The GF1's Digital Zoom function can also be used in Movie mode. You can set it for either 2X or 4X magnification. As with still photography, there is a loss of quality with the digital magnification.

Custom Menu

You can customize your GF1 in all sorts of ways to meet your photographic needs. The Custom menu puts you in touch with five screens worth of options with almost two dozen different controls you can adjust as you desire. Keep in mind though, that if you've set the camera to iA mode, you'll only have three custom settings available to you. (See Figure 3.19.)

Cust. Set Mem.

Custom Set Memory lets you configure four different groups of camera settings. These groups are then accessed by the C1 and C2 controls on the mode dial. The C1 control holds just one set of camera controls, and puts the camera into that configuration as soon as the dial is turned to C1. The C2 setting holds three sets of camera controls. When the dial is set to C2, whichever C-x setting is chosen in the C2 menu will be employed. Once the camera is set to C2, pressing the MENU/SET button brings up the C-1, C-2, C-3 menu so you can change groups.

Each custom set holds information for nearly 20 individual camera settings. These settings include AFL/AEL, P-AF, C-AF, AFL/AEL Hold, Fn, Film style, AF+MF, Noise Reduction, and others.

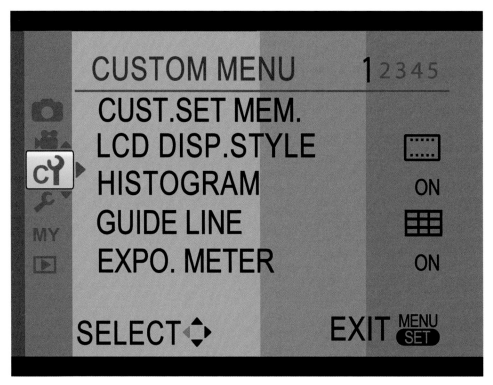

Figure 3.19
The GF1's Custom menu makes it possible for you to set up the camera to your preferences.

Figure 3.20
You can choose between two different screen displays for the GF1. One resembles that of a camera viewfinder, the other that of an LCD computer screen.

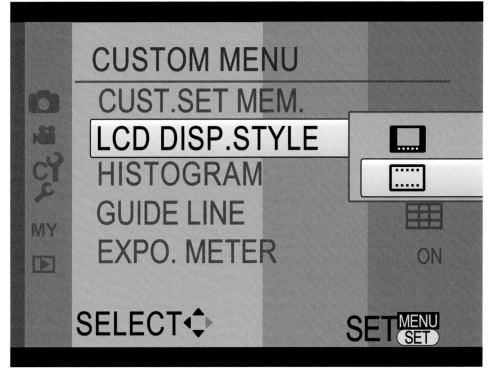

LCD Display Style

You can configure the GF1's LCD display to follow one of two styles, that of an LCD computer monitor or that of an electronic viewfinder (see Figure 3.20). Either way, you see the same image with the same number of pixels and the same screen size, but its placement and surroundings are arranged a bit differently.

Histogram

The GF1 can display a live histogram over the camera's image display. You can even position it to show up where you want on the screen. This is the third option down on the Custom menu's first screen. You choose On or Off. If you choose On, then you also get to position the histogram exactly where you want it on the display.

Guide Line

For years, dSLR owners of top-end cameras have replaced their camera's focusing screens with etched glass screens to help with composition. GF1 owners have a similar option, but without having to spend $$ buying replacement screens. Instead, the camera offers several different guide line configurations to help you achieve your desired composition.

The GF1 offers three different guide line options. The first gives you a 3 × 3 grid to help you follow the rule of thirds (see the note below). The second option provides a series of guide lines that direct you to the center of the screen (effectively a vanishing point perspective guide), while the third offers you a pair of guide lines you can position yourself as desired (See Figure 3.21).

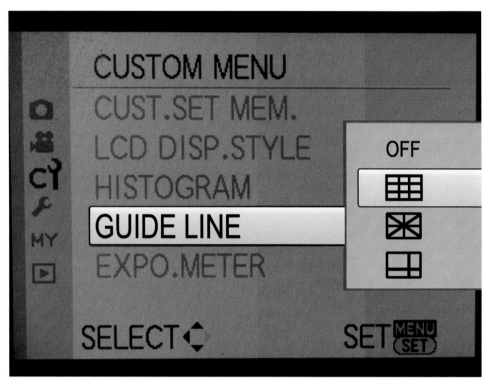

Figure 3.21
The GF1 offers three different guide line options. Use the cursor keys to maneuver each guide into the desired position. The up and down cursor keys position the horizontal guide and the left and right cursor keys position the vertical guide. Once you tap the shutter button you'll be unable to move the guides until you return to the Guidelines menu option and repeat the process.

There are several ways to activate the guide line feature. Working from the Custom menu, you choose the guide line option and then pick A (3 × 3), B (center point), or C (set your own). If you choose A or B, there's nothing left to do. If you choose C, go to the Quick menu next and use the left and right arrow keys to position the vertical guide line. (Pressing the trash can button centers the guide line.)

Exposure Meter

The fifth choice on the Custom menu screen lets you turn your exposure meter view on and off. It's not for disabling the exposure meter though; instead it controls the metering display. This display helps show you which exposure settings will get the right exposure. The exposure meter only shows up in modes where you can change exposure settings via the rear dial. It only appears after you first turn the rear dial too.

AF/AE Lock

Being able to lock focus or exposure and then recompose the image is a useful ability for a camera, since often the actual scene doesn't cooperate the way you might like.

For instance, say you want to focus on someone standing to one side of the frame. If you rely on the camera's AF sensor, you might end up with an object in the center of the frame in focus and your subject out of focus. It's better to acquire focus on your subject, then hold that focus point and recompose the image.

The GF1 has an AF/AE LOCK button just underneath the mode dial that can be used to lock focus, exposure, or both. This button can be configured one of three ways:

1. **AE.** Only the exposure is locked.
2. **AF.** Only the focus is locked.
3. **AF/AE.** Both focus and exposure are locked.

AF/AE Lock Hold

This feature complements the previous one. By setting it to on, you can just press the AF/AE LOCK button to lock focus, exposure, or both (depending how you have the button configured) and then release it. Or, if you've turned this feature off, relax, knowing as soon as you let go of the button, it will no longer hold the information you just registered.

Preview Hold

The GF1 offers photographers a depth-of-field preview function. This is something dSLR shooters have been taking advantage of for a long time, but might not be familiar to photographers moving up from point-and-shoot or cell phone cameras.

A depth-of-field preview function lets you check the depth-of-field (or depth of sharpness) at a certain lens opening by closing down the aperture to the actual f/stop that will be used to take the picture. This is very useful if you're trying to find a focus and aperture setting that gets everything you need in focus.

Preview Hold offers two settings, On and Off. When turned off, pressing the aperture/trash can button still activates the depth-of-field preview, but turns it off once you release the button. If you turn this setting on, you can push the preview button and the camera will remain in preview mode until you press the button again (or tap the shutter button half way).

Pre AF

In an effort to make the GF1 a more useful camera, Panasonic has incorporated an "anticipatory" autofocus feature it calls Pre AF. The camera offers two different versions of this feature, which if used properly, can help you make sharper pictures.

Q-AF

Q-AF (or "Quick" AF) activates when the camera senses the camera becoming steadier. In other words, the camera assumes the photographer is getting ready to take a picture and so begins autofocusing even before the photographer presses the shutter button to activate autofocus.

C-AF

When you set the GF1 to C-AF (or "Continuous" AF), the camera just keeps focusing. Keep in mind, you can't use this feature with lenses that can't be set to AFC (such as the Panasonic 20mm 1.7) or lenses that don't offer autofocus (such as older lenses used with an adaptor). Also, if you switch from wide to telephoto or from a distant subject to a near one, it may take the camera some time to regain focus.

Either setting will drain the camera's battery faster, particularly the C-AF option.

Direct AF Area

This menu function makes it possible for you to reposition and resize the AF sensor area rectangle. In order to do this, you must have the camera in the Single AF area mode (See Figure 3.22) and turn this setting on via the Direct AF area submenu.

Once this setting is turned on and you've set the camera to Single area AF mode, all you have to do is press one of the arrow keys and a yellow highlighted AF rectangle will appear on your screen. Use the arrow keys to position the rectangle where you want it and the rear dial to change the size of the rectangle.

Focus Priority

Which is more important to you, the camera taking a picture when you press the shutter even if the image is not perfectly in focus, or the picture being in sharp focus or not being taken at all?

The GF1's Focus Priority option lets you choose which option you prefer. Turn on Focus Priority and the shutter won't trip unless the subject is in focus. Turn it off and the shutter will trip when you press the shutter button completely whether the subject is in focus or not.

I prefer turning it off myself. Often the subject doesn't have to be perfectly in focus to be acceptably sharp, particularly if I'm using a wide-angle lens and small lens opening. Under such conditions, I'll have enough depth-of-field to make up for less than perfect focus. You may prefer a different approach though.

AF Assist Lamp

Sometimes there just isn't enough light for the camera's autofocus system to focus properly. The GF1 has a built-in AF assist lamp (it's the small light right below the word "Lumix" on the front of the camera) that projects a red focus assist light (see Figure 3.23).

This feature is set to Off when the camera is used in the Scenery, Architecture, Night Scenery, and Sunset settings when you're shooting in SCN mode. It's a good idea to remove the lens hood when using the AF assist lamp since the lens hood can block the light from it.

An AF assist lamp is a nice feature and can help you take sharper photos in low light, but keep several things in mind:

- **Effective distance.** The farther you are away from your subject, the less powerful (and effective) the light can be.

- **Power drain.** If used heavily, this option can drain your camera's battery faster.

- **Distraction.** The light from the AF assist lamp can distract or annoy your subject.

Figure 3.23
The AF assist lamp helps the camera achieve proper focus under difficult conditions.

AF + MF

This feature lets you set the camera to allow you to adjust focus manually after the autofocus system has completed focusing. You can turn it On (to allow manual adjustment) or Off (making manual adjustment impossible).

MF Assist

The GF1 offers a Manual Focus Assist option to make focusing manually easier. When this feature is turned on, the camera enlarges the view of the center area of the frame so you can better judge how sharp your focusing efforts are becoming. When turned off, the image view stays the same.

Picture/Motion Picture Rec Area

You can change the GF1's viewfinder image from picture image dimensions to motion picture dimensions by changing this setting.

The difference is that the motion picture view is a bit wider and shorter than the picture view. It's not a very noticeable difference though. You can feel free to leave the camera in your most commonly used view and be fine.

Remaining Disp.

Since the GF1 can create both high quality stills and high quality video, the camera includes a setting that lets you choose between having the display show the number of shots remaining on your memory card versus the amount of recording time left.

This is a simple control; you just switch between remaining shots and remaining time.

Motion Picture Button

There's a small button with a red center on the far right side of the GF1's top deck. This is the Motion Picture button, and, if enabled, will put the camera in Video mode and start recording with just a quick press of the button. This "one-shot" video mode can be very handy if you're the type that has to switch back and forth between stills and video.

If you disable this button, then pressing it only brings up a message saying to check the setting in the Custom menu.

Dial Guide

Normally, when you're shooting in anything but My Color or Scene mode, and turn on the camera or change the mode dial, a small icon appears in the lower-right part of the display to remind you that you can use the rear dial to add or subtract exposure. You can turn this icon on or off through the Dial Guide submenu in the Custom menu's fourth screen.

Menu Resume

This feature lets you decide between having the menu return to the first menu screen or the last viewed menu screen when you decide you want to change menu settings. If you activate this setting, it will remember the last menu screen you visited even if you turn off the camera.

Pixel Refresh

Sometimes good pixels go bad. They don't start out that way. Panasonic's pixels are nurtured and cared for in the factory, where they're given a good upbringing and plenty of positive reinforcement. Then they become exposed to the real world and have to photograph all sorts of pictures in all sorts of conditions. I'm not saying you're some kind of weirdo of something, but do you really know what your brother-in-law is taking pictures of when he borrows your camera?

Anyway, the GF1 offers a Pixel Refresh feature (also called *pixel mapping*) to restore your pixel display to its best. It does this by mapping out bad pixels and sending them off to military school; well, not quite, but it does keep them out of the picture, much like you try to do with that brother-in-law of yours. Panasonic recommends you refresh your pixels annually, more often if your brother-in-law borrows the camera a lot.

Sensor Cleaning

The GF1 has a built-in sensor cleaning system that is activated every time you turn on the camera. In addition, you can activate the system yourself via this submenu option in case you notice dust on an image.

Do you need to do this often? Probably not. I change lenses a lot and I've never had to activate it myself; the camera does a good enough job on its own. It's possible though if you change lenses a lot and work in dusty, windy conditions, you could need this option, or you could just turn the camera off and back on and accomplish the same thing. Still, it's nice to have a choice.

Shoot without Lens

Yes, Panasonic actually considered that a photographer might want to trip the shutter on the GF1 even though there might not be a lens attached. Actually, the more common reason you need this feature is if you're using an adapter to mount legacy lenses or something like the Lensbaby Composer (see Figure 3.24). Often the adapters and specialty optics don't connect to the camera electronically and so the camera won't operate because it thinks there's no lens attached.

Since one of the really cool things about the Micro Four Thirds concept is that it's easy and inexpensive to design adapters for it, there's a huge range of older lenses that can be used with these cameras at the cost of a few dollars for the right adapter (I've bought a couple off eBay for less than $50 each).

With these adapters I'm able to use old Nikon lenses on my GF1 and E-P2 (see Figure 3.25) and even my current Canon EOS lenses (without aperture control), plus my Lensbaby optics as well.

Figure 3.24
A Lensbaby Composer mounted on the GF1 via a Nikon lens adapter.

Figure 3.25
A Nikkor 500mm mirror lens mounted on the GF1 via a Nikon lens adapter.

LVF Display Style

There are two ways you can set up your live view display on the GF1's optional external viewfinder. The first option is to have it appear as a viewfinder style with a black border around the live view area. The second choice is to configure it so it looks more like the view of an LCD computer monitor. This choice is only available if you're using the optional external viewfinder though.

Setup Menu

The Setup menu's five screens provide all sorts of options for setting up your camera for individual photography (see Figure 3.26). It's here you'll set date and time, make adjustments for travel settings, monitor brightness, volume, number reset, and lots more.

Let's start with the choices on the first screen:

Clock Set

Here's where to tell the GF1 your home time zone and how you want that information displayed. Just press the right arrow key and it will take you to the Clock Set screen and its options.

World Time

Planning a trip in another time zone? The GF1's World Time function lets you set a second time for your camera. Once you get to your destination, all you have to do is

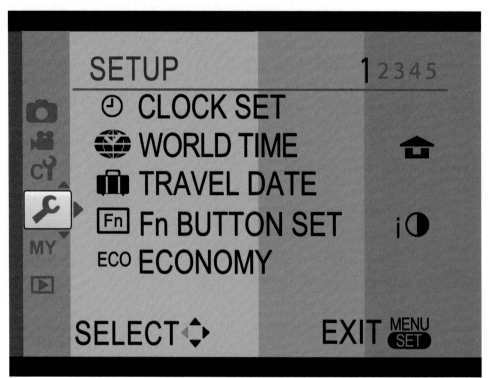

Figure 3.26
The Setup menu is where you select many of the standard settings, such as time and date.

change the World Time from Home to Destination and the time will be changed to your location's time zone. Get back home and set the camera back to Home, and it's back to normal time for your images.

You'll be able to tell at a glance which time your camera is set to (see Figure 3.27) because the live display will show either a house icon (for "home") or an airplane icon (for "destination"). However, you don't need to worry about remembering to make these settings when you arrive at your destination or your home thanks to the next option in the Setup menu.

Travel Date

The Travel Date function lets you set the departure and return dates for your trip. The camera then keeps track of when a photo is made in relation to the departure date plus embeds the number of days since the departure date on the image.

Keep in mind, the Travel Date function must be on before the images are created. If you turn it on after creating an image, the travel date information won't be embedded.

There are some limitations to the Travel Date feature. It can't be used when recording AVCHD Lite, Baby1, Baby2, and Pet settings in SCN mode. It also can't be set in Intelligent Auto mode, and the location can't be recorded when shooting video.

Figure 3.27
The live display will show either a house icon (for "home") or an airplane icon (for "destination").

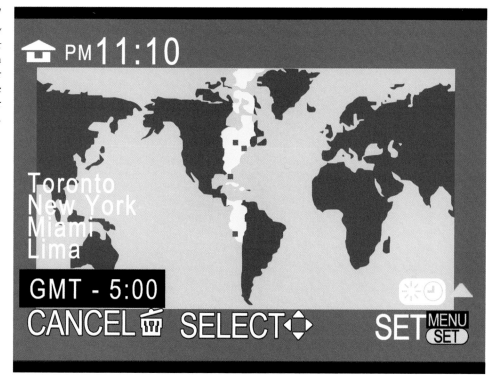

Fn Button Set

The Fn/down arrow button can be set to activate any one of a number of different functions. Keep in mind that in order to use it for this purpose, you'll have to deactivate the AF Rectangle Repositioning function.

The Fn button can be programmed to launch any one of several settings. Check the list that follows for the specific functions and what they do (see Figure 3.28):

■ **Film mode.** As noted earlier in this chapter, you can set the GF1 to various film modes depending on the colors and looks you want.

■ **Aspect ratio.** If you need to change aspect ratios often, setting the Fn button to bring up this submenu might be the right choice.

■ **Quality.** Push the Fn button and your five quality options come up (Fine, Standard, RAW+Fine, RAW+Standard, RAW).

■ **Metering mode.** If you habitually change metering modes a lot, setting the Fn button to bring up this control makes sense.

■ **Intelligent exposure.** This is a good choice if you work under difficult lighting conditions on a regular basis.

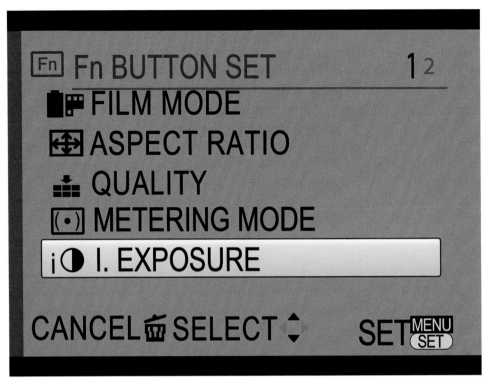

Figure 3.28
The Fn Button
Set lets you
configure the
Fn button
to perform
specific
operations.

- **Guide line.** Change guide line settings quickly with this option.

- **Rec area.** It makes sense to choose this option if you have to switch back and forth between shooting stills and video often.

- **Remaining disp.** It can also make sense to choose this option if you switch back and forth between stills and video.

Economy

If you need to conserve battery power, the Economy submenu is the place to do it. Here you'll find several power/use settings that will help make the most of the camera's battery and maximize your shooting and viewing time.

Power Save

Set the camera to power down after a set amount of time. Your choices for this setting are: Off, 1 minute, 2 minutes, 5 minutes, 10 minutes. Power Save is turned off after 5 minutes when using the iA mode and after 2 minutes when the auto LCD is set to 15 or 30 seconds. Press the shutter halfway or turn the camera off and on to cancel the power save.

Auto LCD Off

You can set the camera to turn off the LCD view display after a set period of time. Your choices are, Off (the LCD view stays on), 15 seconds, and 30 seconds. Pushing any of the camera's buttons turns the LCD view back on.

Auto Review

Every time you take a photo with the GF1, the camera can show you the image you just created. Whether or not it does, or for how long it does, is controlled by this submenu. Here you can configure the review function to best suit your shooting style. Keep in mind that the longer the camera displays review images, the greater the battery drain. Also, you can't use Auto Review when the camera is set to Burst mode.

There are two Auto Review functions, Review and Zoom.

Review

Auto Review can be used in most camera settings, but there are a few that can affect how it operates. For instance, if you've registered a face with face recognition, the display time can only be set to 3 or 5 seconds. Also, the Auto Review function does not work when you're recording audio.

The Auto Review submenu offers five options.

- **Off.** The camera does not show a review image.
- **1 sec.** The camera displays the review image for 1 second.
- **3 sec.** The camera displays the review image for 3 seconds.
- **5 sec.** The camera displays the review image for 5 seconds.
- **Hold.** The camera displays the review image until you tap the shutter button.

Zoom

Zoom provides a 4X view of the image when it's displayed. This can be useful for checking sharpness and detail. You can set the Zoom option for 1 second, 3 seconds, or 5 seconds. The Zoom option does not function if you choose the Hold option for the Review function or if you're using a registered face and shooting with Face Recognition turned on.

Highlight

The bane of digital photography is blown out highlights. While recording dark shadows is also a problem, at least with blocked up shadows you can still pull some detail out of them, at the risk of increased noise. With blown out highlights, there's simply no detail to be recovered.

The GF1, like many digital cameras, offers a Highlight Alert feature that warns you of areas of the image being reviewed that have blown highlights. These areas are identified by blinking hot spots showing the exact areas that have been blown out. This is one of those features that should generally be left on by the way. The control itself is a simple On/Off decision.

Depending on how severe the problem is there are several ways of correcting for blown highlights. For some situations, reshooting with an extra 1/3 or 1/2 stop of exposure compensation (–1/3 or –1/2) may be enough to regain detail. Keep in mind, if the highlights in question are specular (such as those from reflections in glass, metal, or water) it may not be worth the effort to try to correct this way. If the contrast range of the image is too great, then it might be necessary to either use a split neutral-density filter (a filter that blocks the light on one part of the image, but not others) or to try your hand at high dynamic range (HDR) photography.

This feature does not work in Multi Playback, Calendar view, or Playback Zoom.

Monitor

You can adjust the viewing monitor's brightness and color for your own personal preference through the monitor control panel (see Figure 3.29). Use the right/left arrow or the rear dial to adjust the monitor color and the up/down arrows to adjust brightness.

Figure 3.29
The monitor control lets you adjust both monitor color and contrast. It does not affect the image's color or contrast.

Keep in mind, these adjustments do not affect image quality, only the way the image appears in the camera monitor.

LCD Mode

This mode offers two settings, both of which are designed to help you see the monitor image better under difficult lighting conditions. While these options have no effect on the actual images, either will drain the battery faster and can affect the remaining shooting time and number of recordable images.

Auto Power LCD

This option automatically adjusts the monitor brightness based on the lighting conditions under which you're viewing the LCD.

Power LCD

The power LCD option adjusts the monitor to outdoor brightness conditions. When in the Power LCD mode, the added brightness will shut down after 30 seconds. Pressing any camera button will restore it.

Scene Menu

You have two options with this feature, Auto and Off. If you set it to Auto, then when you change the mode dial to SCN, the camera displays the full range of scene choices over two screens for you to cycle through and select (see Figure 3.30). If you turn it off, then you'll have to use the camera's menu system to change scene settings.

Your menu setup will change when the camera is in SCN mode with this option set to Off. Instead of beginning with the Rec menu, your menu options will start with the SCN menu. You'll have to select the SCN menu and then maneuver to the particular scene option you want. It's not a big hassle, but it does add an extra step to the process.

Beep

The camera beeps at you to let you know when focus has been locked, or when the self-timer or alarm has been activated.

You can control the volume of the GF1's beeps and can set it to one of three options: Muted, Low, or High.

Volume

You can set the volume of the camera's audio speaker via a seven-step scale. This only affects the camera's speaker though; if you've hooked up the GF1 to a television, this control does not affect the output of the television's speakers. (Sigh... sadly this control doesn't work on spouses, children, or neighbors with motorcycles either.)

Figure 3.30
The SCN menu lets you tell the camera whether to show or hide the SCN menu options.

No. (Number) Reset

You can use this control to return the frame number to 0001. When you do this, the camera will create a new folder as well, updating the folder number to the next one in the sequence (from 100 to 999).

Once the number of folders reaches 999, you can't reset the numbers on the camera, but instead have to reformat the memory card (make sure you save any images on the card first).

Reset

This control resets the Setup menu functions back to the camera's original factory settings. If you use this option and have registered face recognition data, you will also lose that information. The birthday and name settings for Baby1, Baby2, and Pet are also reset as are the Travel Date and World Time information.

USB Mode

You can connect the GF1 to either a computer or a PictBridge-supported printer via the camera's supplied USB cable. While you need to tell the camera whether you're connecting it to a PC or a printer, you don't have to do this in any special order.

You do need to tell the camera at some point though since the PC and the printer use different communication protocols and the camera needs to know which one to use.

Video Out

The GF1 is designed to work with the two most common video systems, NTSC and PAL. The Video Out submenu is the one you use for this purpose. You can use either the video cables that came with the camera for this or the optional HDMI accessory cable. Each will work for either video system.

TV Aspect

You can set the GF1 for either of two television aspect ratios, 4:3 or a 16:9.

HDMI Mode

The GF1 can record and provide HD-quality video. You can connect the camera to an HDTV and show your video this way, provided you have the optional HDMI cable.

Not all HDTVs work at the same quality level though, and it's necessary for the camera and television to be on the same standard. Fortunately, the GF1 can be set to any of several different output standards. These include

- **Auto.** The camera connects with the television and determines what quality standard to use.

- **1080i.** This standard uses the 1080 available scan lines format.

- **720p.** This standard uses the 720 progressive scan lines format.

- **576/480.** This standard uses either the 576 progressive scan lines or the 480 progressive scan lines format depending on whether the camera is set to NTSC (480) or PAL (576).

Viera Link

If you're going to be using a Viera system remote control, then you can link the remote and the GF1 via this submenu. This is basically an On/Off menu. Use On if you want to link the camera and the Viera remote (part of the Panasonic system designed to enable a remote control linking the manufacturer's televisions, DVD players, home theater systems, and other electronics). This will also limit the button functionality of the camera as long as the link option is turned on.

Version Disp.

Select this submenu to see what firmware version the camera and lens are using.

Language

The GF1 can be configured to display settings in one of four different languages: English, French, Spanish, or Portuguese.

Format

Use this function to format your memory card. This is the best way to format the memory card. If you use your computer to format the card, it can configure the card differently than the camera prefers.

My Menu

Here's where you can really tweak the GF1 to your particular shooting style and preferences. My Menu can remember as many as five recent menu selections, so instead of having to search through different menus trying to remember exactly where a submenu is, you can just pull up the My Menu screen (see Figure 3.31).

Keep in mind that the availability of these selections will depend on whether the shooting mode you're using can utilize these particular functions. You'll be able to tell if you can't use a My Menu option because it will be grayed out on the My Menu screen.

Figure 3.31
The My Menu screen keeps track of the last few menu selections you've used.

Playback Menu

The Playback menu's three screens of submenus give you an array of choices for viewing your videos and images. Here's where you can have your camera play a slide show, embed information into your photos, provide print information, or dub audio onto an image. Let's take a closer look at what the Playback menu can do for you.

Slide Show

The Slide Show submenu offers several different options for displaying your creative efforts. Panasonic has provided GF1 owners with some interesting options for camera-managed slide shows. Here's a list of what the camera can do:

- **All.** Shows every image and video on your memory card.

- **Picture only.** Just shows still images.

- **Motion pic. only.** Just shows the videos on the memory card.

- **Category selection.** If you've been working with SCN mode options for your photography, the camera can sort the various scene options and just show images created with a specific SCN mode (see Figure 3.32).

Figure 3.32
The GF1 can group your images into categories based on the SCN menu settings you've used so you can present a slide show of images from a particular group.

■ **Favorite.** You can mark various images as "favorites." Once you've marked images as favorites, you can then play a slide show made up of just those photos. To designate an image as a favorite, you must be in Playback mode. Push the down cursor and the image will be marked with a star. You cannot designate RAW files as favorites.

Playback Mode

When it comes to playing back images on your GF1's LCD screen, you have a wealth of choices, depending on what it is you're interested in reviewing. You have five different choices for Playback mode. They are as follows:

■ **Normal Play.** This is the default setting for the GF1. When set to Normal Play, the camera will show any file you've created in the order in which it was created.

■ **Picture Play.** This mode plays only still photos. If you've recorded video, you won't know it when reviewing files in this mode.

■ **AVCHD Lite Play.** Only AVCHD Lite files will be shown during review in this mode.

■ **Motion JPEG Play.** Only Motion JPEG files will play in this setting.

■ **Category Play.** This option groups images into categories based on the various SCN modes and other tools. Images will be grouped according to whether face recognition has been used. Page 136 of the GF1's manual provides a chart that shows how these groupings are managed.

Favorite

Turning this feature on makes it possible for you to mark images with a star (designating them as "favorites"). You have three options with this submenu: Off, On, Cancel. Off turns off the possibility of marking photos as favorites, On turns it on, and Cancel simply removes every star. It's impossible to use Cancel unless at least one photo is marked as a favorite.

Title Edit

You can add titles to your images (JPEGs only, not RAW files) on the GF1 (see Figure 3.33). The Title Edit submenu gives you this ability. You can choose to add a title to just one image or to more than one. If you choose the Multi option, you can select the images you want to title and then create a title that will be applied to each image.

To title an image, display the photo you want to title, then press the MENU/SET button and navigate to the Title Edit function. Choose either Single or Multi, then press the DISPLAY button followed by the MENU/SET button. At this point, a letter menu appears and you can use the arrow keys and the MENU/SET button to type the title you want to apply.

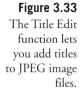

Figure 3.33
The Title Edit function lets you add titles to JPEG image files.

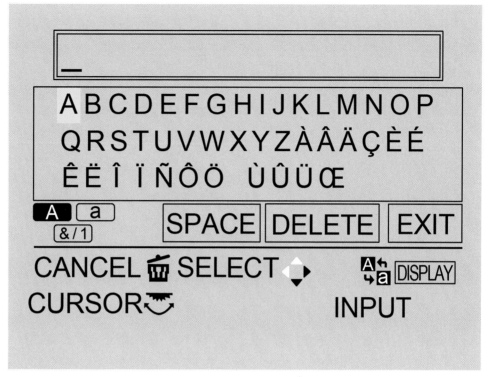

Text Stamp

You can use the Text Stamp feature to embed information with your photos, such as date and time shot, title, travel date, or age. Just like the Title Edit function, you can apply this to one or more photos.

One thing to consider about using it though is that it will ask to resize your images from large or medium sized to small, which makes them easier to share via e-mail.

Resize

You can decide to resize your images while they're still in the camera with the GF1. The Resize function on the Setup menu makes it possible to switch sizes as long as you're not trying to convert a JPEG image to a RAW file. Just like the previous two functions, you can choose to resize one image or multiple images (Multi).

To resize images, first choose the new size you want, then press the MENU/SET button. The camera then takes you to a thumbnail view screen. Use the arrow keys to scroll to the photos you want to resize and then press the DISPLAY button to mark the photos. Then press the MENU/SET button to resize the images or the trash can button to cancel the resizing.

Trimming

The GF1's Trimming function lets you trim photos that may have been too loosely composed. Select the Trimming option, then use the arrow keys to select the photo you want to trim. Once you've found the photo you want to trim, push the MENU/SET button and then use the rear dial to zoom until you have the image reduced to the desired area. You can also use the arrow keys to reposition the image area you want to keep (see Figure 3.34). Once you've got it just the way you want, push the MENU/SET button again and then select either Yes or No as appropriate. Pressing the shutter button halfway takes you out of Trimming mode.

Figure 3.34
The Trimming option lets you crop your image in camera.

After you've completed your trimming, push the MENU/SET button and then confirm that you want the photo saved as a new image. Remember, there needs to be enough space left on your memory card to store the new image. If there isn't, the camera won't let you complete the trim.

Aspect Conversion

The Aspect Conversion menu lets you change the aspect ratio of your images to 3:2, 4:3, or 1:1. Once you select an image, you'll also need to decide what part of the image you want to keep. You can use the arrow keys to adjust the image area you want to

preserve to fit within the new aspect area boundaries. Keep in mind that as you change aspect ratios, you'll probably change file size too, sometimes even for the larger.

Aspect conversion can't be used on movies with audio or images that have a text stamp or audio applied. It also can't be used with any RAW files configuration. It's also likely it won't work on files from another camera.

Rotate

You can rotate your files in-camera if you want. For instance, maybe you're one of those people who actually shoots vertical compositions and you want to have the image rotated vertically now rather than having to do it in an image-editing program in your computer.

Actually, rotating in-camera is probably easier than on a computer. Just go to the Rotate submenu, select the photo, press the MENU/SET button, and choose the directional arrow to rotate the image in the direction you wish.

Rotate Display

If you're shooting with a lens possessing Direction Detection Function, then the camera can recognize whether an image is a horizontal or a vertical composition. If you wish, the camera can rotate the image automatically to the proper orientation. Of course, this also means that verticals will be shown smaller than horizontals since the camera display is wider than it is tall. You may prefer to rotate the camera rather than the image. Generally lenses offering image stabilization make this possible.

Setting the Rotate Display function is a simple On/Off choice.

Print Set

Print Set lets you mark images for printing either individually or in multiples for use with a DPOF (Digital Print Order Format) system and a compatible printer or photo service (many photo kiosks and commercial printers can work with this format). This feature lets you designate the number of prints per image and whether you want the print to display the date information on the print as well.

It's easy to use the Print Set feature. Simply select Print Set, choose Single or Multi, then press the MENU/SET button. At this point, you'll be brought back to Playback. Use the right and left arrow keys to view and select images. When you find an image you want to print, press the MENU/SET button again, then use the up arrow key to set the number of prints you want, from 1 to 999. If you want to have the printer print the image date on the photo, press the DISPLAY button and it will add that information too. If you change your mind, go back to the Print Set menu and select Cancel and then Yes, and it will cancel all the printing commands.

Protect

You can protect images from accidental deletion via the Protect feature. Select Protect and then either Single or Multi. If you select Multi, you'll select images from Thumbnail view by pressing the MENU/SET button for each image you want to protect. Keep in mind, Protect only protects images from being deleted, not from being erased by formatting the memory card.

Audio Dub

You can record audio notes on your images via the Audio Dub feature. This can be handy for a number of uses including recording comments from the people you're photographing or background noise from where you're shooting.

Just choose Audio Dub, select the image you want to add audio to, and press the MENU/SET button. You can then speak into the camera microphone and record your audio. You can't dub audio on protected images or RAW files. The camera stops recording after 10 seconds, whether you're finished or not. Of course, you can press the MENU/SET button to stop recording.

Face Recognition Edit

The GF1's facial recognition capabilities can be pretty useful for helping you get great shots of people you photograph regularly. You can have the camera store names and birthdays for as many as six individuals (see the section on the face recognition settings earlier in this chapter).

This submenu lets you edit or remove face recognition information from a specific image. You can even copy information from one image to another. Images that have been protected cannot have their face recognition information changed and if you remove all face recognition information from an image, it will no longer show up if you do a category search using face recognition as a criteria.

4

Fine-Tuning Exposure

Correct exposure is one of the foundations of good photography, along with accurate focus and sharpness, appropriate color balance, freedom from unwanted noise and excessive contrast, as well as pleasing composition. The Panasonic Lumix DMC-GF1 gives you a great deal of control over all of these, although composition is entirely up to you: there are no "automated" shortcuts for arranging the components of your image in a compelling fashion. All the other parameters, however, are basic functions of the camera. You can let your GF1 set them for you automatically. Just choose one of the Scene modes, or spin the mode dial to Intelligent Auto (iA), Program (P), Aperture-priority (A), or Shutter-priority (S) and shoot away. The GF1 is truly a "smart" camera.

If you prefer, you can also fine-tune how the camera applies its automatic settings, or you can make them yourself, manually. The amount of control you have over exposure, sensitivity (ISO settings), color balance, focus, and image parameters like sharpness and contrast make the GF1 a versatile tool for creating images. That's why I include an entire chapter on exposure in my books. As you learn to use your GF1 creatively, you're going to find that the right settings—as determined by the camera's exposure meter and intelligence—need to be *adjusted* to account for your creative decisions or special situations.

For example, when you shoot under high contrast situations, you run the risk of blown highlights and/or blocked up shadows. The Panasonic Lumix DMC-GF1 deals with these situations nicely, thanks to features like I. Exposure (discussed in Chapter 3), which can fine-tune exposure to preserve detail in the highlights and shadows.

But, what if your goal is to *underexpose* the subject, to produce a silhouette effect? Or, perhaps, you might want to flip up the GF1's built-in flash unit to fill in inky shadows. The more you know about how to use your GF1, the more you'll run into situations where you want to creatively tweak the exposure to provide a different look than you'd get with a straight shot.

This chapter shows you the fundamentals of exposure, so you'll be better equipped to override the Lumix GF1's default settings when you want to, or need to. After all, correct exposure is one of the foundations of good photography, along with accurate focus and sharpness, appropriate color balance, freedom from unwanted noise and excessive contrast, as well as pleasing composition. In the next few pages, I'm going to give you a grounding in one of those foundations, and explain the basics of exposure, either as an introduction or as a refresher course, depending on your current level of expertise. When you finish this chapter, you'll understand most of what you need to know to take well-exposed photographs creatively in a broad range of situations.

Getting a Handle on Exposure

Exposure determines the look, feel, and tone of an image, in more ways than one. Incorrect exposure can impair even the best-composed image by cloaking important tones in darkness, or by washing them out so they become featureless to the eye. On the other hand, correct exposure brings out the detail in the areas you want to picture, and provides the range of tones and colors you need to create the desired image. However, getting the perfect exposure can be tricky, because digital sensors can't capture all the tones we are able to see. If the range of tones in an image is extensive, embracing both inky black shadows and bright highlights, the sensor may not be able to capture them all. Sometimes, we must settle for an exposure that renders most of those tones—but not all—in a way that best suits the photo we want to produce. You'll often need to make choices about which details are important, and which are not, so that you can grab the tones that truly matter in your image. That's part of the creativity you bring to bear in realizing your photographic vision.

For example, look at the two typical tourist snapshots presented side by side in Figure 4.1. The camera was mounted on a tripod for both, so the only way you can really see that they are two different images is by examining the differences in the way the water flows in the ice-free area of the foreground. However, the pair of pictures does vary in exposure. The version on the left was underexposed, which helps bring out detail in the snow and sky in the background, but makes the shadows of the building look murky and dark. The overexposed version on the right offers better exposure for the foreground area, but now the brightest areas of the building and sky are much too light.

With digital camera sensors, it's tricky to capture detail in both highlights and shadows in a single image, because the number of tones, the *dynamic range* of the sensor, is limited. The solution, in this particular case, was to resort to a technique called High Dynamic Range (HDR) photography, in which the two exposures from Figure 4.1 were combined in an image editor such as Photoshop, or a specialized HDR tool like Photomatix (about $100 from www.hdrsoft.com). The resulting shot is shown in Figure 4.2. I'll explain more about HDR photography later in this chapter. For now, though,

Figure 4.1
At left, the image is exposed for the background highlights, losing shadow detail. At right, the exposure captures detail in the shadows, but the background highlights are washed out.

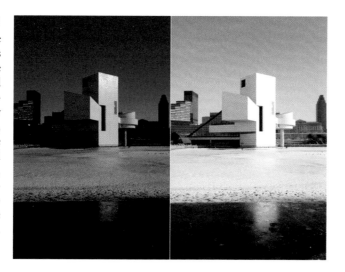

Figure 4.2
Combining the two exposures produces the best compromise image.

I'm going to concentrate on showing you how to get the best exposures possible without resorting to such tools, using only the features of your DMC-GF1.

Understanding Exposure

To understand exposure, you need to understand the six aspects of light that combine to produce an image. Start with a light source—the sun, an interior lamp, or the glow from a campfire—and trace its path to your camera, through the lens, and finally to the sensor that captures the illumination. Here's a brief review of the things within our control that affect exposure.

- **Light at its source.** Our eyes and our cameras—film or digital—are most sensitive to that portion of the electromagnetic spectrum we call *visible light.* That light has several important aspects that are relevant to photography, such as color, and harshness (which is determined primarily by the apparent size of the light source as it illuminates a subject). But, in terms of exposure, the important attribute of a light source is its *intensity.* We may have direct control over intensity, which might be the case with an interior light that can be brightened or dimmed. Or, we might have only indirect control over intensity, as with sunlight, which can be made to appear dimmer by introducing translucent light-absorbing or reflective materials in its path.

- **Light's duration.** We tend to think of most light sources as continuous. But, as you'll learn in Chapter 7, the duration of light can change quickly enough to modify the exposure, as when the main illumination in a photograph comes from an intermittent source, such as an electronic flash.

- **Light reflected, transmitted, or emitted.** Once light is produced by its source, either continuously or in a brief burst, we are able to see and photograph objects by the light that is reflected from our subjects towards the camera lens; transmitted (say, from translucent objects that are lit from behind); or emitted (by a candle or television screen). When more or less light reaches the lens from the subject, we need to adjust the exposure. This part of the equation is under our control to the extent we can increase the amount of light falling on or passing through the subject (by adding extra light sources or using reflectors), or by pumping up the light that's emitted (by increasing the brightness of the glowing object).

- **Light passed by the lens.** Not all the illumination that reaches the front of the lens makes it all the way through. Filters can remove some of the light before it enters the lens. Inside the lens barrel is a variable-sized diaphragm called an *aperture* that opens and closes to control the amount of light that enters the lens. You, or the GF1's autoexposure system, can control exposure by varying the size of the aperture. The relative size of the aperture is called the *f/stop.*

- **Light passing through the shutter.** Once light passes through the lens, the amount of time the sensor receives it is determined by the GF1's shutter, which can remain open for as long as 60 seconds (or even longer if you use the Bulb setting) or as briefly as 1/4,000th second.

- **Light captured by the sensor.** Not all the light falling onto the sensor is captured. If the number of photons reaching a particular photosite doesn't pass a set threshold, no information is recorded. Similarly, if too much light illuminates a pixel in the sensor, then the excess isn't recorded or, worse, spills over to contaminate adjacent pixels. We can modify the minimum and maximum number of pixels that contribute to image detail by adjusting the ISO setting. At higher ISOs, the incoming light is amplified to boost the effective sensitivity of the sensor.

These factors—the quantity of light produced by the light source, the amount reflected or transmitted towards the camera, the light passed by the lens, the amount of time the shutter is open, and the sensitivity of the sensor—all work proportionately and reciprocally to produce an exposure. That is, if you double the amount of light that's available, increase the aperture by one stop, make the shutter speed twice as long, or boost the ISO setting 2X, you'll get twice as much exposure. Similarly, you can increase any of these factors while decreasing one of the others by a similar amount to keep the same exposure.

F/STOPS AND SHUTTER SPEEDS

If you're *really* new to more advanced cameras, you might need to know that the lens aperture, or f/stop, is a ratio, much like a fraction, which is why f/2 is larger than f/4, just as 1/2 is larger than 1/4. However, f/2 is actually *four times* as large as f/4. (If you remember your high school geometry, you'll know that to double the area of a circle, you multiply its diameter by the square root of two: 1.4.)

Lenses are usually marked with intermediate f/stops that represent a size that's twice as much/half as much as the previous aperture. So, a lens might be marked:

f/2, f/2.8, f/4, f/5.6, f/8, f/11, f/16, f/22

with each larger number representing an aperture that admits half as much light as the one before, as shown in Figure 4.3.

Shutter speeds are actual fractions (of a second), but the numerator is omitted, so that 60, 125, 250, 500, 1,000, and so forth represent 1/60th, 1/125th, 1/250th, 1/500th, and 1/1,000th second. To avoid confusion, Panasonic uses quotation marks to signify longer exposures: 2", 2"5, 4", and so forth, representing 2.0, 2.5, and 4.0 second exposures, respectively.

Figure 4.3
Top row (left to right): f/2, f/2.8, f/4; bottom row, f/5.6, f/8, f11.

Most commonly, exposure settings are made using the aperture and shutter speed, followed by adjusting the ISO sensitivity if it's not possible to get the preferred exposure (that is, the one that uses the "best" f/stop or shutter speed for the depth-of-field or action-stopping we want). Table 4.1 shows equivalent exposure settings using various shutter speeds and f/stops.

When the GF1 is set for P mode, the metering system selects the correct exposure for you automatically, but you can change quickly to an equivalent exposure by tapping the shutter release button halfway ("locking" the current exposure), and then spinning the rear dial until the desired equivalent exposure combination is displayed. Rotate the dial to the right to increase the size of the aperture and make the shutter speed faster (for less depth-of-field/more action-stopping power) or to the left to use smaller apertures

Table 4.1 Equivalent Exposures

Shutter speed	f/stop	Shutter speed	f/stop
1/30th second	f/22	1/500th second	f/5.6
1/60th second	f/16	1/1,000th second	f/4
1/125th second	f/11	1/2,000th second	f/2.8
1/250th second	f/8	1/4,000th second	f/2

and slower shutter speeds (to increase depth-of-field while potentially adding some blur from subject or camera motion). The GF1 displays a Program Shift symbol and the Exposure Meter will also be displayed.

In Aperture-priority (A) and Shutter-priority (S) modes, you can change to an equivalent exposure, but only by adjusting either the aperture (the camera chooses the shutter speed) or shutter speed (the camera selects the aperture). I'll cover all these exposure modes later in the chapter.

How the GF1 Calculates Exposure

Your Panasonic Lumix DMC-GF1 calculates exposure by measuring the light that passes through the lens, based on the assumption that each area being measured reflects about the same amount of light as a neutral gray card. That assumption is necessary, because different subjects reflect different amounts of light. In a photo containing a white cat and a dark gray cat, the white cat might reflect five times as much light as the gray cat. An exposure based on the white cat will cause the gray cat to appear to be black, while an exposure based only on the gray cat will make the white cat's fur appear to be washed out. Light-measuring devices handle this by assuming that the areas measured average a standard value, a figure of approximately 18-percent gray that's been used as a rough standard for many years. (Most vendors don't calibrate their metering for exactly 18-percent gray; the actual figure may be closer to 13 or 14 percent.)

In most cases, your camera's light meter will do a good job of calculating the right exposure, especially if you use the exposure tips in the next section. But if you want to double-check, or feel that exposure is especially critical, take the light reading off an object of known reflectance. Photographers sometimes carry around an 18-percent gray card (available from any camera store) and, for critical exposures, actually use that card, placed in the subject area, to measure exposure (or to set a custom white balance if needed).

You could, in many cases, arrive at a reasonable exposure by pointing your GF1 at an evenly lit object, such as an actual gray card or the palm of your hand (the backside of the hand is too variable). It's more practical though, to use your GF1's system to meter the actual scene, using the options available to you when using one of the PASM modes. (In Scene modes, the metering decisions are handled by the camera's programming.)

Tip

Of course, if you use such a gray card, strictly speaking, you need to use about one-half stop *more* exposure than metered, because the GF1 is calibrated for a lighter tone, rather than the 18-percent gray you just measured. If you're using a human palm instead, add one full stop more exposure.

To meter properly you'll want to choose both the *metering method* (how light is evaluated) and *exposure method* (how the appropriate shutter speeds and apertures are chosen). I'll describe both in the following sections. But first, let's clear up that black cat/gray cat/white cat conundrum, without using any actual cats. Black, white, and gray cats have been a standard metaphor for many years, so I'm going to explain this concept using a different, and more cooperative, life form: fruit.

Figure 4.4 shows three ordinary pieces of fruit. The yellow banana at left represents a white cat, or any object that is very light but which contains detail that we want to see in the light areas. The orange in the middle is a stand-in for a gray cat, because it has most of its details in the middle tones. The deep purple plum serves as our black cat, because it is a dark object with detail in its shadows.

The colors confuse the issue, so I'm going to convert our color fruit to black-and-white. For the version shown in Figure 4.5, the exposure (measured by spot metering) was optimized for the white (yellow) banana, changing its tonal value to a medium, 18-percent gray. The dark (purple) and medium-toned (orange) fruit are now *too* dark. For Figure 4.6, the exposure was optimized for the dark (purple) plum, making most of its surface, now, fall into the middle-tone, 18-percent gray range. The light yellow banana and mid-tone orange are now too light.

The solution, of course, is to measure exposure from the object with the middle tones, which most closely correspond to the 18-percent gray "standard." Do that, and you wind up with a picture that more closely resembles the original tonality of the yellow, orange, and purple fruit, which looks, in black-and-white, like Figure 4.7.

MODES, MODES, AND MORE MODES

Call them modes or methods, the Panasonic Lumix DMC-GF1 seems to have a lot of different sets of options that are described using similar terms. Here's how to sort them out:

- **Metering method.** These modes determine the *parts of the image* within the 144-sensor array that are examined in order to calculate exposure. The GF1 may look at many different points within the image, segregating them by zone (Multiple metering), examine the same number of points, but give greater weight to those located in the middle of the frame (Center weighted metering), or evaluate only a limited number of points in a limited area (Spot metering).

- **Exposure method.** These modes determine *which* settings are used to expose the image. The GF1 may adjust the shutter speed, the aperture, or both, depending on the method you choose, or you can set the camera on Manual and make your own decisions.

Figure 4.4
The yellow banana, orange, and deep purple plum represent light, middle, and dark tones.

Figure 4.5 Exposing for the light-colored banana at left renders the other two fruit excessively dark.

Figure 4.6 Exposing for the dark plum (right) causes the two fruit at left to become too light.

Figure 4.7 Exposing for the middle-toned orange produces an image in which the tones of all three subjects appear accurately.

F/STOPS VERSUS STOPS

In photography parlance, *f/stop* always means the aperture or lens opening. However, for lack of a current commonly used word for one exposure increment, the term *stop* is often used. (In the past, EV served this purpose, but Exposure Value and its abbreviation has been inextricably intertwined with its use in describing Exposure Compensation.) In this book, when I say "stop" by itself (no *f*), I mean one whole unit of exposure, and am not necessarily referring to an actual f/stop or lens aperture. So, adjusting the exposure by "one stop" can mean both changing to the next shutter speed increment (say, from 1/125th second to 1/250th second) or the next aperture (such as f/4 to f/5.6). Similarly, 1/3 stop or 1/2 stop increments can mean either shutter speed or aperture changes, depending on the context. Be forewarned.

Choosing a Metering Method

The GF1 has three different schemes for evaluating the light received by its exposure sensors, Multiple; Center weighted; and Spot metering. Multiple metering is always used when you select one of the Scene modes. Exposure will generally be calculated well in one of these Scene modes, but the ability to choose an alternate metering method is one of the major reasons to select Program, Aperture-priority, Shutter-priority, or Manual exposure instead.

In P, A, S, and M exposure modes, select the metering mode you want to use either via the Quick Menu button approach or via the third screen on the Rec menu where you can find the Metering Mode submenu. Here is what you need to know about each metering method:

Multiple Metering

For its (Intelligent) Multiple metering mode ("Multi"), the GF1 slices up the frame into 144 different areas while it considers exposure for the entire scene. This exposure mode sometimes has problems with backlit exposures and has a tendency to underexpose under such conditions as a result. (See Figure 4.8.)

Figure 4.8
You can choose from Spot metering (approximately the red circle area), Center weighted metering (which emphasizes the area shown in green), or 144-zone Multiple metering (blue rectangles).

Center Weighted Metering

In this mode, the exposure meter emphasizes a zone about 8mm in diameter in the center of the frame to calculate exposure, as shown in Figure 4.9. About 75 percent of the exposure is based on that central area, and the remaining exposure is based on the rest of the frame. The theory, here, is that, for most pictures, the main subject will be located in the center. So, if the GF1 reads the center portion and determines that the exposure for that region should be f/8 at 1/250th second, while the outer area, which is a bit

Figure 4.9
Center weighted metering calculates exposure based on the full frame, but gives 75 percent of the weight to the approximate center area shown; the remaining 25 percent of the exposure is determined by the rest of the image area. Center weighted metering was used for this window-lit portrait of Jamie Schreader at Jim's Steaks in Philadelphia. One f/stop of minus exposure compensation was also used.

darker, calls for f/4 at 1/125th second, the camera will give the center portion the most weight and arrive at a final exposure of f/5.6 at 1/250th second.

Center weighting works best for portraits, architectural photos, backlit subjects with extra-bright backgrounds (such as snow or sand), and other pictures in which the most important subject is located in the middle of the frame. As the name suggests, the light reading is *weighted* towards the central portion, but information is also used from the rest of the frame. If your main subject is surrounded by very bright or very dark areas, the exposure might not be exactly right. However, this scheme works well in many situations if you don't want to use one of the other modes. This mode can also be useful for close-ups of subjects like flowers.

Spot Metering

Spot metering is favored by those of us who used to work with a handheld light meter to measure exposure at various points (such as metering highlights and shadows separately). However, you can use Spot metering in any situation where you want to individually measure the light reflecting from light, midtone, or dark areas of your subject—or any combination of areas.

This mode confines the reading to a limited area in the center of the viewfinder, making up only 3.5 percent of the image, as shown in Figure 4.10. The circle is centered on

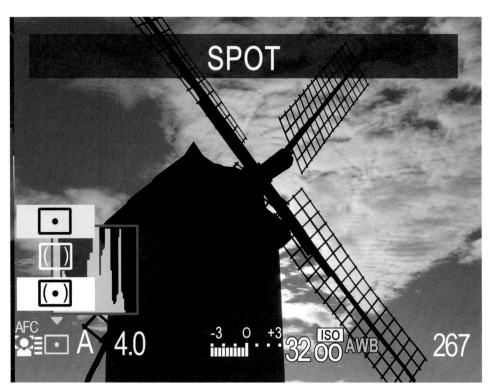

Figure 4.10
Select Spot metering, which calculates exposure based on a center spot that's only 3.5 percent of the image area, and other modes in this screen.

the current focus point. This is the only metering method you can use to tell the GF1 exactly where to measure exposure.

You'll find Spot metering useful when you want to base exposure on a small area in the frame. If that area is in the center of the frame, so much the better. If not, you'll have to make your meter reading for an off-center subject and then lock exposure by pressing the shutter release halfway, or by pressing the AE LOCK button. This mode is best for subjects where the background is significantly brighter or darker.

Choosing an Exposure Method

The Panasonic Lumix DMC-GF1's Scene modes choose an exposure method for you (although you can still set exposure compensation). But there are three semi-automated methods (plus manual) that you can use to choose the appropriate shutter speed and aperture. You can choose among them by rotating the mode dial until the one you want is selected. Your choice of which is best for a given shooting situation will depend on things like your need for lots of (or less) depth-of-field, a desire to freeze action or allow motion blur, or how much noise you find acceptable in an image. Each of the GF1's exposure methods emphasizes one aspect of image capture or another. This section introduces you to all four.

Aperture-Priority

In A mode (don't confuse this with Auto; some point-and-shoot cameras use the letter A to represent automatic mode), you specify the lens opening used, and the GF1 selects the shutter speed. Aperture-priority is especially good when you want to use a particular lens opening to achieve a desired effect. Perhaps you'd like to use the smallest f/stop possible to maximize depth-of-field in a close-up picture. Or, you might want to use a large f/stop to throw everything except your main subject out of focus, as in Figure 4.11, a portrait of a former student, Meghan Angelos.

Aperture-priority can even be used to specify a *range* of shutter speeds you want to use under varying lighting conditions, which seems almost contradictory. But think about it. You're shooting a soccer game outdoors with a telephoto lens and want a relatively high shutter speed, but you don't care if the speed changes a little should the sun duck behind a cloud. Set your GF1 to A, and adjust the aperture until a shutter speed of, say, 1/1,000th second is selected at your current ISO setting. (In bright sunlight at ISO 400, that aperture is likely to be around f/11.) Then, go ahead and shoot, knowing that your GF1 will maintain that f/11 aperture (for sufficient depth-of-field as the soccer players move about the field), but will drop down to 1/750th or 1/500th second if necessary should the lighting change a little.

Figure 4.11
Use Aperture-priority to "lock in" a large f/stop when you want to blur the background.

If the shutter speed values turn red and begin blinking in the viewfinder, it is an indication that the GF1 is unable to select an appropriate shutter speed at the selected aperture and that over- and underexposure will occur at the current ISO setting. That's the major pitfall of using A: you might select an f/stop that is too small or too large to allow an optimal exposure with the available shutter speeds. For example, if you choose f/2.8 as your aperture and the illumination is quite bright (say, at the beach or in snow), even your camera's fastest shutter speed might not be able to cut down the amount of light reaching the sensor to provide the right exposure. Or, if you select f/8 in a dimly lit

room, you might find yourself shooting with a very slow shutter speed that can cause blurring from subject movement or camera shake. Aperture-priority is best used by those with a bit of experience in choosing settings. Many seasoned photographers leave their GF1 set on A all the time.

Shutter-Priority

Shutter-priority (S) is the inverse of Aperture-priority: you choose the shutter speed you'd like to use, and the camera's metering system selects the appropriate f/stop. Perhaps you're shooting action photos and you want to use the absolute fastest shutter speed available with your camera; in other cases, you might want to use a slow shutter speed to add some blur to a sports photo that would be mundane if the action were completely frozen. Or, you might want to give a feeling of motion using some blur. (See Figure 4.12.) Shutter-priority mode gives you some control over how much action-freezing capability your digital camera brings to bear in a particular situation.

Figure 4.12
Lock the shutter at a high speed to freeze action—or use a slower speed to allow some interesting motion blur.

You'll also encounter the same problem as with Aperture-priority when you select a shutter speed that's too long or too short for correct exposure under some conditions. This time the f/stop setting will blink red. I've shot outdoor soccer games on sunny Fall evenings and used Shutter-priority mode to lock in a 1/1,000th second shutter speed, only to find my GF1 underexposed the image when the sun dipped behind some trees and there was no longer enough light to shoot at that speed, even with the lens wide open.

Like A mode, it's possible to choose an inappropriate shutter speed. If that's the case, the maximum aperture of your lens (to indicate underexposure) or the minimum aperture (to indicate overexposure) will blink.

Program Mode

Program mode (P) uses the GF1's built-in smarts to select the correct f/stop and shutter speed using an algorithm that tells it which combination of shutter speed and aperture will work best under existing lighting conditions. If the correct exposure cannot be achieved at the current ISO setting, the f/stop and shutter speed readings will begin blinking in red. You can then boost or reduce the ISO to increase or decrease sensitivity.

The GF1's recommended exposure can be overridden if you want. Use the EV setting feature (described later, because it also applies to S and A modes) to add or subtract exposure from the metered value. And, as I mentioned earlier in this chapter, in Program mode you can rotate the rear dial to change from the recommended setting to an equivalent setting (as shown in Table 4.1) that produces the same exposure, but uses a different combination of f/stop and shutter speed. Since Program mode in the GF1 tends to favor fast shutter speeds over depth-of-field, the experienced photographer should be willing to second guess its suggested settings and take advantage of this feature as necessary.

This is called "Program Shift" by Panasonic. Rotate the rear dial counterclockwise to reduce the size of the aperture (going from, say, f/4 to f/5.6), so that the GF1 will automatically use a slower shutter speed (going from, say, 1/250 second to 1/125 second). Rotate the rear dial clockwise to use a larger f/stop, while automatically producing a shorter shutter speed that provides the same equivalent exposure as metered in P mode. A diagonal two-headed arrow appears next to the P in the LCD and viewfinder so you'll know you've overridden the GF1's default program setting. Your adjustment remains in force until you rotate the rear dial until the arrow disappears, you switch to a different exposure mode, or turn off the GF1.

MAKING EV CHANGES

Sometimes you'll want more or less exposure than indicated by the GF1's metering system. Perhaps you want to underexpose to create a silhouette effect, or overexpose to produce a high-key look. It's easy to use the GF1's exposure compensation system to override the exposure recommendations. Push the rear dial in to select the exposure compensation scale and rotate the dial to the left to add exposure or to the right to subtract it. When done, push the dial in again to leave EV input. Then rotate the rear dial counterclockwise to add exposure, and clockwise to subtract exposure. The EV change you've made remains for the exposures that follow, until you manually zero out the EV setting. The EV scale with the compensation set appears in the viewfinder to warn you that an exposure compensation change has been entered. You can increase or decrease exposure over a range of plus or minus three stops (see Figure 4.13).

Figure 4.13
Exposure compensation scale.

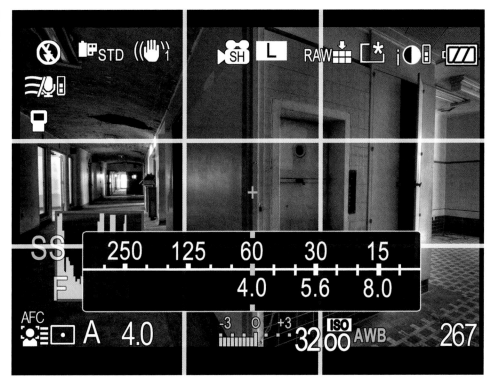

Manual Exposure

Part of being an experienced photographer comes from knowing when to rely on your GF1's automation (with Scene modes or P mode), when to go semi-automatic (with S or A), and when to set exposure manually (using M). Some photographers actually prefer to set their exposure manually, as the GF1 will be happy to provide an indication of when its metering system judges your manual settings provide the proper exposure, using the analog exposure scale at the bottom of the viewfinder.

Manual exposure can come in handy in some situations. You might be taking a silhouette photo and find that none of the exposure modes or EV correction features give you exactly the effect you want. Set the exposure manually to use the exact shutter speed and f/stop you need. Or, you might be working in a studio environment using multiple flash units. The additional flash units are triggered by slave devices (gadgets that set off the flash when they sense the light from another flash, or, perhaps from a radio or infrared remote control). Your camera's exposure meter doesn't compensate for the extra illumination, so you need to set the aperture manually.

Although, depending on your proclivities, you might not need to set exposure manually very often, you should still make sure you understand how it works. Fortunately, the GF1 makes setting exposure manually very easy. Just rotate the mode dial to change to Manual mode, and then turn the rear dial to set the shutter speed, and aperture. (The rear dial controls whichever setting is highlighted in yellow. You press the rear dial in to switch back and forth between f/stop and shutter speed.) The exposure scale at the bottom of the viewfinder will let you know how far off the light meter reading is from your settings in 1/3 f/stop increments.

Adjusting Exposure with ISO Settings

Another way of adjusting exposures is by changing the ISO sensitivity setting. Sometimes photographers forget about this option, because the common practice is to set the ISO once for a particular shooting session (say, at ISO 200 for bright sunlight outdoors, or ISO 800 when shooting indoors) and then forget about ISO. The reason for that is that ISOs higher than ISO 200 or 400 are seen as "bad" or "necessary evils." However, changing the ISO is a valid way of adjusting exposure settings, particularly with the Panasonic Lumix DMC-GF1, which produces good results at ISO settings that create grainy, unusable pictures with some other camera models.

Indeed, I find myself using ISO adjustment as a convenient alternate way of adding or subtracting exposure when shooting in Manual mode, and as a quick way of choosing equivalent exposures when in Program or Shutter-priority or Aperture-priority modes. For example, I've selected a Manual exposure with both f/stop and shutter speed suitable for my image using, say, ISO 200. I can change the exposure in one-third-stop increments by using the Quick menu or ISO button to change the ISO to 400 (for one

additional stop) or to 100 (for one less stop's worth of exposure). I keep my preferred f/stop and shutter speed in either case, but still adjust the exposure.

Or, perhaps, I am using S mode and the metered exposure at ISO 200 is 1/500th second at f/11. If I decide on the spur of the moment I'd rather use 1/500th second at f/8, I can change the ISO to 100. Of course, it's a good idea to monitor your ISO changes, so you don't end up at ISO 3200 accidentally.

ISO settings can, of course, also be used to boost or reduce sensitivity in particular shooting situations. The GF1 can use ISO settings from ISO 100 up to 3200 (and actually delivers quite good results at 1600 and even 3200 ISO). The camera can also adjust the ISO automatically as appropriate for various lighting conditions. When you choose the Auto ISO setting in the Shooting menu, as described in Chapter 3, the GF1 adjusts the sensitivity dynamically to suit the brightness of the scene. If you select Intelligent ISO, the camera bases the ISO selection on your subject's movement. As I noted in Chapter 3, you should use Auto ISO and Intelligent ISO cautiously if you don't want the GF1 to use an ISO higher than you might otherwise have selected.

Dealing with Noise

Visual image noise is that random grainy effect that some like to use as a special effect, but which, most of the time, is objectionable because it robs your image of detail even as it adds that "interesting" texture. Noise is caused by two different phenomena: high ISO settings and long exposures.

High ISO noise commonly appears when you raise your camera's sensitivity setting above ISO 400. With the Panasonic Lumix DMC-GF1, noise may become visible at ISO 1600, and is often fairly noticeable at ISO 3200. High ISO noise appears as a result of the amplification needed to increase the sensitivity of the sensor. While higher ISOs do pull details out of dark areas, they also amplify non-signal information randomly, creating noise. You can set the GF1's Noise Reduction feature by tweaking the NR control in the Film mode menu for whichever film mode you're using (see Figure 4.14). Advancing this setting in the + direction increases the noise reduction, while advancing it in the – direction decreases it. Because noise reduction tends to soften the grainy look while robbing an image of detail, you may want to disable the feature if you're willing to accept a little noise in exchange for more details.

A similar noisy phenomenon occurs during long time exposures, which allow more photons to reach the sensor, increasing your ability to capture a picture under low-light conditions. However, the longer exposures also increase the likelihood that some pixels will register random phantom photons, often because the longer an imager is "hot" the warmer it gets, and that heat can be mistaken for photons. With a Live MOS sensor, like the one used in the GF1, the entire signal is conveyed off the chip and funneled

Figure 4.14
Tweak the Noise Reduction setting with the Film mode controls.

through a single amplifier and analog-to-digital conversion circuit. Any noise introduced there is, at least, consistent.

Fortunately, Panasonic's electronics geniuses have done an exceptional job minimizing noise from all causes in the GF1. Even so, you might still want to apply the optional long exposure noise reduction that can be activated using Long Shutter NR in the Rec menu, where the feature can be turned On or Off. This type of noise reduction involves the GF1 taking a second, blank exposure, and comparing the random pixels in that image with the photograph you just took. Pixels that coincide in the two represent noise and can safely be suppressed. This noise reduction system, called *dark frame subtraction,* effectively doubles the amount of time required to take a picture, and is used only for exposures longer than one second. Noise reduction can reduce the amount of detail in your picture, as some image information may be removed along with the noise. So, you might want to use this feature with moderation.

You can also apply noise reduction to a lesser extent using Photoshop, and when converting RAW files to some other format, using your favorite RAW converter, or an industrial-strength product like Noise Ninja (www.picturecode.com) to wipe out noise after you've already taken the picture.

Bracketing

Bracketing is a method for shooting several consecutive exposures using different settings, as a way of improving the odds that one will be exactly right. Before digital cameras took over the universe, it was common to bracket exposures, shooting, say, a series of three photos at 1/125th second, but varying the f/stop from f/8 to f/11 to f/16. In practice, smaller than whole-stop increments were used for greater precision, and lenses with apertures that were set manually commonly had half/stop detents on their aperture rings, or could easily be set to a mid-way position between whole f/stops. It was just as common to keep the same aperture and vary the shutter speed, although in the days before electronic shutters, film cameras often had only whole increment shutter speeds available.

Today, cameras like the GF1 can bracket exposures much more precisely, using "in between" settings. The GF1 has a pretty powerful and easy to use auto bracketing feature that's set through the Rec menu and activated by switching the drive mode lever to the Auto Bracket setting.

To use this feature, choose Auto Bracket from the Rec menu. Once there you'll have several choices, how many steps you want to bracket (from three to seven), how great you want the bracketing to be (1/3 or 2/3 f/stop), and in what order you want the exposures to be made (–/0/+ or 0/–/+).

Bracketing and Merge to HDR

One reason you might want to use manual bracketing is to create high dynamic range (HDR) photographs, which have become all the rage as a way to extend the number of tones that a digital camera like the GF1 can capture. While my goal in this book is to show you how to take great photos *in the camera* rather than how to fix your errors in Photoshop, the Merge to HDR (high dynamic range) feature in Adobe's flagship image editor is too cool to ignore. The ability to have a bracketed set of exposures that are identical except for exposure, is key to getting good results with this Photoshop feature, which allows you to produce images with a full, rich dynamic range that includes a level of detail in the highlights and shadows that is almost impossible to achieve with digital cameras. In contrasty lighting situations, even the Panasonic Lumix DMC-GF1 has a tendency to blow out highlights when you expose solely for the shadows or midtones.

Suppose you wanted to photograph a dimly lit room that had a bright window showing an outdoors scene. Proper exposure for the room might be on the order of 1/60th second at f/2.8 at ISO 200, while the outdoors scene probably would require f/11 at 1/400th second. That's almost a 7 EV step difference (approximately 7 f/stops) and well beyond the dynamic range of any digital camera, including the Panasonic Lumix DMC-GF1.

When you're using Merge to HDR, you'd take two to three pictures (or more), one for the shadows, one for the highlights, and perhaps one for the midtones. Then, you'd use

the Merge to HDR command to combine all of the images into one HDR image that integrates the well-exposed sections of each version. You can use the Panasonic Lumix DMC-GF1's bracketing feature to produce those images.

The images should be as identical as possible, except for exposure. So, it's a good idea to mount the GF1 on a tripod, use a remote release like the Panasonic DMW-RSL1, and take all the exposures in one burst. If you want to manually bracket, then just follow these steps:

1. Mount the GF1 on a tripod, as you'll find it easier to merge your shots if the camera remains absolutely stationary.

2. Use the Q. MENU screen to choose RAW exposure format. You'll need RAW files to give you the 16-bit high dynamic range images that the Merge to HDR feature processes best.

3. Set the GF1 to S (Shutter-priority). This forces the GF1 to bracket the exposures by changing the shutter speed. You don't want the bracketed exposures to have different aperture settings, because the depth-of-field will change, perhaps enough to disturb a smooth merger of the final shots.

4. Manually focus or autofocus the GF1.

5. Press the shutter release button to take the first exposure.

6. Hold down the Aperture/EV button and increase the exposure by a value of one EV. Take a second shot, being careful not to shake the camera while changing the settings or tripping the shutter. (Using the self-timer or the remote release may help.)

7. Repeat Step 6 for a third shot, this time decreasing the exposure by two EV (giving you a net reduction of one stop from the original exposure).

8. Copy your images to your computer and continue with the Merge to HDR steps listed next.

The next steps show you how to combine the separate exposures into one merged high dynamic range image. The sample images shown in Figures 4.15, 4.16, and 4.18 show the results you can get from a three-shot bracketed sequence. In this case, I merged only two pictures of the three pictures for simplicity, because the differences between three or more bracketed exposures, even when taken at exposures that are two stops apart, can be too subtle to show up well on the printed page. My two examples were taken from a longer sequence, and actually have a three-stop difference.

1. If you use an application to transfer the files to your computer, make sure it does not make any adjustments to brightness, contrast, or exposure. You want the real raw information for Merge to HDR to work with. If you do everything correctly, you'll end up with at least two photos like the ones shown in Figures 4.15 and 4.16.

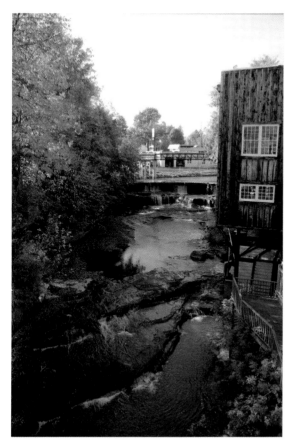

Figure 4.15 Make one exposure for the shadow areas.

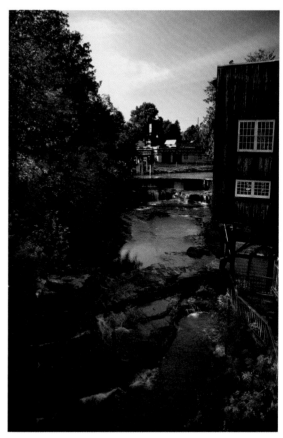

Figure 4.16 Make a second exposure for the highlights, such as the sky.

2. Load the images into Photoshop using your preferred RAW converter. Make sure the 16-bits-per-channel depth is retained (don't reduce them to 8-bit files). You can load them ahead of time and save as 16-bit Photoshop .PSD files, as I did for my example photos.

3. Activate Merge to HDR by choosing File > Automate > Merge to HDR.

4. Select the photos to be merged, as shown in Figure 4.17, where I have specified the two 16-bit PSD files. You'll note a check box that can be used to automatically align the images if they were not taken with the GF1 mounted on a rock-steady support.

5. Once HDR merge has done its thing, you must save in .PSD, .PFM, .TIFF, or .EXR formats to retain the 16-bit file's floating-point data, in case you want to work with the HDR image later. Otherwise, you can convert to a normal 24-bit file and save in any compatible format.

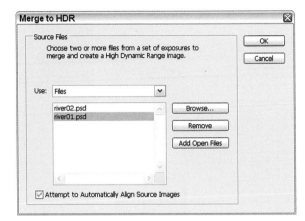

Figure 4.17
Use the Merge to HDR command to combine the two images.

If you do everything correctly, you'll end up with a photo like the one shown in Figure 4.18, which has the properly exposed foreground of the first shot, and the well-exposed sky of the second image. Note that, ideally, nothing should move between shots. In the example pictures, the river is moving, but the exposures were made so close together that, after the merger, you can't really tell.

What if you don't have the opportunity, inclination, or skills to create several images at different exposures, as described? If you shoot in RAW format, you can still use Merge to HDR, working with a *single* original image file. What you do is import the image into Photoshop several times, using Adobe Camera Raw to create multiple copies of the file at different exposure levels.

For example, you'd create one copy that's too dark, so the shadows lose detail, but the highlights are preserved. Create another copy with the shadows intact and allow the highlights to wash out. Then, you can use Merge to HDR to combine the two and end up with a finished image that has the extended dynamic range you're looking for. (This concludes the image-editing portion of the chapter. We now return you to our alternate sponsor: photography.)

Fixing Exposures with Histograms

While you can often recover poorly exposed photos in your image editor, your best bet is to arrive at the correct exposure in the camera, minimizing the tweaks that you have to make in post-processing. However, you can't always judge exposure just by viewing the image on your GF1's LCD after the shot is made. Instead, you can use a histogram, which is a chart displayed on the GF1's LCD that shows the number of tones being captured at each brightness level. You can use the information to provide correction for the next shot you take.

Figure 4.18
You'll end up with an extended dynamic range photo like this one.

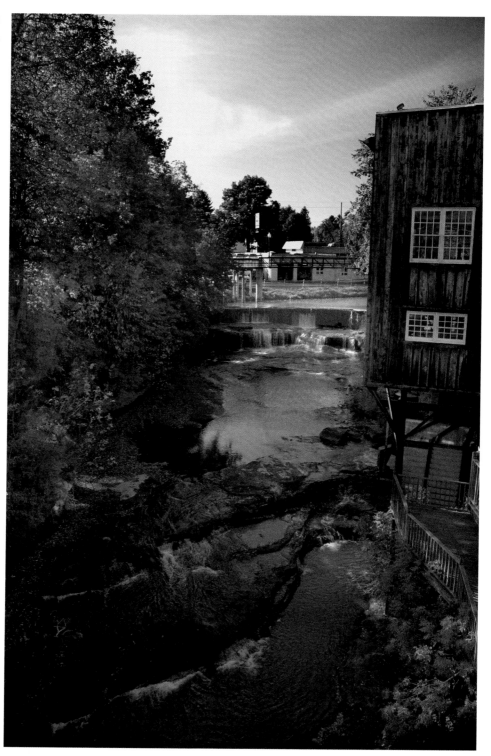

You can view a histogram for an image displayed during playback by pressing the DIS-PLAY button to switch the histogram overlay described in Chapter 3. The Histogram screen view for a properly exposed image is shown in Figure 4.19.

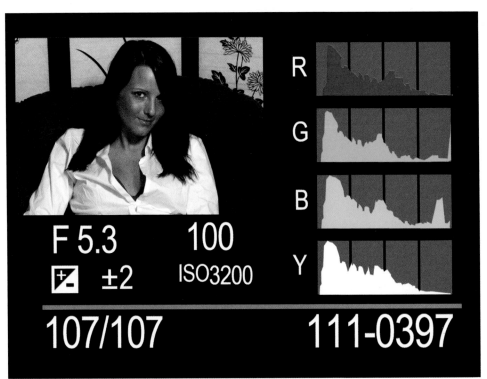

Figure 4.19
A histogram shows the relationship of tones in an image

The histogram at bottom, in white, is called a brightness or *luminance* histogram. It is a chart that includes a representation of up to 256 vertical lines on a horizontal axis that show the number of pixels in the image at each brightness level, from 0 (black) on the left side to 255 (white) on the right. (The LCD doesn't have enough pixels to show each and every one of the 256 lines, but, instead provides a representation of the shape of the curve formed.) The more pixels at a given level, the taller the bar at that position. If no bar appears at a particular position on the scale from left to right, there are no pixels at that particular brightness level. The three charts above it, in red, green, and blue, show the same tonal relationships in the red, green, and blue channels of your image, respectively.

As you can see, a typical histogram produces a mountain-like shape, with most of the pixels bunched in the middle tones, with fewer pixels at the dark and light ends of the scale. Ideally, though, there will be at least some pixels at either extreme, so that your image has both a true black and a true white representing some details. Learn to spot histograms that represent over- and underexposure, and add or subtract exposure using an EV modification to compensate.

For example, Figure 4.20 shows the histogram for an image that is badly underexposed. You can guess from the shape of the histogram that many of the dark tones to the left of the graph have been clipped off. There's plenty of room on the right side for additional pixels to reside without having them become overexposed. Or, a histogram might look like Figure 4.21, which is overexposed. In either case, you can increase or decrease the exposure (either by changing the f/stop or shutter speed in Manual mode or by adding or subtracting an EV value in A or S modes) to produce the corrected histogram shown in Figure 4.19, earlier, in which the tones "hug" the right side of the histogram to produce as many highlight details as possible. See "Making EV Changes," above for information on dialing in exposure compensation.

The histogram can also be used to aid in fixing the contrast of an image, although gauging incorrect contrast is more difficult. For example, if the histogram shows all the tones bunched up in one place in the image, the photo will be low in contrast. If the tones are spread out more or less evenly, the image is probably high in contrast. In either case, your best bet may be to switch to RAW (if you're not already using that format) so you can adjust contrast in post processing. However, you can also change to a user-defined Film mode setting using either MyFilm1 or MyFilm2 with contrast set lower (−1 to −2) or higher (+1 to +2) as required.

Figure 4.20
This histogram shows an underexposed image.

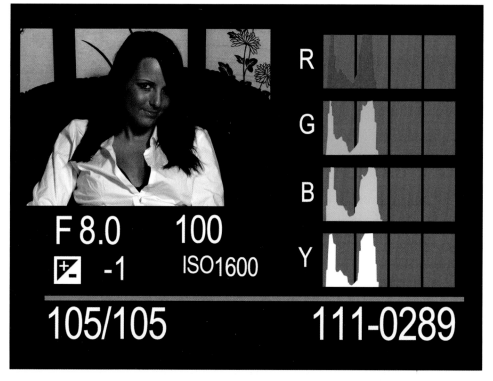

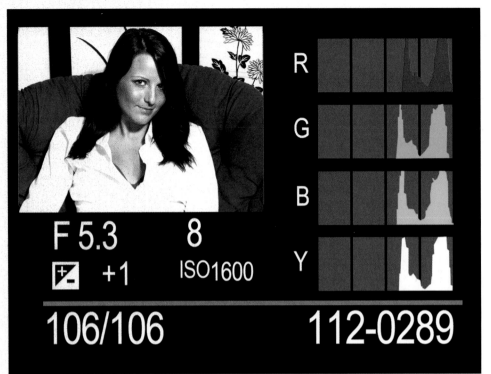

Figure 4.21
This histogram reveals that the image is over-exposed.

One useful, but often overlooked tool in evaluating histograms is the Highlight display (which can be activated under Highlight in the Setup menu), as described in Chapter 3. The Highlight display shows blown-out highlights in the image with a black blinking border. Highlights can give you a better picture of what information is being lost to overexposure.

In working with histograms, your goal should be to have all the tones in an image spread out between the edges, with none clipped off at the left and right sides. Underexposing (to preserve highlights) should be done only as a last resort, because retrieving the under-exposed shadows in your image editor will frequently increase the noise, even if you're working with RAW files. A better course of action is to expose for the highlights, but, when the subject matter makes it practical, fill in the shadows with additional light, using reflectors, fill flash, or other techniques rather than allowing them to be seriously underexposed.

Advanced Shooting Tips for Your Panasonic Lumix DMC-GF1

Getting the right exposure is one of the foundations of a great photograph, but a lot more goes into a compelling shot than good tonal values. A sharp image, proper white balance, good color, and other factors all can help elevate your image from good to exceptional. So, now that you've got a good understanding of exposure tucked away, you'll want to learn how to work with some additional exposure options, use the automatic and manual focusing controls available with the Panasonic Lumix DMC-GF1, and master some of the many ways you can fine-tune your images.

This chapter is a bit of a grab bag, because I'm including some specific advanced shooting techniques that didn't quite fit into the other chapters. If you master these concepts, you can be confident that you're well on your way towards mastering your Panasonic Lumix DMC-GF1. In fact, you'll be ready for the discussions of using lenses (Chapter 6) and working with light (Chapter 7).

How Focus Works

Once upon a time, all focusing was always done manually. Honest. Even though viewfinders were bigger and brighter than they are today, special focusing screens, magnifiers, and other gadgets were often used to help the photographer achieve correct focus. Imagine what it must have been like to focus manually under demanding, fast-moving conditions such as sports photography.

Focusing was problematic because our eyes and brains have poor memory for correct focus, which is why your eye doctor must shift back and forth between sets of lenses and ask, "Does that look sharper—or was it sharper before?" in determining your correct prescription. Similarly, manual focusing involves jogging the focus ring back and forth as you go from almost in focus, to sharp focus, to almost focused again. The little clockwise and counterclockwise arcs decrease in size until you've zeroed in on the point of correct focus. What you're looking for is the image with the most contrast between the edges of elements in the image. The camera also looks for these contrast differences among pixels to determine relative sharpness.

Locking in Focus

The GF1's autofocus mechanism evaluates the degree of focus, but, unlike the human eye, it is able to remember the progression perfectly, so that autofocus can lock in much more quickly and, with an image that has sufficient contrast, more precisely. Unfortunately, while the GF1's focus system finds it easy to measure degrees of apparent focus at each of the focus points in the viewfinder, it doesn't really know with any certainty which object should be in sharpest focus. Is it the closest object? The subject in the center? Something lurking behind the closest subject? A person standing over at the side of the picture?

Many of the techniques for using autofocus effectively involve telling the Panasonic Lumix DMC-GF1 exactly what it should be focusing on, by choosing a focus zone or by allowing the camera to choose a focus zone for you. Figure 5.1 uses two similar compositions to show how controlling the focus point controls what the viewer concentrates on. As the camera collects focus information from the sensors, it then evaluates it to determine whether the desired sharp focus has been achieved. The calculations may include whether the subject is moving, and whether the camera needs to "predict" where the subject will be when the shutter release button is fully depressed and the picture is taken. With the GF1's face recognition capability, you can even register a particular face so the camera knows to look for it when shooting. (You can actually register multiple faces.) Still, as Figure 5.1 suggests, it's often up to the photographer to decide what should be in focus and what should not.

The speed with which the camera is able to evaluate focus and then move the lens elements into the proper position to achieve the sharpest focus determines how fast the autofocus mechanism is. Although your GF1 will almost always focus more quickly than a human, there are types of shooting situations where that's not fast enough. For example, if you're having problems shooting sports because the GF1's autofocus system manically follows each moving subject, a better choice might be to switch autofocus modes or shift into Manual and pre-focus on a spot where you anticipate the action will be, such as a goal line or soccer net. At night football games, for example, when I am shooting with a telephoto lens almost wide open, I sometimes focus manually on one

Figure 5.1 Achieving "sharp" focus is often more complicated than just adjusting the lens. It's also important to make sure your subject is "sharp." The GF1 offers several different focusing options to help you do this, but sometimes you'll still have to make the call yourself.

of the referees who happens to be standing where I expect the action to be taking place (say, a halfback run or a pass reception).

Focus Modes

The GF1 has two AF modes: AFS (also known as Single Autofocus or Single Servo Autofocus) and AFC (Continuous Autofocus or Continuous Servo Autofocus). But first, some confusion…

MANUAL FOCUS

Manual focus is activated by sliding the switch on the lens to the M position (if you have a lens that has such a switch), or by using the AF/MF focus button at the top right of the LCD monitor. There are some advantages and disadvantages to focusing yourself. While your batteries will last longer in Manual focus mode, it will take you longer to focus the camera for each photo, a process that can be difficult. Modern digital cameras, even dSLRs, depend so much on autofocus that the viewfinders of models that have less than full-frame-sized sensors are no longer designed for optimum manual focus. Pick up any film camera and you'll see a bigger, brighter viewfinder with a focusing screen that's a joy to focus on manually.

Adding Circles of Confusion

You know that increased depth-of-field brings more of your subject into focus. But more depth-of-field also makes autofocusing (or manual focusing) more difficult because the contrast is lower between objects at different distances. So, autofocus with a 200mm lens (or zoom setting) may be easier than at a 28mm focal length (or zoom setting) because the longer lens has less apparent depth-of-field. By the same token, a lens with a maximum aperture of f/1.8 will be easier to autofocus (or manually focus) than one of the same focal length with an f/4 maximum aperture, because the f/4 lens has more depth-of-field *and* a dimmer view. That's yet another reason why lenses with a maximum aperture smaller than f/5.6 can give your GF1's autofocus system fits—increased depth-of-field joins forces with a dimmer image, and more difficulty in achieving contrast detection.

To make things even more complicated, many subjects aren't polite enough to remain still. They move around in the frame, so that even if the GF1 is sharply focused on your main subject, it may change position and require refocusing.

In other cases, an intervening subject may pop into the frame and pass between you and the subject you meant to photograph. You (or the GF1) have to decide whether to lock focus on this new subject, or remain focused on the original subject. Finally, there are some kinds of subjects that are difficult to bring into sharp focus because they lack enough contrast to allow the GF1's AF system (or our eyes) to lock in. Blank walls, a clear blue sky, or other subject matter may make focusing difficult.

If you find all these focus factors confusing, you're on the right track. Focus is, in fact, measured using something called a *circle of confusion.* An ideal image consists of zillions of tiny little points, which, like all points, theoretically have no height or width. There is perfect contrast between the point and its surroundings. You can think of each point as a pinpoint of light in a darkened room. When a given point is out of focus, its edges decrease in contrast and it changes from a perfect point to a tiny disc with blurry edges (remember, blur is the lack of contrast between boundaries in an image). (See Figure 5.2.)

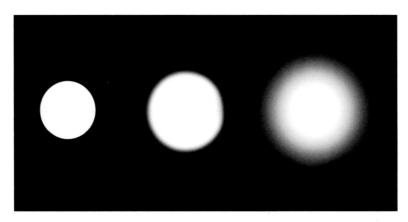

Figure 5.2
When a pinpoint of light (left) goes out of focus, its blurry edges form a circle of confusion (center and right).

If this blurry disc—the circle of confusion—is small enough, our eye still perceives it as a point. It's only when the disc grows large enough that we can see it as a blur rather than a sharp point that a given point is viewed as out of focus. You can see, then, that enlarging an image, either by displaying it larger on your computer monitor or by making a large print, also enlarges the size of each circle of confusion. Moving closer to the image does the same thing. So, parts of an image that may look perfectly sharp in a 5 × 7-inch print viewed at arm's length, might appear blurry when blown up to 11 × 14 and examined at the same distance. Take a few steps back, however, and it may look sharp again.

To a lesser extent, the viewer also affects the apparent size of these circles of confusion. Some people see details better at a given distance and may perceive smaller circles of confusion than someone standing next to them. For the most part, however, such differences are small. Truly blurry images will look blurry to just about everyone under the same conditions.

Technically, there is just one plane within your picture area, parallel to the back of the camera (or sensor, in the case of a digital camera) that is in sharp focus. That's the plane in which the points of the image are rendered as precise points. At every other plane in front of or behind the focus plane, the points show up as discs that range from slightly blurry to extremely blurry until, as you can see in Figure 5.3, the out-of-focus areas become blurry and less distracting.

In practice, the discs in many of these planes will still be so small that we see them as points, and that's where we get depth-of-field. Depth-of-field is just the range of planes

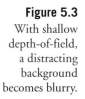

Figure 5.3
With shallow depth-of-field, a distracting background becomes blurry.

that include discs that we perceive as points rather than blurred splotches. The size of this range increases as the aperture is reduced in size and is allocated roughly one-third in front of the plane of sharpest focus, and two-thirds behind it. The range of sharp focus is always greater behind your subject than in front of it.

Using Autofocus with the Panasonic Lumix DMC-GF1

Autofocus can sometimes be frustrating for the new digital photographer, especially those coming from the point-and-shoot world. That's because correct focus plays a greater role among your creative options with a camera like the GF1, even when photographing the same subjects. Most point-and-shoot digital cameras have sensors that are much tinier than the sensor in the GF1. Those smaller sensors require shorter focal lengths, which (as you'll learn in Chapter 6) have, effectively, more depth-of-field.

The bottom line is that with the average point-and-shoot camera, *everything* is in focus from about one foot to infinity and at virtually every f/stop. Unless you're shooting close-up photos a few inches from the camera, the depth-of-field is prodigious, and autofocus is almost a non-factor. The GF1, on the other hand, uses longer focal length lenses to achieve the same field of view with its larger sensor, so there is less depth-of-field. That's a *good* thing, creatively, because you have the choice to use selective focus to isolate subjects. But it does make the correct use of autofocus more critical. To maintain the most creative control, you have to choose three attributes:

- **How much is in focus.** Generally, by choosing the f/stop used, you'll determine the *range* of sharpness/amount of depth-of-field. The larger the DOF, the "easier" it is for the autofocus system's locked-in focus point to be appropriate (even though, strictly speaking, there is only one actual plane of sharp focus). With less depth-of-field, the accuracy of the focus point becomes more critical, because even a small error will result in an out-of-focus shot.

- **What subject is in focus.** The portion of your subject that is zeroed in for autofocus is determined by the autofocus zone that is active, and which is chosen either by you or by the Panasonic Lumix DMC-GF1 (as described next). For example, when shooting portraits, it's actually okay for part of the subject—or even part of the subject's face—to be slightly out of focus as long as the eyes (or even just the *nearest* eye) appear sharp.

- **When focus is applied.** For static shots of objects that aren't moving, *when* focus is applied doesn't matter much. But when you're shooting sports, or birds in flight (see Figure 5.4), or children, the subject may move within the viewfinder as you're framing the image. Whether that movement is across the frame or headed right towards you, timing the instant when autofocus is applied can be important.

Figure 5.4
When capturing moving subjects, such as birds in flight, timing the instant when autofocus is applied can be important.

Your Autofocus Mode Options

Choosing the right Autofocus mode and the way in which focus points are selected is your key to success. Using the wrong mode for a particular type of photography can lead to a series of pictures that are all sharply focused—on the wrong subject. When I first started shooting sports with an autofocus SLR (back in the film camera days), I covered one game alternating between shots of base runners and outfielders with pictures of a promising young pitcher, all from a position next to the third base dugout.

The base runner and outfielder photos were great, because their backgrounds didn't distract the autofocus mechanism. But all my photos of the pitcher had the focus tightly zeroed in on the fans in the stands behind him. Because I was shooting film instead of a digital camera, I didn't know about my gaffe until the film was developed. A simple change, such as locking in focus or focus zone manually, or even manually focusing, would have done the trick.

There are three main autofocus options you need to master to make sure you get the best possible automatic focus with your Panasonic Lumix DMC-GF1: autofocus mode, autofocus method, and Pre AF. I'll explain each of them separately.

Autofocus Mode

This choice determines *when* your GF1 starts to autofocus, and what it does when focus is achieved. Automatic focus is not something that happens all the time when your camera is turned on. To save battery power, your GF1 generally doesn't start to focus the lens until you partially depress the shutter release. (You can also use the AE-L/AF-L button to start autofocus, as described in Chapter 3.) Autofocus isn't some mindless beast out there snapping your pictures in and out of focus with no feedback from you after you press that button. There are several settings you can modify that return at least a modicum of control to you.

Your first decision should be whether you set the GF1 to AFS, AFC, or Manual. To change to any of the Automatic focus modes, press the AF/MF button and select the desired focus mode. To switch to Manual mode, either choose MF via the AF/MF button or slide the AF/M or M-A/M switch on the lens to M if it has one.

AFS

In this mode, also called *Single Autofocus*, focus is set once and remains at that setting until the button is fully depressed, taking the picture, or until you release the shutter button without taking a shot. For non-action photography, this setting is usually your best choice, as it minimizes out-of-focus pictures (at the expense of spontaneity). The drawback here is that you might not be able to take a picture at all while the camera is seeking focus; you're locked out until the autofocus mechanism is happy with the current setting. AFS/Single Autofocus is sometimes referred to as *Focus Priority* for that reason. Because of the small delay while the camera zeroes in on correct focus, you might experience slightly more shutter lag. This mode uses less battery power.

When sharp focus is achieved, the focus confirmation light at the upper right will remain green, without flashing. By keeping the shutter button depressed halfway, you'll find you can reframe the image while retaining the focus (and exposure) that's been set.

AFC

This mode, also known as *Continuous Autofocus* is the one to use for sports and other fast-moving subjects. In this mode, once the shutter release is partially depressed, the camera sets the focus but continues to monitor the subject, so that if it moves or you move, the lens will be refocused to suit. Focus and exposure aren't really locked until you press the shutter release down all the way to take the picture. You'll often see Continuous Autofocus referred to as *Release Priority.* If you press the shutter release down all the way while the system is refining focus, the camera will go ahead and take a picture, even if the image is slightly out of focus. You'll find that AFC produces less shutter lag than AFS: press the button and the camera fires. It also uses the most battery power, because the autofocus system operates as long as the shutter release button is partially depressed. Not every lens will be able to work in AFC mode, even lenses designed for the Panasonic Micro Four Thirds system such as the 20mm 1.7 can't be used this way. If such is the case, the AFC icon will be grayed out on the camera when you try to change focusing modes. Most other MFT system lenses won't be able to work in AFC mode either.

Manual Focus

If you've chosen Manual focus via the AF/MF button, or when you've set the lens autofocus switch to Manual (or when you're using a non AFS lens, which lacks an internal autofocus motor), the GF1 always focuses manually using the rotating focus ring on the lens barrel. However, if you are using a lens with a maximum aperture of at least f/5.6, the focus confirmation light in the viewfinder will glow a steady green when the image is correctly manually focused.

Autofocus Method

Where Autofocus mode chooses when to autofocus, the Autofocus method parameter tells your Panasonic Lumix DMC-GF1 which autofocus method the camera should use. The GF1 offers four different approaches to autofocus (See Figure 5.5). Each has its own merits to consider and each lends itself to particular shooting situations.

While the AF method can be set via the menu system, it's another one of those controls that can be manipulated faster through the Q.MENU approach. The AF method options are found on the lower-left part of the camera's information display. The four options are as follows:

Face Detection

This autofocus method uses the camera's powerful Face Recognition capability. Face Recognition can be used anytime you're photographing people. If you have people you regularly photograph, then you can even register those faces so the camera will recognize them and give them priority when they're in a scene.

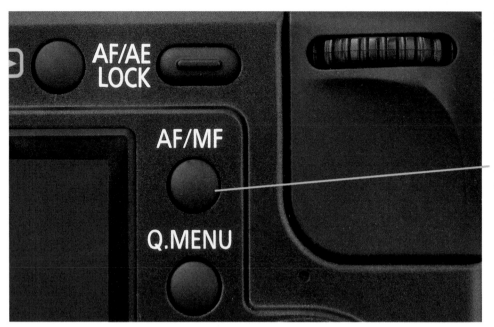

Figure 5.5
Push the AF/MF button to choose the AF method you prefer.

Autofocus/ Manual focus button

When set to Face Recognition, the GF1 viewfinder will place a yellow box around a face. The box will turn green when you press the shutter button halfway and the selected face is in focus. If there are other faces in the scene then white boxes will appear around them. If you're photographing a face the camera is familiar with, it may automatically recognize it and, if it's a registered face, even identify the person by name.

Face Recognition does not work in certain modes including: peripheral defocus, food, night scenery, or illuminations. Additionally, if the lens or camera is set to Manual focus mode, registration isn't possible. If you've set the camera to Multi metering, then the camera will base its exposure on the face in the yellow rectangle to make sure your subject is properly exposed. While the GF1's face recognition capability is robust, it does have some limitations. These include

- **Face not directly facing the camera.** If your subject's face is at an angle, or even worse, his head is turned away from the camera, face recognition won't work.

- **Bad lighting.** If the face is lit extremely bright or extremely dark, or there's too little contrast, face recognition will be hard to achieve.

- **Subject makes things hard.** If your subject is wearing sunglasses, is too far away or moving quickly, face recognition will have trouble. Also, if your subject isn't human (insert ex-wife joke here) it also probably won't work.

- **Burst mode.** If you're shooting in Burst mode, face recognition information will only be stored on the first exposure. (Page 106 of the user manual lists other conditions where face recognition might not be particularly effective.)

Face Registration

The GF1 can remember as many as six different faces. To register a face, take a simple head shot with your subject facing the camera head on and with his eyes open and his mouth closed (See Figure 5.6). Make sure that hair doesn't obscure the eyes or eyebrows and that the face is not in shadow. The camera will not fire a flash during this operation, so trying to use flash to clean up shadows won't work.

Figure 5.6

A simple head shot provides the basis for face recognition for the GF1.

Autofocus Tracking

This is also known as dynamic tracking. This autofocus method lets you designate a subject for your autofocus target to follow and the camera will then do its best to track that subject. AF Tracking is a very useful tool when you're trying to get good photos of a moving subject. Unlike face recognition autofocus, your subject need not be human either.

Setting up your camera for autofocus tracking is really very simple and only requires a few easy steps. All you need do is

1. **Choose the autofocus mode.** Press the left arrow key (a.k.a. the AF mode button).

2. **Select AF Tracking.** Use the right arrow key to pick AF Tracking (it's the second option).

3. **Push the MENU/SET button.** This confirms AF Tracking and positions a small rectangle on the viewfinder.

4. **Identify the target.** Position your target subject inside the target rectangle (by pointing the camera appropriately) and then press the shutter button halfway to register the subject. If the AF area turns green, the subject has been properly registered. Once you release the shutter button, the target rectangle will turn yellow. Cancel the registration by pressing the left arrow key again.

Twenty-three Area AF

The GF1's autofocus system offers you a 23-area AF sensor array that covers the entire area of the viewfinder. This is a good default AF mode to leave the camera in since it does a good job with either people or objects. Once set to this method, you don't have to do anything else except for pointing the camera in the right direction.

One-Area AF

The GF1 also offers a 1-area AF approach that lets you custom tailor the camera's AF sensor to your preferences. You can make it as large or small as suits your needs and with minimal effort. Here's how:

1. **Push the AF method button (it's the left arrow key).** Maneuver to the 1-area AF icon (it's the one all the way to the right).

2. **Push the down arrow key.** This brings up a yellow rectangle with triangles on each side to indicate the rectangle can be moved in those directions.

3. **Use the rear dial to size the rectangle.** This confirms AF tracking and positions a small rectangle on the viewfinder.

4. **Position the target wherever you want it.** Use the arrow keys to move the rectangle around the viewfinder.

Pre AF

In an effort to improve autofocus accuracy, Panasonic has added a couple of pre auto-focus options that can make the camera's AF more effective, but at the cost of faster battery drain.

- **Off.** Press the shutter button halfway and the camera focuses.

- **Q-AF.** The camera begins autofocusing as soon as it senses camera vibration diminishes. The logic here is that the photographer is steadying the camera just before taking the shot, so the GF1 grabs a quick head start on focusing.

- **C-AF.** The camera focuses continuously, even when you're not composing a photo. This can speed up autofocus for you but can also drain the battery faster than the other two settings. C-AF is only possible with lenses that can be set to AFC.

Setting Pre AF

The Pre AF control is located on the Custom menu's second screen and is the fourth option down. Once you get the Pre AF setting highlighted, the right arrow cursor will give you the available choices (Off, Q-AF, and C-AF, provided you have a lens that can operate in AFC mode).

Burst Mode

The Panasonic Lumix DMC-GF1's 3 frames-per-second Burst mode reminds me how far digital photography has brought us. The first accessory I purchased when I worked as a newspaper sports photographer some years ago was a motor drive for my film SLR. It enabled me to snap off a series of shots in rapid succession, which came in very handy when a fullback broke through the line and headed for the end zone. Even a seasoned action photographer can miss the decisive instant when a crucial block is made, or a baseball superstar's bat shatters and pieces of cork fly out. Continuous shooting simplifies taking a series of pictures, either to ensure that one has more or less the exact moment you want to capture or to capture a sequence that is interesting as a collection of successive images.

The GF1's "motor drive" capabilities are, in many ways, much superior to what you get with a film camera. For one thing, a motor-driven film camera can eat up film at an incredible pace, which is why many of them were used with cassettes that held hundreds of feet of film stock. At three frames per second (typical of film cameras), a short burst of a few seconds can burn up as much as half of an ordinary 36 exposure roll of film. The Panasonic Lumix DMC-GF1, which fires off bursts at a comparable frame rate, has reusable "film," so if you waste a few dozen shots on non-decisive moments, you can erase them and shoot more.

The increased capacity of digital film cards gives you a prodigious number of frames to work with. At a basketball game I covered earlier this year, I took more than 1,000 images in a couple hours. Yet, even shooting JPEG Fine, I could fit more than 560 images on a single 4GB memory card. Given an average burst of about three frames per sequence (nobody really takes 15-20 shots or more at one stretch in a basketball game), I was able to capture almost 100 different sequences before I needed to swap cards. Figure 5.7 shows the kind of results you can expect.

To use the GF1's Burst mode, just switch the drive mode lever to continuous shooting. When you partially depress the shutter button, the viewfinder will display at the right side a number representing the maximum number of shots you can take at the current quality settings with your current memory card. Burst mode can't be used when using the built-in flash.

To get the maximum number of shots, reduce the image-quality setting by switching to JPEG only (from RAW+Basic). The reason the size of your bursts is limited is that continuous images are first shuttled into the camera's internal memory buffer, then doled out to the memory card as quickly as they can be written to the card. Technically, the

Figure 5.7 Burst mode allows you to capture an entire sequence of exciting moments as they unfold.

GF1 takes the RAW data received from the digital image processor and converts it to the output format you've selected—either .JPG or RAW—and deposits it in the buffer ready to store on the card.

This internal "smart" buffer can suck up photos much more quickly than the memory card and, indeed, some memory cards are significantly faster or slower than others. When the buffer fills, you can't take any more continuous shots until the GF1 has written some of them to the card, making more room in the buffer. (You should keep in mind that faster memory cards write images more quickly, freeing up buffer space faster.) In my experience, the GF1's buffer can keep up with the camera's fastest Burst mode for quite a while (40 shots or more when I tried it) even at highest resolution JPEG. It can probably keep going until your memory card is full.

A Tiny Slice of Time

Exposures that seem impossibly brief can reveal a world we didn't know existed. In the 1930s, Dr. Harold Edgerton, a professor of electrical engineering at MIT, pioneered high-speed photography using a repeating electronic flash unit he patented called the *stroboscope*. As the inventor of the electronic flash, he popularized its use to freeze objects in motion, and you've probably seen his photographs of bullets piercing balloons and drops of milk forming a coronet-shaped splash.

Electronic flash freezes action by virtue of its extremely short duration—as brief as 1/50,000th second or less. Although the GF1's built-in flash unit can give you these ultra-quick glimpses of moving subjects, an external flash, such as one of the Panasonic flash units, offers even more versatility. You can read more about using electronic flash to stop action in Chapter 7.

Of course, the GF1 is fully capable of immobilizing all but the fastest movement using only its shutter speeds, which range all the way up to a respectably quick 1/4,000th second. Indeed, you'll rarely have need for such a brief shutter speed in ordinary shooting. If you wanted to use an aperture of f/1.8 at ISO 200 outdoors in bright sunlight, for some reason, a shutter speed of 1/4,000th second would more than do the job. You'd need a faster shutter speed only if you moved the ISO setting to a higher sensitivity, say, to compensate for a polarizing filter you attached to your lens. Under less than full sunlight, 1/4,000th second is more than fast enough for any conditions you're likely to encounter.

Most sports action can be frozen at 1/2,000th second or slower, and for many sports a slower shutter speed is actually preferable—for example, to allow the wheels of a racing automobile or motorcycle, or the propeller on a classic aircraft to blur realistically. If you want to do some exotic action-freezing photography, you can use the Panasonic Lumix DMC-GF1's faster shutter speeds, or resort to an electronic flash (internal or

external), which as you'll also learn in Chapter 7, provides the effect of a high shutter speed because of its short duration.

Of course, you'll need a lot of light. High shutter speeds cut very fine slices of time and sharply reduce the amount of illumination that reaches your sensor. To use 1/4,000th second at an aperture of f/6.3, you'd need an ISO setting of 800—even in full daylight. To use an f/stop smaller than f/6.3 or an ISO setting lower than 1,600, you'd need more light than full daylight provides. (That's why electronic flash units work so well for high-speed photography when used as the sole illumination; they provide both the effect of a brief shutter speed and the high levels of illumination needed.)

High shutter speeds with electronic flash come with a penalty: you have to use a shutter speed slower than 1/160th second. Perhaps you want to stop some action in daylight with a brief shutter speed and use electronic flash only as supplemental illumination to fill in the shadows. Unfortunately, under most conditions you can't use flash with your GF1 at any shutter speed faster than 1/160th second. That's the fastest speed at which the camera's focal plane shutter is fully open: at shorter speeds, the "slit" (described in more detail in Chapter 7) comes into play, so that the flash will expose only the small portion of the sensor exposed by the slit during its duration.

Working with Short Exposures

You can have a lot of fun exploring the kinds of pictures you can take using very brief exposure times, whether you decide to take advantage of the action-stopping capabilities of your built-in or external electronic flash or work with the Panasonic Lumix DMC-GF1's faster shutter speeds. Here are a few ideas to get you started:

- **Take revealing images.** Fast shutter speeds can help you reveal the real subject behind the façade, by freezing constant motion to capture an enlightening moment in time. Legendary fashion/portrait photographer Philippe Halsman used leaping photos of famous people, such as the Duke and Duchess of Windsor, Richard Nixon, and Salvador Dali to illuminate their real selves. Halsman said, "*When you ask a person to jump, his attention is mostly directed toward the act of jumping and the mask falls so that the real person appears.*" Try some high-speed portraits of people you know in motion to see how they appear when concentrating on something other than the portrait. Check out the shot of Lindsey Miller in Figure 5.8, which shows her cheerful and upbeat personality.

- **Create unreal images.** High-speed photography can also produce photographs that show your subjects in ways that are quite unreal. A helicopter in mid-air with its rotors frozen or a motocross cyclist leaping over a ramp, but with all motion stopped so that the rider and machine look as if they were frozen in mid-air, make for an unusual picture. When we're accustomed to seeing subjects in motion, seeing them stopped in time can verge on the surreal.

Figure 5.8
A fast shutter speed was used to capture this photo of jumping model Lindsey Miller.

- **Capture unseen perspectives.** Some things are *never* seen in real life, except when viewed in a stop-action photograph. M.I.T's Dr. Harold Edgerton captured a series of famed balloon burst images back in the 1930s that were only a starting point. Freeze a hummingbird in flight for a view of wings that never seem to stop.

- **Vanquish camera shake and gain new angles.** Here's an idea that's so obvious it isn't always explored to its fullest extent. A high enough shutter speed can free you from the tyranny of a tripod, making it easier to capture new angles, or to shoot quickly while moving around, especially with longer lenses. I tend to use a mono-pod or tripod for almost everything when I'm not using an image-stabilized lens, and I end up missing some shots because of a reluctance to adjust my camera sup-port to get a higher, lower, or different angle. If you have enough light and can use an f/stop wide enough to permit a high shutter speed, you'll find a new freedom to choose your shots. I have a favored 170mm-500mm lens that I use for sports and wildlife photography, almost invariably with a tripod, as I don't find the "recipro-cal of the focal length" rule particularly helpful in most cases. I would *not* handhold this hefty lens at its 500mm setting with a 1/500th second shutter speed under most circumstances. Nor, if you want to account for the crop factor, would I use 1/750th second. However, at 1/2,000th second or faster, it's entirely possible for a steady hand to use this lens without a tripod or monopod's extra support, and I've found that my whole approach to shooting animals and other elusive subjects changes in High-Speed mode. Selective focus allows dramatically isolating my prey wide open at f/6.3, too.

Long Exposures

Longer exposures are a doorway into another world, showing us how even familiar scenes can look much different when photographed over periods measured in seconds. At night, long exposures produce streaks of light from moving, illuminated subjects like automobiles or amusement park rides. Extra-long exposures of seemingly pitch-dark subjects can reveal interesting views using light levels barely bright enough to see by. At any time of day, including daytime (in which case you'll often need the help of neutral-density filters to make the long exposure practical), long exposures can cause moving objects to vanish entirely, because they don't remain stationary long enough to register in a photograph.

Three Ways to Take Long Exposures

There are actually three common types of lengthy exposures: *timed exposures, bulb expo-sures,* and *time exposures.* The Panasonic Lumix DMC-GF1 offers only the first two. Because of the length of the exposure, all shots with very slow shutter speeds should be taken with a tripod to hold the camera steady.

■ **Timed exposures.** These are long exposures from 1 second to 60 seconds, measured by the camera itself. To take a picture in this range, simply use Manual or S modes and use the rear dial to set the shutter speed to the length of time you want, choosing from preset speeds of 1.0, 1.3, 1.6, 2.0, 2.5, 3.2, 4.0, 5.0, 6.0, 8.0, 10.0, 13.0, 15.0, 20.0, 25.0, 30.0, and 60.0 seconds (because the GF1 uses 1/3 stop increments). The advantage of timed exposures is that the camera does all the calculating for you. There's no need for a stopwatch. If you review your image on the LCD and decide to try again with the exposure doubled or halved, you can dial in the correct exposure with precision. The disadvantage of timed exposures is that you can't take a photo for longer than 60 seconds.

■ **Bulb exposures.** This type of exposure is so-called because in the olden days the photographer squeezed and held an air bulb attached to a tube that provided the force necessary to keep the shutter open. Traditionally, a bulb exposure is one that lasts as long as the shutter release button is pressed; when you release the button, the exposure ends. To make a bulb exposure with the GF1, set the camera on Manual mode, set the f/stop, and then use the rear dial to select the shutter speed immediately after 60 seconds—Bulb. Then, press the shutter to start the exposure, and release it again to close the shutter. (You can only use "B" when shooting in Manual exposure mode with the GF1 and only when in Single drive mode.)

■ **Time exposures.** This is a setting found on some cameras to produce longer exposures. With cameras that implement this option, the shutter opens when you press the shutter release button, and remains open until you press the button again. With the Panasonic Lumix DMC-GF1, you can't get this exact effect; the best you can do is use a Bulb exposure.

Working with Long Exposures

Because the GF1 produces such good images at longer exposures, and there are so many creative things you can do with long-exposure techniques, you'll want to do some experimenting. Get yourself a tripod or another firm support and take some test shots with long exposure noise reduction both enabled and disabled (to see whether you prefer low noise or high detail) and get started. Here are some things to try:

■ **Make people invisible.** One very cool thing about long exposures is that objects that move rapidly enough won't register at all in a photograph, whereas the subjects that remain stationary are portrayed in the normal way. That makes it easy to produce people-free landscape photos and architectural photos at night or, even, in full daylight if you use a plain gray neutral-density filter (or two or three) to allow an exposure of at least a few seconds. At ISO 100, f/22, and a pair of ND8 neutral-density filters (which each remove three stops' worth of light—giving you, in effect, the equivalent of ISO 1.5!), you can use exposures of nearly two seconds; overcast days and/or even more neutral-density filtration would work even better if daylight

people-vanishing is your goal. They'll have to be walking *very* briskly and across the field of view (rather than directly toward the camera) for this to work. At night, it's much easier to achieve this effect with the 20- to 30-second exposures that are possible, as you can see in Figures 5.9 and 5.10.

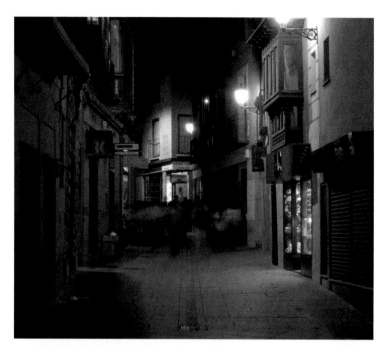

Figure 5.9
This alleyway is thronged with people, as you can see in this two-second exposure using only the available illumination.

Figure 5.10
With the camera still on a tripod, a 30-second exposure rendered the passersby almost invisible.

- **Create streaks.** If you aren't shooting for total invisibility, long exposures with the camera on a tripod can produce some interesting streaky effects. Even a single ND8 filter will let you shoot at f/22 and 1/6th second in daylight. Figure 5.11 shows one kind of effect you can get indoors, without the need for a special filter.

- **Produce light trails.** At night, car headlights and taillights and other moving sources of illumination can generate interesting light trails. If the lights aren't moving, you can make them move by zooming or jiggling the camera during a long exposure. Your camera doesn't even need to be mounted on a tripod; handholding

Figure 5.11 A modest shutter speed (1/60th) plus image stabilization allowed the photographer to keep one butterfly sharp and throw the other into a blur of movement in this image.

the GF1 for longer exposures adds movement and patterns to your trails. If you're shooting fireworks, a longer exposure may allow you to combine several streaks into one picture (see Figure 5.12).

- **Blur waterfalls, etc.** You'll find that waterfalls and other sources of moving liquid produce a special type of long-exposure blur, because the water merges into a fantasy-like veil that looks different at different exposure times, and with different waterfalls. Cascades with turbulent flow produce a rougher look at a given longer exposure than falls that flow smoothly. Although blurred waterfalls have become almost a cliché, there are still plenty of variations for a creative photographer to explore (see Figure 5.13).

- **Show total darkness in new ways.** Even on the darkest, moonless nights, there is enough starlight or glow from distant illumination sources to see by, and, if you use a long exposure, there is enough light to take a picture, too.

Figure 5.12 A long exposure allows capturing streaks of light.

Figure 5.13 A 15-second exposure of the American Falls from the Canadian side of Niagara Falls produced this image. The falls were being illuminated by colored lights at the time.

Movie Making with the GF1

Once upon a time, the ability to shoot video with a digital still camera was one of those "Gee whiz" gimmicks camera makers seemed to include just to have a reason to get you to buy a new camera. That hasn't been true for a couple of years now, as the video quality of many digital still cameras has gotten quite good. The Panasonic Lumix DMC-GF1 is a stellar example. It's capable of HD quality video and is actually capable of outperforming typical modestly priced digital video camcorders, especially when you consider the range of lenses and other helpful accessories available for it.

The GF1 offers two different video formats with three different quality settings for each one. Your primary decision is whether you want to go for the highest quality video (perhaps for use on an HDTV) at the cost of greater memory usage versus lower quality

video (appropriate for web and PC use) with greater recording time available with the same memory card. To complicate matters, the two formats offer different strengths and weaknesses based on your plans for viewing and showing the video.

In general, AVCHD Lite is a better choice if you plan on showing your video on an HDTV directly from the camera. Unless you're working with a pretty up to date computer with a fair amount of processing power, AVCHD Lite may not be the way to go if you plan on editing it on your computer. In this case, Motion JPEG is probably a better choice. One problem with using Motion JPEG though is that you're limited to 2GB of recording time before the camera stops recording video.

AVCHD Lite

Use this option if you want high quality video for display on your HDTV set. Keep in mind though, that to get that highest quality video, you're going to need to have an HDMI cable to transfer your video from the GF1 to the HDTV. HDMI cables are not included with your camera, so you'll have to plan on making an additional purchase to benefit from this option. You could still capture the video to your computer and write it to a DVD, which could then be shown on your HDTV if you wanted. Panasonic does provide a video-editing program for PCs on the CD that accompanies the camera. Mac users will have to rely on a later version of iMovie (8.6 or later) or use some other video-editing suite that can recognize the Panasonic format.

Motion JPEG

While this option produces lower quality video, it does use up space on your memory card at a much slower rate. Motion JPEG is fine for YouTube and other web videos and is a better choice if you're working with an older or budget computer and want to edit your video.

Quality Settings

While AVCHD Lite and Motion JPEG deal with resolution issues, the next settings deal with how heavily compressed those files become while being written to the memory card. Lower quality settings use less memory space, but can result in visible artifacts or pixilation in your video (particularly when movement is involved).

Set the recording quality via the Motion Picture menu screen (it's the second choice on the first screen) or by using the Q.MENU while the camera is set to the Motion Picture mode. You have several quality options with the GF1 depending on whether you're shooting AVCHD Lite or Motion JPEG.

For AVCHD Lite, your options are as follows:

- **SH.** This is the best video quality setting the GF1 offers for AVCHD Lite. SH video is recorded at 1280×720 pixels resolution at a rate of 17 Mbps (Megabits per second) and 25 fps (frames per second) and an aspect ratio of 16:9.

- **H.** Still 1280×720, 25 fps, and 16:9 aspect ratio, but the video is recorded at a greater compression rate resulting in data being recorded at a rate of 13 Mbps.

- **L.** Still 1280×720, 25 fps, and 16:9 aspect ratio, but the video is recorded at a greater compression rate resulting in data being recorded at a rate of 9 Mbps.

For Motion JPEG your options are as follows:

- **HD.** HD video is recorded at 1280×720 pixels resolution at a rate of 30 fps (frames per second) and an aspect ratio of 16:9. You will need an HDMI cable to play this video on your HDTV directly from the camera.

- **WVGA.** Resolution drops to 848×480 pixels, 30 fps, and 16:9.

- **VGA.** Resolution drops to 640×480 pixels, 30 fps, and a 4:3 aspect ratio.

- **QVGA.** Resolution drops to 320×240 pixels, 30 fps, and a 4:3 aspect ratio.

Panasonic recommends using an SD card with a rating of Class 6 or higher when recording motion pictures. The company says you should also make a habit of formatting your memory cards in the camera and not your computer. Cards that have been formatted in the computer or filled and erased many times may cause the camera to randomly stop recording when shooting video.

Still, producing good quality video is more complicated than just buying good equipment. There are techniques that make for gripping storytelling and a visual language the average person is very used to, but also pretty unaware of. While this book can't make you a professional videographer in half a chapter, there is some advice I can give you that will help you improve your results with the camera.

Keep Things Stable and on the Level

Camera shake's enough of a problem with still photography, but it becomes even more of a nuisance when you're shooting video. While the GF1's image-stabilization feature can help minimize this, it can't work miracles. Placing your camera on a tripod will work much better than trying to handhold it while shooting. One bit of really good news is that compared to pro dSLRs like my Canon EOS 1D Mark IIn (which weighs a ton), the GF1 can work very effectively on a lighter tripod. Using a double bubble level in the hot shoe mount can help you produce a nicely leveled video.

Shooting Video with the GF1

It's easy to operate the GF1 as a video camera. Just set the mode dial to Movie mode (it's the icon that looks like a movie projector with a P next to it) or press the little red button to the right of the shutter button (provided you've activated it via the instructions in Chapter 3). (See Figure 5.14.) Menu 2 (the Motion Picture menu screen) gives you a range of settings you can manipulate to get the video quality you need. You have some choices you can make here (covered in Chapter 3 in detail). The most important include

■ **Record mode.** Choose AVCHD Lite for HD video for your television (higher quality) or MOTION JPEG for use on the Web or your PC (smaller file sizes).

■ **Record quality.** The GF1 gives you three quality options: SH, H, and L. SH is the highest quality setting and records 17 Mbps (Megabits of information per second). H records 13 Mbps, and L records 9 Mbps. All three settings work at 1280 × 720 pixels so the difference is all about resolution rather than sizing. Keep in mind, the higher the quality setting, the less video you'll be able to fit on a memory card.

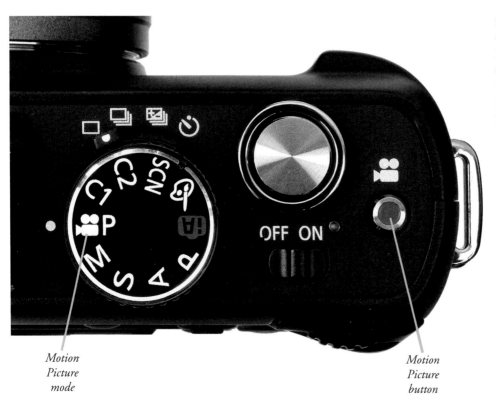

Figure 5.14
Choose Motion Picture Mode, and begin recording by pressing the Motion Picture button.

Motion Picture mode

Motion Picture button

■ **Continuous AF.** Do you want the camera to focus continuously while recording video? This can be a smart choice when you're following a moving subject or moving the camera in an effort to pan around a scene, but isn't as helpful for a static shot where refocusing may be more annoying than useful.

■ **Wind cut.** Wind noise is an annoying problem with video recording and the GF1's wind cut feature is a nice capability that can improve sound quality. You have four options with this control: Off, Low, Standard, or High. Keep in mind that audio quality will be changed by employing the Wind Cut feature and could make for a noticeable difference between audio recorded outside and audio recorded inside.

Tips for Shooting Better Video

Producing high quality videos can be a real challenge for amateur photographers. After all, by comparison we're used to watching the best productions that television, video, and motion pictures can offer. Whether it's fair or not, our efforts are compared to what we're used to seeing produced by experts. While this chapter can't make you into a pro videographer, it can help you improve your efforts.

There are a number of different things to consider when planning a video shoot, and when possible, a shooting script and storyboard can help you produce a higher quality video.

Shooting Script

A shooting script is nothing more than a coordinated plan that covers both audio and video and provides order and structure for your video. A detailed script will cover what types of shots you're going after, what dialogue you're going to use, audio effects, transitions, and graphics.

Storyboards

A storyboard is a series of panels providing visuals of what each scene should look like. While the ones produced by Hollywood are generally of very high quality, there's nothing that says drawing skills are important for this step. Stick figures work just fine if that's the best you can do. The storyboard just helps you visualize locations, placement of actors/actresses, props and furniture, and also helps everyone involved get an idea of what you're trying to show. It also helps show how you want to frame or compose a shot. You can even shoot a series of still photos and transform them into a "storyboard" if you want such as in Figure 5.15.

Storytelling in Video

Today's audience is used to fast-paced, short scene storytelling. In order to produce interesting video for such viewers, it's important to view video storytelling as a kind of shorthand code for the more leisurely efforts print media offers. Audio and video should

Figure 5.15 A storyboard is a series of simple sketches to help visualize a segment of video.

always be advancing the story. While it's okay to let the camera linger from time to time, it should only be for a compelling reason and only briefly.

It only takes a second or two for an establishing shot to impart the necessary information. For example, many of the scenes for a video documenting a model being photographed in a Rock and Roll music setting might be close-ups and talking heads, but an establishing shot showing the studio where the video was captured helps set the scene. (See Figure 5.16.)

Figure 5.16 An establishing shot from a distance sets the stage for closer views.

Provide variety too. Change camera angles and perspectives often and never leave a static scene on the screen for a long period of time. (You can record a static scene for a reasonably long period and then edit in other shots that cut away and back to the longer scene with close-ups that show each person talking.)

When editing, keep transitions basic! I can't stress this one enough. Watch a television program or movie. The action "jumps" from one scene or person to the next. Fancy transitions that involve exotic "wipes," dissolves, or cross fades take too long for the average viewer and make your video ponderous.

Composition

In movie shooting, several factors restrict your composition, and impose requirements you just don't always have in still photography (although other rules of good composition do apply). Here are some of the key differences to keep in mind when composing movie frames:

- **Horizontal compositions only.** Some subjects, such as basketball players and tall buildings, just lend themselves to vertical compositions. But movies are shown in horizontal format only. So if you're interviewing a local basketball star, you can end up with a worst-case situation like the one shown in Figure 5.17. Using the GF1's 1280×720 movie format, if you want to show how tall your subject is, it's often

Figure 5.17
Movie shooting requires you to fit all your subjects into a horizontally oriented frame.

impractical to move back far enough to show him full-length. You really can't capture a vertical composition. Tricks like getting down on the floor and shooting up at your subject can exaggerate the perspective, but aren't a perfect solution.

■ **Wasted space at the sides.** Moving in to frame the basketball player as outlined by the yellow box in the Figure 5.17, means that you're still forced to leave a lot of empty space on either side. (Of course, you can fill that space with other people and/or interesting stuff, but that defeats your intent of concentrating on your main subject.) So when faced with some types of subjects in a horizontal frame, you can be creative, or move in *really* tight. For example, if I was willing to give up the "height" aspect of my composition, I could have framed the shot as shown by the green box in the figure, and wasted less of the image area at either side. The least attractive option is to switch to a movie recording format that has less "wide-screen" perspective, specifically 640 × 480 pixels, in which case you lose the resolution advantage of the HD 1280 × 720-pixel aspect ratio.

■ **Seamless (or seamed) transitions.** Unless you're telling a picture story with a photo essay, still pictures often stand alone. But with movies, each of your compositions must relate to the shot that preceded it, and the one that follows. It can be jarring to jump from a long shot to a tight close-up unless the director—you—is very creative. Another common error is the "jump cut" in which successive shots vary only slightly in camera angle, making it appear that the main subject has "jumped" from one place to another. (Although everyone from French New Wave director Jean-Luc Goddard to Guy Ritchie—Madonna's ex—have used jump cuts effectively in their films.) The rule of thumb is to vary the camera angle by at least 30 degrees between shots to make it appear to be seamless. Unless you prefer that your images flaunt convention and appear to be "seamy."

■ **The time dimension.** Unlike still photography, with motion pictures there's a lot more emphasis on using a series of images to build on each other to tell a story. Static shots where the camera is mounted on a tripod and everything is shot from the same distance are a recipe for dull videos. Watch a television program sometime and notice how often camera shots change distances and directions. Viewers are used to this variety and have come to expect it. Professional video productions are often done with multiple cameras shooting from different angles and positions. But many professional productions are shot with just one camera and careful planning, and you can do just fine with your GF1.

Here's a look at the different types of commonly used compositional tools:

■ **Establishing shot.** Much like it sounds, this type of composition, as shown earlier in Figure 5.16, establishes the scene and tells the viewer where the action is taking place. Let's say you're shooting a video of your offspring's move to college;

the establishing shot could be a wide shot of the campus with a sign welcoming you to the school in the foreground. Another example would be for a child's birthday party; the establishing shot could be the front of the house decorated with birthday signs and streamers or a shot of the dining room table decked out with party favors and a candle-covered birthday cake. Or, in Figure 5.16, I wanted to show the studio where the video was shot.

- **Medium shot.** This shot is composed from about waist to head room (some space above the subject's head). It's useful for providing variety from a series of close-ups and also makes for a useful first look at a speaker. (See Figure 5.18.)

- **Close-up.** The close-up, usually described as "from shirt pocket to head room," provides a good composition for someone talking directly to the camera. Although it's common to have your talking head centered in the shot, that's not a requirement. In Figure 5.19 the subject was offset to the right. This would allow other images, especially graphics or titles, to be superimposed in the frame in a "real"(professional) production. But the compositional technique can be used with GF1 videos, too, even if special effects are not going to be added.

Figure 5.18 A medium shot is used to bring the viewer into a scene without shocking them. It can be used to introduce a character and provide context via their surroundings.

Figure 5.19 A close up generally shows the full face with a little head room at the top and down to the shoulders at the bottom of the frame.

- **Extreme close-up.** When I went through broadcast training back in the '70s, this shot was described as the "big talking face" shot and we were actively discouraged from employing it. Styles and tastes change over the years and now the big talking face is much more commonly used (maybe people are better looking these days?) and so this view may be appropriate. Just remember, the GF1 is capable of shooting in high-definition video and you may be playing the video on a high-def TV; be careful that you use this composition on a face that can stand up to high definition. (See Figure 5.20.)

- **"Two" shot.** A two shot shows a pair of subjects in one frame. They can be side by side or one in the foreground and one in the background. This does not have to be a head to ground composition. Subjects can be standing or seated. A "three shot" is the same principle except that three people are in the frame. (See Figure 5.21.)

- **Over the shoulder shot.** Long a composition of interview programs, the "Over the shoulder shot" uses the rear of one person's head and shoulder to serve as a frame for the other person. This puts the viewer's perspective as that of the person facing away from the camera. (See Figure 5.22.)

Figure 5.20 An extreme close-up is a very tight shot that cuts off everything above the top of the head and below the chin (or even closer!). Be careful using this shot since many of us look better from a distance!

Figure 5.21 A "two-shot" features two people in the frame. This version can be framed at various distances such as medium or close up.

Figure 5.22 An "over-the-shoulder" shot is a popular shot for interview programs. It helps make the viewers feel like they're the one asking the questions.

Lighting for Video

Much like in still photography, how you handle light pretty much can make or break your videography. Lighting for video though can be more complicated than lighting for still photography, since both subject and camera movement is often part of the process.

Lighting for video presents several concerns. First off, you want enough illumination to create a useable video. Beyond that, you want to use light to help tell your story or increase drama. Let's take a better look at both.

Illumination

You can significantly improve the quality of your video by increasing the light falling in the scene. This is true indoors or out, by the way. While it may seem like sunlight is more than enough, it depends on how much contrast you're dealing with. If your subject is in shadow (which can help them from squinting) or wearing a ball cap, a video light can help make them look a lot better.

Lighting choices for amateur videographers are a lot better these days than they were a decade or two ago. An inexpensive shoe mount video light, which will easily fit in a camera bag, can be found for $15 or $20. You can even get a good quality LCD video light for less than $100. Work lights sold at many home improvement stores can also serve as video lights since you can set the camera's white balance to correct for any colorcasts.

Much of the challenge depends upon whether you're just trying to add some fill light on your subject versus trying to boost the light on an entire scene. A small video light in the camera's hot shoe mount or on a flash bracket will do just fine for the former. It won't handle the latter. Fortunately, the versatility of the GF1 comes in quite handy here. Since the camera shoots video in Auto ISO mode, it can compensate for lower lighting levels and still produce a decent image. For best results though, better lighting is necessary.

Creative Lighting

While ramping up the light intensity will produce better technical quality in your video, it won't necessarily improve the artistic quality of it. Whether we're outdoors or indoors, we're used to seeing light come from above. Videographers need to consider how they position their lights to provide even illumination while up high enough to angle shadows down low and out of sight of the camera.

When considering lighting for video, there are several factors. One is the quality of the light. It can either be hard (direct) light or soft (diffused). Hard light is good for showing detail, but can also be very harsh and unforgiving. "Softening" the light, but diffusing it somehow, can reduce the intensity of the light but make for a kinder, gentler light as well.

While mixing light sources isn't always a good idea, one approach is to combine window light with supplemental lighting. Position your subject with the window to one side and bring in either a supplemental light or a reflector to the other side for reasonably even lighting.

Lighting Styles

Some lighting styles are more heavily used than others. Some forms are used for special effects, while others are designed to be invisible. At its most basic, lighting just illuminates the scene, but when used properly it can also create drama. Let's look at some types of lighting styles:

- **Three-point lighting.** This is a basic lighting setup for one person. A main light illuminates the strong side of a person's face, while a fill light lights up the other side. A third light is then positioned above and behind the subject to light the back of the head and shoulders. (See Figures 5.23 and 5.24.)

- **Flat lighting.** Use this type of lighting to provide illumination and nothing more. It calls for a variety of lights and diffusers set to raise the light level in a space enough for good video reproduction, but not to create a particular mood or emphasize a particular scene or individual. With flat lighting, you're trying to create even lighting levels throughout the video space and minimizing any shadows. Generally the lights are placed up high and angled downward (or possibly pointed straight up to bounce off of a white ceiling). (See Figure 5.25.)

Figure 5.23
With three-point lighting, two lights are placed in front and to the side of the subject (45-degree angles are ideal) and positioned about a foot higher than the subject's head. Another light is directed on the background in order to separate the subject and the background.

Figure 5.24
Three-point lighting provides a nice, even illumination for when lighting doesn't play a role in creating drama. It's generally "clean" lighting creating minimal shadows.

Figure 5.25

Flat lighting is another approach for creating even illumination. Here the lights can be bounced off a white ceiling and walls to fill in shadows as much as possible. It is a flexible lighting approach since the subject can change positions without needing a change in light direction.

- **"Ghoul lighting."** This is the style of lighting used for old horror movies. The idea is to position the light down low, pointed upwards. It's such an unnatural style of lighting that it makes its targets seem weird and unnatural.

- **Outdoor lighting.** While shooting outdoors may seem easier because the sun provides more light, it also presents its own problems. As a general rule of thumb, keep the sun behind you when you're shooting video outdoors, except when shooting faces (anything from a medium shot and closer) since the viewer won't want to see a squinting subject. When shooting another human this way, put the sun behind them and use a video light to balance light levels between the foreground and background. If the sun is simply too bright, position the subject in the shade and use the video light for your main illumination. Using reflectors (white board panels or aluminum foil covered cardboard panels are cheap options) can also help balance light effectively.

■ **On-camera lighting.** While not "technically" a lighting style, this method is commonly used. A hot shoe mounted light provides direct lighting in the same direction the lens is pointing. It's commonly used at weddings, events, and in photojournalism since it's easy and portable. LED video lights are all the rage these days and a wide variety of these lights are available at various price points. At the low end, these lights tend to be small and produce minimal light (but useful for fill work). More expensive versions offer greater light output and come with built-in barn doors (panels that help you control and shape the light) and diffusers and filters. (See Figure 5.26.)

Figure 5.26
A spotlight like effect can be created by using a "snoot"—a conical light modifier that creates a circular lighting pattern. This can be very effective in creating a film noir kind of look to your video.

Audio

When it comes to making a successful video, audio quality is one of those things that separates the professionals from the amateurs. We're used to watching top-quality productions on television and in the movies, yet the average person has no idea of how much effort goes in to producing what seems to be "natural" sound. Much of the sound you hear in such productions is actually recorded on carefully controlled sound stages and "sweetened" with a variety of sound effects and other recordings of "natural" sound.

Tips for Better Audio

Since recording high quality audio is such a challenge, it's a good idea to do everything possible to maximize recording quality. Here are some ideas for improving the quality of the audio your GF1 records

- **Get the camera and microphone close to the speaker.** The farther the microphone is from the audio source, the less effective it will be in picking up that sound. While having to position the camera and microphone closer to the subject affects your lens choices and lens perspective options, it will make the most of your audio source. Of course, if you're lucky enough to have the Panasonic 7-14mm zoom or the new 8mm Fisheye lens, getting too close to your subject can have unflattering results, so don't take this advice too far.

- **Turn off any sound makers you can.** Little things like fans and air handling units aren't obvious to the human ear, but will be picked up by the microphone. Turn off any machinery or devices that you can plus make sure cell phones are set to silent mode. Also, do what you can to minimize sounds such as wind, radio, television, or people talking in the background.

- **Make sure to record some "natural" sound.** If you're shooting video at an event of some kind, make sure you get some background sound that you can add to your audio as desired in postproduction.

- **Consider recording audio separately.** Lip-syncing is probably beyond most of the people you're going to be shooting, but there's nothing that says you can't record narration separately and add it later. It's relatively easy if you learn how to use simple software video-editing programs like iMovie (for the Macintosh) or Windows Movie Maker (for Windows PCs). Any time the speaker is off-camera, you can work with separately recorded narration rather than recording the speaker on-camera. This can produce much cleaner sound.

- **Wind Cut.** If you're shooting outdoors the GF1's Wind Cut feature can be used to help reduce noise from air movement. It's a good idea to employ this any time you're shooting outside since the noise from even a mild breeze can be picked up by the camera's microphone.

6

Working with Lenses

The ability to change lenses is what makes the Panasonic Lumix GF1 special among the various point-and-shoot, compact, and superzoom competitors. If the lens currently mounted on your GF1 doesn't have the features you need, you can remove it and replace it with a lens that does what you want—quickly, and often at a reasonable price. Indeed, we have an entire new class of cameras that didn't exist only a few years ago, known by the acronym EVIL (Electronic Viewfinder—Interchangeable Lens).

The simplest point-and-shoot cameras may be smaller than the GF1 and others in its class, but they usually have a very limited zoom range, perhaps with a 4:1 or 4X magnification ratio. More fully featured compact cameras aren't much better in the lens department, with optics that are often equivalent to a 35-175mm or 28-140mm lens on a full-frame camera. (I'll explain about *equivalents* later in the next section.) So-called superzoom cameras have lenses with prodigious zoom ranges, offering the equivalent of 12X-15X (or more magnification), giving you the equivalent of, say 28mm wide angle to 420mm super telephoto (or what would be a 14mm to 210mm lens on a Four Thirds camera) in one lens. But superzoom cameras can approach the size of the smaller digital SLR cameras, making them a bit less portable than a camera like the DMC-GF1, and you still can't remove the lens and substitute one that provides a wider angle of view, more magnification, a larger f/stop with more light-gathering capabilities, or closer focus.

Your DMC-GF1 is compact, and is probably fitted with a lens that provides most of what you need under a variety of circumstances, such as the 14-45mm or 20mm f/1.7 kit lenses, which is the equivalent (there's that word again!) of a 28mm-84mm general purpose optic (on a *full-frame* camera, as described in the next section). But if you need a different lens, such as the awesome (and expensive, at $1,000-plus) 14-150mm f/3.5-5.6 Leica D Vario-Elmar ASPH. MEGA O.I.S. lens, you can remove the lens already mounted on your camera and replace it with another.

ALPHABET SOUP

While there is no consistent chart translating the various alphabet soup of abbreviations and terms used by the various lens and camera manufacturers, I'll explain many of them—including the cryptic Micro Four Thirds label itself—as we go along. In this case, the translation goes like this: Vario is a term used to mean "zoom" or variable focal length lens. ASPH represents aspherical, a non-spherical lens surface better equipped to correct aberrations; optical image stabilization is anti-shake built into the lens rather than camera body. Mega stands for "really humongous/cool." Elmar is a lens appellation derived from the initials of the big boss man at Ernst Leitz Optische Werke—Ernst Leitz II—who authorized Oskar Barnack to create the first successful 35mm camera in 1913.

And, as you'll see, there is a vast array of lenses available for your DMC-GF1, even though the camera's Micro Four Thirds mount is relatively new, and only a small number of lenses have been produced in that configuration. Through the use of adapters, you can use a variety of other lenses, including the growing roster of four thirds optics, as well as lenses offered by other camera manufacturers (such as Olympus), and lenses from third-party vendors who service the needs of owners of those other cameras.

I'll explain your lens options in detail in this chapter and show you how to select the best lenses for the kinds of photography you want to do. But first, a word from our sensor.

Sensor Sensibilities

From time to time, you've heard the term *crop factor*, and you've probably also heard the term *lens multiplier factor*. Both are misleading and inaccurate terms used to describe the same phenomenon: the fact that cameras like the GF1 (and most other affordable digital cameras) provide a field of view that's smaller and narrower than that produced by certain other cameras (called *full-frame* models), when fitted with exactly the same lens.

Figure 6.1 quite clearly shows the phenomenon at work. Let's assume, for the sake of illustration, that you happen to own a 28mm wide-angle lens intended for use on a Nikon full-frame dSLR, but want to mount it on your DMC-GF1 with an adapter. (Bear with me through all the Nikon references; I promise to leave them behind once the "crop factor" has been explained. Nikon happens to offer cameras with a range of sensor sizes that are well-suited for the comparison that follows.)

The outer rectangle, marked 1X, shows the field of view you might expect with that 28mm lens mounted on the Nikon D3s, a "full-frame" (non-cropped) camera. The area

Figure 6.1

Cameras with interchangeable lenses are offered in full-frame (1X) crops, as well as 1.5/1.6X crops, and the four thirds format's 2X crop.

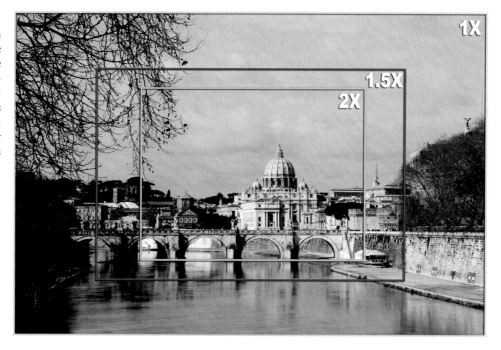

marked 1.5 shows the field of view you'd get with that same 28mm lens installed on one of Nikon's own "cropped-sensor" cameras, like the Nikon D300s. It's easy to see from the illustration that the 1X rendition provides a wider, more expansive view, while the 1.5X inner field of view is, in comparison, *cropped*. The field of view on the 1.5X sensor is the equivalent of that of a 42mm lens on the "full-frame" camera.

That same lens, mounted on your DMC-GF1 with an adapter, would have an even narrower field of view, the equivalent of a (decidedly *not* wide-angle) 56mm lens. That's because the GF1's crop factor is 2X.

The cropping effect is produced because the sensors of cameras like the Panasonic Lumix DMC-GF1 are smaller than the sensors of the full-frame models. The "full-frame" camera has a sensor that's the size of the standard 35mm film frame, 24mm × 36mm. Your GF1's sensor does *not* measure 24mm × 36mm; instead, it specs out at 13.0 × 17.3mm, roughly half the dimensions of a full-frame sensor. You can calculate the relative field of view by dividing the focal length of the lens by 0.5. Thus, a 100mm lens mounted on a GF1 has the same field of view as a 200mm lens on a full-frame camera.

We humans tend to perform multiplication operations in our heads more easily than division, and the crop factors of most other cameras are not so easily calculated as with a Four Thirds or Micro Four Thirds model (I'll explain the difference later in this chapter), so such field of view comparisons are traditionally figured using the reciprocal

of the crop factor—in this case, the reciprocal of 0.5 (2.0). We can multiply instead. (100 / .5=200; 100 × 2.0=200.) Of course, some lenses come furnished with a helpful sticker (as with the 70-300mm zoom pictured later in this chapter) that includes the equivalent focal lengths right on the barrel.

This translation is generally useful only if you're accustomed to using full-frame cameras (usually of the film variety) and want to know how a familiar lens will perform on a digital camera. I strongly prefer the term *crop factor* over *lens multiplier*, because nothing is being multiplied; a 100mm lens doesn't "become" a 200mm lens—the depth-of-field and lens aperture remain the same. (I'll explain more about these later in this chapter.) Only the field of view is cropped.

But the designation *crop factor* isn't much better, as it implies that the 24 × 36mm frame is "full" and anything else is "less." I get e-mails all the time from photographers who point out that they own full-frame cameras with 36mm × 48mm sensors (like the Mamiya 645ZD or Hasselblad H3D-39 medium format digitals). By their reckoning, the "half-size" sensors found in cameras like the Nikon D3s are "cropped."

If you're accustomed to using full-frame film cameras, you might find it helpful to use the crop factor "multiplier" to translate a lens's real focal length into the full-frame equivalent, even though, as I said, nothing is actually being multiplied. Throughout most of this book, I've been using actual focal lengths and not equivalents, except when referring to specific wide-angle or telephoto focal length ranges and their fields of view.

Crop or Not?

There's a lot of debate over the "advantages" and "disadvantages" of using a camera with a "cropped" sensor, versus one with a "full-frame" sensor. The arguments go like this:

- **More compact lenses.** Theoretically, lenses designed specifically for a cropped sensor should be smaller and more compact than those intended for full-frame cameras. Outside the Micro Four Thirds world, however, that's not always the case. Nikon and Canon lenses for 1.5X/1.6X cropped sensors (called *APS-C* format, after the defunct Advanced Photo System sub-35mm film format) are often only marginally smaller than their full-frame counterparts. The folks at Panasonic and their Micro Four Thirds compatriots at Olympus, however, have taken full advantage of the demands of the Micro Four Thirds and Four Thirds lens mount designs (which I'll explain later in this chapter) and have come up with an array of lenses that are, in fact, admirably compact and noticeably smaller in size. With the DMC-GF1, smaller lenses are a reality, not a theoretical possibility.

- **"Free" 2X teleconverter.** The Panasonic Lumix GF1 (and other Micro Four Thirds and Four Thirds cameras with the 2X crop factor) magically transforms any telephoto lens you have into a longer lens, which can be useful for sports, wildlife

photography, and other endeavors that benefit from more reach. Yet, your f/stop remains the same (that is, a 300mm f/4 becomes a very fast 600mm f/4 lens). Some discount this advantage, pointing out that the exact same field of view can be had by taking a full-frame image, and trimming it to the 2X equivalent. While that is strictly true, it doesn't take into account a factor called *pixel density.*

While both the Panasonic Lumix GF1 and several full-frame cameras have sensors with 12 megapixels of resolution, the GF1 packs all those pixels together much more tightly, into that 13.0×17.3mm area. So, your 300mm f/4 lens delivers the same field-of-view as a 600mm optic at the GF1's full 12MP resolution. When you crop the full-frame image to get the same field of view, you're using only four megapixels worth of resolution. So, while both images will be framed the same, the GF1 version, with its higher pixel density, will be sharper.

- **Dense pixels=more noise.** The other side of the pixel density coin is that the denser packing of pixels in the GF1 sensor means that each pixel must be smaller, and will have less light-gathering capabilities. Larger pixels capture light more efficiently, reducing the need to amplify the signal when boosting ISO sensitivity, and, therefore, producing less noise. In an absolute sense, this is true, and some full-frame cameras *do* have sensational high-ISO performance. However, the GF1's sensor performs very well at higher ISOs.

- **Lack of wide-angle perspective.** Of course, the 2X "crop" factor applies to wide-angle lenses, too, so a 20mm ultrawide lens becomes a hum-drum 40mm near-wide-angle, and a 28mm focal length is transformed into what photographers call a "normal" lens. To get a true wide-angle perspective, you need a lens like the Panasonic 7-14mm, which, as I write this, is the widest interchangeable-lens zoom in the world.

The Four Thirds/Micro Four Thirds Sensor and Lens Design

There is a lot of confusion over exactly what Four Thirds and Micro Four Thirds means, starting with "Four thirds of *what?*" and "What is the difference between Four Thirds and Micro Four Thirds?" The consortium that originally developed the standard (and which now includes Kodak, Leica, Panasonic, Olympus, Sanyo, Sigma, and Fuji) didn't help themselves by naming the format after the sizing system used to describe vacuum tube video camera imagers—which are now obsolete. So, the terminology you find applied to the system ranges from confusing to irrelevant. I'll demystify the system—for those who are interested—in this section. While the descriptions won't be overly technical, those of you who simply want to know what lenses they can use with their DMC-GF1 can skim through this section, and come back when your curiosity gets the better of you.

Where Four Thirds/Micro Four Thirds Came From

Most advanced digital cameras can trace their heritage at least partially back to the film cameras of the ancient past (that is, the 20th Century), starting with the sensor sizes, such as *full-frame* (24 × 36mm) and *APS* (typically around 24 × 16mm). Many of the lenses used with these cameras are based on the requirements of film technology, too. Recycling old lens designs was good from the standpoint that existing lenses could be fitted to new digital cameras with little or no modification. The bad news is that digital sensors have requirements that are very different from film.

For example, old design lenses tend to direct light onto the sensor from obtuse angles that make it difficult for the sensor to latch onto incoming photons. Such lenses often exhibit darkening in the corners and may cause contrast-robbing flare when light bounces off the sensor, strikes the rear components of the lens, and reflects back to the sensor to, essentially, "fog" the digital image. These effects either didn't exist or were much less of a problem with film cameras. New digital lens designs have partially accommodated the needs of digital cameras, but vendors have developed their own "solutions," with no two exactly alike.

The Four Thirds system was developed from scratch as a design standard for digital single lens reflex cameras and their lenses. Because Four Thirds/Micro Four Thirds was developed especially for digital cameras, the standard incorporates many features that are ideal for the digital age, such as the ability to upgrade the capabilities of particular lenses (say, to accommodate a particular autofocus scheme) through the use of a firmware change (a reprogramming of some lens characteristics, such as how it focuses), funneled to the lens through its connection with the camera. Four Thirds/Micro Four Thirds designs are optimized for other things, such as the ideal approach angle of photons, which is different for digital sensors than it is for film, because film is flat and sensors have bucket-like photosites that have depth.

The Four Thirds specification can be used by any manufacturer willing to adhere to the standard and sign a non-disclosure agreement. The name refers *not* to the exact size of the sensor itself, nor to the proportions of the image. In fact, the specification locks down only the diagonal measurement of the sensor, at 22.5mm. That happens to be the diagonal of the image produced by a 4/3-inch diameter video tube, and that's where the name comes from.

The sensor itself does not measure 4/3-inch in any dimension, and it's only a coincidence that the proportions of a typical Four Thirds image happen to be 4:3. (Some Four Thirds cameras, in fact, use a "multi-aspect" sensor, which has a larger sensor area that can be cropped down to 4:3, 3:2, and 16:9 aspect ratios, each with a diagonal measurement of 22.5mm to conform to the standard.)

Micro Four Thirds is an offshoot of the original Four Thirds specification. The sensors themselves are identical, but the lens mounting systems are different and the depth of the Micro Four Thirds camera body from the back of the lens flange to the sensor plane is about half that of the original Four Thirds measurement. The Four Thirds flange-to-sensor distance is 38.67mm. Because Micro Four Thirds cameras don't have the mirror box and shutter mechanism found in dSLRs, this distance is only 20mm. (See Figure 6.2.)

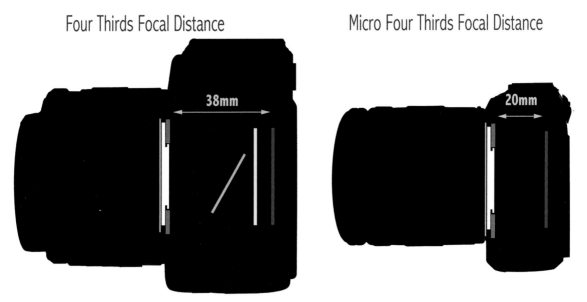

Four Thirds Focal Distance　　Micro Four Thirds Focal Distance

Figure 6.2 The flange-to-sensor distance of a Micro Four Thirds camera is 18mm less than the distance in a Four Thirds model, allowing room for adapters.

That means you can fit an adapter between a lens designed for a Four Thirds system and the GF1's body and still maintain the correct distance from the back of the lens to the sensor focal plane. In practice, Four Thirds lenses can be used on a Micro Four Thirds camera like the GF1 with an adapter, and maintain all functions. (Some Four Thirds lenses require a firmware upgrade to allow accurate contrast detect autofocus on the GF1; others must be used in manual focus mode.) Indeed, this extra working room means that there are adapters for many different types of lenses that allow them to be used with the DMC-GF1 (although sometimes with manual focus and limited auto-exposure options—or none—as I'll explain later).

The Micro Four Thirds flange diameter (the width of the lens bayonet mount) is 6mm less than that of the Four Thirds standard, and Micro Four Thirds lenses use an electrical connector with 11 contacts instead of nine. However, adapters to mount Four Thirds lenses on Micro Four Thirds cameras maintain full compatibility between the lenses.

Advantages of Micro Four Thirds

The Micro Four Thirds system offers some significant advantages, not all of which are limited to the ability to make smaller and lighter camera bodies and lenses. The key advantages are as follows:

- **Faster lenses.** An offshoot of the smaller lens designs is that these more compact lenses can be built with relatively larger maximum apertures. For example, Panasonic offers Lumix 20mm f/1.7 lens and superfast 25mm f/1.4 Four Thirds lenses that can be used on the GF1. If you care to cross over to the Olympus realm, that company has a moderately fast 17mm f/2.8 lens in Micro Four Thirds format. There are two zoom Four Thirds zoom lenses with an f/2 maximum aperture (14-35mm and 35-100mm f/2 zooms). Number of fully automatic f/2 zoom lenses available for other camera systems: zilch. (I'll describe other fast lenses later in this chapter.)

- **Telecentric optical path.** This is just a techie term for an optical path in which the photons striking the sensor are traveling virtually perpendicular to the sensor plane, rather than arriving at an angle (a phenomenon that is at its worst with systems that use lenses originally designed for film cameras). The result is less vignetting in the corners of the image, particularly with wide-angle lenses, and improved resolution off-center.

- **More lens options.** As I noted previously, the reduced flange-to-sensor distance of the Micro Four Thirds format allows more room for adapters that allow the use of many different types of lenses from other manufacturers. These lenses may require manual focus and aperture setting (and some don't actually have manually settable apertures), but your overall options are vast.

- **Quieter operation.** No mirror slap noise and vibration allows for stealthy shooting in the mode photojournalists favored with their Leica M-series rangefinder film cameras.

Your First Lens

I bought my GF1 with the 14-45mm lens. There may be others that better suit your needs, such as the Panasonic 20mm f/1.7 lens mentioned earlier, or the Olympus 17mm f/2.8 "pancake" lens, which is super compact, or even one of the other Micro Four Thirds or Four Thirds lenses that are available. Depending on which category of photographer you fall into, you'll need to make a decision about what lens to buy, or decide what other kind of lenses you need to fill out your complement of optics. This section will cover "first lens" concerns, while later in the chapter we'll look at "add-on lens" considerations.

When deciding on a first lens, there are several factors you'll want to consider.

- **Cost.** You might have stretched your budget a bit to purchase your Panasonic Lumix GF1, so the 14-45mm VR and 20mm f/1.7 kit lenses help you keep the cost of your first lens fairly low. In addition, there are excellent moderately priced lenses available that will add from $250 to $300 to the price of your camera if purchased at the same time.

- **Zoom range.** If you have only one lens, you'll want a fairly long zoom range to provide as much flexibility as possible. Fortunately, several popular basic lenses that are compatible with the GF1 have longer zoom ranges (up to 14-150mm; I'll list some of them next), extending from moderate wide-angle/normal out to medium telephoto. Either is fine for everyday shooting, portraits, and some types of sports.

- **Adequate maximum aperture.** You'll want an f/stop of at least f/3.5 to f/4 for shooting under fairly low light conditions. The thing to watch for is the maximum aperture when the lens is zoomed to its telephoto end. You may end up with no better than an f/5.6 maximum aperture. That's not great, but you can often live with it, particularly because many of the longer lenses available for the DMC-GF1's have built-in anti-shake capabilities in the form of MEGA O.I.S. (Optical Image Stabilization). With image stabilization, you can often shoot at lower shutter speeds to compensate for the limited maximum aperture. Or, you can increase the ISO sensitivity in low-light situations.

- **Image quality.** Your starter lens should have good image quality, because that's one of the primary factors that will be used to judge your photos. Several of the different lenses that can be used with the GF1 kit include aspherical elements (that's the ASPH. abbreviation you'll find in many of the Panasonic lens names) that minimize distortion and chromatic aberration; they are sharp enough for most applications. If you read the user evaluations in the online photography forums, you know that owners of these lenses have been very pleased with their image quality.

- **Size matters.** A good walking-around lens is compact in size and light in weight. That's why the 17mm pancake lens and 14-45mm kit lens make good choices.

- **Close focusing.** Your first lens should have close focusing (12 inches at a minimum, and, preferably much closer) to let you use your basic lens for some types of macro photography.

You can find comparisons of the lenses discussed in the next section, chiefly lenses from Panasonic and Olympus. Sigma has also adapted a group of its lenses for the Four Thirds and Micro Four Thirds formats, and you'd be smart to check them out as well using the online forums at websites such as www.dpreview.com.

Buy Now, Expand Later

When the Panasonic Lumix GF1 was introduced, it was available only in kit form with either the 14-45mm zoom for 20mm f/1.7 lens. However, there are many other lenses available. The following list describes only the Micro Four Thirds lenses; you can also mount regular Four Thirds lenses, but should check to see if they are compatible with all functions.

IMAGE STABILIZATION DIFFERENCE

One key difference between the DMC-GF1 and its counterpart Olympus PEN cameras is that the GF1 does not have in-camera-body image stabilization. Olympus does have that feature, so any lens you use on the Olympus cameras gains, in effect, free anti-shake properties. That means that Olympus lenses, unlike many Panasonic lenses, do not have in-lens optical image stabilization (that MEGA O.I.S. feature I mentioned earlier). So, purchases of Olympus lenses work best in the wide-angle focal lengths, where IS is less essential when using shutter speeds of 1/60th second or faster. If you're purchasing a tele-photo lens, however, you're better off with a Panasonic lens that *does* have MEGA O.I.S.

- **7-14mm f/4 Panasonic Lumix G Vario ASPH.** This $1,100 lens offers true ultra-wide coverage in a lightweight 11-ounce package. Producing a lens with such a short focal length with a fixed (non-variable) f/4 aperture requires two aspherical and four ED elements, accounting for its high cost. The built-in lens hood keeps flare to a minimum. Just be aware that at the widest 114-degree setting, you may get some darkening of the corners when using a flash unit, as they may not spread the light widely enough to cover the whole frame.

- **14-45mm f/3.5-5.6 Panasonic Lumix G Vario ASPH Mega O.I.S.** This $350 lens rivals the competing Olympus 14-42mm zoom in most of its specifications, but has an additional feature of MEGA O.I.S., which is optical image stabilization built into the lens (as opposed to the Super Sonic Wave Shift in-camera image sta-bilization found in the Olympus PEN series of Micro Four Thirds cameras). (See Figure 6.3.)

- **14-140mm f/4-5.6 Panasonic Lumix G Vario HD ASPH Mega O.I. S.** This hard-to-find $850 lens was used for the Niagara Falls and butterfly images that you'll find in this book. Among Micro Four Thirds lenses, its 10X zoom range is the longest. It's especially suitable for use in movie making, because the lens has a fast, accurate, and silent inner focus direct-drive linear motor for focusing. The focus mechanism of other lenses may be noisy enough to register in your clips' audio. (See Figure 6.4.)

Figure 6.3 The 14-45mm kit lens is fairly compact and has a useful zoom range.

Figure 6.4 The 14-140mm zoom has a longer zoom range, equivalent to 28-280mm on a full-frame camera.

- **20mm f/1.7 Panasonic Lumix G ASPH.** If you need an extra fast "normal" lens and can handle its $400 price tag, consider this lens. The pancake-style lens's main drawback is that the autofocus mechanism is a bit noisy, and continuous autofocus does not work when shooting still photographs. You might need to turn it off if you want to use this lens in photojournalism stealth mode.

- **45mm f/2.8 Leica DG Macro-Elmarit f/2.8 ASPH Mega O.I.S.** This lens, priced at close to $1,000, was the first Micro Four Thirds lens from Leica. It focuses as close as 0.5 feet in macro mode (and can be limited to a 1.64-foot closest focus distance if you want to use it for portraits and other non-close-up subjects). This sophisticated lens includes 14 different elements (both aspherical and ED) in 10 groups, further divided into three focusing groups. The result: you can expect tack-sharp images at all f/stops from an optical marvel with an internal focus system that allows life-size magnification to infinity focus without changing the length of the lens.

- **45-200mm f/4.-5.6 Panasonic Lumix G Vario Mega O.I.S.** This lens has the price and feel of a kit lens—reasonably tagged at about $300, but with non-metallic components that don't have the solid feel of more expensive lenses. (The lens mount is metal, however.) But, it's small and light (less than four inches long and about 13 ounces) for a lens that zooms to "super" telephoto range.

- **14-42mm f/3.5-6 Olympus M.Zuiko Digital ED.** Over in the Olympus world, you'll find lenses like this one. Not to be confused with the Olympus Four Thirds version of similar specifications (Olympus adds the "M." prefix to the name to differentiate Micro Four Thirds lenses), this 3X zoom kit lens is extremely compact. It has an overall length of just 1.7 inches when collapsed. It covers the moderate wide-angle to moderate telephoto range, making it suitable for both landscapes and portraits. Smaller lenses like this one can use more sophisticated optics while retaining a reasonable price. Like many Micro Four Thirds lenses, this one incorporates ED (extra-low dispersion) and HR (high refractive index) lens elements, which combine to remove chromatic aberration. (A tendency for different colors of light to focus at different points on the focal plane.) Most lens surfaces in this lens are multi-coated to reduce flare, particularly when shooting towards the sun. At about $270, it's a bargain.

- **17mm f/2.8 Olympus M.Zuiko Digital.** In size, this pancake lens, just .87 inches long, competes with the Panasonic 20mm f/1.7. It's not as fast, but is wider, producing a true wide-angle view with the Four Thirds format (the 20mm lens is closer to a "normal" lens in perspective). A small lens like this one doesn't need to be retracted to fit with the GF1 into a (large) pocket. It's not quite as wide as the 14-45mm zoom, but this similarly priced $280 optic focuses down to about 6 inches, making it a good choice for macro photography. The multi-coating reduces flare, which can be important when using this lens for landscape and other photography when the sun is in the frame or near its periphery. An optional auxiliary viewfinder ($100, see Figure 6.5) can be used for eye level viewing without use of the bulkier (and more expensive) electronic viewfinder.

 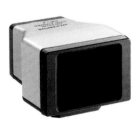

Figure 6.5
Olympus makes the widest "pancake" lens for Micro Four Thirds; it works fine on the GF1.

■ **9-18mm f/4-5.6 Olympus M.Zuiko Digital ED**. For an ultrawide-angle zoom, this new lens is not quite as wide as the 7-14mm Panasonic lens discussed later, but, at $700 it costs about $400 less, too. Part of the cost reduction comes from the variable—rather than fixed—maximum aperture. Zoom in to 18mm, and it becomes an f/5.6 lens. The variable aperture allowed Olympus to design a very compact lens, measuring just two inches in length and tipping the scales at just 5.5 ounces. If you want a small lens and most of your shooting is in the wide-angle focal length range, this one is a viable alternative to the 14-45mm zoom as a walk-about optic.

■ **14-150mm f/4-5.6 Olympus M.Zuiko Digital ED**. A direct competitor to the 14-140mm Panasonic zoom described earlier, this one costs about $250 less at $600. If you wanted to stick with Olympus optics, your closest alternative to this focal length range was the much larger and heavier 18-180mm f/3.5-6.3 Zuiko Four Thirds lens, plus an adapter. But remember that this one, as an Olympus lens, does not have optical image stabilization, unlike its (roughly) comparable 14-140mm Panasonic equivalent.

What Lenses Can You Use?

The previous section helped you sort out what basic lens you need to buy with your Panasonic Lumix GF1. Now, you're probably wondering what lenses can be added to your growing collection (trust me, it will grow). You need to know which lenses are suitable and at least reasonably compatible with your Panasonic Lumix GF1. Not all of the lenses you can buy are compact enough to fit the Micro Four Thirds philosophy (indeed, some are ridiculously large for such a tiny camera), and not all of them support all functions, including metering and autofocus, particularly if you are using an adapter to fit "foreign" lenses to your GF1. Usually, however, you can work with Aperture-priority mode with any lens that has an aperture ring that the user can adjust.

Google "Four Thirds adapters" and "Micro Four Thirds adapters" to find the latest crop of converters (their numbers are growing all the time) from Voightlander, Novoflex, and other vendors. You may have to convert a particular lens to Four Thirds first, and then use a Four Thirds to Micro Four Thirds adapter to complete the connection. Here's a quick summary that will help you decipher which lenses you can use:

■ **Micro Four Thirds.** Lenses from Olympus and Panasonic/Leica that are designated as Micro Four Thirds lenses (or by one of the nomenclature conventions, such as μ) will mount directly on your DMC-GF1, and will operate with all the functions built into them.

- **Four Thirds.** Lenses from Olympus, Panasonic/Leica, and third-party vendors (currently only Sigma) designated for Four Thirds use can be mounted on the DMC-GF1 with an adapter. Some older lenses may require a firmware update to operate with certain camera models. Olympus, for example, offers a firmware update needed to make its Micro Four Thirds lenses compatible with Panasonic cameras, starting with the Lumix DMC-G1. See Table 6.1 for a list of some current Four Thirds lenses already available.

FOCUS OR NOT?

In Chapter 5, I outlined the difference between phase detection and contrast detection in autofocus designs. The DMC-GF1 is designed to use contrast detection AF, in which the sharpness of edges in an image are evaluated and used to judge whether sharp focus has been achieved. Micro Four Thirds lenses all have autofocus motors with sufficient power to handle the demands of contrast-detect autofocus. Four Thirds lenses, on the other hand, may be optimized for the more sophisticated phase detection autofocus system used in Olympus dSLR cameras like the Olympus E-620, and may not have autofocus motors powerful enough to allow speedy contrast detect autofocus. If autofocus is important to you, you'll want to check reviews of any Four Thirds lens to see if they work well with the GF1.

- **Leica mount.** Because DMC-GF1 resembles Leica rangefinder cameras somewhat in size and application, adapting Leica lenses to the camera has been a primary focus (so to speak) of those looking for a compact camera kit with a body that's less expensive than a Leica but which uses the same optics. There are cheap Leica-to-Micro Four Thirds adapters for $60-$100 that look and feel cheap. Then, there are expensive adapters like the $200 version offered by Voightlander. You can use your L-, ZM-, and M-mount lenses from Leica, Zeiss, and other vendors on your GF1 with one of these adapters. However, since they are mechanical devices with no way to communicate electrically with the camera, you can't control or read the aperture from the GF1, even with newer lenses that have processor chips installed. Even so, the ability to mount your favorite 50mm f/2 Summicron may be worth a little inconvenience. If you have an old Leica screw mount lens, just use a Leica screw to M bayonet adapter first.
- **Nikon mount.** You can use most Nikon F-mount lenses except for those with G in their names, as these do not have aperture rings you can use to set the f/stop. Nor can you use lenses that protrude deeply into the camera, such as the 7.5mm f/5.6 Fisheye Nikkor.

■ **Other mounts.** Good news! Adapters are available for Canon FD/FL lens breech mounts and Canon FD bayonet mounts (but *not* Canonmatic R mount lenses). Adapters can also be found for Leica R, Contax/Yashica mounts, Olympus OM, and Pentax KA and K mounts. A Sony Alpha to Micro Four Thirds adapter is available from Novoflex. I've seen Micro Four Thirds adapter combinations to allow use of Mamiya 645, Pentax 67, and even Hasselblad lenses on your DMC-GF1, but I haven't used any of these, and the prices for the adapters can be as much as $370. You have to *really* want to use an oddball lens with your Panasonic Lumix to go this route. Keep in mind that for all these camera mounts, you generally need lenses that have their own aperture rings.

Available Four Thirds Lenses

As I noted, Micro Four Thirds lenses are your best choice when you want compact lenses produced especially for cameras like the Panasonic Lumix GF1, and which can be used without an adapter. However, true Micro Four Thirds lenses are less common than those originally designed for the Four Thirds format. Until a comparable Micro Four Thirds lens is introduced, you may find an existing Four Thirds lens irresistible. Indeed, now and in the future you'll see some overlap—lenses with focal lengths that seem almost identical in both Micro Four Thirds and Four Thirds varieties. The "secret" is that some of these lenses were originally designed for "full-sized" Four Thirds cameras, and adapted to the Micro Four Thirds mount. Such hybrids may not be much smaller at all. Some of the announced upcoming Micro Four Thirds optics are adaptations of this sort.

If you're willing to mount a larger lens on your DMC-GF1, the list of Four Thirds lenses is a long one, especially as Sigma adapts its lenses—already used on a variety of cameras from Nikon to Canon to Sony—by grafting Four Thirds mounts and electronics onto them. Table 6.1 offers a list of the most popular Four Thirds lenses available when this book was written; expect more to be offered in the future. (When multiple maximum apertures are listed, the effective f/stop of those lenses varies, depending on the focal length.)

What Lenses Can Do for You

As you can see from the previous list, no one can afford to buy even a small percentage of the lenses available. The sanest approach to expanding your lens collection is to consider what each of your options can do for you and then choose the type of lens and specific model that will really boost your creative opportunities.

Table 6.1 Four Thirds Lenses

	Focal Length	Aperture	Vendor
Wide Zoom	7-14mm	f/4	Olympus
	9-18mm	f/4-5.6	Olympus
	10-20mm	f/4-5.6	Sigma
	11-22mm	f/2.8-3.5	Olympus
Standard Zoom	12-60mm	f/2.8-4	Olympus
	14-35mm	f/2	Olympus
	14-45mm	f/3.5-5.6	Olympus
	14-50mm	f/2.8-3.5	Panasonic
	14-50mm	f/3.8-5.6	Panasonic
	14-54mm	f/2.8-3.5	Panasonic
	14-150mm	f/3.5-5.6	Panasonic
	18-50mm	f/2.8	Sigma
	18-180mm	f/3.5-6.3	Olympus
Telephoto Zoom	35-100mm	f/2	Olympus
	40-150mm	f/4-5.6	Olympus
	50-200mm	f/2.8-3.5	Olympus
	50-500mm	f/4-6.3	Sigma
	70-200mm	f/2.8	Sigma
	70-300mm	f/4-5.6	Olympus
	90-250mm	f/2.8	Olympus
Macro	35mm	f/3.5	Olympus
	50mm	f/2	Olympus
	105mm	f/2.8	Sigma
	150mm	f/2.8	Sigma
Prime Lenses	8mm fisheye	f/3.5	Olympus/Panasonic
	25mm	f/1.4	Panasonic
	25mm	f/2.8	Olympus
	30mm	f/1.4	Sigma
	50mm	f/1.4	Sigma
	150mm	f/2.8	Olympus
	300mm	f/2.8	Olympus

So, in the sections that follow, I'm going to provide a general guide to the sort of capabilities you can gain for your GF1 by adding a lens to your repertoire.

- **Wider perspective.** Your 14-45mm f/3.5-5.6 lens has served you well for moderate wide-angle shots. Now you find your back is up against a wall and you *can't* take a step backwards to take in more subject matter. Perhaps you're standing on the rim of the Grand Canyon, and you want to take in as much of the breathtaking view as you can. You might find yourself just behind the baseline at a high school basketball game and want an interesting shot with a little perspective distortion tossed in the mix.

- **Bring objects closer.** A long lens brings distant subjects closer to you, offers better control over depth-of-field, and avoids the perspective distortion that wide-angle lenses provide. The image shown in Figure 6.6 was taken using a 14mm zoom setting, while the images in Figure 6.7 and 6.8 were taken from the same position, but with zoom settings of 30mm and 45mm, respectively.

- **Bring your camera closer.** Macro lenses allow you to focus to within an inch or two of your subject. The best close-up lenses are all fixed focal length optics in the 35mm to 150mm range, if you include the available Four Thirds lenses. Longer, close-focusing lenses provide a bit of flexibility when you want to vary your subject distance (say, to avoid spooking a skittish creature).

- **Look sharp.** Many lenses are prized for their sharpness and overall image quality. While your run-of-the-mill lens is likely to be plenty sharp for most applications, the very best optics are even better over their entire field of view (which means no fuzzy corners), are sharper at a wider range of focal lengths (in the case of zooms), and have better correction for various types of distortion. Of course, these lenses cost a great deal more, especially Leica lenses available for your GF1.

- **More speed.** That 14-140mm f/4-5.8 telephoto zoom lens might have the perfect focal length and sharpness for sports photography, but the maximum aperture won't cut it for night baseball or football games, or, even, any sports shooting in daylight if the weather is cloudy or you need to use some ungodly fast shutter speed, such as 1/4,000th second. You might be happier to gain a few f/stops with the Olympus 35-100 f/2 Four Thirds lens, or its 90-250mm f/2.8 optic. Panasonic has a nice 25mm f/1.4, while Sigma offers 30mm and 50mm f/1.4 lenses in Four Thirds mounts.

- **Special features.** Accessory lenses can give you special features, such as fisheye perspectives.

Figure 6.6
A wide-angle setting provided this view of the Grand Canyon.

Figure 6.7
This photo, taken from the same distance shows the view using a short telephoto focal length setting.

Figure 6.8
A longer telephoto setting captured this close-up view of the formation, from the same shooting position.

Zoom or Prime?

Zoom lenses have changed the way serious photographers take pictures, and they have gotten better since the days when a fixed focal length or *prime* lens was the best choice when you wanted the ultimate in sharpness. When selecting between zoom and prime lenses, there are several considerations to ponder. Here's a checklist of the most important factors. I already mentioned image quality and maximum aperture earlier, but those aspects take on additional meaning when comparing zooms and primes.

- **Logistics.** Because prime lenses offer just a single focal length, you'll need more of them to encompass the full range offered by a single zoom. More lenses mean additional slots in your camera bag, and extra weight to carry. If you cross over to Olympus's Four Thirds line you can choose from five general-purpose prime lenses alone (listed previously), and Panasonic and Sigma offer even more. Even if your zoom lens does the job most of the time, you might be willing to carry an extra prime lens or two in order to gain the speed or image quality that lens offers.

- **Image quality.** Prime lenses usually produce better image quality at their focal length than even the most sophisticated zoom lenses at the same magnification. Zoom lenses, with their shifting elements and f/stops that can vary from zoom position to zoom position, are in general more complex to design than fixed focal length lenses. That's not to say that the very best prime lenses can't be complicated as well. However, the exotic designs, aspheric elements, and low-dispersion glass can be applied to improving the quality of the lens, rather than wasting a lot of it on compensating for problems caused by the zoom process itself.

- **Maximum aperture.** Because of the same design constraints, zoom lenses usually have smaller maximum apertures than prime lenses, and the most affordable zooms have a lens opening that grows effectively smaller as you zoom in. Prime lenses often have very large maximum apertures that allow optimum exposure under dimmer lighting conditions, without the need to boost ISO sensitivity. Figure 6.9 shows an image taken with a 50mm f/1.4 lens.

- **Speed.** Using prime lenses takes time and slows you down. It takes a few seconds to remove your current lens and mount a new one, and the more often you need to do that, the more time is wasted. If you choose not to swap lenses, when using a fixed focal length lens you'll still have to move closer or farther away from your subject to get the field of view you want. A zoom lens allows you to change magnifications and focal lengths with the twist of a ring and generally saves a great deal of time.

Figure 6.9
A 50mm f/1.4 lens was perfect for this hand-held photo at a concert.

Categories of Lenses

Lenses can be categorized by their intended purpose—general photography, macro photography, and so forth—or by their focal length. The range of available focal lengths is usually divided into three main groups: wide-angle, normal, and telephoto. Prime lenses fall neatly into one of these classifications. Zooms can overlap designations, with a significant number falling into the catch-all wide-to-telephoto zoom range. This section provides more information about focal length ranges, and how they are used.

In the Four Thirds/Micro Four Thirds realm, any lens with an equivalent focal length of 7mm to 14mm is said to be an *ultrawide-angle lens*; from about 14mm to 20mm is said to be a *wide-angle lens*. *Normal lenses* have a focal length roughly equivalent to the diagonal of the film or sensor, in millimeters, and so fall into the range of about 22.5mm (the diagonal measurement of the Four Thirds frame) to 30mm on a GF1. *Short telephoto lenses* start at about 30mm to 50mm, with anything from 50mm to 150mm qualifying as a conventional *telephoto*. For the Panasonic Lumix GF1, anything from about 150mm to 400mm or longer can be considered a *super-telephoto*.

Using Wide-Angle and Wide-Zoom Lenses

To use wide-angle prime lenses and wide zooms, you need to understand how they affect your photography. Here's a quick summary of the things you need to know.

- **More depth-of-field.** Practically speaking, wide-angle lenses offer more depth-of-field at a particular subject distance and aperture. (But, see the sidebar below for an important note.) You'll find that helpful when you want to maximize sharpness of a large zone, but not very useful when you'd rather isolate your subject using selective focus (telephoto lenses are better for that).

- **Stepping back.** Wide-angle lenses have the effect of making it seem that you are standing farther from your subject than you really are. They're helpful when you don't want to back up, or can't because there are impediments in your way.

- **Wider field of view.** While making your subject seem farther away, as implied above, a wide-angle lens also provides a larger field of view, including more of the subject in your photos.

- **More foreground.** As background objects retreat, more of the foreground is brought into view by a wide-angle lens. That gives you extra emphasis on the area that's closest to the camera. Photograph your home with a normal lens/normal zoom setting, and the front yard probably looks fairly conventional in your photo (that's why they're called "normal" lenses). Switch to a wider lens and you'll discover that your lawn now makes up much more of the photo. So, wide-angle lenses are great when you want to emphasize that lake in the foreground, but problematic when your intended subject is located farther in the distance.

- **Super-sized subjects.** The tendency of a wide-angle lens to emphasize objects in the foreground, while de-emphasizing objects in the background can lead to a kind of size distortion that may be more objectionable for some types of subjects than others. Shoot a bed of flowers up close with a wide angle, and you might like the distorted effect of the larger blossoms nearer the lens. Take a photo of a family member with the same lens from the same distance, and you're likely to get some complaints about that gigantic nose in the foreground.

- **Perspective distortion.** When you tilt the camera so the plane of the sensor is no longer perpendicular to the vertical plane of your subject, some parts of the subject are now closer to the sensor than they were before, while other parts are farther away. So, buildings, flagpoles, or NBA players appear to be falling backwards, as you can see in Figure 6.10. While this kind of apparent distortion (it's not caused by a defect in the lens) can happen with any lens, it's most apparent when a wide angle is used.

- **Steady cam.** You'll find that you can handhold a wide-angle lens at slower shutter speeds, without need for image stabilization, than you can with a telephoto lens. The reduced magnification of the wide-lens or wide-zoom setting doesn't emphasize camera shake like a telephoto lens does.

- **Interesting angles.** Many of the factors already listed combine to produce more interesting angles when shooting with wide-angle lenses. Raising or lowering a telephoto lens a few feet probably will have little effect on the appearance of the distant subjects you're shooting. The same change in elevation can produce a dramatic effect for the much-closer subjects typically captured with a wide-angle lens or wide-zoom setting.

DOF IN DEPTH

The DOF advantage of wide-angle lenses is diminished when you enlarge your picture; believe it or not, a wide-angle image enlarged and cropped to provide the same subject size as a telephoto shot would have the *same* depth-of-field. Try it: take a wide-angle photo of a friend from a fair distance, and then zoom in to duplicate the picture in a telephoto image. Then, enlarge the wide shot so your friend is the same size in both. The wide photo will have the same depth-of-field (and will have much less detail, too).

Figure 6.10
Tilting the
camera back
produces this
"falling back"
look in archi-
tectural photos.

Avoiding Potential Wide-Angle Problems

Wide-angle lenses have a few quirks that you'll want to keep in mind when shooting so you can avoid falling into some common traps. Here's a checklist of tips for avoiding common problems:

- **Symptom: converging lines.** Unless you want to use wildly diverging lines as a creative effect, it's a good idea to keep horizontal and vertical lines in landscapes, architecture, and other subjects carefully aligned with the sides, top, and bottom of the frame. That will help you avoid undesired perspective distortion. Sometimes it helps to shoot from a slightly elevated position so you don't have to tilt the camera up or down.

- **Symptom: color fringes around objects.** Lenses are often plagued with fringes of color around backlit objects, produced by *chromatic aberration*, which is produced when all the colors of light don't focus in the same plane or same lateral position (that is, the colors are offset to one side). This phenomenon is more common in wide-angle lenses and in photos of subjects with contrasty edges. Some kinds of chromatic aberration can be reduced by stopping down the lens, while all sorts can be reduced by using lenses with low diffraction index glass and by incorporating elements that cancel the chromatic aberration of other glass in the lens.

- **Symptom: lines that bow outward.** Some wide-angle lenses cause straight lines to bow outwards, with the strongest effect at the edges. In fisheye (or *curvilinear*) lenses, this defect is a feature. When distortion is not desired, you'll need to use a lens that has corrected barrel distortion. Manufacturers like Panasonic do their best to minimize or eliminate it (producing a *rectilinear* lens), often using *aspherical* lens elements (which are not cross-sections of a sphere). You can also minimize barrel distortion simply by framing your photo with some extra space all around, so the edges where the defect is most obvious can be cropped out of the picture. Some image editors, including Photoshop and Photoshop Elements, have a lens distortion correction feature.

- **Symptom: dark corners and shadows in flash photos.** While the Panasonic Lumix GF1 has a built-in flash, it can also use any of several external flash units, and they can produce darkening, or *vignetting*, in the corners of the frame when used with some ultrawide angle lenses.

Using Telephoto and Tele-Zoom Lenses

Telephoto lenses also can have a dramatic effect on your photography, and the Four Thirds/Micro Four Thirds lineups are especially strong in the long-lens arena, with lots of choices in many focal lengths and zoom ranges. You should be able to find an affordable telephoto or tele-zoom to enhance your photography in several different ways. Here are the most important things you need to know. In the next section, I'll concentrate on telephoto considerations that can be problematic—and how to avoid those problems.

- **Selective focus.** Long lenses have reduced depth-of-field within the frame, allowing you to use selective focus to isolate your subject. You can open the lens up wide to create shallow depth-of-field, or close it down a bit to allow more to be in focus. The flip side of the coin is that when you *want* to make a range of objects sharp, you'll need to use a smaller f/stop to get the depth-of-field you need. Like fire, the depth-of-field of a telephoto lens can be friend or foe. Figure 6.11 shows a photo of a water fowl shot with a 140mm zoom setting and an f/5.6 f/stop to de-emphasize the lake in the background.

- **Getting closer.** Telephoto lenses bring you closer to wildlife, sports action, and candid subjects. No one wants to get a reputation as a surreptitious or "sneaky" photographer (except for paparazzi), but when applied to candids in an open and honest way, a long lens can help you capture memorable moments while retaining enough distance to stay out of the way of events as they transpire.

- **Reduced foreground/increased compression.** Telephoto lenses have the opposite effect of wide angles: they reduce the importance of things in the foreground by squeezing everything together. This compression even makes distant objects appear to be closer to subjects in the foreground and middle ranges. You can use this effect as a creative tool to squeeze subjects together.

- **Accentuates camera shakiness.** Telephoto focal lengths hit you with a double-whammy in terms of camera/photographer shake. The lenses themselves are bulkier, more difficult to hold steady, and may even produce a barely perceptible see-saw rocking effect when you support them with one hand halfway down the lens barrel. Telephotos also magnify any camera shake. It's no wonder that image stabilization is popular in longer lenses.

- **Interesting angles require creativity.** Telephoto lenses require more imagination in selecting interesting angles, because the "angle" you do get on your subjects is so narrow. Moving from side to side or a bit higher or lower can make a dramatic difference in a wide-angle shot, but raising or lowering a telephoto lens a few feet probably will have little effect on the appearance of the distant subjects you're shooting.

Figure 6.11
A long zoom setting and relatively large f/stop helped isolate the bird while allowing the background to go out of focus.

Avoiding Telephoto Lens Problems

Many of the "problems" that telephoto lenses pose are really just challenges and are not that difficult to overcome. Here is a list of the seven most common picture maladies and suggested solutions.

- **Symptom: flat faces in portraits.** Head-and-shoulders portraits of humans tend to be more flattering when a focal length of 25mm to 50mm is used. Longer focal lengths compress the distance between features like noses and ears, making the face look wider and flat. A wide angle might make noses look huge and ears tiny when you fill the frame with a face. So stick with 25mm to 50mm focal lengths, going longer only when you're forced to shoot from a greater distance, and wider only when shooting three-quarters/full-length portraits, or group shots.

- **Symptom: blur due to camera shake.** Use a higher shutter speed (boosting ISO if necessary), consider an image-stabilized lens, or mount your camera on a tripod, monopod, or brace it with some other support. Of those three solutions, only the first will reduce blur caused by *subject* motion; image stabilization (discussed elsewhere) won't help you freeze a racecar in mid-lap.

- **Symptom: color fringes.** Chromatic aberration is the most pernicious optical problem found in telephoto lenses. There are others, including spherical aberration, astigmatism, coma, curvature of field, and similarly scary-sounding phenomena. The best solution for any of these is to use a better lens that offers the proper degree of correction, or stop down the lens to minimize the problem. But that's not always possible. Your second-best choice may be to correct the fringing in your favorite RAW conversion tool or image editor. Photoshop's Lens Correction filter offers sliders that minimize both red/cyan and blue/yellow fringing.

- **Symptom: lines that curve inwards.** Pincushion distortion is found in many telephoto lenses. You might find after a bit of testing that it is worse at certain focal lengths with your particular zoom lens. Like chromatic aberration, it can be partially corrected using the correction tools built into Photoshop and Photoshop Elements. You can see an exaggerated example in Figure 6.12, especially at the right edge where the walls of the tower bend noticeably; pincushion distortion isn't always this obvious.

- **Symptom: low contrast from haze or fog.** When you're photographing distant objects, a long lens shoots through a lot more atmosphere than other focal lengths, which generally is muddied up with extra haze and fog. That dirt or moisture in the atmosphere can reduce contrast and mute colors. Some feel that a skylight or UV filter can help, but this practice is mostly a holdover from the film days. Digital sensors are not sensitive enough to UV light for a UV filter to have much effect. So you should be prepared to boost contrast and color saturation in your Picture controls menu or image editor if necessary if haze or fog is a problem.

Figure 6.12
Pincushion distortion in telephoto lenses causes lines to bow inwards from the edges.

- **Symptom: low contrast from flare.** Lenses are furnished with lens hoods for a good reason: to reduce flare from bright light sources at the periphery of the picture area, or completely outside it. Because telephoto lenses often create images that are lower in contrast in the first place, they are even more susceptible to flare than shorter focal lengths, so you'll want to be especially careful to use a lens hood to prevent further effects on your image (or shade the front of the lens with your hand).

- **Symptom: dark flash photos.** Edge-to-edge flash coverage isn't a problem with telephoto lenses as it is with wide angles. The shooting distance is. A long lens might make a subject that's 50 feet away look as if it's right next to you, but your camera's flash isn't fooled. You'll need extra power for distant flash shots. More powerful flash units are available, and you should use them if you're photographing distant subjects.

Telephotos and Bokeh

Bokeh describes the aesthetic qualities of the out-of-focus parts of an image and whether out-of-focus points of light—circles of confusion—are rendered as distracting fuzzy discs or smoothly fade into the background. *Boke* is a Japanese word for "blur," and the h was added to keep English speakers from rendering it monosyllabically to rhyme with *broke*. Although bokeh is visible in blurry portions of any image, it's of particular concern with telephoto lenses, which, thanks to the magic of reduced depth-of-field, produce more obviously out-of-focus areas.

Bokeh can vary from lens to lens, or even within a given lens depending on the f/stop in use. Bokeh becomes objectionable when the circles of confusion are evenly illuminated, making them stand out as distinct discs, or, worse, when these circles are darker in the center, producing an ugly "doughnut" effect. A lens defect called spherical aberration may produce out-of-focus discs that are brighter on the edges and darker in the center, because the lens doesn't focus light passing through the edges of the lens exactly as it does light going through the center. (Mirror or *catadioptric* lenses also produce this effect.)

Other kinds of spherical aberration generate circles of confusion that are brightest in the center and fade out at the edges, producing a smooth blending effect, as you can see at bottom in Figure 6.13. Ironically, when no spherical aberration is present at all, the discs are a uniform shade, which, while better than the doughnut effect, is not as pleasing as the bright center/dark edge rendition. The shape of the disc also comes into play, with round smooth circles considered the best, and nonagonal (nine-sided) or some other polygon (determined by the shape of the lens diaphragm) considered less desirable.

If you plan to use selective focus a lot, you should investigate the bokeh characteristics of a particular lens before you buy. User groups and forums will usually be full of comments and questions about bokeh, so the research is fairly easy.

Add-ons and Special Features

Once you've purchased your telephoto lens, you'll want to think about some appropriate accessories for it. There are some handy add-ons available that can be valuable. Here are a couple of them to think about.

Lens Hoods

Lens hoods are an important accessory for all lenses, but they're especially valuable with telephotos. As I mentioned earlier, lens hoods do a good job of preserving image contrast by keeping bright light sources outside the field of view from striking the lens and, potentially, bouncing around inside that long tube to generate flare that, when coupled with atmospheric haze, can rob your image of detail and snap. In addition, lens hoods

Figure 6.13 Bokeh is less pleasing when the discs are prominent (top), and less obtrusive when they blend into the background (bottom).

serve as valuable protection for that large, vulnerable, front lens element. It's easy to forget that you've got that long tube sticking out in front of your camera and accidentally whack the front of your lens into something. It's cheaper to replace a lens hood than it is to have a lens repaired, so you might find that a good hood is valuable protection for your prized optics.

When choosing a lens hood, it's important to have the right hood for the lens, usually the one offered for that lens by Panasonic or the third-party manufacturer. You want a hood that blocks precisely the right amount of light: neither too much light nor too little. A hood with a front diameter that is too small can show up in your pictures as vignetting. A hood that has a front diameter that's too large isn't stopping all the light it should. Generic lens hoods may not do the job.

When your telephoto is a zoom lens, it's even more important to get the right hood, because you need one that does what it is supposed to at both the wide-angle and telephoto ends of the zoom range. Lens hoods may be cylindrical, rectangular (shaped like the image frame), or petal shaped (that is, cylindrical, but with cut-out areas at the corners that correspond to the actual image area). Lens hoods should be mounted in the correct orientation (a bayonet mount for the hood usually takes care of this).

Telephoto Converters

Teleconverters multiply the actual focal length of your lens, giving you a longer telephoto for much less than the price of a lens with that actual focal length. These converters fit between the lens and your camera and contain optical elements that magnify the image produced by the lens. Available in 1.4X and 2.0X configurations from Olympus (but not Panasonic, unfortunately), a teleconverter transforms, say, a 200mm lens into a 280mm or 400mm optic, respectively. At around $360-$430 each, converters are quite a bargain, aren't they?

There are other downsides. While extenders retain the closest focusing distance of your original lens, you lose an effective one or two f/stops of light with the 1.4X and 2.0X converters, respectively. That loss forces you to use slower shutter speeds and/or larger apertures, and can make focusing more difficult. So, your 150mm f/2.8 lens becomes a 210mm f/4 or 300mm f/5.6 lens. Although Olympus converters are precision optical devices that work with the GF1, they do cost you a little sharpness in addition to the lost lens speed, but sharpness improves when you reduce the aperture by a stop or two.

If you're shooting under bright lighting conditions, the Olympus extenders make handy accessories for a Panasonic user. I recommend the 1.4X version because it robs you of very little sharpness and only one f/stop. I've found the 2X teleconverter to exact too much of a sharpness and speed penalty to be of much use.

You'll also find macro lenses, macro zooms, and other close-focusing lenses available for your DMC-GF1. If you want to focus closer with a macro lens, or any other lens, you can add an accessory called an *extension tube*. This add-on moves the lens farther from the focal plane, allowing it to focus more closely. You can also find add-on close-up lenses, which look like filters, and allow lenses to focus more closely.

Image Stabilization

Panasonic includes optical image stabilization (MEGA O.I.S.) in many of its lenses (unlike the Olympus PEN models, which include IS produced by a moveable sensor that counters camera motion through shifts that compensate for any shakiness in the camera [or its operator]). Image stabilization of either the in-lens or in-camera type is particularly effective when used with telephoto lenses, which magnify the effects of camera and photographer motion.

Image stabilization offers two to three shutter speed increments' worth of shake reduction. This extra margin can be invaluable when you're shooting under dim lighting conditions or handholding a lens for, say, wildlife photography. Perhaps that shot of a foraging deer would require a shutter speed of 1/2,000th second at f/5.6. Relax. You can shoot at 1/250th second at f/11 and get a photo that is just as sharp, as long as the deer doesn't decide to bound off. Or, perhaps you're shooting indoors and would prefer to shoot at 1/15th second at f/4. Your anti-shake feature can grab the shot for you at its wide-angle position. However, consider these facts:

- **IS doesn't freeze subject motion.** Image stabilization won't freeze moving subjects in their tracks, because it is effective only at compensating for *camera* motion. It's best used in reduced illumination, to steady the up-down swaying of telephoto lenses, and to improve close-up photography. If your subject is in motion, you'll still need a shutter speed that's fast enough to stop the action.

- **IS adds to shutter lag.** The process of adjusting the lens elements, like autofocus, takes time, so image stabilization may contribute to a slight increase in shutter lag. If you're shooting sports, that delay may be annoying, but I still use IS for sports all the time!

- **Use when appropriate.** You may find that your results are worse when using IS while panning. Otherwise, the camera may confuse the panning motion with camera wobble and provide too much compensation. Or, you might want to switch off IS when panning or when your camera is mounted on a tripod.

- **Do you need IS at all?** Remember that an inexpensive monopod might be able to provide the same additional steadiness as IS. If you're out in the field shooting wild animals or flowers and think a tripod isn't practical, try a monopod first.

Making Light Work for You

Successful photographers and artists have an intimate understanding of the importance of light in shaping an image. Rembrandt was a master of using light to create moods and reveal the character of his subjects. Artist Thomas Kinkade's official tagline is "Painter of Light." The late Dean Collins, co-founder of Finelight Studios, revolutionized how a whole generation of photographers learned and used lighting. It's impossible to underestimate how the use of light adds to—and how misuse can detract from—your photographs.

All forms of visual art use light to shape the finished product. Sculptors don't have control over the light used to illuminate their finished work, so they must create shapes using planes and curved surfaces so that the form envisioned by the artist comes to life from a variety of viewing and lighting angles. Painters, in contrast, have absolute control over both shape and light in their work, as well as the viewing angle, so they can use both the contours of their two-dimensional subjects and the qualities of the "light" they use to illuminate those subjects to evoke the image they want to produce.

Photography is a third form of art. The photographer may have little or no control over the subject (other than posing human subjects) but can often adjust both viewing angle *and* the nature of the light source to create a particular compelling image. The direction and intensity of the light sources create the shapes and textures that we see. The distribution and proportions determine the contrast and tonal values: whether the image is stark or high key, or muted and low in contrast. The colors of the light (because even "white" light has a color balance that the sensor can detect), and how much of those colors the subject reflects or absorbs, paint the hues visible in the image.

As a Panasonic Lumix DMC-GF1 photographer, you must learn to be a painter and sculptor of light if you want to move from *taking* a picture to *making* a photograph.

This chapter introduces the two main types of illumination: *continuous* lighting (such as daylight, incandescent, or fluorescent sources) and the brief, but brilliant snippets of light we call *electronic flash*.

Continuous Illumination versus Electronic Flash

Continuous lighting is exactly what you might think: uninterrupted illumination that is available all the time during a shooting session. Daylight, moonlight, and the artificial lighting encountered both indoors and outdoors count as continuous light sources (although all of them can be "interrupted" by passing clouds, solar eclipses, a blown fuse, or simply by switching off a lamp). Indoor continuous illumination includes both the lights that are there already (such as incandescent lamps or overhead fluorescent lights indoors) and fixtures you supply yourself, including photoflood lamps or reflectors used to bounce existing light onto your subject.

The surge of light we call electronic flash is produced by a burst of photons generated by an electrical charge that is accumulated in a component called a *capacitor* and then directed through a glass tube containing xenon gas, which absorbs the energy and emits the brief flash. Electronic flash is notable because it can be much more intense than continuous lighting, lasts only a brief moment, and can be much more portable than supplementary incandescent sources. It's a light source you can carry with you and use anywhere.

Your GF1 comes equipped with a small pop-up electronic flash unit built in, which is useful for fill flash if nothing else. Adding a compatible external flash unit to your camera bag will increase your photographic options. Flash options are a little limited with the camera since there's no flash connection such as a PC hookup. Your only choice is to use the camera's hot shoe, meaning you can't use both a flash and the GF1's electronic viewfinder at the same time. Studio flash units are electronic flash, too, and aren't limited to "professional" shooters, as there are economical "monolight" (one-piece flash/power supply) units available in the $200 price range. Serious photographers with some spare cash can buy a couple to store in a closet and use to set up a home studio, or use as supplementary lighting when traveling away from home. You'll need a remote trigger mounted on the GF1's accessory/hot shoe, the GF1's built-in flash, or a small on-camera flash with a slave trigger to fire studio flashes, or connect them directly with a shoe mount adapter that has a PC/X connector. Another choice is to use a continuous light source off camera. Both photoflood light sources and simple work lights from the local hardware store (about $100) can provide useable light. Even room lights, table lamps, or floor lamps can be pressed into service for photography. Windows can provide beautiful sources of light too.

There are advantages and disadvantages to each type of illumination. Here's a quick checklist of pros and cons:

■ **Lighting preview—Pro: continuous lighting.** With continuous lighting, you always know exactly what kind of lighting effect you're going to get and, if multiple light sources are used (such as the sunlight and reflectors put to work in Figure 7.1), how they will interact with each other.

Figure 7.1
You always know how the lighting will look when using continuous illumination.

- **Lighting preview—Con: electronic flash.** With electronic flash, the general effect you're going to see may be a mystery until you've built some experience, and you may need to review a shot on the LCD, make some adjustments, and then reshoot to get the look you want. (In this sense, a digital camera's review capabilities replace the Polaroid test shots pro photographers relied on in decades past.) (See Figure 7.2.)

- **Exposure calculation—Pro: continuous lighting.** Your GF1 has no problem calculating exposure for continuous lighting, because it remains constant and can be measured through a sensor that interprets the light reaching the viewfinder. The amount of light available just before the exposure will, in almost all cases, be the same amount of light present when the shutter is released. The GF1's Spot metering mode can be used to measure and compare the proportions of light in the highlights and shadows, so you can make an adjustment (such as using more or less fill light) if necessary. You can even use a handheld light meter to measure the light yourself.

Figure 7.2 Electronic flash requires the photographer to visualize the effect of the light. Here I positioned the flash unit, connected to the camera with a shoe mount adapter and cord, off camera to the left of Baxter (my youngest cat), knowing the strong directional light would bring out detail and highlight his face. Catching him in mid-yawn was a combination of luck and the good fortune that comes to photographers who keep shooting even after they've gotten good photos. I could have also used a radio trigger such as a Pocket Wizard or Radio Slave and its receiver to trigger the flash wirelessly.

- **Exposure calculation—Con: electronic flash.** Electronic flash illumination doesn't exist until the flash fires, and so it can't be measured by the GF1's exposure sensor when the shutter is opened during the exposure. Instead, the light must be measured by metering the intensity of a preflash that is triggered an instant before the main flash, as it is reflected back to the camera and through the lens. An alternative is to use a sensor built into the flash itself and measure reflected light that has not traveled through the lens. If you have a do-it-yourself bent, there are handheld flash meters, too, including models that measure both flash and continuous light.

- **Evenness of illumination—Pro/con: continuous lighting.** Of continuous light sources, daylight, in particular, provides illumination that tends to fill an image completely, lighting up the foreground, background, and your subject almost equally. Shadows do come into play, of course, so you might need to use reflectors or fill-in light sources to even out the illumination further, but barring objects that block large sections of your image from daylight, the light is spread fairly evenly. Indoors, however, continuous lighting is commonly less evenly distributed. The average living room, for example, has hot spots and dark corners. But on the plus side, you can *see* this uneven illumination and compensate with additional lamps.

- **Evenness of illumination—Con: electronic flash.** Electronic flash units (like continuous light sources such as lamps that don't have the advantage of being located 93 million miles from the subject) suffer from the effects of their proximity. The *inverse square law*, first applied to both gravity and light by Sir Isaac Newton, dictates that as a light source's distance increases from the subject, the amount of light reaching the subject falls off proportionately to the square of the distance. In plain English, that means that a flash or lamp that's six feet away from a subject provides only one-quarter as much illumination as a source that's 12 feet away (rather than half as much). (See Figure 7.3.) This translates into relatively shallow "depth-of-light."

Figure 7.3
A light source that is twice as far away provides only one-quarter as much illumination.

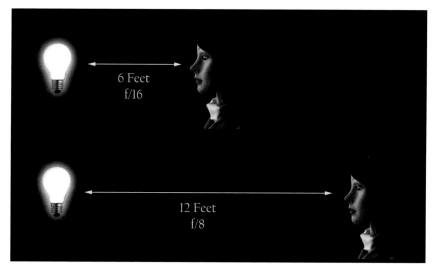

- **Action stopping—Con: continuous lighting.** Action stopping with continuous light sources is completely dependent on the shutter speed you've dialed in on the camera. And the speeds available are dependent on the amount of light available and your ISO sensitivity setting. Outdoors in daylight, there will probably be enough sunlight to let you shoot at 1/2,000th second and f/6.3 with a non-grainy sensitivity setting of ISO 400. That's a fairly useful combination of settings if you're not using a super-telephoto with a small maximum aperture. But inside, the reduced illumination quickly has you pushing your GF1 to its limits. For example, if you're shooting indoor sports, there probably won't be enough available light to allow you to use a 1/2,000th second shutter speed (although I routinely shoot indoor basketball with my GF1 at ISO 1600 and 1/500th second at f/4). In many indoor sports situations, you may find yourself limited to 1/500th second or slower.

- **Action stopping—Pro: electronic flash.** When it comes to the ability to freeze moving objects in their tracks, the advantage goes to electronic flash. The brief duration of electronic flash serves as a very high "shutter speed" when the flash is the main or only source of illumination for the photo. Your GF1's shutter speed may be set for 1/160th second during a flash exposure, but if the flash illumination predominates, the *effective* exposure time will be the 1/1,000th to 1/50,000th second or less duration of the flash, as you can see in Figure 7.4, because the flash unit reduces the amount of light released by cutting the burst short. The only fly in the ointment is that, if the ambient light is strong enough, it may produce a secondary, "ghost" exposure, as I'll explain later in this chapter.

- **Cost—Pro: continuous lighting.** Incandescent or fluorescent lamps are generally much less expensive than electronic flash units, which can easily cost several hundred dollars. I've used everything from desktop hi-intensity lamps to reflector floodlights for continuous illumination at very little cost. There are lamps made especially for photographic purposes, too, priced up to $50 or so. Maintenance is economical, too; many incandescent or fluorescents use bulbs that cost only a few dollars. Newer portable LCD light panels offer powerful continuous light sources in small packages, albeit at potentially higher prices (pro units can cost several hundred dollars each). An added advantage of continuous light sources is that you don't have to use the GF1's hot shoe to use them, meaning you can stick with the EVF as you shoot.

- **Cost—Con: electronic flash.** Electronic flash units aren't particularly cheap. The lowest-cost dedicated flash designed specifically for the Panasonic Four Thirds and Micro Four Thirds series cameras is about $160 (although you can sometimes find specials on a refurbished DMW-FL360, bringing the price down to $149 compared to its list price of $299.95). Units such as the DMW-FL220, a basic fill flash model, are also available for about $120. Such units are limited in features, however, and intended for those with entry-level cameras. Plan to spend some money to get the features that a sophisticated electronic flash offers.

Figure 7.4
Electronic flash can freeze almost any action, such as in this shot of Amanda Scull cooling off.

■ **Flexibility—Con: continuous lighting.** Because incandescent and fluorescent lamps are not as bright as electronic flash, the slower shutter speeds required (see "Action stopping," above) mean that you may have to use a tripod more often, especially when shooting portraits. The incandescent variety of continuous lighting gets hot, especially in the studio, and the side effects range from discomfort (for your human models) to disintegration (if you happen to be shooting perishable foods like ice cream). The heat also makes it more difficult to add filtration to incandescent sources. Newer LED light sources don't have this problem, but are also more expensive than other forms of continuous lighting. Also, since continuous light sources don't have to be connected to the camera there are no compatibility issues the way there are with shoe mount flash units.

■ **Flexibility—Pro: electronic flash.** Electronic flash's action-freezing power allows you to work without a tripod in the studio (and elsewhere), adding flexibility and speed when choosing angles and positions. Flash units can be easily filtered, and, because the filtration is placed over the light source rather than the lens, you don't need to use high-quality filter material. For example, a couple sheets of unexposed, processed Ektachrome film can make a dandy infrared-pass filter for your flash unit. Roscoe or Lee lighting gels, which may be too flimsy to use in front of the lens, can be mounted or taped in front of your flash with ease. Flash filter kits specifically designed for hot shoe mount flash units make filtering strobe light even easier.

Continuous Lighting Basics

While continuous lighting and its effects are generally much easier to visualize and use than electronic flash, there are some factors you need to take into account, particularly the color temperature of the light. (Color temperature concerns aren't exclusive to continuous light sources, of course, but the variations tend to be more extreme and less predictable than those of electronic flash, which output relatively consistent daylight-like illumination.)

Color temperature, in practical terms, is how "bluish" or how "reddish" the light appears to be to the digital camera's sensor. Indoor illumination is quite warm, comparatively, and appears reddish to the sensor. Daylight, in contrast, seems much bluer to the sensor. Our eyes (our brains, actually) are quite adaptable to these variations, so white objects don't appear to have an orange tinge when viewed indoors, nor do they seem excessively blue outdoors in full daylight. Yet, these color temperature variations are real and the sensor is not fooled. To capture the most accurate colors, we need to take the color temperature into account in setting the color balance (or *white balance*) of the GF1—either automatically using the camera's smarts or manually using our own knowledge and experience.

The Panasonic Lumix DMC-GF1 will let you set white balance using color temperature values, which are measured in *degrees Kelvin*. This makes it useful to know that warmer (more reddish) color temperatures (measured in degrees Kelvin) are the *lower* numbers, while cooler (bluer) color temperatures are *higher* numbers. It might not make sense to say that 3,400K is warmer than 6,000K, but that's the way it is. If it helps, think of a glowing red ember contrasted with a white-hot welder's torch, rather than fire and ice.

You can set white balance by type of illumination, and then fine-tune it in the GF1 using the White Balance option. In most cases, however, the Panasonic Lumix DMC-GF1 will do an acceptable job of calculating white balance for you, so Auto (AWB) can be used as your choice most of the time. Use the preset values or set a custom white balance that matches the current shooting conditions when you need to. The only really problematic light sources are likely to be fluorescents. Vendors, such as GE and Sylvania, may actually provide a figure known as the *color rendering index* (or CRI), which is a measure of how accurately a particular light source represents standard colors, using a scale of 0 (some sodium-vapor lamps) to 100 (daylight and most incandescent lamps). Daylight fluorescents and deluxe cool white fluorescents might have a CRI of about 79 to 95, which is perfectly acceptable for most photographic applications. Warm white fluorescents might have a CRI of 55. White deluxe mercury vapor lights are less suitable with a CRI of 45, while low-pressure sodium lamps can vary from CRI 0-18.

Daylight

Daylight is produced by the sun, and so is moonlight (which is just reflected sunlight). Daylight is present, of course, even when you can't see the sun. When sunlight is direct, it can be bright and harsh. If daylight is diffused by clouds, softened by bouncing off objects such as walls or your photo reflectors, or filtered by shade, it can be much dimmer and less contrasty.

Daylight's color temperature can vary quite widely. It is highest in temperature (most blue) at noon when the sun is directly overhead; because the light is traveling through a minimum amount of the filtering layer we call the atmosphere. The color temperature at high noon may be 6,000K. At other times of day, the sun is lower in the sky and the particles in the air provide a filtering effect that warms the illumination to about 5,500K for most of the day. Starting an hour before dusk and for an hour after sunrise, the warm appearance of the sunlight is even visible to our eyes when the color temperature may dip to 5,000-4,500K, as shown in Figure 7.5.

Figure 7.5
At dawn and dusk, the color temperature of daylight may dip as low as 4,500K, and at sunset can go even lower.

Incandescent/Tungsten Light

The term incandescent or tungsten illumination is usually applied to the direct descendents of Thomas Edison's original electric lamp. Such lights consist of a glass bulb that contains a vacuum, or is filled with a halogen gas, and contains a tungsten filament that is heated by an electrical current, producing photons and heat. Tungsten-halogen lamps are a variation on the basic light bulb, using a more rugged (and longer-lasting) filament that can be heated to a higher temperature, housed in a thicker glass or quartz envelope, and filled with iodine or bromine ("halogen") gases. The higher temperature allows tungsten-halogen (or quartz-halogen/quartz-iodine, depending on their construction) lamps to burn "hotter" and whiter. Although popular for automobile headlamps today, they've also been used for photographic illumination.

The other qualities of this type of lighting, such as contrast, are dependent on the distance of the lamp from the subject, type of reflectors used, and other factors that I'll explain later in this chapter.

Fluorescent Light/Other Light Sources

Fluorescent light has some advantages in terms of illumination, but some disadvantages from a photographic standpoint. This type of lamp generates light through an electro-chemical reaction that emits most of its energy as visible light, rather than heat, which is why the bulbs don't get as hot. The type of light produced varies depending on the phosphor coatings and type of gas in the tube. So, the illumination fluorescent bulbs produce can vary widely in its characteristics.

That's not great news for photographers. Different types of lamps have different "color temperatures" that can't be precisely measured in degrees Kelvin, because the light isn't produced by heating. Worse, fluorescent lamps have a discontinuous spectrum of light that can have some colors missing entirely. A particular type of tube can lack certain shades of red or other colors (see Figure 7.6), which is why fluorescent lamps and other alternative technologies such as sodium-vapor illumination can produce ghastly looking human skin tones if the white balance isn't set correctly. Their spectra can lack the reddish tones we associate with healthy skin and emphasize the blues and greens popular in horror movies.

There *is* good news, however. There are special fluorescent and LED lamps compatible with the Spiderlite lighting fixtures sold through dealers affiliated with the F. J. Westcott Company (www.fjwestcott.com), designed especially for photography, with the color balance and other properties required. They can be used for direct light, placed in softboxes (described later), and used in other ways. New forms of LED photographic lighting are showing up everyday too, so photographers and videographers (and with a GF1 you can be both) have more choices.

Figure 7.6
The uncorrected fluorescent lighting in this space added a distinct greenish cast to this image when exposed with a daylight white balance setting.

Adjusting White Balance

In most cases, however, the GF1 will do a good job of calculating white balance for you, so Auto can be used as your choice most of the time. Use the preset values or set a custom white balance that matches the current shooting conditions when you need to. The only really problematic light sources are likely to be fluorescents. Vendors, such as GE and Sylvania, may actually provide a figure known as the *color rendering index* (or CRI), which is a measure of how accurately a particular light source represents standard colors, using a scale of 0 (some sodium-vapor lamps) to 100 (daylight and most incandescent lamps). Daylight fluorescents and deluxe cool white fluorescents might have a CRI of about 79 to 95, which is perfectly acceptable for most photographic applications. Warm white fluorescents might have a CRI of 55. White deluxe mercury vapor lights are less suitable with a CRI of 45, while low-pressure sodium lamps can vary from CRI 0-18.

Remember that if you shoot RAW, you can specify the white balance of your image when you import it into Photoshop, Photoshop Elements, or another image editor using your preferred RAW converter. While color-balancing filters that fit on the front of the lens exist, they are primarily useful for film cameras, because film's color balance can't be tweaked as extensively as that of a sensor.

Electronic Flash Basics

Until you delve into the situation deeply enough, it might appear that serious photographers have a love/hate relationship with electronic flash. You'll often hear that flash photography is less natural looking, and that the built-in flash in most cameras should never be used as the primary source of illumination because it provides a harsh, garish look. Indeed, most "pro" cameras don't have a built-in flash at all. Available ("continuous") lighting is praised, and built-in flash photography seems to be roundly denounced.

In truth, however, the bias is against *bad* flash photography. Indeed, flash has become the studio light source of choice for pro photographers, because it's more intense (and its intensity can be varied to order by the photographer), freezes action, frees you from using a tripod (unless you want to use one to lock down a composition), and has a snappy, consistent light quality that matches daylight. (While color balance changes as the flash duration shortens, some Panasonic flash units can communicate to the camera the exact white balance provided for that shot.)

But electronic flash isn't as inherently easy to use as continuous lighting. As I noted earlier, electronic flash units are more expensive, don't show you exactly what the lighting effect will be (unless you use a second source called a *modeling light* for a preview), and the exposure of electronic flash units is more difficult to calculate accurately.

How Electronic Flash Works

The bursts of light we call electronic flash are produced by a flash of photons generated by an electrical charge that is accumulated in a component called a *capacitor* and then directed through a glass tube containing xenon gas, which absorbs the energy and emits the brief flash. For the typical small flash unit, such as the Panasonic DMW-FL220, the full burst of light lasts about 1/1,000th second and provides enough illumination to shoot a subject 10 feet away at f/4 using the ISO 100 setting. In a more typical situation, you'd use ISO 200, f/5.6 to f/8, and photograph something 8 to 10 feet away. As you can see, a small flash is somewhat limited in range; you'll see why more powerful external flash units are often a good idea later in this chapter.

An electronic flash (whether built in or connected to the GF1 through a cable plugged into a hot shoe adapter) is triggered at the instant of exposure, during a period when the sensor is fully exposed by the shutter. As I mentioned earlier in this book, the GF1 has a vertically traveling shutter that consists of two curtains. The first curtain opens

and moves to the bottom of the frame, at which point the shutter is completely open. The flash can be triggered at this point (so-called *first-curtain sync*), making the flash exposure. Then, after a delay that can vary from 60 seconds to 1/160th second (with the GF1; other cameras may sync at a faster or slower speed), a second curtain begins moving across the sensor plane, covering up the sensor again. If the flash is triggered just before the second curtain starts to close, then *rear-curtain sync* (also called *second-curtain sync*) is used. In both cases, though, a shutter speed of 1/160th second is the maximum that can be used to take a photo with the GF1.

Figure 7.7 illustrates how this works, with a fanciful illustration of a generic shutter (your GF1's shutter does *not* look like this, and some vertically traveling shutters move bottom to top rather than the top-to-bottom motion shown). Both curtains are tightly closed at upper left. At upper right, the first curtain begins to move downward, starting to expose a narrow slit that reveals the sensor behind the shutter. At lower left, the first curtain moves downward farther until, as you can see at lower right in the figure, the sensor is fully exposed.

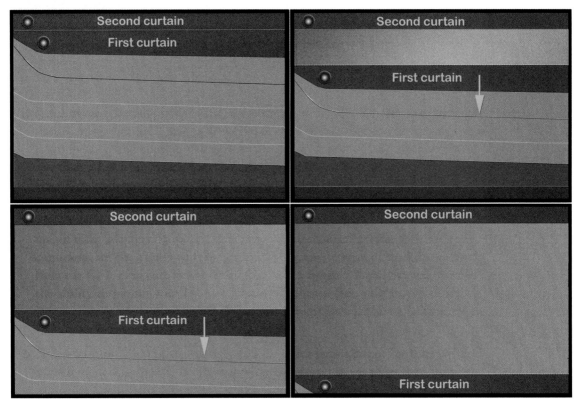

Figure 7.7 A focal plane shutter has two curtains, the lower, or front curtain, and an upper, second curtain.

When first-curtain sync is used, the flash is triggered at the instant that the sensor is completely exposed. The shutter then remains open for an additional length of time (from 60 seconds to 1/160th second), and the second curtain begins to move downward, covering the sensor once more. When second-curtain sync is activated, the flash is triggered *after* the main exposure is over, just before the second curtain begins to move downward.

Ghost Images

The difference between triggering the flash when the shutter just opens, or just when it begins to close might not seem like much. But whether you use first-curtain sync (the default setting) or second-curtain sync (an optional setting) can make a significant difference to your photograph *if the ambient light in your scene also contributes to the image.*

At faster shutter speeds, such as 1/160th second, there isn't much time for the ambient light to register under dimmer lighting conditions. It's likely that the electronic flash will provide almost all the illumination, so first-curtain sync or second-curtain sync isn't very important in such cases. However if it is very bright and you're using a higher ISO setting, ambient light can be a problem. At slower shutter speeds, or with very bright ambient light levels, there is a significant difference, particularly if your subject is moving, or the camera isn't steady.

In any of those situations, the ambient light will register as a second image accompanying the flash exposure, and if there is movement (camera or subject), that additional image will not be in the same place as the flash exposure. It will show as a ghost image and, if the movement is significant enough, as a blurred ghost image trailing in front of or behind your subject in the direction of the movement.

As I noted, when you're using first-curtain sync, the flash's main burst goes off the instant the shutter opens fully (a preflash used to measure exposure in auto flash modes fires *before* the shutter opens). This produces an image of the subject on the sensor. Then, the shutter remains open for an additional period (60 seconds to 1/160th second, as I said). If your subject is moving, say, towards the right side of the frame, the ghost image produced by the ambient light will produce a blur on the right side of the original subject image, making it look as if your sharp (flash-produced) image is chasing the ghost. For those of us who grew up with lightning-fast superheroes that always left a ghost trail *behind them,* that looks unnatural (see Figure 7.8).

So, Panasonic uses second-curtain sync to remedy the situation. In that mode, the shutter opens, as before. The shutter remains open for its designated duration, and the ghost image forms. If your subject moves from the left side of the frame to the right side, the ghost will move from left to right, too. *Then,* about 1.5 milliseconds before the second shutter curtain closes; the flash is triggered, producing a nice, sharp flash image *ahead* of the ghost image. Voilà! We have monsieur *Speed Racer* outdriving his own trailing

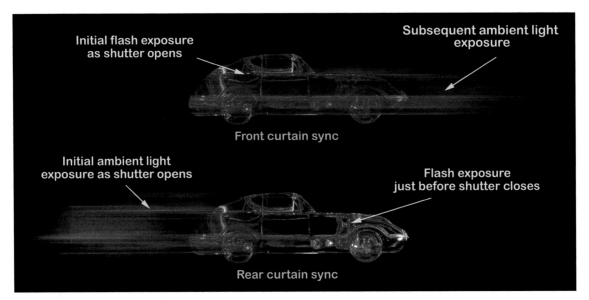

Figure 7.8 First-curtain sync produces an image that trails in front of the flash exposure (top), while second-curtain sync creates a more "natural looking" trail behind the flash image.

image. Keep in mind, if you're using second-curtain shutter sync with a long exposure, the preflash will fire before the shutter opens and then the exposure will take place followed by the actual flash firing at the appropriate time. The preflash can confuse people into thinking the exposure has already been made.

Avoiding Sync Speed Problems

Using a shutter speed faster than 1/160th second can cause problems. Triggering the electronic flash only when the shutter is completely open makes a lot of sense if you think about what's going on. To obtain shutter speeds faster than 1/160th second, the GF1 exposes only part of the sensor at one time, by starting the second curtain on its journey before the first curtain has completely opened, as shown in Figure 7.9. That effectively provides a briefer exposure as a slit that's narrower than the full height of the sensor passes over the surface of the sensor. If the flash were to fire during the time when the first and second curtains partially obscured the sensor, only the slit that was actually open would be exposed.

You'd end up with only a narrow band, representing the portion of the sensor that was exposed when the picture is taken. For shutter speeds *faster* than 1/160th second, the second curtain begins moving *before* the first curtain reaches the bottom of the frame. As a result, a moving slit, the distance between the first and second curtains, exposes one portion of the sensor at a time as it moves from the top to the bottom. Figure 7.9 shows three views of our typical (but imaginary) focal plane shutter. At left is pictured

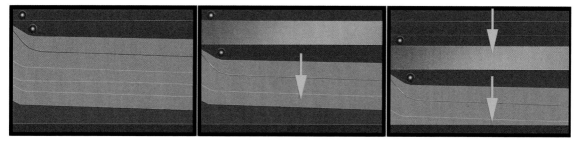

Figure 7.9 A closed shutter (left); partially open shutter as the first curtain begins to move downwards (middle); only part of the sensor is exposed as the slit moves (right).

the closed shutter; in the middle version you can see the first curtain has moved down about 1/4 of the distance from the top; and in the right-hand version, the second curtain has started to "chase" the first curtain across the frame towards the bottom.

If the flash is triggered while this slit is moving, only the exposed portion of the sensor will receive any illumination. You end up with a photo like the one shown in Figure 7.10. Note that a band across the bottom of the image is black. That's a shadow of the second shutter curtain, which had started to move when the flash was triggered. Sharp-eyed readers will wonder why the black band is at the *bottom* of the frame rather than at the top, where the second curtain begins its journey. The answer is simple: your lens flips the image upside down and forms it on the sensor in a reversed position. You never

Figure 7.10
If a shutter speed faster than 1/160th second is used, you can end up photographing only a portion of the image.

notice that, because the camera is smart enough to show you the pixels that make up your photo in their proper orientation during picture review. But this image flip is why, if your sensor gets dirty and you detect a spot of dust in the upper half of a test photo, if cleaning manually, you need to look for the speck in the *bottom* half of the sensor.

I generally end up with sync speed problems only when shooting in the studio, using studio flash units rather than my Panasonic dedicated Speedlight. That's because if you're using a "smart" flash (one whose output can be controlled by the camera instead of just pumping out a set amount of light), the camera knows that a strobe is attached, and remedies any unintentional goof in shutter speed settings. If you happen to set the GF1's shutter to a faster speed in S or M mode, the camera will automatically adjust the shutter speed down to 1/160th second. In A, P, or any of the Scene modes, where the GF1 selects the shutter speed, it will never choose a shutter speed higher than 1/160th second when using flash. In P mode, shutter speed is automatically set between 1/60th to 1/160th second when using flash. But when using a non-dedicated flash, such as a studio unit plugged into the GF1's hot shoe connector (via an accessory that provides a PC connection to the camera via the hot shoe), the camera has no way of knowing that a flash is connected, so shutter speeds faster than 1/160th second can be set inadvertently. (The GF1 can effectively take photos at shutter speeds faster than 1/160th second when using a dedicated flash that can shoot in FP (focal plane) mode, which manipulates flash output to avoid the sync problem.) In FP mode the flash unit emits a series of rapid bursts of light timed to the movement of the shutter curtain. While this makes it possible to shoot at faster shutter speeds than the true shutter sync speed, it does drain the flash batteries faster and reduces the effective range of the flash too.

Determining Exposure

Calculating the proper exposure for an electronic flash photograph is a bit more complicated than determining the settings for continuous light. The right exposure isn't simply a function of how far away your subject is (which the GF1 can figure out based on the autofocus distance that's locked in just prior to taking the picture). Various objects reflect more or less light at the same distance so, obviously, the camera needs to measure the amount of light reflected back and through the lens. Yet, as the flash itself isn't available for measuring until it's triggered, the GF1 has nothing to measure.

The solution is to fire the flash twice. The initial shot is a *monitor preflash* that can be analyzed, then followed virtually instantaneously by a main flash (to the eye the bursts appear to be a single flash) that's given exactly the calculated intensity needed to provide a correct exposure. As a result, the primary flash may be longer in duration for distant objects and shorter in duration for closer subjects, depending on the required intensity for exposure. This through-the-lens flash exposure system is called TTL (Through-The-Lens), and it operates whenever an appropriate dedicated flash unit is used with the GF1.

Guide Numbers

Guide numbers, usually abbreviated GN, are a way of specifying the power of an electronic flash in a way that can be used to determine the right f/stop to use at a particular shooting distance and ISO setting. In fact, before automatic flash units became prevalent, the GN was actually used to do just that. A GN is usually given as a number for distance in combination with focal length at a particular ISO, often ISO 100. For example, the Panasonic DMW-FL360 companion flash for the GF1 has a GN in TTL mode of 36 when used with a 28 mm lens (in 35 mm terms) at ISO 100.

Using a Panasonic DMW-FL360 flash as an example, at ISO 100 with its GN of 36 in Manual mode, if you wanted to shoot a subject at a distance of 10 feet, you'd use f/3.6 (36 divided by 10), or, in practice, f/4.0. At 5 feet, an f/stop of f/8 would be used. Some quick mental calculations with the GN will give you any particular electronic flash's range. You can easily see that the built-in flash with its GN of 6, would begin to peter out at about 10 feet if you stuck to the lowest ISO of 100, because you'd need an aperture of f/1.7. Of course, in the real world you'd probably bump the sensitivity up to a setting of ISO 800 so you could use a more practical f/8 at 13 feet, and the flash would be effective all the way out to 20 feet or more at wider f/stops.

Today, guide numbers are most useful for comparing the power of various flash units, rather than actually calculating what exposure to use. You don't need to be a math genius to see that an electronic flash with a GN in feet of, say, 111.5 at ISO 100 would be *a lot* more powerful than a built-in flash. At ISO 100, you could use f/5.6 to shoot as far as 20 feet.

Flash Control

The Panasonic Lumix DMC-GF1 can operate in anywhere from one to seven flash modes depending on the flash unit and exposure mode.

There are two ways to set your flash mode. You can press the Q.MENU button and set it via the LCD screen or EVF (it's located on the upper-right side) or via the Rec menu. It's the second option on the second screen.

Your Flash Control options are as follows:

- **Auto.** When the flash unit is triggered, the GF1 first fires a preflash and measures the light reflected back and through the lens to calculate the proper exposure when the full flash is emitted a fraction of a second later. The flash is automatically activated whenever shooting conditions make supplemental light necessary.

- **Auto/Red-eye reduction.** The flash fires automatically in low light conditions or when your subject is backlit, plus it fires a preflash to minimize the red-eye effect before firing the main flash burst.

- **Forced flash on.** Think of this as "manual" control. The flash will fire every time the shutter button is pressed (and the flash has a sufficient charge). Panasonic recommends this mode for times when the subject is backlit or you're shooting under fluorescent lights (since using the flash as the main light source will correct for any lighting caused color casts).

- **Forced flash on/Red-eye reduction.** The flash unit fires every time the shutter button is pressed after first firing a preflash burst of light to help prevent red-eye.

- **Slow sync.** This mode helps you balance the light between the flash and a dark background. Normally when you use flash against a dark background, the subject ends up properly lit and everything beyond the effective range of the flash unit (usually from 10 to 20 feet) turns out too dark to see. Slow sync mode reduces the shutter speed enough to allow the background to register via ambient light, while the flash burst illuminates and freezes your subject. It's a good idea to have the camera on a tripod or solid surface when you shoot in this mode since the long shutter speed can cause blur from camera shake. (This is something Panasonic calls "jitter.") (See Figure 7.11.)

- **Slow sync/Red-eye reduction.** This works the same way as the Slow sync mode, but fires a preflash burst of light to reduce the red-eye effect.

- **Forced flash off.** Flash operation is turned off no matter what the conditions.

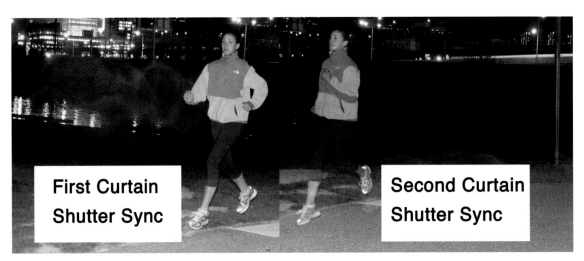

Figure 7.11 The Slow sync, second-curtain flash makes a variety of creative shots possible.

Flash Metering Mode

You don't select the way your flash meters the exposure directly; instead, flash metering is determined by the camera metering mode—Multi , Center weighted, or Spot—that you select. Indeed, the Panasonic Lumix DMC-GF1 uses the same metering modes that are available for continuous light sources. So, you can choose the flash's metering mode based on the same subject factors as those explained in Chapter 4 (for example, use Spot metering to measure exposure from an isolated subject within the frame).

Choosing a Flash Sync Mode

The Panasonic Lumix DMC-GF1 has as many as seven flash sync modes (depending on the exposure mode you're using) that determine when and how the flash is fired (as I'll explain shortly). They are selected from either the Q.MENU approach or via the Flash option on the second screen of the Rec menu.

Not all sync modes are available with all exposure modes. Depending on whether you're using Scene modes, or Program, Aperture-priority, Shutter-priority, or Manual exposure modes, one or more of the following sync modes may not be available. I'm going to list the sync options available for each exposure mode separately, although that produces a little duplication among the options that are available with several exposure modes. However, this approach should reduce the confusion over which sync method is available with which exposure mode. (There is also a useful chart on page 60 of the camera's user guide that breaks this down for you as well.)

In Aperture-priority and Program modes, the GF1 gives you all seven flash choices. These options give you a nice range of control with your flash unit. Shutter-priority omits the two slow shutter sync modes since you're the one setting the shutter speed in this mode anyway and Manual mode provides forced flash, forced flash/red-eye reduction, and flash off for similar reasons.

Motion Picture and My Color modes provide only one option—flash off.

In iAuto Exposure mode, the GF1 gives you two flash choices. This keeps flash operation pretty simple for those who don't want to spend a lot of time trying to decide on the best flash mode.

- **Auto.** The flash fires automatically when it judges light levels to be too low, or if the subject is backlit. (The camera will decide which of the appropriate flash modes to choose, so you may end up with it using a red-eye reduction or slow sync mode.)

- **Flash Off.** The flash system is turned off. The flash will not fire even if it is turned on.

When you're working with one of the GF1's Scene mode options, the camera decides what flash mode to set, leaving you free from having to make that decision. Here's a breakdown of what each scene mode chooses:

- **Portrait.** Auto, Auto with/Red-eye reduction (default mode), Forced flash, Flash off.

- **Landscape.** Flash off.

- **Architectural.** Flash off.

- **Sport.** Auto (default mode), Forced flash, Flash off.

- **Peripheral Defocus.** Auto (default mode), Auto with/red-eye reduction, Forced flash, Flash off.

- **Flower.** Auto (default mode), Forced flash, Flash off.

- **Food.** Auto (default mode), Forced flash, Flash off.

- **Objects.** Auto (default mode), Forced flash, Flash off.

- **Night Portrait.** Slow sync/red-eye reduction.

- **Night Scene.** Flash off.

- **Illuminations.** Flash off.

- **Baby1 and Baby2.** Auto, Auto with/red-eye reduction (default mode), Forced flash, Flash off.

- **Pet.** Auto (default mode), Forced flash, Flash off.

- **Party.** Forced flash/red-eye reduction, Slow sync/red-eye reduction, Flash off.

- **Sunset.** Flash off.

A Typical Electronic Flash Sequence

Here's what happens when you take a photo using electronic flash.

1. **Sync mode.** Choose the flash sync mode from the second screen on the Rec menu (it's the fourth option).

2. **Metering method.** Choose the metering method you want, Multi, Center weighted, or Spot, using either the Q.MENU screen or via the camera's menu system.

3. **Activate flash.** Activate the pop-up flash or mount an external flash and turn it on. A ready light appears in the viewfinder (it's the standard solid green flash "lightning bolt" symbol) or a white lightning bolt on the LCD screen. A yellow light on the back of the flash illuminates when the unit is ready to take a picture.

4. **Check exposure.** Select a shutter speed when using Manual, Program, or Shutter-priority modes; select an aperture when using Aperture-priority and Manual exposure modes. The GF1 will set both shutter speed and aperture if you're using a Scene mode.

5. **Take photo.** Press the shutter release down all the way.

6. **GF1 receives distance data.** A compatible Micro Four Thirds lens now supplies focus distance to the GF1.

7. **Preflash emitted.** The internal flash, if used, or external flash sends out one pre-flash burst used to determine exposure.

8. **Exposure calculated.** The preflash bounces back and is measured by the GF1. It measures brightness and contrast of the image to calculate exposure. If you're using Multi metering, the GF1 evaluates the scene to determine whether the subject may be backlit (for fill flash), or a subject that requires extra ambient light exposure to balance the scene with the flash exposure, or classifies the scene in some other way. The camera to subject distance information is evaluated. The GF1 also considers where the lens has focused in order to locate the subject within the frame.

9. **Flash fired.** At the correct triggering moment (depending on whether front or rear sync is used), the camera sends a signal to the flash to start flash discharge. The flash is quenched as soon as the correct exposure has been achieved.

10. **Shutter closes.** The shutter closes. You're ready to take another picture.

11. **Exposure confirmed.** Ordinarily, the full charge in the flash may not be required. Be sure to review your image on the LCD to make sure it's not underexposed, and, if it is, make adjustments (such as increasing the ISO setting of the GF1) to remedy the situation. Some Panasonic flash units also have an "Auto Check" light on the upper-left part of the back panel that blinks green to let you know the flash was sufficient for the exposure.

Working with Panasonic Flash Units

If you want to work with dedicated Panasonic flash units, at this time you have several choices: the Panasonic DMW-FL28, DMW-FL220, DMW-FL360, or the DMW-FL500. These share certain features, which I'll discuss while pointing out differences among them. Panasonic may introduce additional flash units during the life of this book, but the current batch were significant steps forward.

Panasonic DMW-FL500

This is currently the flagship of the Panasonic flash line up, and has a guide number of 50 when the "zooming" flash head (which can be set to adjust the coverage angle of the lens) is set to the 42mm position with a 42mm focal length lens and the camera set at

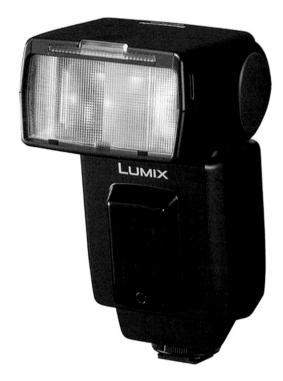

Figure 7.12
The Panasonic DMW-FL500 is currently the flagship of the Panasonic electronic flash line up.

ISO 100. It has a number of features, including selectable power output, along with some extra capabilities (See Figure 7.12).

For example, you can angle the flash and rotate it to provide bounce flash. It includes additional, non-through-the-lens exposure modes, thanks to its built-in light sensor, and can "zoom" and diffuse its coverage angle to illuminate the field of view of lenses from 8mm (with the wide angle/diffusion dome attached, this equates to a 16mm lens on a 35mm film camera) to 42mm (85mm equivalent with 35mm film) on a GF1. The FL500 also has its own powerful focus assist lamp to aid autofocus in dim lighting, and has reduced red-eye effects simply because the unit, when attached to the GF1, is mounted in a higher position that tends to eliminate reflections from the eye back to the camera lens.

Panasonic DMW-FL360

This lower-cost unit (see Figure 7.13) has a guide number of 36 at ISO 100 when set to the 42mm zoom position. It has many of the DMW-FL500's features, including zoomable flash coverage equal to the field of view of a 12-42mm lens on the GF1 (24-84mm settings with a full-frame camera), and 16mm with a built-in diffuser panel. This is a good choice for a photographer on a budget who wants a versatile and capable flash unit. Keep in mind, since it runs off of only two AA batteries (many shoe mount flash

Figure 7.13
The Panasonic
DMW-FL360
is a popular
medium-priced
electronic flash
with most of
the features of
the FLW-500.

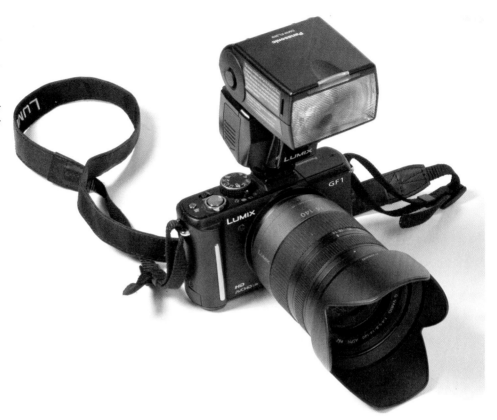

units use four), recycle times may be on the slow side. I prefer rechargeable Nickel metal hydride batteries in my DMW-FL360 and try to carry several extra sets with me whenever I plan on using this flash unit.

Panasonic DMW-FL220

The entry-level DMW-FL220 is a good choice for many basic GF1 applications. It's built specifically for Panasonic cameras like the GF1, and has a limited, easy-to-use feature set. It has a limited ISO 100 guide number of 22. This is a small, lightweight unit that's a good choice for someone with simple flash needs. Since it's more powerful than the built-in flash, it provides more options for fill flash work, but still doesn't offer a bounce or swivel capability.

Flash Techniques

This next section will discuss using specific features of the Panasonic Lumix DMC-GF1's with those of the Panasonic dedicated external flash units. It's not possible to discuss every feature and setting of the external flash units in this chapter (entire books have been written to do that), so I'll simply provide an overview here.

Using the Zoom Head

Many external flash units that have zoom heads can adjust themselves automatically to match lens focal length changes as reported by the GF1 to the flash unit. If not, then you'll have to adjust the zoom head manually.

You can manually adjust the zoom position yourself, if you want the flash coverage to correspond to something other than the focal length in use. Just press the Zoom button on the DMW-FL500 or DMW-FL360 and then press it repeatedly to change zoom settings. If you zoom it too far, then just keep pressing the Zoom button and it will cycle back through the settings until you get the one that you want. Just be sure you press it repeatedly instead of just holding it in.

Flash Modes

The Panasonic external flash units have various flash modes that work with the GF1.

The TTL automatic flash modes available for the FL500 and FL360 are as follows:

- **TTL Auto.** Auto Aperture flash. The GF1 measures the amount of flash illumination seen by the camera's lens and adjusts the output to produce an appropriate exposure based on the ISO, aperture, flash to subject distance, focal length, and flash compensation values set on the GF1. This setting on the flash can be used with the GF1 in Program or Aperture-priority modes.

- **Auto.** Non-TTL auto flash. Light intensity is adjusted based on the brightness captured by the light receptor on the flash unit.

- **Manual.** Flash output is determined by the guide number setting for the focal length being used.

- **FP TTL Auto.** High-Speed Auto Aperture flash. Use this mode to get TTL exposure while using shutter speeds that are faster than the GF1's normal shutter sync speed. This is useful for using flash outdoors in bright light when you want to shoot with the lens wide open for minimal depth-of-field. FP works by emitting pulses of light to synchronize with the shutter curtain. This feature is only available with Panasonic's top two flash units. (Third-party flash makers may offer a similar feature.)

- **FP Manual.** High-Speed Manual flash. Makes it possible to use faster shutter speeds than the camera's normal sync speed while emitting flash according to the guide number for a particular focal length/flash combination. FP works by emitting pulses of light to synchronize with the shutter curtain. This feature is only available with Panasonic's top two flash units. (Third-party flash makers may offer a similar feature.)

BURN OUT

When using repeating flash with the FL500 or FL360, or *any* large number of consecutive flashes in any mode (more than about 10 shots at full power), allow the flash to cool off (Panasonic recommends a 10-minute time out) to avoid overheating the flash.

Connecting External Flash

Your simplest choice for linking an external flash unit to your Panasonic Lumix DMC-GF1, is to slide a compatible flash unit into the Panasonic Lumix DMC-GF1's accessory shoe. With a Panasonic dedicated flash, all functions of the flash are supported. If you're willing to work a little harder, there are some other options though.

Off-Camera Flash

You can buy a simple hot shoe to PC connection adapter for about $20. This will make it possible for you to hook up the camera to any strobe or flash that can be triggered via PC cable. You'll have to calculate the exposure yourself (or use a flash meter) but can also achieve some excellent results with this kind of lighting. You can also connect a radio slave via the PC connection and trigger your lights wirelessly.

Another option would be to use a photo slave (a light-sensitive accessory that tells the off-camera flash to fire when it senses another flash firing). These are also inexpensive, but can be unreliable (or triggered by someone else's flash unit if there are other people taking pictures at the same time you are).

More Advanced Lighting Techniques

As you advance in your Panasonic Lumix DMC-GF1 photography, you'll want to learn more sophisticated lighting techniques, using more than just straight-on flash, or using just a single flash unit. Entire books have been written on lighting techniques (check out *David Busch's Quick Snap Guide to Lighting*). I'm going to provide a quick introduction to some of the techniques you should be considering.

Diffusing and Softening the Light

Direct light can be harsh and glaring, especially if you're using the flash built in to your camera, or an auxiliary flash mounted in the hot shoe and pointed directly at your subject. The first thing you should do is stop using direct light (unless you're looking for a stark, contrasty appearance as a creative effect).

There are a number of simple things you can do with both continuous and flash illumination.

- **Use window light.** Light coming in a window can be very dramatic, and a good choice for human subjects. Move your subject close enough to the window that its light provides the primary source of illumination. You might want to turn off other lights in the room, particularly to avoid mixing daylight and incandescent light (see Figure 7.14).

- **Use fill light.** Your GF1's built-in flash makes a perfect fill-in light for the shadows, brightening inky depths with a kicker of illumination (see Figure 7.15). Don't be afraid to combine the built-in flash with another light source such as a table lamp or window.

- **Bounce the light.** Some external electronic flash units mounted on the GF1 may have a swivel that allows them to be pointed up at a ceiling for a bounce light effect. You can also bounce the light off a wall. You'll want the ceiling or wall to be white or have a neutral gray color to avoid a colorcast.

- **Use reflectors.** Another way to bounce the light is to use reflectors or umbrellas that you can position yourself to provide a greater degree of control over the quantity and direction of the bounced light. Good reflectors can be pieces of foamboard, Mylar, or a reflective disk held in place by a clamp and stand. Although some expensive umbrellas and reflectors are available, spending a lot isn't necessary. A simple piece of white foamboard does the job beautifully. Umbrellas have the advantage of being compact and foldable, while providing a soft, even kind of light. They're relatively cheap, too, with a good 40-inch umbrella available for as little as $20. A reasonably new option is the Vertex, a set of small panels that mount on the head of the flash via a rubber band and arm assembly. Each panel has a diffusion side and a mirrored side, and they can be rotated independently of each other. This clever little light modifier takes up very little room in a camera bag, and, used properly, can turn your flash into what amounts to multiple light sources as the mirrors direct some flash output in different directions and the flash head points to the ceiling. This makes it possible to bounce light off of walls and ceiling simultaneously providing a soft, even lighting. This device works best indoors and does take some practice to master. It costs about $50 (see Figure 7.16).

- **Use diffusers.** You can purchase a variety of diffusers that mount on the flash head from companies such as Stofen. They fit over your electronic flash head and provide a soft, flattering light. These add-ons are more portable than umbrellas and other reflectors, yet provide a nice diffuse lighting effect. (See Figure 7.17.)

Figure 7.14
Light from the
window located
off to the upper
left makes the
perfect diffuse
illumination
for informal
soft-focus por-
traits like this
one of Cassie.

Figure 7.15
Fill flash illuminated the shadows for this candid portrait of the conductor of the Grand Canyon Railway.

Figure 7.16
The Vertex light modifier lets you redirect light from your strobe in different directions simulating multiple light sources.

Figure 7.17
Softboxes use Velcro strips to attach them to just about any shoe-mount flash unit.

Using Multiple Light Sources

Once you gain control over the qualities and effects you get with a single light source, you'll want to graduate to using multiple light sources. Using several lights allows you to shape and mold the illumination of your subjects to provide a variety of effects, from backlighting to side lighting to more formal portrait lighting. You can start simply with several incandescent light sources, bounced off umbrellas or reflectors that you construct. Or you can use more flexible multiple electronic flash setups.

Effective lighting is the one element that differentiates great photography from candid or snapshot shooting. Lighting can make a mundane subject look a little more glamorous. Make subjects appear to be soft when you want a soft look, or bright and sparkly when you want a vivid look, or strong and dramatic if that's what you desire. As you might guess, having control over your lighting means that you probably can't use the lights that are already in the room. You'll need separate, discrete lighting fixtures that can be moved, aimed, brightened, and dimmed on command.

Selecting your lighting gear will depend on the type of photography you do, and the budget you have to support it. It's entirely possible for a beginning GF1 photographer to create a basic, inexpensive lighting system capable of delivering high-quality results for a few hundred dollars, just as you can spend megabucks ($1,000 and up) for a sophisticated lighting system.

Basic Flash Setups

While designed primarily as a "walking around" camera, the GF1 can do some exciting work with flash photography and even be paired with studio flash units with just a little bit of creativity on the part of the user. Since the camera doesn't have a PC connection or flash connection of any kind beyond the hot shoe, you have to trigger the studio units with the pop-up flash, a small on-camera flash unit, use a hot shoe triggered wireless remote, or use a hot shoe to PC cord adapter.

Studio Flash

If you're serious about using multiple flash units, a studio flash setup might be more practical, although for most of us, studio flash are a bit of overkill for a compact camera like the DMC-GF1. However, with its interchangeable lenses and versatility, I know there are some who may end up taking it into the studio.

The traditional studio flash is a multi-part unit, consisting of a flash head that mounts on your light stand, and is tethered to an AC (or sometimes battery) power supply. A single power supply can feed two or more flash heads at a time, with separate control over the output of each head.

When they are operating off AC power, studio flash units don't have to be frugal with the juice, and are often powerful enough to illuminate very large subjects or to supply lots and lots of light to smaller subjects. The output of such units is measured in watt

seconds (ws), so you could purchase a 200ws, 400ws, or 800ws unit, and a power pack to match.

Their advantages include greater power output, much faster recycling, built-in modeling lamps, multiple power levels, and ruggedness that can stand up to transport, because many photographers pack up these kits and tote them around as location lighting rigs. Studio lighting kits can range in price from a few hundred dollars for a set of lights, stands, and reflectors, to thousands for a high-end lighting system complete with all the necessary accessories.

A more practical choice these days is *monolights,* which are "all-in-one" studio lights that sell for about $200-$800 or more. They have the flash tube, modeling light, and power supply built in to a single unit that can be mounted on a light stand. Monolights are available in AC-only and battery-pack versions, although an external battery eliminates some of the advantages of having a flash with everything in one unit. They are very portable, because all you need is a case for the monolight itself, plus the stands and other accessories you want to carry along. Because these units are so popular with photographers who are not full-time professionals, the lower-cost monolights are often designed more for lighter duty than professional studio flash. That doesn't mean they aren't rugged; you'll just need to handle them with a little more care, and, perhaps, not expect them to be used eight hours a day for weeks on end. In most other respects, however, monolights are the equal of traditional studio flash units in terms of fast recycling, built-in modeling lamps, adjustable power, and so forth.

Connecting Multiple Non-Dedicated Units to Your Panasonic Lumix DMC-GF1

Non-dedicated electronic flash units can't use the automated TTL features of your Panasonic Lumix DMC-GF1; you'll need to calculate exposure manually, through test shots evaluated on your camera's LCD, or by using an electronic flash meter. Moreover, you don't have to connect them to the accessory shoe on top of the camera. Instead, you can remove them from the camera and use a hot shoe to PC cord adapter so you can fire the flash off-camera via an extension PC cord.

You should be aware that older electronic flash units sometimes use a triggering voltage that is too much for your GF1 to handle. You can actually damage the camera's electronics if the voltage is too high. You won't need to worry about this if you purchase brand-new units from Alien Bees, Adorama, or other vendors. But if you must connect an external flash with an unknown triggering voltage, I recommend using a Wein Safe Sync, which isolates the flash's voltage from the camera triggering circuit.

Finally, some flash units have an optical slave trigger built in, or can be fitted with one, so that they fire automatically when another flash, including your camera's built-in unit, fires. Or, you can use radio-control devices like the Pocket Wizards shown in

Figure 7.18, and used to produce the image in Figure 7.19. Radio slaves (such as the Pocket Wizards and other brands) require both a transmitting unit, which is mounted on the camera, and a receiver, which is connected to the flash unit.

Figure 7.18
Pocket Wizards are popular radio control devices.

Figure 7.19 A radio-control device frees you from a sync cord tether between your flash and camera and makes shots like this one of Callie Harlan possible. In this case, the flash unit was mounted on a light stand outside the window and fired remotely via a Pocket Wizard radio slave. The flash head was fitted with a yellow gel to give the color you see in the image.

Other Lighting Accessories

Once you start working with light, you'll find there are plenty of useful accessories that can help you. Here are some of the most popular.

Softboxes

Softboxes are large square or rectangular devices that may resemble a square umbrella with a front cover, and produce a similar lighting effect. They can extend from a few feet square to massive boxes that stand five or six feet tall—virtually a wall of light. With a flash unit or two inside a softbox, you have a very large, semi-directional light source that's very diffuse and very flattering for portraiture and other people photography.

Softboxes are also handy for photographing shiny objects. They not only provide a soft light, but if the box itself happens to reflect in the subject (say you're photographing a chromium toaster), the box will provide an interesting highlight that's indistinct and not distracting.

You can buy softboxes (like the one shown in Figure 7.20) or make your own. Some lengths of friction-fit plastic pipe and a lot of muslin cut and sewed just so may be all that you need.

Figure 7.20
Softboxes provide an even, diffuse light source. The RPS unit used in this photo is collapsible and designed to work with a variety of shoe mount strobe units.

Light Stands

Both electronic flash and incandescent lamps can benefit from light stands. These are lightweight, tripod-like devices (but without a swiveling or tilting head) that can be set on the floor, tabletops, or other elevated surfaces and positioned as needed. Light stands should be strong enough to support an external lighting unit, up to and including a relatively heavy flash with a softbox or umbrella reflectors. You want the supports to be capable of raising the lights high enough to be effective. Look for light stands capable of extending six to seven feet high. The nine-foot units usually have larger, steadier bases, and extend high enough that you can use them as background supports. You'll be using these stands for a lifetime, so invest in good ones.

Backgrounds

Backgrounds can be backdrops of cloth, sheets of muslin you've painted yourself using a sponge dipped in paint, rolls of seamless paper, or any other suitable surface your mind can dream up. Backgrounds provide a complementary and non-distracting area behind subjects (especially portraits) and can be lit separately to provide contrast and separation that outlines the subject, or which helps set a mood.

I like to use plain-colored backgrounds for portraits, and white seamless backgrounds for product photography. You can usually construct these yourself from cheap materials and tape them up on the wall behind your subject, or mount them on a pole stretched between a pair of light stands.

Snoots and Barn Doors

These fit over the flash unit and direct the light at your subject. Snoots are excellent for converting a flash unit into a hair light, while barn doors give you enough control over the illumination by opening and closing their flaps that you can use another flash as a background light, with the capability of feathering the light exactly where you want it on the background.

Painting with Light

Sometimes all you need for creative photography is a dark room, a flashlight, and an interesting subject. Mount the camera on a stable tripod or surface, open the shutter for half a dozen seconds or so, and then use the flashlight to "paint" your subject.

While this technique takes some trial and error, it can result in some fun images. Take advantage of your GF1's instant feedback to make adjustments to your ISO, exposure time, and painting technique and make lots of exposures to improve your chances of getting a great shot. (See Figure 7.21.) That's what we did for the image of Lauren in the bathtub (a 15-second exposure at f/16, 100 ISO, Manual mode with the camera mounted on a tripod).

Figure 7.21
Lauren held
still for 15 sec-
onds while I
used a flash-
light to "paint"
her and certain
background
items into the
image while
leaving other
parts of the
room dark.

Another version of the technique is to have someone stand behind your subject waving a flash light or rope lights around. Your helper should be wearing dark clothes (or draped with a dark blanket) so he or she doesn't show up as a ghost image. (See Figure 7.22.) This image of Lauren called for an 8-second exposure at f/12, 100 ISO, Manual mode with the camera mounted on a tripod. Obviously, when working with such long exposures, you need a subject who can hold still a long time.

Figure 7.22 A helper (draped in dark fabric) stood behind Lauren waving a collection of rope lights during this 8-second exposure.

8

Useful Software for the Panasonic Lumix DMC-GF1

Unless you only take pictures and then immediately print them directly to a PictBridge-compatible printer, somewhere along the line you're going to need to make use of the broad array of software available for the Panasonic Lumix DMC-GF1. The picture-fixing options in the camera itself let you make only modest modifications to your carefully crafted photos. If your needs involve more than fixing red-eye, cropping, and trimming, you're definitely going to want to use a utility or editor of some sort to perfect your images. After you've captured some great images and have them safely stored on your Panasonic Lumix DMC-GF1's memory card, you'll need to transfer them from your camera and Secure Digital card to your computer, where they can be organized, fine-tuned in an image editor, and prepared for web display, printing, or some other final destination.

Fortunately, there are lots of software utilities and applications to help you do all these things. This chapter will introduce you to a few of them. Please note that this is *not* a "how-to-do-it" software chapter. I'm going to use every available page in this book to offer advice on how to get the most from your GF1. There's no space to explain how to use all the features of Panasonic software, nor how to tweak RAW file settings in Adobe Camera Raw. This chapter is intended solely to help you get your bearings among the large number of utilities and applications available, to help you better understand what each does, and how you might want to use them. At the very end of the chapter, however, I'm going to make an exception and provide some simple instructions for using Adobe Camera Raw, to help those who have been using Panasonic's software exclusively get a feel for what you can do with the Adobe product.

The basic functions found in most of the programs discussed in this chapter include image transfer and management, camera control, and image editing. You'll find that many of the programs overlap several of these capabilities, so it's not always possible to categorize the discussions that follow by function.

Panasonic PHOTOfunSTUDIO

Your first stop should be with the Panasonic PHOTOfunSTUDIO software application supplied on CD with your camera. It is a Windows-only basic editing utility that allows you to transfer images and movies from your camera to your computer using the USB cable or a memory card reader, and then browse through and organize them on your hard disk. You can also perform simple editing modifications and print your photos. (Mac owners can use iPhoto or Silkypix Developer Studio.)

There's a feature that allows you to create a DVD from the motion pictures you shoot with your GF1, and another that allows you to back up your still pictures and movies. You can e-mail photos, post them on the Internet, and upload videos to YouTube. That's quite an array of features for a free program!

You can configure PHOTOfunSTUDIO so it launches automatically whenever you link the GF1 to your computer using the supplied USB cable, or when you insert a memory card in a card reader. A screen like the one shown in Figure 8.1 pops up with thumbnail preview images of the photos on your card. Click to select the ones you want to transfer to your computer, and then click Next. Choose a destination folder and then apply a subfolder name (See Figure 8.2). Select Day of Acquisition or Recording Month or Recording Day, and a folder name will be created using those parameters. Or, create a folder with a name of your choice. Apply key words (up to 32 characters) to each transferred image (such as Madrid or World Cup) for use later in searching/organizing the images, and click Execute to transfer your photos.

Once images have been transferred, you can sort them, view detailed information about each shot with the File > Properties command, or play them back as a slide show. If you've categorized pictures using the GF1's Face Recognition feature, you can search for images of specific people, look for shots taken with a certain Scene mode (Portrait, Scenery, Baby, Pet, and so forth), in addition to searching by keywords. I admit it's pretty cool to be able to display only photos that include a specific person, but you need to set up Face Recognition, described earlier, to do that. The alternative is to manually "tell" the software which people are in particular photos by dragging and dropping them into one of your defined Face Recognition categories (Mom, Spouse, Elvis, etc.).

Simple editing functions can be carried out, such as resizing a picture, simple retouching for color, brightness, hue/saturation, sharpness, plus rotation and red-eye correction. Motion picture editing is limited to extracting still pictures from your movies, and removing unwanted parts of clips that are longer than two seconds. If you want to use

Figure 8.1
Choose which images to transfer…

Figure 8.2
…then select a destination before clicking Execute to copy the pictures from your camera to your PC.

other applications to edit your GF1 photos, you can register up to 10 different programs with PHOTOfunSTUDIO and transfer images to those applications.

Basic image-editing features include the ability to adjust tonal values, color balance, correct for distortion, and edit Panasonic RW2 RAW files. Editing in RAW mode allows maximum flexibility for changing color temperature, exposure compensation, gradation, noise filter application, and other features. Auto features for things like tone correction can be applied, or you can make these adjustments manually.

SILKYPIX Developer Studio 3.0

A more advanced image-editing program, SILKYPIX Developer Studio 3.0, is also furnished on CD (See Figure 8.3). It is quite complete, the only Panasonic choice available to Mac owners, and will do the job for anyone on a budget who doesn't already own or plan to own a program like Photoshop Elements. It has a full range of controls for adjusting contrast, brightness, exposure, color saturation, and sharpness, and includes useful tools for noise reduction.

Figure 8.3
SILKYPIX Developer Studio 3.0 is an unconventional but powerful image-editing program.

SILKYPIX does have most of the manual tools built into Photoshop Elements (but not the same array of automated tools and styles), and the price is right. The chief barrier to embracing this program is its odd nomenclature and unfamiliar arrangement of the tools and features among its palettes and menus. The program and its manual read a lot like one of those badly translated VCR menus from the 1980s. (For example, one choice is "Faint sharp for noisy scene," and what most programs would call "styles" are located in the Parameters menu under "Add New Taste.") I got a special kick out of a message that popped up in the registration screen, a check box labeled "I don't hope to receive SILKYPIX newsletter."

If you enjoy exploring an unconventional program that has a few unexpected features tucked away here and there (I especially liked Dynamic Range Expansion, which can be adjusted from +0 to +6 EV), give SILKYPIX Developer Studio a try before jumping back to Photoshop Elements, Photoshop, or iPhoto.

Other Software

Other useful software for your Panasonic Lumix DMC-GF1 falls into several categories. You might want to fine-tune your images, retouch them, change color balance, composite several images together, and perform other tasks we know as image editing, with a program like Adobe Photoshop, or Photoshop Elements.

You might want to play with the settings in RAW files, too, as you import them into an image editor. There are specialized tools expressly for tweaking RAW files, ranging from Adobe Camera Raw to PhaseOne's Capture One Pro (C1 Pro). A third type of manipulation is the specialized task of noise reduction, which can be performed within Photoshop, Adobe Camera Raw, or tools like Bibble Professional. There are also specialized tools just for noise reduction, such as Noise Ninja (also included with Bibble) and Neat Image. Some programs, like the incomparable DxO Optics Pro, perform magical transformations that you can achieve in few other ways, such as straightening out the curvy lines taken with third-party fisheye lenses you might use with your GF1.

Each of these utilities and applications deserves a chapter of its own, so I'm simply going to enumerate some of the most popular applications and utilities and tell you a little about what they do.

DxO Optics Pro

DxO Labs (www.DxO.com) offers an incredibly useful program called Optics Pro for both Windows and Mac OS ($170-$300) that is unique in the range of functions it provides. Ostensibly an image-quality enhancement utility that "cures" some of the ails that plague even the best lenses, the latest release also features a new RAW conversion engine that uses a demosaicing algorithm to translate your NEF files into images with more detail, less noise, and fewer artifacts than previous versions of this program. These

features meld well with the program's original mission: fixing the optical "geometry" of images, using settings custom-tailored for each individual lens. (I'm not kidding: when you "assemble" the program, you specify each and every camera body you want to use with Optics Pro, and designate exactly which lenses are included in your repertoire.)

Once an image has been imported into Optics Pro, it can be manipulated within one of four main sections: Light, Color, Geometry, and Details. It's especially useful for correcting optical flaws, color, exposure, and dynamic range, while adjusting perspective, distortion, and tilting. If you own a fisheye lens, Optics Pro will "de-fish" your images to produce a passable rectilinear photo from your curved image. A new Dust/Blemish Removal tool creates a dust/blemish template, and the program removes dust from the marked area in multiple images. Figure 8.4 shows you DxO Optics Pro's clean user interface.

Figure 8.4
DxO Optics Pro fixes lens flaws and functions as a high-tech RAW converter and noise reduction utility, too.

Phase One Capture One Pro (C1 Pro)

If there is a Cadillac of RAW converters for Panasonic and Canon digital SLR cameras, C1 Pro has to be it. This premium-priced program from Phase One (www.phaseone.com) does everything, does it well, and does it quickly. If you can't justify the price tag of this professional-level software (as much as $500 for the top-of-the-line edition), there are "lite" versions for serious amateurs and cash-challenged professionals for as little as $130.

Aimed at photographers with high-volume needs (that would include school and portrait photographers, as well as busy commercial photographers), C1 Pro is available for

both Windows and Mac OS X, and supports a broad range of digital cameras. Phase One is a leading supplier of megabucks digital camera backs for medium and larger format cameras, so they really understand the needs of photographers.

The latest features include individual noise reduction controls for each image, automatic levels adjustment, a "quick develop" option that allows speedy conversion from RAW to TIFF or JPEG formats, dual-image side-by-side views for comparison purposes, and helpful grids and guides that can be superimposed over an image. Photographers concerned about copyright protection will appreciate the ability to add watermarks to the output images.

Bibble Pro

One of my personal favorites among third-party RAW converters is Bibble Pro. It supports one of the broadest ranges of RAW file formats available. The utility supports lots of different platforms, too. It's available for Windows, Mac OS X, and, believe it or not, Linux.

Bibble (www.bibblelabs.com) works fast, which is important when you have to convert many images in a short time (event photographers will know what I am talking about!). Bibble's batch-processing capabilities also let you convert large numbers of files using settings you specify without further intervention. Its customizable interface lets you organize and edit images quickly and then output them in a variety of formats, including 16-bit TIFF and PNG. You can even create a web gallery from within Bibble. I often want to change the generic filenames applied to digital images by cameras, so I really like Bibble's ability to rename batches of files.

Bibble is fully color managed, which means it can support all the popular color spaces (Adobe sRGB and so forth) and use custom profiles generated by third-party color-management software. There are two editions of Bibble, a Pro version and a Lite version. Because the Pro version is reasonably priced at $129, I don't really see the need to save $60 with the Lite edition, which lacks the top-line's options for tethered shooting, embedding IPTC-compatible captions in images, and can also be used as a Photoshop plug-in (if you prefer not to work with the application in its standalone mode). Bibble Pro incorporates Noise Ninja technology, so you can get double-duty from this valuable application.

Photoshop/Photoshop Elements

Photoshop is the high-end choice for image editing, and Photoshop Elements (see Figure 8.5) is a great alternative for those who need some of the features of Photoshop, but can do without the most sophisticated capabilities, including editing CMYK files. Both editors use the latest version of Adobe's Camera Raw plug-in, which makes it easy to adjust

Figure 8.5
Photoshop Elements is a great general purpose image editor with both automated and manual tools.

things like image resolution, white balance, exposure, shadows, brightness, sharpness, luminance, and noise reduction. One plus with the Adobe products is that they are available in identical versions for both Windows and Macs.

The latest version of Photoshop includes a built-in RAW plug-in that is compatible with the proprietary formats of a growing number of digital cameras, both new and old, and which can perform a limited number of manipulations on JPEG and TIFF files, too. This plug-in also works with Photoshop Elements, but with fewer features. Here's how easy it is to manipulate a RAW file using the Adobe converter:

1. Transfer the RAW images from your camera to your computer's hard drive.

2. In Photoshop, choose Open from the File menu, or use Bridge or the Organizer.

3. Select a RAW image file. The Adobe Camera Raw plug-in will pop up, showing a preview of the image, like the one shown in Figure 8.6.

Figure 8.6
The basic ACR dialog box looks like this when processing a single image.

4. If you like, use one of the tools found in the toolbar at the top left of the dialog box. From left to right, they are as follows:

■ **Zoom.** Operates just like the Zoom tool in Photoshop.

■ **Hand.** Use like the Hand tool in Photoshop.

■ **White Balance.** Click an area in the image that should be neutral gray or white to set the white balance quickly.

■ **Color Sampler.** Use to determine the RGB values of areas you click with this eyedropper.

■ **Crop.** Pre-crops the image so that only the portion you specify is imported into Photoshop. This option saves time when you want to work on a section of a large image, and you don't need the entire file.

■ **Straighten.** Drag in the preview image to define what should be a horizontal or vertical line, and ACR will realign the image to straighten it.

■ **Retouch.** Use to heal or clone areas you define.

■ **Red-Eye Removal.** Quickly zap red pupils in your human subjects.

■ **ACR Preferences.** Produces a dialog box of Adobe Camera Raw preferences.

■ **Rotate Counterclockwise.** Rotates counterclockwise in 90-degree increments with a click.

■ **Rotate Clockwise.** Rotates clockwise in 90-degree increments with a click.

5. Using the Basic tab, you can have ACR show you red and blue highlights in the preview that indicate shadow areas that are clipped (too dark to show detail) and light areas that are blown out (too bright). Click the triangles in the upper-left corner of the histogram display (shadow clipping) and upper-right corner (highlight clipping) to toggle these indicators on or off.

6. Also in the Basic tab you can choose white balance, either from the drop-down list or by setting a color temperature and green/magenta color bias (tint) using the sliders.

7. Other sliders are available to control exposure, recovery, fill light, blacks, brightness, contrast, vibrance, and saturation. A check box can be marked to convert the image to grayscale.

8. Make other adjustments (described in more detail below).

9. ACR makes automatic adjustments for you. You can click Default and make the changes for yourself, or click the Auto link (located just above the Exposure slider) to reapply the automatic adjustments after you've made your own modifications.

10. If you've marked more than one image to be opened, the additional images appear in a "filmstrip" at the left side of the screen. You can click on each thumbnail in the filmstrip in turn and apply different settings to each.

11. Click Open Image/Open Image(s) into Photoshop using the settings you've made.

The Basic tab is displayed by default when the ACR dialog box opens, and it includes most of the sliders and controls you'll need to fine-tune your image as you import it into Photoshop. These include

- **White Balance.** Leave it As Shot or change to a value such as Daylight, Cloudy, Shade, Tungsten, Fluorescent, or Flash. If you like, you can set a custom white balance using the Temperature and Tint sliders.

- **Exposure.** This slider adjusts the overall brightness and darkness of the image.

- **Recovery.** Restores detail in the red, green, and blue color channels.

- **Fill Light.** Reconstructs detail in shadows.

- **Blacks.** Increases the number of tones represented as black in the final image, emphasizing tones in the shadow areas of the image.

- **Brightness.** This slider adjusts the brightness and darkness of an image.

- **Contrast.** Manipulates the contrast of the midtones of your image.

- **Convert to Grayscale.** Mark this box to convert the image to black-and-white.

- **Vibrance.** Prevents over-saturation when enriching the colors of an image.

- **Saturation.** Manipulates the richness of all colors equally, from zero saturation (gray/black, no color) at the −100 setting to double the usual saturation at the +100 setting.

Additional controls are available on the Tone Curve, Detail, HSL/Grayscale, Split Toning, Lens Corrections, Camera Calibration, and Presets tabs. The Tone Curve tab can change the tonal values of your image. The Detail tab lets you adjust sharpness, luminance smoothing, and apply color noise reduction. The HSL/Grayscale tab offers controls for adjusting hue, saturation, and lightness and converting an image to black-and-white. Split Toning helps you colorize an image with sepia or cyanotype (blue) shades. The Lens Corrections tab has sliders to adjust for chromatic aberrations and vignetting. The Camera Calibration tab provides a way to calibrate the color corrections made in the Camera Raw plug-in. The Presets tab is used to load settings you've stored for reuse.

9

Panasonic Lumix DMC-GF1: Troubleshooting and Prevention

You won't expend a lot of effort keeping your Panasonic Lumix DMC-GF1 humming and operating smoothly. There's not a lot that can go wrong. An electronically controlled camera like the DMC-GF1 has fewer mechanical moving parts to fail, so they are less likely to "wear out." There is no film transport mechanism, no wind lever or motor drive, and no complicated mechanical linkages from camera to lens to adjust the automatic focus. Instead, tiny, reliable motors are built into each lens (and you lose the use of only that lens should something fail). Your camera even lacks one of the few moving parts found in its dSLR siblings in the Panasonic family, the mirror that flips up and down with each shot.

Of course, the camera also has a moving shutter that can fail, but the shutter is built rugged enough that, even though Panasonic doesn't provide an official toughness "rating," you can expect tens of thousands of trouble-free shutter cycles. Unless you're shooting sports in Burst mode day in and day out, the shutter on your GF1 is likely to last as long as you expect to use the camera.

The only other things on the camera that move are switches, dials, buttons, and the door that slides open to allow you to remove and insert the Secure Digital card and battery. Unless you're extraordinarily clumsy or unlucky and manage to give your built-in flash a good whack while it is in use, there's not a lot that can go wrong mechanically with your Panasonic Lumix DMC-GF1.

There are numerous electrical and electronic connections in the camera (many connected to those mechanical switches and dials), and components like the color LCD that can potentially fail or suffer damage. You must sometimes contend with dust lodging itself on your sensor, and, from time to time, perhaps with the need to update your camera's internal software, called *firmware*. This chapter will show you how to diagnose problems, fix some common ills, and, importantly, learn how to avoid them in the future.

Battery Powered

One of the chief liabilities of modern electronic cameras is that they are modern *electronic* cameras. Your GF1 is fully dependent on its battery power. Without it, the camera can't be used. Photographers from both the film and digital eras have grown used to this limitation, and I've grown to live with the need for batteries even though I shot for years using all-mechanical cameras that had no batteries (or even a built-in light meter!). The need for electrical power is the price we pay for modern conveniences like autofocus, autoexposure, LCD image display, backlit menus, and, of course, digital images.

So, your main concern will be to provide a continuous, reliable source of power for your GF1. As I noted in Chapter 1, you should always have a spare battery or two so you won't need to stop shooting when your internal battery dies. I recommend buying Panasonic-brand batteries: saving $20 or so for an after-market battery may seem like a good deal, but it can cost you much more than that if the battery malfunctions and damages your camera.

KEEPING TRACK OF YOUR BATTERIES AND MEMORY CARDS

Here's a trick I use to keep track of which batteries are fresh/discharged, and which memory cards are blank/exposed. I cut up some small slips of paper and fold them in half, forming a tiny "booklet." Then I write EXPOSED in red on the "inside" pages of the booklet and UNEXPOSED in green on the outside pages. Folded one way, the slips read EXPOSED on both sides; folded the other way, the slips read UNEXPOSED. I slip them inside the plastic battery cover, which you should *always* use when the batteries are not in the camera (to avoid shorting out the contacts), folded so the appropriate "state" of the batteries is visible. The same slips are used in the translucent plastic cases I use for my memory cards (see Figure 9.1). For my purposes, EXPOSED means the same as DISCHARGED, and UNEXPOSED is the equivalent of CHARGED. The color-coding is an additional clue as to which batteries/memory cards are good to go, or not ready for use.

Figure 9.1
Mark your
batteries—or
memory
cards—so
you'll know
which are
ready for use.

Update Your Firmware

The camera relies on its "operating system," or *firmware*, which should be updated in a reasonable fashion as new releases become available. The firmware in your Panasonic Lumix DMC-GF1 handles everything from menu display (including fonts, colors, and the actual entries themselves), what languages are available, and even support for specific devices and features. Upgrading the firmware to a new version makes it possible to add or fine-tune features while fixing some of the bugs that sneak in.

Firmware upgrades are used most frequently to fix bugs in the software, and much less frequently to add or enhance features. The exact changes made to the firmware are generally spelled out in the firmware release announcement. You can examine the remedies provided and decide if a given firmware patch is important to you. If not, you can usually safely wait a while before going through the bother of upgrading your firmware—at least long enough for the early adopters (such as those who haunt the Digital Photography Review forums at www.dpreview.com) to report whether the bug fixes have introduced new bugs of their own. Each new firmware release incorporates the changes from previous releases, so if you skip a minor upgrade you should have no problems.

The Version 1.2 update for the GF1 fixed a few notable problems, so if you haven't updated yet from 1.0, you're overdue. The improvements in the 1.2 update include

- Added MF Assist operation for "MF operation only" lenses by pressing the rear dial

- Improved AF performance in Motion Picture recording

- Improved picture quality for high sensitivity shooting

- Improved performance of the Auto White Balance

- Improved representation in the human face modes

- Improved AE program functions in some Scene modes

WHEN TO UPGRADE YOUR FIRMWARE

I *always* recommend waiting at least two weeks after a new firmware upgrade is announced before changing the software in your camera. This is often in direct contradiction to the online Panasonic "gurus" who breathlessly announce each new firmware release on their web pages. *Don't do it!* Yet. Some vendors have, in the past, introduced firmware upgrades that were buggy and added problems of their own. If you own a camera affected by a new round of firmware upgrades, I urge you to wait and let a few million over-eager fellow users "beta test" this upgrade for you. Within a few weeks, any problems (although I don't expect there will be any) will surface and you'll know whether the update is safe. Your camera is working fine right now, so why take the chance?

How It Works

If you're computer savvy, you might wonder how your Panasonic Lumix DMC-GF1 is able to overwrite its own operating system—that is, how can the existing firmware be used to load the new version on top of itself? Panasonic has made the process quite sensible and easy, when compared to the cameras from some other vendors. Those non-Panasonic models may require tedious steps like copying the new software module to a memory card, then going through a maze of menus to locate the firmware installation routine.

Panasonic, on the other hand, handles firmware upgrades the smart way. You connect your camera to your computer, run the Panasonic Master software, and allow that utility to evaluate the GF1's firmware status, locate any updated firmware over the internet, and install it through the USB cable link. What could be simpler?

WARNING

Use a fully charged battery to ensure that you'll have enough power to operate the camera for the entire upgrade. Moreover, you should not turn off the camera while your old firmware is being overwritten. Don't open the Secure Digital card door, jiggle the USB cable, or do anything else that might disrupt operation of the GF1 while the firmware is being installed.

Getting Ready

The first thing to do is determine whether you need the current firmware update. Confirm the version number of your Panasonic Lumix DMC-GF1's current firmware, and see if an update is available.

1. **Mount a lens onto the camera body.** Both lenses and camera bodies can be updated with new firmware versions. So, you need to know the firmware installed on both your lens and GF1 body.

2. **Turn on the GF1.**

3. **Access Version Display.** Press the MENU/SET button, navigate to the Setup menu and select Version DISP (it's on the fourth page of entries). Press the right arrow button.

4. **Note the version.** You'll be shown both Body Firmware and Lens Firmware values. Open the Browse window and pull down the Camera menu. Unfortunately, certain Four Thirds (not Micro Four Thirds) lens accessories, such as a teleconverter, may also require a firmware update, but that is not possible with the GF1, even if the accessory is linked to the camera through the Mount Adapter (DMW-MA1). You'll need to locate an actual Four Thirds camera body and update your lens accessory using that camera instead.

Next, find the latest firmware, determine if it's newer than the version installed on your camera, then download, and install it. Just follow these steps:

1. **Locate the firmware.** The URL for downloading firmware updates has changed from time to time. Your best bet is to go to www.panasonic.com and wend your way through the menus to the support page, then choose Drivers and Downloads. Or you can try this URL, which worked as I was writing this book: http://panasonic.jp/support/global/cs/dsc/download/fts/index.html (no www. prefix).

2. **Download.** The filename will be something like GF1_V12.exe (for PCs) or GF1_V12.zip (for Macs). Either of them will extract to the actual firmware file named GF1_122.bin (or something similar if it's a newer version than the one I installed).

3. **Copy to card.** Copy the extracted firmware .bin file to an SD memory card that has been freshly formatted in your GF1. Make sure you are copying the .bin file and not the .exe or .zip file!

4. **Insert card in camera.** Power up the camera.

5. **Activate Play mode.** Press the Play button. You'll see a message "Start Version Up?" on the camera LCD. Choose Yes. This will initiate updating of the firmware for your lens (if necessary) or camera body, if no lens update is required.

6. **Update begins.** You'll see a message, "Version Up Ongoing. Do not operate any of the buttons on the camera." A green progress bar shows the status. When the update is finished, turn the camera off and then on again, with the new firmware activated.

7. **Repeat steps 5-6 to update camera body.** If a lens update has been installed, you may have to repeat the process to update the body firmware. The steps are the same, but this time the camera body firmware will be updated.

8. **Reformat memory card.** Once you've installed the firmware update, reformat the memory card for use in storing pictures.

Protect Your LCD

The large 3-inch color LCD on the back of your Panasonic Lumix DMC-GF1 almost seems like a target for banging, scratching, and other abuse. The LCD itself is quite rugged, and a few errant knocks are unlikely to shatter the protective cover over the LCD, and scratches won't easily mar its surface. However, if you want to be on the safe side, there are a number of protective products you can purchase to keep your LCD safe—and, in some cases, make it a little easier to view. Here's a quick overview of your other options, some of which are likely to add enough thickness to your LCD to prevent you from reversing the LCD when you need to. That's a choice you'll have to make.

■ **Plastic overlays.** The simplest solution (although not always the cheapest) is to apply a plastic overlay sheet or "skin" cut to fit your LCD. These adhere either by static electricity or through a light adhesive coating that's even less clingy than stick-it notes. You can cut down overlays made for PDAs (although these can be pricey at up to $19.95 for a set of several sheets), or purchase overlays sold specifically for digital cameras. Vendors such as Hoodman (www.hoodmanusa.com) offer overlays of this type. These products will do a good job of shielding your GF1's LCD screen from scratches and minor impacts, but will not offer much protection from a good whack.

■ **Acrylic and glass shields.** These scratch-resistant acrylic and tempered glass panels, laser cut to fit your camera perfectly, are my choice as the best protection solution. At about $6 each, they also happen to be the least expensive option as well. I get mine from a company called Da Products (www.daproducts.com). GGS also makes excellent glass shields (see Figure 9.2), but, unfortunately, there seems to be no direct importer of these shields in the USA. You can find them by Googling or searching eBay auctions and stores. They attach using sticky adhesive that holds the panel flush and tight, but which allows the shield to be pried off and the adhesive removed easily if you want to remove or replace the shield. They don't attenuate your view of the LCD and are non-reflective enough for use under a variety of lighting conditions.

Figure 9.2
A tough tempered glass shield can protect your LCD from scratches.

■ **Flip-up hoods.** These protectors slip on using adhesive or some other means of attachment. (I haven't seen one for the GF1 yet, but know some vendor will offer one eventually.) The hood provides a cover that completely shields the LCD, but unfolds to provide a three-sided hood that allows viewing the LCD while minimizing the extraneous light falling on it and reducing contrast. If you want to completely protect your LCD from hard knocks and need to view the screen outdoors in bright sunlight, there is nothing better. However, I have a couple problems with these devices. First, with the cover closed, you can't peek down after taking a shot to see what your image looks like during picture review. You must open the cap each time you want to look at the LCD. Moreover, with the hood unfolded, it's difficult to look through the viewfinder: Don't count on being able to use the viewfinder *and* the LCD at the same time with one of these hoods in place.

■ **Magnifiers.** If you look hard enough, you should be able to find an LCD magnifier that fits over the monitor panel and provides a 2X magnification. These often strap on clumsily, and serve better as a way to get an enlarged view of the LCD than as protection.

Troubleshooting Memory Cards

Sometimes good memory cards go bad. Sometimes good photographers can treat their memory cards badly. It's possible that a memory card that works fine in one camera won't be recognized when inserted into another. In the worst case, you can have a card full of important photos and find that the card seems to be corrupted and you can't access any of them. Don't panic! If these scenarios sound horrific to you, there are many things you can do to prevent them from happening, and a variety of remedies available if they do occur. You'll want to take some time—before disaster strikes—to consider your options.

All Your Eggs in One Basket?

The debate about whether it's better to use one large memory card or several smaller ones has been going on since even before there were memory cards. I can remember when computer users wondered whether it was smarter to install a pair of 200MB (not *gigabyte*) hard drives in their computer, or if they should go for one of those new-fangled 500MB models. By the same token, a few years ago the user groups were full of proponents who insisted that you ought to use 128MB memory cards rather than the huge 512MB versions. Today, most of the arguments involve 8GB cards versus 4GB cards, and I expect that as prices for 16GB SD cards continue to drop, they'll find their way into the debate as well.

Why all the fuss? Are 8GB memory cards more likely to fail than 4GB cards? Are you risking all your photos if you trust your images to a larger card? Isn't it better to use several smaller cards, so that if one fails you lose only half as many photos? Or, isn't it wiser to put all your photos onto one larger card, because the more cards you use, the better your odds of misplacing or damaging one and losing at least some pictures?

In the end, the "eggs in one basket" argument boils down to statistics, and how you happen to use your GF1. The rationales can go both ways. If you have multiple smaller cards, you do increase your chances of something happening to one of them, so, arguably, you might be boosting the odds of losing some pictures. If all your images are important, the fact that you've lost 100 rather than 200 pictures isn't very comforting.

Also, consider that the eggs/basket scenario assumes that the cards that are lost or damaged are always full. It's actually likely that your 8GB card might suffer a mishap when it's less than half full (indeed, it's more likely that a large card won't be completely filled before it's offloaded to a computer), so you really might not lose any more shots with a single 8GB card than with multiple 4GB or 2GB cards.

If you shoot photojournalist-type pictures, you probably change memory cards when they're less than completely full in order to avoid the need to do so at a crucial moment.

(When I shoot sports, my cards rarely reach 80 to 90 percent of capacity before I change them.) Using multiple smaller cards means you have to change them that more often, which can be a real pain when you're taking a lot of photos. In my book, I prefer keeping all my eggs in one basket, and then making very sure that nothing happens to that basket.

The other reason comes into play when every single picture is precious to you and the loss of any of them would be a disaster. If you were a wedding photographer, for example, and unlikely to be able to restage the nuptials if a memory card goes bad, you'd probably want to shoot no more pictures than you can afford to lose on a single card, and have an assistant ready to copy each card removed from the camera onto a backup hard drive or DVD onsite.

If none of these options are available to you, consider *interleaving* your shots. Say you don't shoot weddings with a Panasonic Lumix DMC-GF1, but you do go on vacation from time to time. Take 50 or so pictures on one card, or whatever number of images might fill about 25 percent of its capacity. Then, replace it with a different card and shoot about 25 percent of that card's available space. Repeat these steps with diligence (you'd have to be determined to go through this inconvenience), and, if you use four or more memory cards you'll find your pictures from each location scattered among the different Secure Digital cards. If you lose or damage one, you'll still have *some* pictures from all the various stops on your trip on the other cards. That's more work than I like to do (I usually tote around a portable hard disk and copy the files to the drive as I go), but it's an option.

Another option is to transmit your images, as they are shot, over a network to your laptop, assuming a network and a laptop are available. A company called Eye-Fi (www.eye.fi [no .com]) markets a clever SD card with wireless capabilities built in. They currently offer four models, including the basic Eye-Fi Home (about $50), which can be used to transmit your photos from the GF1 to a computer on your home network (or any other network you set up somewhere, say, at a family reunion). Eye-Fi Share and Eye-Fi Share Video (about $60 and $80, respectively) are basically exactly the same; however, the Share Video version is 4GB instead of 2GB in capacity, and includes software to allow you to upload your images from your camera through your computer network directly to websites such as Flickr, Facebook, Shutterfly, and also to upload to digital printing services that include Walmart Digital Photo Center. The most sophisticated option is Eye-Fi Explore, a 4GB SDHC (Secure Digital High Capacity) card (see Figure 9.3) that adds geographic location labels to your photo (so you'll know where you took it), and frees you from your own computer network by allowing uploads from more than 10,000 WiFi hotspots around the USA. Very cool, and the ultimate in picture backup.

Figure 9.3
Eye-Fi cards allow transmitting from your camera directly to your computer, or to online galleries.

What Can Go Wrong?

There are lots of things that can go wrong with your memory card, but the ones that aren't caused by human stupidity are statistically very rare. Yes, a Secure Digital card's internal bit bin or controller can suddenly fail due to a manufacturing error or some inexplicable event caused by old age. However, if your SD card works for the first week or two that you own it, it should work forever. There's really not a lot that can wear out.

The typical Secure Digital card is rated for a Mean Time Between Failures of 1,000,000 hours of use. That's constant use 24/7 for more than 100 years! According to the manufacturers, they are good for 10,000 insertions in your camera, and should be able to retain their data (and that's without an external power source) for something on the order of 11 years. Of course, with the millions of SD cards in use, there are bound to be a few lemons here or there.

Given the reliability of solid-state memory compared to magnetic memory, though, it's more likely that your Secure Digital problems will stem from something that you do. SD cards are small and easy to misplace if you're not careful. For that reason, it's a good idea to keep them in their original cases or a "card safe" offered by Gepe (www.gepecardsafe.com), Pelican (www.pelican.com), and others. Always placing your memory card in a case can provide protection from the second-most common mishap that befalls Secure Digital cards: the common household laundry. If you slip a memory card in a pocket, rather than a case or your camera bag often enough, sooner or later it's going to end up in the washing machine and probably the clothes dryer, too. There are plenty of reports of relieved digital camera owners who've laundered their memory cards and found they still worked fine, but it's not uncommon for such mistreatment to do some damage.

Memory cards can also be stomped on, accidentally bent, dropped into the ocean, chewed by pets, and otherwise rendered unusable in myriad ways. Or, if the card is formatted in your computer with a memory card reader, your GF1 may fail to recognize it. Occasionally, I've found that a memory card used in one camera would fail if used in a different camera (until I reformatted it in Windows, and then again in the camera). Every once in awhile, a card goes completely bad and—seemingly—can't be salvaged.

Another way to lose images is to do commonplace things with your SD card at an inopportune time. If you remove the card from the GF1 while the camera is writing images to the card, you'll lose any photos in the buffer and may damage the file structure of the card, making it difficult or impossible to retrieve the other pictures you've taken. The same thing can happen if you remove the SD card from your computer's card reader while the computer is writing to the card (say, to erase files you've already moved to your computer). You can avoid this by *not* using your computer to erase files on a Secure Digital card but, instead, always reformatting the card in your GF1 before you use it again.

What Can You Do?

Pay attention: If you're having problems, the *first* thing you should do is *stop* using that memory card. Don't take any more pictures. Don't do anything with the card until you've figured out what's wrong. Your second line of defense (your first line is to be sufficiently careful with your cards that you avoid problems in the first place) is to *do no harm* that hasn't already been done. Read the rest of this section and then, if necessary, decide on a course of action (such as using a data recovery service or software, described later) before you risk damaging the data on your card further.

Now that you've calmed down, the first thing to check is whether you've actually inserted a card in the camera. Things get more exciting when the card itself is put in jeopardy. If you lose a card, there's not a lot you can do other than take a picture of a similar card and print up some "Have You Seen This Lost Flash Memory?" flyers to post on utility poles all around town.

If all you care about is reusing the card, and have resigned yourself to losing the pictures, try reformatting the card in your camera. You may find that reformatting removes the corrupted data and restores your card to health. Sometimes I've had success reformatting a card in my computer using a memory card reader (this is normally a no-no because your operating system doesn't understand the needs of your GF1), and *then* reformatting again in the camera.

If your Secure Digital card is not behaving properly, and you *do* want to recover your images, things get a little more complicated. If your pictures are very valuable, either to you or to others (for example, a wedding), you can always turn to professional data recovery firms. Be prepared to pay hundreds of dollars to get your pictures back, but

these pros often do an amazing job. You wouldn't want them working on your memory card on behalf of the police if you'd tried to erase some incriminating pictures. There are many firms of this type, and I've never used them myself, so I can't offer a recommendation. Use a Google search to turn up a ton of them.

THE ULTIMATE IRONY

I recently purchased an 8GB Kingston memory card that was furnished with some nifty OnTrack data recovery software. The first thing I did was format the card to make sure it was OK. Then I hunted around for the free software, only to discover it was preloaded onto the memory card. I was supposed to copy the software to my computer before using the memory card for the first time.

Fortunately, I had the OnTrack software that would reverse my dumb move, so I could retrieve the software. No, wait. I *didn't* have the software I needed to recover the software I erased. I'd reformatted it to oblivion. Chalk this one up as either the ultimate irony or Stupid Photographer Trick #523.

A more reasonable approach is to try special data recovery software you can install on your computer and use to attempt to resurrect your "lost" images yourself. They may not actually be gone completely. Perhaps your SD card's "table of contents" is jumbled, or only a few pictures are damaged in such a way that your camera and computer can't read some or any of the pictures on the card. Some of the available software was written specifically to reconstruct lost pictures, while other utilities are more general-purpose applications that can be used with any media, including floppy disks and hard disk drives. They have names like OnTrack, Photo Rescue 2, Digital Image Recovery, MediaRecover, Image Recall, and the aptly named Recover My Photos. You'll find a comprehensive list and links, as well as some picture-recovery tips at www.ultimateslr.com/memory-card-recovery.php. I like the RescuePRO software that SanDisk supplies (see Figure 9.4), especially since it came on a mini-CD that was impossible to erase by mistake.

DIMINISHING RETURNS

Usually, once you've recovered any images on a Secure Digital card, reformatted it, and returned it to service, it will function reliably for the rest of its useful life. However, if you find a particular card going bad more than once, you'll almost certainly want to stop using it forever. See if you can get it replaced by the manufacturer if you can, but, in the case of SD card failures, the third time is never the charm.

Figure 9.4
SanDisk
supplies
RescuePRO
recovery soft-
ware with some
of its memory
cards.

Figure 9.4
SanDisk
supplies
RescuePRO
recovery soft-
ware with some
of its memory
cards.

Clean Your Sensor

Panasonic cameras have what independent observers have repeatedly called the absolute best anti-dust features of any removable lens digital camera system. Indeed, the sensor-shaking system (actually, a filter in front of the sensor vibrates, shedding dust) is so good that the sensor can be safely exposed at all times (making live view possible), and the shutter closes only in the instant before the charge on the sensor is "dumped" to allow capturing a fresh dose of light during exposure. You'll see your naked sensor every time you change lenses in fact (see Figure 9.5).

Those who have used other interchangeable lens cameras will agree that one of the Panasonic Lumix DMC-GF1's most useful features is the automatic sensor cleaning system that reduces the need to clean your camera's sensor manually. The sensor vibrates ultrasonically each time the GF1 is powered on, shaking loose any dust. For that reason you should hold the camera vertically or lens pointing downward to allow the "shaker" to remove the dust.

Of course, even with the Panasonic Lumix DMC-GF1's automatic sensor cleaning feature, you may still be required to manually clean your sensor from time to time. This section explains the phenomenon and provides some tips on minimizing dust and eliminating it when it begins to affect your shots.

Figure 9.5
Your sensor is exposed to dust every time you change lenses.

Dust the FAQs, Ma'am

Here are some of the most frequently asked questions about sensor dust issues.

Q. I see a bright spot in the same place in all of my photos. Is that sensor dust?

A. You've probably got either a "hot" pixel or one that is permanently "stuck" due to a defect in the sensor. A hot pixel is one that shows up as a bright spot only during long exposures as the sensor warms. A pixel stuck in the "on" position always appears in the image. Both show up as bright red, green, or blue pixels, usually surrounded by a small cluster of other improperly illuminated pixels, caused by the camera's interpolating the hot or stuck pixel into its surroundings, as shown in Figure 9.6. A stuck pixel can also be permanently dark. Either kind is likely to show up when they contrast with plain, evenly colored areas of your image.

Finding one or two hot or stuck pixels in your sensor is unfortunately fairly common. They can be "removed" by telling the GF1 to ignore them through a simple process called *pixel mapping*, an option mentioned in Chapter 3. Bad pixels can also show up on your camera's color LCD panel, within the LCD itself, but, unless they are abundant, the wisest course is to just ignore them.

Figure 9.6
A stuck pixel is surrounded by improperly interpolated pixels created by the GF1's demosaicing algorithm.

Q. I see an irregular out-of-focus blob in the same place in my photos. Is that sensor dust?

A. Yes. Sensor contaminants can take the form of tiny spots, larger blobs, or even curvy lines if they are caused by minuscule fibers that have settled on the sensor. They'll appear out of focus because they aren't actually on the sensor surface but, rather, a fraction of a millimeter above it on the filter that covers the sensor. The smaller the f/stop used, the more in-focus the dust becomes. At large apertures, it may not be visible at all.

Q. I never see any dust on my sensor. What's all the fuss about?

A. Those who never have dust problems with their Panasonic Lumix DMC-GF1 fall into one of four categories: those for whom the camera's automatic dust removal features are working well; those who seldom change their lenses and have clean working habits that minimize the amount of dust that invades their cameras in the first place; those who simply don't notice the dust (often because they don't shoot many macro photos or other pictures using the small f/stops that makes dust evident in their images); and those who are very, very lucky.

Identifying and Dealing with Dust

Sensor dust is less of a problem than it might be because it shows up only under certain circumstances. Indeed, you might have dust on your sensor right now and not be aware of it. The dust doesn't actually settle on the sensor itself, but, rather, on a protective filter a very tiny distance above the sensor, subjecting it to the phenomenon of *depth-of-focus*. Depth-of-focus is the distance the focal plane can be moved and still render an object in sharp focus. At f/2.8 to f/5.6 or even smaller, sensor dust, particularly if small, is likely to be outside the range of depth-of-focus and blur into an unnoticeable dot.

However, if you're shooting at f/16 to f/22 or smaller, those dust motes suddenly pop into focus. Forget about trying to spot them by peering directly at your sensor with the shutter open and the lens removed. The period at the end of this sentence, about .33mm in diameter, could block a group of pixels measuring 40 × 40 pixels (160 pixels in all!). Dust spots that are even smaller than that can easily show up in your images if you're shooting large, empty areas that are light colored. Dust motes are most likely to show up in the sky, as in Figure 9.7, or in white backgrounds of your seamless product shots and are less likely to be a problem in images that contain lots of dark areas and detail.

To see if you have dust on your sensor, take a few test shots of a plain, blank surface (such as a piece of paper or a cloudless sky) at small f/stops, such as f/22, and a few wide open. Open Photoshop or another image editor, copy several shots into a single document in separate layers, then flip back and forth between layers to see if any spots you see are present in all layers. You may have to boost contrast and sharpness to make the dust easier to spot.

Figure 9.7
Dust on the sensor appears as out-of-focus artifacts.

Avoiding Dust

Of course, the easiest way to protect your sensor from dust is to prevent it from settling on the sensor in the first place. Here are my stock tips for eliminating the problem before it begins.

- **Clean environment.** Avoid working in dusty areas if you can do so. Hah! Serious photographers will take this one with a grain of salt, because it usually makes sense to go where the pictures are. Only a few of us are so paranoid about sensor dust (considering that it is so easily removed) that we'll avoid moderately grimy locations just to protect something that is, when you get down to it, just a tool. If you find a great picture opportunity at a raging fire, during a sandstorm, or while surrounded by dust clouds, you might hesitate to take the picture, but, with a little caution (don't remove your lens in these situations, and clean the camera afterwards!) you can still shoot. However, it still makes sense to store your camera in a clean environment. One place cameras and lenses pick up a lot of dust is inside a camera bag. Clean your bag from time to time, and you can avoid problems.

- **Clean lenses.** There are a few paranoid types that avoid swapping lenses in order to minimize the chance of dust getting inside their cameras. It makes more sense just to use a blower or brush to dust off the rear lens mount of the replacement lens first, so you won't be introducing dust into your camera simply by attaching a new, dusty lens. Do this before you remove the current lens from your camera, and then avoid stirring up dust before making the exchange.

- **Work fast.** Minimize the time your camera is lens-less and exposed to dust. That means having your replacement lens ready and dusted off, and a place to set down the old lens as soon as it is removed, so you can quickly attach the new lens.

- **Let gravity help you.** Face the camera downward when the lens is detached so any dust in the interior will tend to fall away from the sensor. Turn your back to any breezes, indoor forced air vents, fans, or other sources of dust to minimize infiltration.

- **Protect the lens you just removed.** Once you've attached the new lens, quickly put the end cap on the one you just removed to reduce the dust that might fall on it.

- **Clean out the vestibule.** From time to time, remove the lens while in a relatively dust-free environment and use a blower bulb like the one shown in Figure 9.8 (*not* compressed air or a vacuum hose) to clean out the area. A blower bulb is generally safer than a can of compressed air, or a strong positive/negative airflow, which can tend to drive dust further into nooks and crannies.

Figure 9.8
Use a robust air bulb for cleaning your sensor.

- **Be prepared.** If you're embarking on an important shooting session, it's a good idea to clean your sensor *now*, rather than come home with hundreds or thousands of images with dust spots caused by flecks that were sitting on your sensor before you even started. Before I left on my most recent trip to Spain, I put both cameras I was taking through a rigid cleaning regimen, figuring they could remain dust-free for a measly 10 days. I even left my bulky blower bulb at home, and took along a new, smaller version for emergencies.

- **Clone out existing spots in your image editor.** Photoshop and other editors have a clone tool or healing brush you can use to copy pixels from surrounding areas over the dust spot or dead pixel. This process can be tedious, especially if you have lots of dust spots and/or lots of images to be corrected. The advantage is that this sort of manual fix-it probably will do the least damage to the rest of your photo. Only the damaged pixels will be affected.

- **Use filtration in your image editor.** A semi-smart filter like Photoshop's Dust & Scratches filter can remove dust and other artifacts by selectively blurring areas that the plug-in decides represent dust spots. This method can work well if you have many dust spots, because you won't need to patch them manually. However, any automated method like this has the possibility of blurring areas of your image that you didn't intend to soften.

Sensor Cleaning

Those new to the concept of sensor dust actually hesitate before deciding to clean their camera themselves. Isn't it a better idea to pack up your GF1 and send it to a Panasonic service center so their crack technical staff can do the job for you? Or, at the very least, shouldn't you let the friendly folks at your local camera store do it?

Of course, if you choose to let someone else clean your sensor, they will be using methods that are more or less identical to the techniques you would use yourself. None of these techniques are difficult, and the only difference between their cleaning and your cleaning is that they might have done it dozens or hundreds of times. If you're careful, you can do just as good a job.

Of course vendors like Panasonic won't tell you this, but it's not because they don't trust you. It's not that difficult for a real goofball to mess up his camera by hurrying or taking a shortcut. Perhaps the person uses the "bulb" method of holding the shutter open and a finger slips and presses the shutter button, allowing the shutter curtain to close on top of a sensor cleaning brush. Or, someone tries to clean the sensor using masking tape, and ends up with goo all over its surface. If Panasonic recommended *any* method that's mildly risky, someone would do it wrong, and then the company would face lawsuits from those who'd contend they did it exactly in the way the vendor suggested, so the ruined camera is not their fault.

You can see that vendors like Panasonic tend to be conservative in their recommendations, and, in doing so, make it seem as if sensor cleaning is more daunting and dangerous than it really is. Some vendors recommend only dust-off cleaning, through the use of reasonably gentle blasts of air, while condemning more serious scrubbing with swabs and cleaning fluids. However, these cleaning kits for the exact types of cleaning they recommended against are for sale in Japan only, where, apparently, your average photographer is more dexterous than those of us in the rest of the world. These kits are similar to those used by official repair staff to clean your sensor if you decide to send your camera in for a dust-up.

As I noted, sensors can be affected by dust particles that are much smaller than you might be able to spot visually on the surface of your lens. The filters that cover sensors tend to be fairly hard compared to optical glass. Cleaning the sensor in your Panasonic Lumix DMC-GF1 within the tight confines of the mirror box can call for a steady hand and careful touch. If your sensor's filter becomes scratched through inept cleaning, you can't simply remove it yourself and replace it with a new one.

There are four basic kinds of cleaning processes that can be used to remove dusty and sticky stuff that settles on your dSLR's sensor. All of these must be performed with the shutter locked open. I'll describe these methods and provide instructions for locking the shutter later in this section.

- **Air cleaning.** This process involves squirting blasts of air from a blower bulb inside your camera. This works well for dust that's not clinging stubbornly to your sensor.

- **Brushing.** A soft, very fine brush is passed across the surface of the sensor's filter, dislodging mildly persistent dust particles and sweeping them off the imager.

- **Liquid cleaning.** A soft swab dipped in a cleaning solution such as ethanol is used to wipe the sensor filter, removing more obstinate particles.

- **Tape cleaning.** There are some who get good results by applying a special form of tape to the surface of their sensor. When the tape is peeled off, all the dust goes with it. Supposedly. I'd be remiss if I didn't point out right now that this form of cleaning is somewhat controversial; the other three methods are much more widely accepted.

Air Cleaning

Your first attempts at cleaning your sensor should always involve gentle blasts of air. Many times, you'll be able to dislodge dust spots, which will fall off the sensor and, with luck, out of the interior of the camera. Attempt one of the other methods only when you've already tried air cleaning and it didn't remove all the dust.

Here are some tips for doing air cleaning:

- **Use a clean, powerful air bulb.** Your best bet is bulb cleaners designed for the job. Smaller bulbs, like those air bulbs with a brush attached sometimes sold for lens cleaning or weak nasal aspirators may not provide sufficient air or a strong enough blast to do much good.

- **Hold the Panasonic Lumix DMC-GF1 upside down.** Then look up into the interior as you squirt your air blasts, increasing the odds that gravity will help pull the expelled dust downward, away from the sensor. You may have to use some imagination in positioning yourself.

- **Never use air canisters.** The propellant inside these cans can permanently coat your sensor if you tilt the can while spraying. It's not worth taking a chance.

- **Avoid air compressors.** Super-strong blasts of air are likely to force dust under the sensor filter and possibly damage some internal parts.

Brush Cleaning

If your dust is a little more stubborn and can't be dislodged by air alone, you may want to try a brush, charged with static electricity, which can pick off dust spots by electrical attraction. One good, but expensive, option is the sensor brush sold at www.visible-dust.com. A cheaper version can be purchased at www.copperhillimages.com. You need a brush like the one shown in Figure 9.9, which can be stroked across the long dimension of your GF1's sensor.

Ordinary artist's brushes are much too coarse and stiff and have fibers that are tangled or can come loose and settle on your sensor. A good sensor brush's fibers are resilient and described as "thinner than a human hair." Moreover, the brush has a wooden handle that reduces the risk of static sparks. Check out my *Digital SLR Pro Secrets* book if you want to make a sensor brush (or sensor swabs) yourself.

Figure 9.9

A proper brush, such as this model with a grounding strap, is required for dusting off your sensor.

Brush cleaning is done with a dry brush by gently swiping the surface of the sensor filter with the tip. The dust particles are attracted to the brush particles and cling to them. You should clean the brush with compressed air before and after each use, and store it in an appropriate air-tight container between applications to keep it clean and dust-free. Although these special brushes are expensive, one should last you a long time.

Liquid Cleaning

Unfortunately, you'll often encounter really stubborn dust spots that can't be removed with a blast of air or flick of a brush. These spots may be combined with some grease or a liquid that causes them to stick to the sensor filter's surface. In such cases, liquid cleaning with a swab may be necessary. During my first clumsy attempts to clean my own sensor, I accidentally got my blower bulb tip too close to the sensor, and some sort of deposit from the tip of the bulb ended up on the sensor. I panicked until I discovered that liquid cleaning did a good job of removing whatever it was that took up residence on my sensor.

You can make your own swabs out of pieces of plastic (some use fast food restaurant knives, with the tip cut at an angle to the proper size) covered with a soft cloth or Pec-Pad, as shown in Figures 9.10 and 9.11. However, if you've got the bucks to spend, you can't go wrong with good quality commercial sensor cleaning swabs, such as those sold by Photographic Solutions, Inc. (www.photosol.com/swabproduct.htm).

You want a sturdy swab that won't bend or break so you can apply gentle pressure to the swab as you wipe the sensor surface. Use the swab with methanol (as pure as you can get it, particularly medical grade; other ingredients can leave a residue), or the Eclipse solution also sold by Photographic Solutions. Eclipse is actually quite a bit purer than even medical-grade methanol. A couple drops of solution should be enough, unless you have a spot that's extremely difficult to remove. In that case, you may need to use extra solution on the swab to help "soak" the dirt off.

Figure 9.10 You can make your own sensor swab from a plastic knife that's been truncated.

Figure 9.11 Carefully wrap a Pec-Pad around the swab.

Once you overcome your nervousness at touching your GF1's sensor, the process is easy. You'll wipe continuously with the swab in one direction, then flip it over and wipe in the other direction. You need to completely wipe the entire surface; otherwise, you may end up depositing the dust you collect at the far end of your stroke. Wipe; don't rub.

Tape Cleaning

There are people who absolutely swear by the tape method of sensor cleaning. The concept seems totally wacky, and I have never tried it personally, so I can't say with certainty that it either does or does not work. In the interest of completeness, I'm including it here. I can't give you a recommendation, so if you have problems, please don't blame me. The Panasonic Lumix DMC-GF1 is still too new to have generated any reports of users accidentally damaging the anti-dust coating on the sensor filter using this method.

Tape cleaning works by applying a layer of Scotch Brand Magic Tape to the sensor. This is a minimally sticky tape that some of the tape-cleaning proponents claim contains no adhesive. I did check this out with 3M, and can say that Magic Tape certainly *does* contain an adhesive. The question is whether the adhesive comes off when you peel back the tape, taking any dust spots on your sensor with it. The folks who love this method

claim there is no residue. There have been reports from those who don't like the method that residue is left behind. This is all anecdotal evidence, so you're pretty much on your own in making the decision whether to try out the tape cleaning method.

Checking Your Work

If you want a close-up look at your sensor to make sure the dust has been removed, you can pay $50-$100 for a special sensor "microscope" with an illuminator, like the one shown in Figure 9.12. I use such a device when I'm close to home, but it's too bulky and too expensive to tuck a sensorscope into every camera bag I own. Instead, I have four or five plain old Carson MiniBrite PO-25 illuminated 3X magnifiers, as seen in Figure 9.13. (Older packaging and ads may call this a 2X magnifier, but it's actually a 3X unit.) It has a built-in LED and, held a few inches from the lens mount with the lens removed from your camera, provides a sharp, close-up view of the sensor, with enough contrast to reveal any dust that remains. You can find out more information about this magnifier, and a link to buy one, at www.dslrguides.com/carson/.

Figure 9.12 A special "sensorscope" viewer can help detect any remaining dust on your sensor.

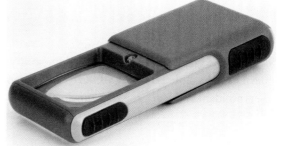

Figure 9.13 An illuminated magnifier like this Carson MiniBrite PO-25 is an inexpensive substitute 'scope that costs less than $10.

Glossary

It's always handy to have a single resource where you can look up various terms you'll encounter while working with your digital camera. Here is the latest update of a glossary I've compiled over the years, with some new additions specifically for the Panasonic Lumix DMC-GF1.

ambient lighting Diffuse, non-directional lighting that doesn't appear to come from a specific source but, rather, bounces off walls, ceilings, and other objects in the scene when a picture is taken.

analog/digital converter The module in the camera that electronically converts the analog information captured by the GF1's sensor into digital bits that can be stored as an image.

angle of view The area of a scene that a lens can capture, determined by the focal length of the lens. Lenses with a shorter focal length have a wider angle of view than lenses with a longer focal length.

anti-alias A process that smoothes the look of rough edges in images (called *jaggies* or *staircasing*) by adding partially transparent pixels along the boundaries of diagonal lines that are merged into a smoother line by our eyes. *See also* jaggies.

aperture The size of the opening in the iris or diaphragm of a lens, relative to the lens's focal length. Also called an *f/stop*. For example, with a lens having a focal length of 100mm, an f/stop with a diameter of 12.5mm would produce an aperture value of f/8.

Aperture-priority A camera setting that allows you to specify the lens opening or f/stop that you want to use, with the camera selecting the required shutter speed automatically based on its light-meter reading. *See also* Shutter-priority.

artifact A type of noise in an image, or an unintentional image component produced in error by a digital camera during processing, usually caused by the JPEG compression process in digital cameras, or, in some cases, by dust settling on the sensor.

aspect ratio The proportions of an image as printed, displayed on a monitor, or captured by a digital camera.

Autofocus A camera setting that allows the Panasonic Lumix DMC-GF1 to choose the correct focus distance for you, based on the contrast of an image (the image will be at maximum contrast when in sharp focus). The camera can be set for *Single-Servo Autofocus (AFS)*, in which the lens is not focused until the shutter release is partially depressed, *Continuous-Servo Autofocus (AFC)*, in which the lens refocuses constantly as you frame and reframe the image. The GF1 can also be set for *Manual* focus.

backlighting A lighting effect produced when the main light source is located behind the subject. Backlighting can be used to create a silhouette effect, or to illuminate translucent objects. *See also* front lighting and side lighting.

barrel distortion A lens defect that causes straight lines at the top or side edges of an image to bow outward into a barrel shape. *See also* pincushion distortion.

blooming An image distortion caused when a photosite in an image sensor has absorbed all the photons it can handle so that additional photons reaching that pixel overflow to affect surrounding pixels, producing unwanted brightness and overexposure around the edges of objects.

blur To soften an image or part of an image by throwing it out of focus, or by allowing it to become soft due to subject or camera motion. Blur can also be applied creatively in an image-editing program.

bokeh A term derived from the Japanese word for blur, which describes the aesthetic qualities of the out-of-focus parts of an image. Some lenses produce "good" bokeh and others offer "bad" bokeh. Some lenses produce uniformly illuminated out-of-focus discs. Others produce a disc that has a bright edge and a dark center, producing a "doughnut" effect, which is the worst from a bokeh standpoint. Lenses that generate a bright center that fades to a darker edge are favored, because their bokeh allows the circle of confusion to blend more smoothly with the surroundings. The bokeh characteristics of a lens are most important when you're using selective focus (say, when shooting a portrait) to deemphasize the background, or when shallow depth-of-field is a given because you're working with a macro lens, with a long telephoto, or with a wide-open aperture. *See also* circle of confusion.

bounce lighting Light bounced off a reflector, including ceiling and walls, to provide a soft, natural-looking light.

bracketing A technique that involves taking several shots of the same subject using different camera settings, adjusting the exposure or white balance between them to provide a selection of effects. The procedure can be done manually by the photographer adjusting f/stops and shutter speeds (and, sometimes ISO) to produce exposures that are less than, more than, and the same as the metered exposure. The DMC-GF1 can also make these changes when using autobracketing. With white balance bracketing, the color balance of the image is changed between shots, rather than the exposure.

buffer The digital camera's internal memory where an image is stored immediately after it is taken until it can be written to the camera's non-volatile (semi-permanent) memory card.

Burst mode The digital camera's equivalent of the film camera's motor drive, used to take multiple shots within a short period of time, each stored in a memory buffer temporarily before writing them to the media.

calibration A process used to correct for the differences in the output of a printer or monitor when compared to the original image. Once you've calibrated your scanner, monitor, and/or your image editor, the images you see on the screen more closely represent what you'll get from your printer, even though calibration is never perfect.

Camera Raw A plug-in included with Photoshop and Photoshop Elements that can manipulate the unprocessed images captured by digital cameras, such as the Panasonic Lumix DMC-GF1's RAW files. The latest versions of this module can also work with JPEG and TIFF images.

camera shake Movement of the camera, aggravated by slower shutter speeds, which produces a blurred image.

Center weighted meter A light-measuring device that emphasizes the area in the middle of the frame when calculating the correct exposure for an image. *See also* Spot meter.

chromatic aberration An image defect, often seen as green or purple fringing around the edges of an object, caused by a lens failing to focus all colors of a light source at the same point. *See also* fringing.

circle of confusion A term applied to the fuzzy discs produced when a point of light is out of focus. The circle of confusion is not a fixed size. The viewing distance and amount of enlargement of the image determine whether we see a particular spot on the image as a point or as a disc. *See also* bokeh.

close-up lens A lens add-on that allows you to take pictures at a distance that is less than the closest-focusing distance of the lens alone.

color correction Changing the relative amounts of color in an image to produce a desired effect, typically a more accurate representation of those colors. Color correction can fix faulty color balance in the original image, or compensate for the deficiencies of the inks used to reproduce the image.

compression Reducing the size of a file by encoding using fewer bits of information to represent the original. Some compression schemes, such as JPEG, operate by discarding some image information, while others have options that preserve all the detail in the original, discarding only redundant data.

Continuous-Servo Autofocus An automatic focusing setting (AFC) in which the camera constantly refocuses the image as you frame the picture. This setting is often the best choice for moving subjects. *See also* Single-Servo Autofocus.

contrast The range between the lightest and darkest tones in an image. A high-contrast image is one in which the shades fall at the extremes of the range between white and black. In a low-contrast image, the tones are closer together.

dedicated flash An electronic flash unit, such as the Panasonic SB-900 Speedlight, designed to work with the automatic exposure features of a specific camera.

depth-of-field A distance range in a photograph in which all included portions of an image are at least acceptably sharp.

diaphragm An adjustable component, similar to the iris in the human eye, which can open and close to provide specific-sized lens openings, or f/stops, and thus control the amount of light reaching the sensor or film.

diffuse lighting Soft, low-contrast lighting.

digital processing chip A solid-state device found in digital cameras that's in charge of applying the image algorithms to the raw picture data prior to storage on the memory card.

diopter A value used to represent the magnification power of a lens, calculated as the reciprocal of a lens's focal length (in meters). Diopters are most often used to represent the optical correction used in a viewfinder to adjust for limitations of the photographer's eyesight, and to describe the magnification of a close-up lens attachment.

equivalent focal length A digital camera's focal length translated into the corresponding values for a 35mm film camera. This value can be calculated for lenses used with the Panasonic Lumix DMC-GF1 by multiplying by 2.0.

exchangeable image file format (Exif) Developed to standardize the exchange of image data between hardware devices and software. A variation on JPEG, Exif is used by most digital cameras, and includes information such as the date and time a photo was taken, the camera settings, resolution, amount of compression, and other data.

Exif *See* exchangeable image file format (Exif).

exposure The amount of light allowed to reach the film or sensor, determined by the intensity of the light, the amount admitted by the iris of the lens, the length of time determined by the shutter speed, and the sensitivity of the sensor or film to light.

exposure compensation Exposure compensation, which uses exposure value (EV) settings, is a way of adding or decreasing exposure without the need to reference f/stops or shutter speeds. For example, if you tell your camera to add +1EV, it will provide twice as much exposure, either by using a larger f/stop, slower shutter speed, or both. The GF1 offers both conventional exposure compensation and flash exposure compensation.

fill lighting In photography, lighting used to illuminate shadows. Reflectors or additional incandescent lighting or electronic flash can be used to brighten shadows. One common technique outdoors is to use the camera's flash as a fill in sunlit situations.

filter In photography, a device that fits over the lens, changing the light in some way. In image editing, a feature that changes the pixels in an image to produce blurring, sharpening, and other special effects. Photoshop includes several interesting filter effects, including Lens Blur and Photo Filters.

flash sync The timing mechanism that ensures that an internal or external electronic flash fires at the correct time during the exposure cycle. A digital SLR's flash sync speed is the highest shutter speed that can be used with flash, ordinarily 1/180th of a second with the Panasonic Lumix DMC-GF1. *See also* front-curtain sync and rear-curtain sync.

focal length The distance between the film and the optical center of the lens when the lens is focused on infinity, usually measured in millimeters.

focal plane A line, perpendicular to the optical axis, which passes through the focal point forming a plane of sharp focus when the lens is set at infinity. A focal plane indicator is etched into the Panasonic Lumix DMC-GF1 on the top panel.

focus tracking The ability of the automatic focus feature of a camera to change focus as the distance between the subject and the camera changes. One type of focus tracking is *predictive,* in which the mechanism anticipates the motion of the object being focused on, and adjusts the focus to suit.

format To erase a memory card and prepare it to accept files.

fringing A chromatic aberration that produces fringes of color around the edges of subjects, caused by a lens's inability to focus the various wavelengths of light onto the same spot. Purple fringing is especially troublesome with backlit images.

front-curtain sync (first-curtain sync) The default kind of electronic flash synchronization technique, originally associated with focal plane shutters, consisting of a traveling set of curtains, including a *front curtain*, which opens to reveal the film or sensor, and a *rear curtain*, which follows at a distance determined by shutter speed to conceal the film or sensor at the conclusion of the exposure. For a flash picture to be taken, the entire sensor must be exposed at one time to the brief flash exposure, so the image is exposed after the front curtain has reached the other side of the focal plane, but before the rear curtain begins to move. Front-curtain sync causes the flash to fire at the beginning of this period when the shutter is completely open, in the instant that the first curtain of the focal plane shutter finishes its movement across the film or sensor plane. With slow shutter speeds, this feature can create a blur effect from the ambient light, showing as patterns that follow a moving subject with the subject shown sharply frozen at the beginning of the blur trail. *See also* rear-curtain sync.

front lighting Illumination that comes from the direction of the camera. *See also* back-lighting and side lighting.

f/stop The relative size of the lens aperture, which helps determine both exposure and depth-of-field. The larger the f/stop number, the smaller the f/stop itself.

graduated filter A lens attachment with variable density or color from one edge to another. A graduated neutral-density filter, for example, can be oriented so the neutral-density portion is concentrated at the top of the lens's view with the less dense or clear portion at the bottom, thus reducing the amount of light from a very bright sky while not interfering with the exposure of the landscape in the foreground. Graduated filters can also be split into several color sections to provide a color gradient between portions of the image.

gray card A piece of cardboard or other material with a standardized 18-percent reflectance. Gray cards can be used as a reference for determining correct exposure or for setting white balance.

group A way of bundling more than one wireless flash unit into a single cluster that all share the same flash output setting, as controlled by the master flash unit.

HDMI High Definition Multimedia Interface is a connection for transmitting digital audio and video information, including standard, enhanced, and high definition video and multiple channels of audio. Panasonic includes an HDMI port in the GF1.

high contrast A wide range of density in a print, negative, or other image.

highlights The brightest parts of an image containing detail.

histogram A kind of chart showing the relationship of tones in an image using a series of 256 vertical bars, one for each brightness level. A histogram chart, such as the one the Panasonic Lumix DMC-GF1 can display during picture preview or review, typically looks like a curve with one or more slopes and peaks, depending on how many high-light, midtone, and shadow tones are present in the image.

hot shoe A mount on top of a camera used to hold an electronic flash, while providing an electrical connection between the flash and the camera. Also called an accessory shoe.

hyperfocal distance A point of focus where everything from half that distance to infinity appears to be acceptably sharp. For example, if your lens has a hyperfocal distance of four feet, everything from two feet to infinity would be sharp. The hyperfocal distance varies by the lens and the aperture in use. If you know you'll be making a grab shot without warning, sometimes it is useful to turn off your camera's automatic focus, and set the lens to infinity, or, better yet, the hyperfocal distance. Then, you can snap off a quick picture without having to wait for the lag that occurs with most digital cameras as their autofocus locks in.

image rotation A feature that senses whether a picture was taken in horizontal or vertical orientation. That information is embedded in the picture file so that the camera and compatible software applications can automatically display the image in the correct orientation.

image stabilization A technology that compensates for camera shake, usually by adjusting the position of the camera sensor or (with the implementation used by some vendors) by rearranging the position of certain lens elements in response to movements of the camera (with certain Micro Four Thirds lenses offered by Panasonic).

incident light Light falling on a surface.

International Organization for Standardization (ISO) A governing body that provides standards used to represent film speed, or the equivalent sensitivity of a digital camera's sensor. Digital camera sensitivity is expressed in ISO settings.

interpolation A technique digital cameras, scanners, and image editors use to create new pixels required whenever you resize or change the resolution of an image based on the values of surrounding pixels. Devices such as scanners and digital cameras can also use interpolation to create pixels in addition to those actually captured, thereby increasing the apparent resolution or color information in an image.

ISO *See* International Organization for Standardization (ISO).

jaggies Staircasing effect of lines that are not perfectly horizontal or vertical, caused by pixels that are too large to represent the line accurately. *See also* anti-alias.

JPEG A file "lossy" format (short for Joint Photographic Experts Group) that supports 24-bit color and reduces file sizes by selectively discarding image data. Digital cameras generally use JPEG compression to pack more images onto memory cards. You can select how much compression is used (and, therefore, how much information is thrown away) by selecting from among the Standard, Fine, Super Fine, or other quality settings offered by your camera. *See also* RAW.

Kelvin (K) A unit of measure based on the absolute temperature scale in which absolute zero is zero; it's used to describe the color of continuous-spectrum light sources and applied when setting white balance. For example, daylight has a color temperature of about 5,500K, and a tungsten lamp has a temperature of about 3,400K.

lag time The interval between when the shutter is pressed and when the picture is actually taken. During that span, the camera may be automatically focusing and calculating exposure. With digital SLRs like the Panasonic Lumix DMC-GF1, lag time is generally very short; with non-dSLRs, the elapsed time easily can be one second or more under certain conditions.

latitude The degree by which exposure can be varied and still produce an acceptable photo.

lens flare A feature of conventional photography that is both a bane and a creative outlet. It is an effect produced by the reflection of light internally among elements of an optical lens. Bright light sources within or just outside the field of view cause lens flare. Flare can be reduced by the use of coatings on the lens elements or with the use of lens hoods. Photographers sometimes use the effect as a creative technique, and Photoshop includes a filter that lets you add lens flare at your whim.

lighting ratio The proportional relationship between the amount of light falling on the subject from the main light and other lights, expressed in a ratio, such as 3:1.

lossless compression An image-compression scheme, such as TIFF, that preserves all image detail. When the image is decompressed, it is identical to the original version.

lossy compression An image-compression scheme, such as JPEG, that creates smaller files by discarding image information, which can affect image quality.

macro lens A lens that provides continuous focusing from infinity to extreme close-ups, often to a reproduction ratio of 1:2 (half life-size) or 1:1 (life-size).

maximum burst The number of frames that can be exposed at the current settings until the buffer fills.

midtones Parts of an image with tones of an intermediate value, usually in the 25 to 75 percent brightness range. Many image-editing features allow you to manipulate midtones independently from the highlights and shadows.

Multi metering Multi metering is a system of exposure calculation that looks at many different segments of an image to determine the brightest and darkest portions, and bases f/stop and shutter speed on settings derived from a database of images.

neutral color A color in which red, green, and blue are present in equal amounts, producing a gray.

neutral-density filter A gray camera filter reducing the amount of light entering the camera without affecting the colors.

noise In an image, pixels with randomly distributed color values. Noise in digital photographs tends to be the product of low-light conditions and long exposures, particularly when you've set your camera to a higher ISO rating than normal.

noise reduction A technology used to cut down on the amount of random information in a digital picture, usually caused by long exposures or increased ISO sensitivity ratings.

normal lens A lens that makes the image in a photograph appear in a perspective that is like that of the original scene, typically with a field of view of roughly 45 degrees.

overexposure A condition in which too much light reaches the film or sensor, producing a dense negative or a very bright/light print, slide, or digital image.

pincushion distortion A type of lens distortion in which lines at the top and side edges of an image are bent inward, producing an effect that looks like a pincushion. *See also* barrel distortion.

polarizing filter A filter that forces light, which normally vibrates in all directions, to vibrate only in a single plane, reducing or removing the specular reflections from the surface of objects and darkening blue skies.

RAW An image file format, such as the RAW format in the Panasonic Lumix DMC-GF1, which includes all the unprocessed information captured by the camera after conversion to digital form. RAW files are very large compared to JPEG files and must be processed by a special program such as Adobe's Camera Raw filter after being downloaded from the camera.

rear-curtain sync (second-curtain sync) An optional kind of electronic flash synchronization technique, originally associated with focal plane shutters, which consists of a traveling set of curtains, including a *front (first) curtain* (which opens to reveal the film or sensor) and a *rear (second) curtain* (which follows at a distance determined by shutter speed to conceal the film or sensor at the conclusion of the exposure). For a flash picture to be taken, the entire sensor must be exposed at one time to the brief flash exposure, so the image is exposed after the front curtain has reached the other side of the focal plane, but before the rear curtain begins to move. Rear-curtain sync causes the flash to fire at the end of the exposure, an instant before the second or rear curtain of the focal plane shutter begins to move. With slow shutter speeds, this feature can create a blur effect from the ambient light, showing as patterns that follow a moving subject with the subject shown sharply frozen at the end of the blur trail. If you were shooting a photo of The Flash, the superhero would appear sharp, with a ghostly trail behind him. *See also* front-curtain sync (first-curtain sync).

red-eye An effect from flash photography that appears to make a person's eyes glow red, or an animal's yellow or green. It's caused by light bouncing from the retina of the eye and is most pronounced in dim illumination (when the irises are wide open) and when the electronic flash is close to the lens and, therefore, prone to reflect directly back. Image editors can fix red-eye through cloning other pixels over the offending red or orange ones.

RGB color A color model that represents the three colors—red, green, and blue—used by devices such as scanners or monitors to reproduce color. Photoshop works in RGB mode by default, and even displays CMYK images by converting them to RGB.

saturation The purity of color; the amount by which a pure color is diluted with white or gray.

Scene mode An exposure mode intended for specific types of shooting situations, such as portraits or landscapes, with settings suitable for those scenes set by the camera with little or no user control.

selective focus Choosing a lens opening that produces a shallow depth-of-field. Usually this is used to isolate a subject in portraits, close-ups, and other types of images, by causing most other elements in the scene to be blurred.

self-timer A mechanism that delays the opening of the shutter for some seconds after the release has been operated.

sensitivity A measure of the degree of response of a film or sensor to light, measured using the ISO setting.

shadow The darkest part of an image, represented on a digital image by pixels with low numeric values.

sharpening Increasing the apparent sharpness of an image by boosting the contrast between adjacent pixels that form an edge.

shutter In a conventional film camera, the shutter is a mechanism consisting of blades, a curtain, a plate, or some other movable cover that controls the time during which light reaches the film. Digital cameras can use both a mechanical shutter and an electronic shutter for higher effective speeds.

Shutter-priority An exposure mode in which you set the shutter speed and the camera determines the appropriate f/stop. *See also* Aperture-priority.

side lighting Applying illumination from the left or right sides of the camera. *See also* backlighting and front lighting.

Single-Servo Autofocus An automatic focusing setting (AFS) in which the camera focuses once when the shutter release is pressed down halfway. *See also* Continuous-Servo Autofocus.

slave unit An accessory flash unit that supplements the main flash, usually triggered electronically when the slave senses the light output by the main unit, or through radio waves.

slow sync An electronic flash synchronizing method that uses a slow shutter speed so that ambient light is recorded by the camera in addition to the electronic flash illumination. This allows the background to receive more exposure for a more realistic effect.

specular highlight Bright spots in an image caused by reflection of light sources.

Spot meter An exposure system that concentrates on a small area in the image. *See also* Center weighted meter.

time exposure A picture taken by leaving the shutter open for a long period, usually more than one second. The camera is generally locked down with a tripod to prevent blur during the long exposure.

Through-The-Lens (TTL) A system of providing viewing and exposure calculation through the actual lens taking the picture.

tungsten light Light from ordinary room lamps and ceiling fixtures, as opposed to fluorescent illumination.

underexposure A condition in which too little light reaches the film or sensor, producing a thin negative, a dark slide, a muddy-looking print, or a dark digital image.

unsharp masking The process for increasing the contrast between adjacent pixels in an image, increasing sharpness, especially around edges.

vignetting Dark corners of an image, often produced by using a lens hood that is too small for the field of view, a lens that does not completely fill the image frame, or generated artificially using image-editing techniques.

white balance The adjustment of a digital camera to the color temperature of the light source. Interior illumination is relatively red; outdoor light is relatively blue. Digital cameras like the Panasonic Lumix DMC-GF1 set correct white balance automatically or let you do it through menus. Image editors can often do some color correction of images that were exposed using the wrong white balance setting, especially when working with RAW files that contain the information originally captured by the camera before white balance was applied.

Index

Nikkor 500mm lenses, 95
Nikon
 crop factor with cameras, 180–181
 F-mount lenses, working with, 192
Nixon, Richard, 154
no display for reviewing images,
 53–54
noise, 129–130. *See also* long exposure
 noise; wind cut
 audio noise, 177
 dark frame subtraction, 130
 Film mode menu's noise reduction
 feature, 129–130
 high ISO noise, 129–130
 pixel density and, 183
 underexposed photos and, 138
Noise Ninja, 130, 253
 Bibble Professional and, 255
noon, color temperature at, 219
normal lenses, 199
Normal Play option, Playback menu,
 106
Nostalgic film mode, 64
Novoflex Micro Four Thirds adapter,
 193
NTSC Video Out options, 103
number reset options, Setup menu,
 102

O

Objects mode, 26
 flash options with, 73, 232
off-camera flash, connecting, 237
older lenses, adapters for, 94–95
Olympus
 adapters for lenses, 193
 Four Thirds/Micro Four Thirds
 standard, 183

image stabilization in PEN cameras,
 188
 9-18mm f/4-5.6 M.Zuiko Digital ED
 lens, 191
 14-42mm f/3.5-5.6 M.Zuiko Digital
 ED lens, 190
 14-150mm f/4-5.6 M.Zuiko Digital
 ED lens, 191
 17mm f/2.8 M.Zuiko Digital lens,
 190
 teleconverters, 209
on-camera lighting for movies, 176
ON/OFF switch, 1, 42–43
One-area AF, 31, 150
OnTrack data recovery, 272
optical image stabilization. *See* image
 stabilization
optical image stabilization switch,
 40–41, 55–56
Optics Pro, 253–254
over the shoulder shot in movies, 170,
 172
overexposure
 example of, 112–113
 histograms for, 136–138
overheating
 with flash, 237
 incandescent light and heat, 218

P

P (Program) mode, 28, 111
 equivalent exposures in, 116
 flash sync mode with, 231
 ISO adjustments in, 128
 overriding exposure in, 126
 working with, 126
painting with light, 246–248
PAL Video Out options, 103